REMBRANDT'S ENTERPRISE

Rembrandt's Enterprise

THE STUDIO AND

THE MARKET

SVETLANA ALPERS

‡

THE UNIVERSITY OF

CHICAGO PRESS

The University of Chicago Press, Chicago 60637
The University of Chicago Press, Ltd., London
Thames and Hudson Ltd., London
© 1988 by The University of Chicago
All rights reserved. Published 1988
Paperback edition 1990
Printed in the United States of America

97 96 95 94 93 92 91 90 5432

Chapters 1–3 are revised from the Mary
Flexner Lectures delivered at Bryn Mawr
College in the spring of 1985.

LIBRARY OF CONGRESS CATALOGING-IN-PUBLICATION DATA

Alpers, Svetlana.
 Rembrandt's enterprise.

 Includes bibliographies and index.
 1. Rembrandt Harmenszoon van Rijn, 1606–1669—
Criticism and interpretation. 2. Rembrandt school.
3. Art, Dutch—Marketing. I. Title.
N6953.R4A88 1988 759.9492 87-16161
ISBN 0-226-01514-9 (cloth)
ISBN 0-226-01518-1 (paper)

TO MY PARENTS
ESTELLE AND WASSILY

CONTENTS

PREFACE

THIS BOOK is a revised version of the Mary Flexner Lectures delivered at Bryn Mawr College in the spring of 1985. The format in which it was first presented has largely determined its length and the focus of the argument. The fourth chapter was not one of the original lectures.

I want to thank the several institutions which subsequently invited me to lecture on the subject: in particular the Newberry Library and the Folger Institute for giving me the opportunity to hold workshops on this work in progress. I have tried to respond to at least some of the many questions raised on those occasions.

A number of people have offered comments and patiently answered my questions about materials—the theater, economics, points of language, and others—about which they have far more expertise than I. For their help and their interest I want to thank Joel Altman, Jonas Barish, Natalie Zemon Davis, Rudolf Dekker, E. H. Gombrich, Wolfgang Kemp, Wassily Leontief, Mark Meadow, Gridley McKim-Smith, Stephen Orgel, Herman Roodenburg, Charles Rhyne, Maria A. Schenkeveld-van der Dussen, Simon Schaffer, Simon Schama, Randolph Starn, and Jan de Vries. I also want to thank Forrest Bailey, John Brealey, and Joyce Plesters for taking the time to share their technical knowledge of Rembrandt's modes of painting. And finally, many thanks to Ernst van de Wetering, a friendly member of the Rembrandt Research Project, who generously served as a native informant about Rembrandt's studio and works.

Discussion with colleagues on *Representations* challenged the formulations of an early draft. I am grateful to friends who took the time to read the entire manuscript at one stage or another. I have accepted many of their suggestions and have tried to respond to

their criticisms: Paul Alpers, Michael Baxandall, Margaret Carroll, and Michael Podro. As always, talking with Stephen Greenblatt helped me see the way to and through a number of problems.

There are a few minor points about format:

The footnotes do not attempt to be comprehensive. They are designed to serve two functions: to assist the reader in locating relevant materials and to locate this text in relationship to current research. Where it seems useful, sources are quoted in the notes in the original language—to make texts, even when well-known, immediately available to the specialist and to offer at least their flavor to the general reader. To minimize the interruption to reading, I have tried to gather notes at paragraph ends.

The introduction is divided into two parts. The second section aims to place this study in the context of current scholarly research and writing on Rembrandt. It may be of less interest to general readers, who may skip if they wish.

S.A.

ABBREVIATIONS

B.: A. Bartsch, *Catalogue raisonné de toutes les estampes qui forment l'oeuvre de Rembrandt et ceux de ses principaux imitateurs*, 2 vols., Vienna, 1797.

Baldinucci: Filippo Baldinucci, *Cominciamento, e progresso dell'arte dell'intagliare in rame, colle vite de'piu eccellenti Maestri della stessa Professione*, Florence, 1686.

Ben.: O. Benesch, *The Drawings of Rembrandt*, 2d ed., ed. Eva Benesch, 6 vols., London: Phaidon, 1973.

Br.: A. Bredius, *Rembrandt: The Complete Edition of the Paintings*, revised by H. Gerson, London: Phaidon, 1969.

Corpus: J. Bruyn, B. Haak, S. H. Levie, P. J. J. van Thiel, and E. van de Wetering, *A Corpus of Rembrandt Paintings*, The Hague, Boston, London: Martinus Nijhoff, 1982–.

Documents: Walter L. Strauss and Marjon van der Meulen, with the assistance of S. A. C. Dudok van Heel and P. J. M. de Baar, *The Rembrandt Documents*, New York: Abaris, 1979.

Hoogstraten: Samuel van Hoogstraten, *Inleyding tot de hooge schoole der schilderkonst, anders de zichtbaere werelt*, Rotterdam, 1678; reprint, Utrecht: Davaco, 1969.

Houbraken: Arnold Houbraken, *De groote schouburgh der nederlantsche konstschilders en schilderessen*, 3 vols., Amsterdam, 1718–21; reprint of Hague edition of 1753, Amsterdam: B. M. Israel, 1976.

COLOR PLATES

PLATE 1. Rembrandt, *Self-Portrait*. By courtesy of the Rijks-museum-Stichting, Amsterdam.

PLATE 2. Rembrandt, *Aristotle Contemplating the Bust of Homer*, 1653, detail (hand on bust). Metropolitan Museum of Art, New York. Purchased with special funds and gifts of the friends of the Museum, 1961 (61.198).

PLATE 3. Rembrandt, *Aristotle Contemplating the Bust of Homer*, 1653, detail (hand, sleeve, chain). Metropolitan Museum of Art, New York. Purchased with special funds and gifts of the friends of the Museum, 1961 (61.198).

PLATE 4. Rembrandt, *The Oath of Claudius Civilis*, 1661, detail (swords and hands). Nationalmuseum, Stockholm. Photo Statens Konstmuseer.

PLATE 5. Rembrandt, *The Money-Changer* (The Rich Man?), 1627, detail (man with coin). Gemäldegalerie, Staatliche Museen Preussischer Kulturbesitz, Berlin (West). Photo Jörg P. Anders.

PLATE 6. Rembrandt, *The Jewish Bride*, detail (sleeve). By courtesy of the Rijksmuseum-Stichting, Amsterdam.

PLATE 7. Rembrandt, *The Jewish Bride*, detail (hands). By courtesy of the Rijksmuseum-Stichting, Amsterdam.

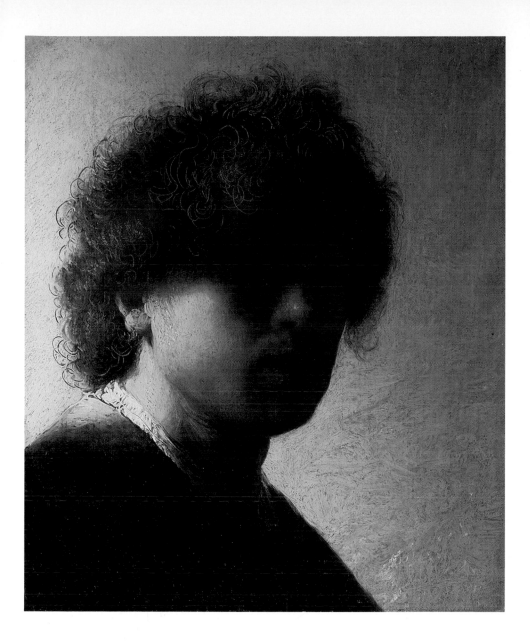

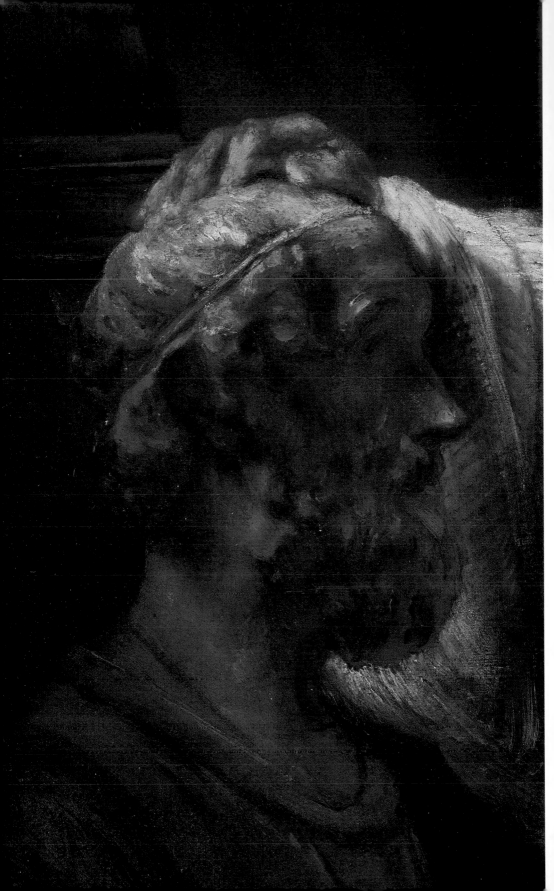

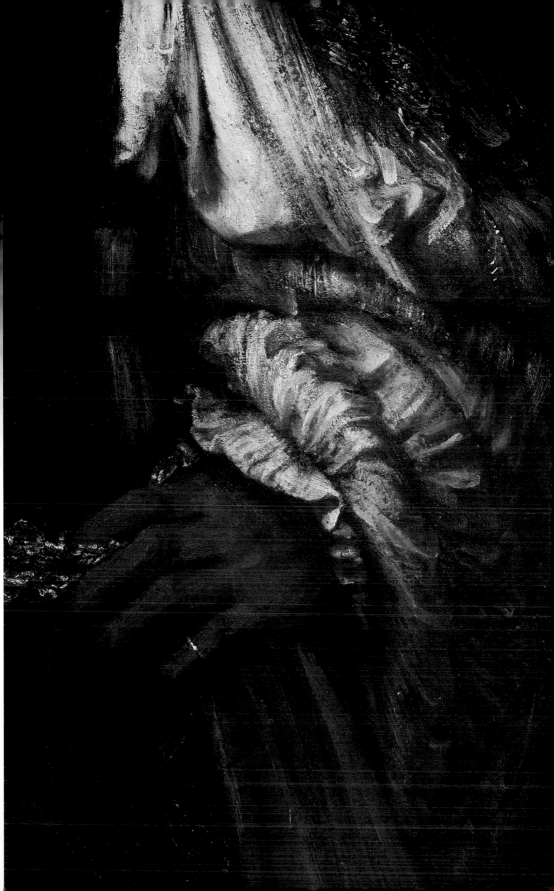

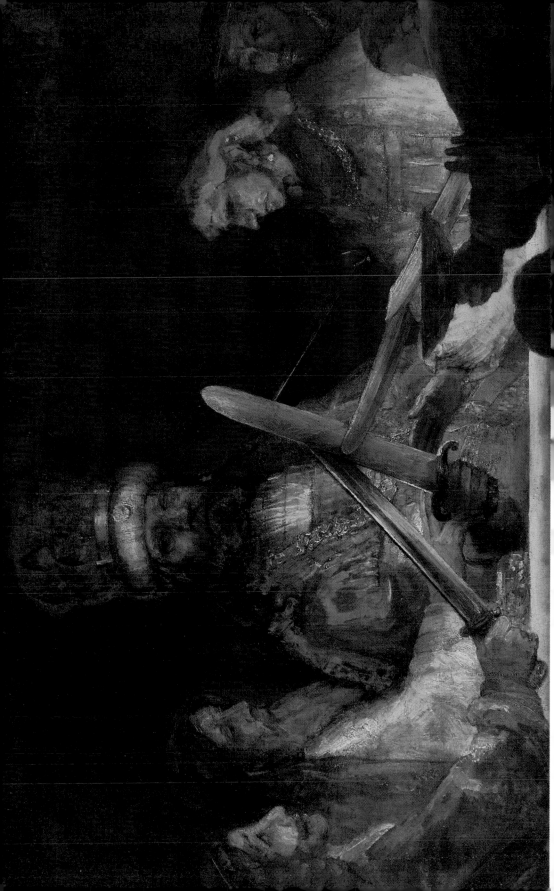

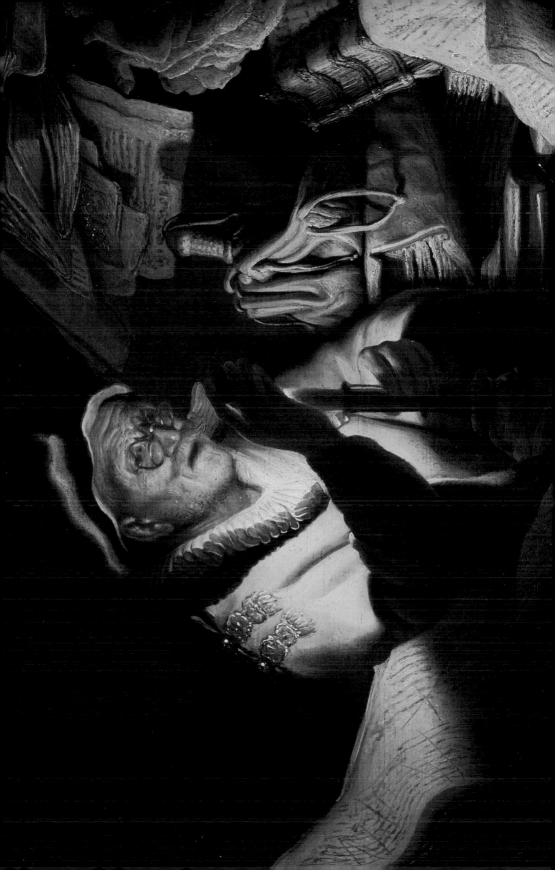

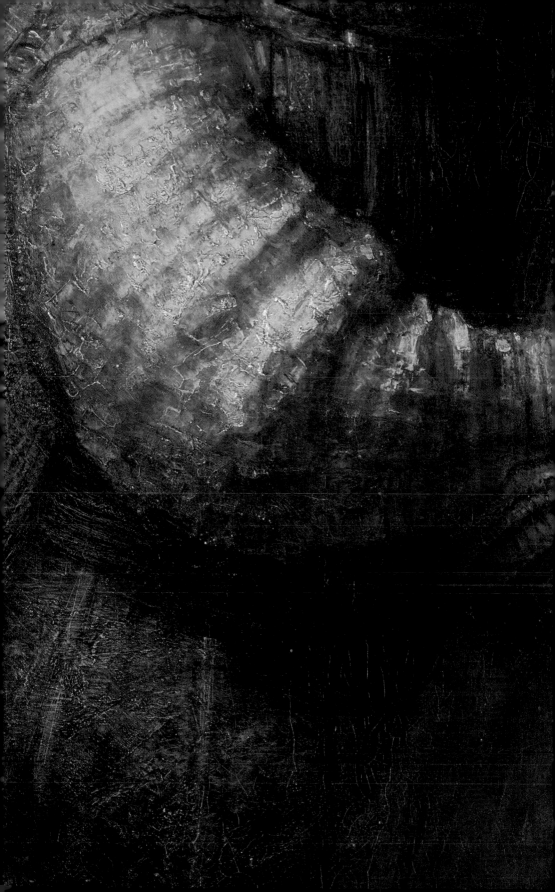

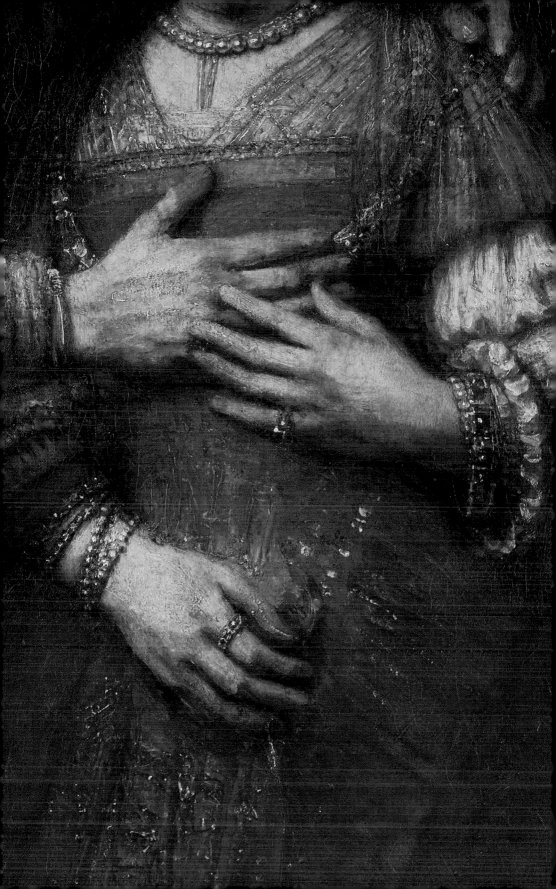

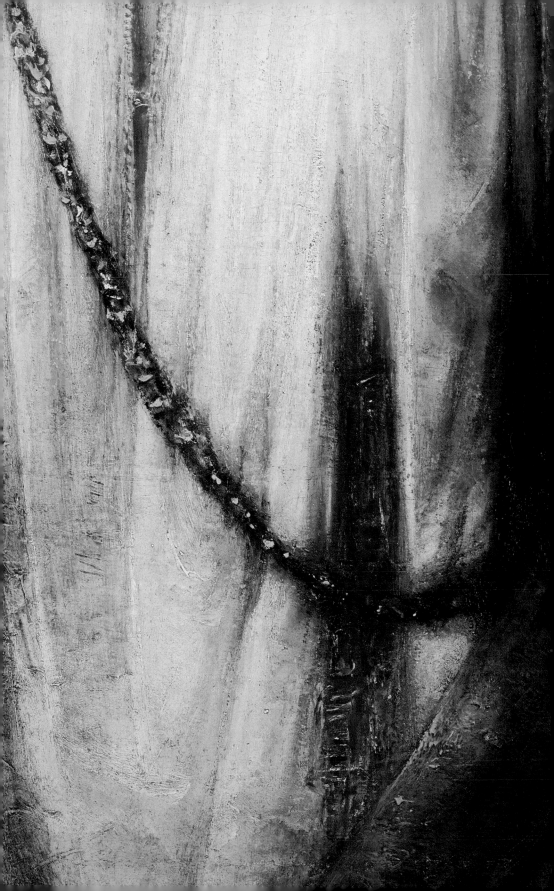

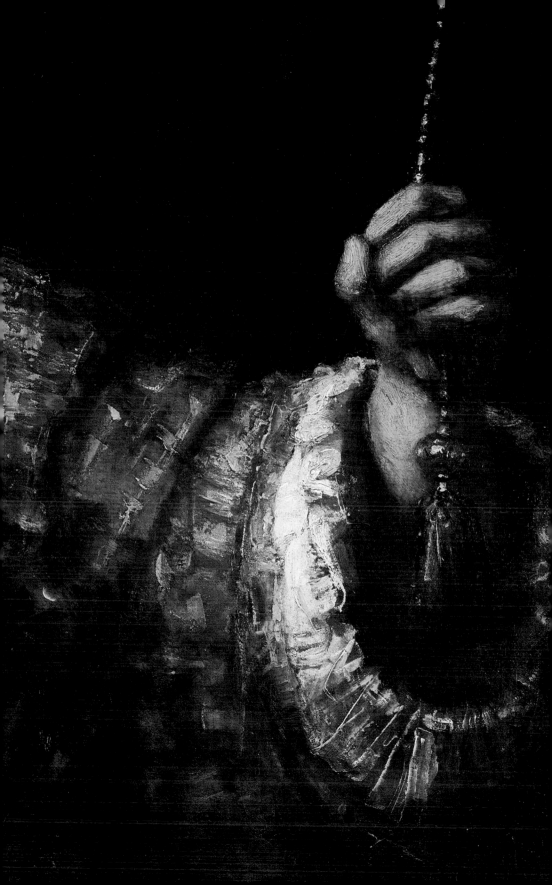

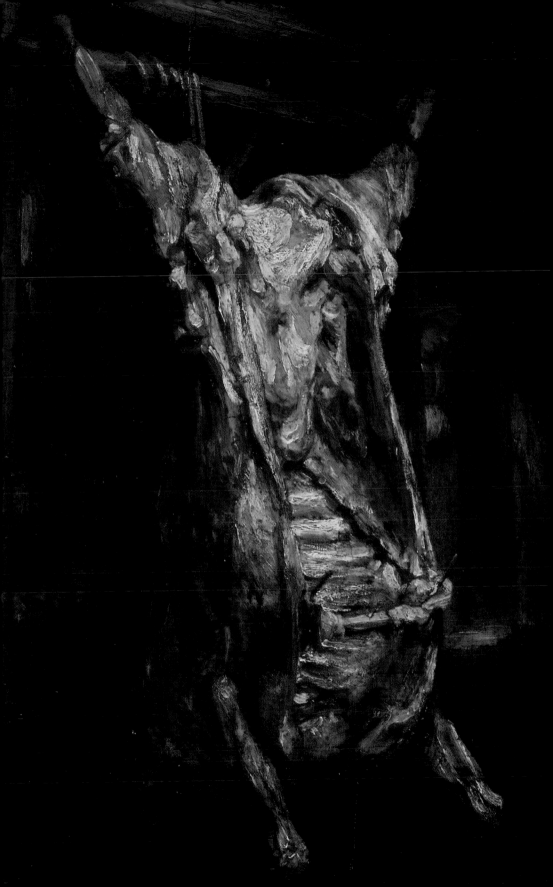

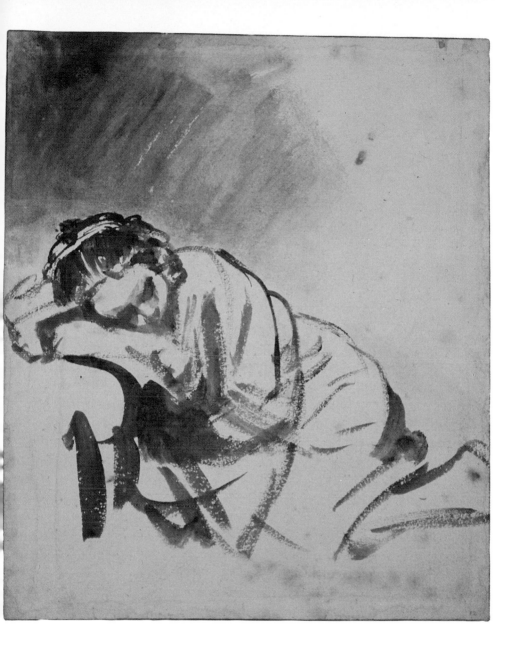

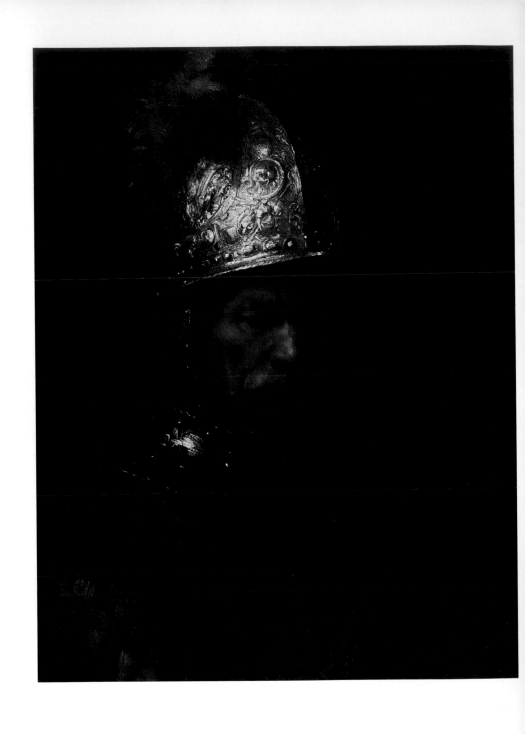

INTRODUCTION

I

REMBRANDT is in the news again. It used to be the discovery of a new painting by the master, or the purchase of an old one at a record-breaking price. But today it is the discovery that many attributions of pictures to him are false. The *Sunday Times* of London announces that the "Queen's paintings are 'fake.'"[1] Some of the most famous and best-loved works by Rembrandt—among them *The Polish Rider* and *David and Saul* in The Hague—are not, leading experts have concluded, by his hand (figs. 4.31–4.38.). They were probably painted by assistants who worked in his studio.

It was the case of the so-called *Man with the Golden Helmet* (pl. 12) in Berlin that brought the entire issue to the attention of the public in 1985. Forty years ago, in his basic book on Rembrandt, Jacob Rosenberg described the picture at some length and in glowing terms:

> The *Man with the Golden Helmet* in the Kaiser Friedrich Museum, rightly deserves its fame. A few words cannot do justice to this masterpiece, which modern critics have especially praised for the boldness of Rembrandt's technique in the powerful impasto of the helmet. It would be difficult to find anywhere a more emphatic glorification of the beauty of gold and of old craftsmanship in this precious metal. But Rembrandt's aim was not a still-life effect for its own sake. This phenomenon of pictorial beauty is placed in a mysterious and even tragic setting. . . . The spiritual content dominates in spite of the brilliance of the upper part of the composition. This contrast between the splendor of the helmet and the subdued tonality of the face makes one deeply conscious of both the tangible and the intan-

gible forces in Rembrandt's world, and of their inseparable inner re-
lationship. As in all his greatest works, one feels here a fusion of the
real with the visionary, and this painting through its inner glow and
deep harmonies, comes closer to the effect of music than to that of
the plastic arts.[2]

On the basis of a detailed study of the way it was painted, and in
particular on the evidence of the substructure, that is, what is de-
scribed as the underlying drawing, which was revealed by auto-
radiography, it has been concluded that the painting is by a Rem-
brandt student, assistant, or follower whose name is unknown. In
the face of its "disattribution," a specialist at the Berlin museum
assured the press that the painting was neither a copy nor a fake,
but "an independent original in its own right, with its own indepen-
dent worth."[3] But it is hard to value a painting which is not the
product of a particular artist's hand. "This is an authentic work by
x" has been central to the marketing, to the study, and even to the
definition of pictures. "Reattribution" is an accepted procedure,
but what exactly is "disattribution"? Just where does this leave us as
viewers, where does this leave Rembrandt, or, for that matter, where
does this leave the value of the work of art?

The questions are pressing ones, because to a remarkable degree
Rembrandt has come to be synonymous with value itself, whether it
is a matter of having the taste to choose the right hotel in New York
("The Fine Art of Doing Business in New York" illustrated with a
Rembrandt self-portrait—said of the Stanhope Hotel), or reaching
for a compliment to female beauty ("Her features are perfect; to
disfigure her face is difficult; it's like putting your foot through a
Rembrandt"—said of Farah Fawcett), buying a unique commodity
as an investment ("If you could buy a Rembrandt in its infancy and
then have it now, it would be the same as having this car several
years from now when it will probably sell for $100 million"—said of
a 1931 Bugatti Royale), or distinguishing a quality athletic perfor-
mance ("As it was he had to settle for the best one-hitter in recent
Oakland A's history, a one-hour, 58-minute, 93-pitch Rembrandt"—
said of a perfect game that wasn't).[4] And one could go on.

Individual uniqueness, monetary worth, aesthetic aura—the
name of Rembrandt summons up different but nevertheless con-
vergent notions of value. And to what precisely does the name itself
refer? "Rembrandt" as it is commonly deployed tends to elide the
works with the man. Is all of this a recent invention, a prejudice of

the nineteenth century to which we are heir? Or is it appropriate to
Rembrandt's own making and marketing of his works that they
should offer an example of that relationship between the production
and valuing of a person, property, and aesthetic worth that lies so
deep in our culture?

To argue Rembrandt's responsibility in these matters involves a
certain adjustment in our view of the man and of his works. Exer-
cise of authority—in the double sense of the claim to be the maker
of his works and the claim to exercise rule—takes its place beside
his long-reputed sympathy for the poor, the weak, and the outcast,
whether in the household, the studio, the Bible, or myth. And an
interest in the marketplace takes its place beside his interest in man
and womankind. One need not defend the legitimacy of the estab-
lished view to point out that far from being contradictory, these ten-
dencies are joined together in an ideology which is part of our cul-
ture. Charlie Chaplin is a good, if unexpected, example. Charlie
played the little man out to undermine the very system which Chap-
lin supported by buying into control of his own studio and impos-
ing his will on the acting troupe he hired and directed. Despite the
scruples we may feel, when IBM adopts Chaplin as its corporate
emblem, it is cashing in on those entrepreneurial values that have
been sustained by a certain kind of ambitious artist.[5]

But what can one make of the disturbing fact that some of the
works of the very artist whose paintings have been seen as paradig-
matic of individuality are painted by other hands? And to Rem-
brandt's identifiable laying on of his paint, and his fabled respon-
siveness to each individual sitter, we must add his proclivity towards
self-portrayal: almost single-handed, Rembrandt established the
self-portrait as a central mode for painters and as a major type of
western painting. It is now generally acknowledged that the nine-
teenth century shaped its myth of the lone genius out of a selective
reading of Rembrandt's life and his art. But are there not things
about the paintings that accommodate them to such a view? Was
Jacob Rosenberg, at least insofar as he was making a general point
about Rembrandt, totally wrong? Don't his paintings give off an
effect of singularity, and of individuality—a sense of an almost tan-
gible or material human presence wrought in paint? It seems a cruel
paradox that questions of authenticity are raised about the very art-
ist whose art seems to have been devoted to displaying it as a major
virtue.

A number of suggestions have been made about how to deal with

the situation. Let us consider three—the first and the last written in response to the "disattribution" of *The Man with the Golden Helmet:*

In the 19th century it was felt that only the genius could paint what was worth looking at. So any painting that seemed Rembrandtesque had to be by him. Now we know that there were lots of artists who painted as well as the master. In contemporary life we believe in many people besides the main movers.[6]

It is of much greater historical importance to know whether—and for whom—Rembrandt painted or inspired the painting of a particular composition at a particular moment in his career, than to know whether this or that existing canvas is by the master's own hand.[7]

The Man with the Golden Helmet is as great as it ever was, not the least bit fake. But to be described in the future as a work by "Anon." or perhaps "School of Rembrandt" is to be changed forever. And the change somehow diminishes the picture and therefore diminishes us. This continuous search for truth can be a painful and punishing process. Sometimes it seems that all of education consists of first learning things and then learning that they are not true.[8]

The first writer finds virtue in recognition of the democratic spread of talent, the second argues for transferring authority to the artist's patrons, and the third draws the conclusion that things are seldom what they seem in the human search for truth. But whether opting for equality among artists, or patrons, or for the general condition of human loss, they are unanimous in registering a sense of Rembrandt's weakened authority over the production of Rembrandts. And yet there is something a bit unseemly about the haste with which Rembrandt is being cut down to size in the name of emptying out what is referred to as a nineteenth-century notion of genius. Is it true that Rembrandt's accomplishment was no different from other artists at the time, or that not he but his patrons provide the key to his art? What we are faced with is a growing number of paintings like *The Man with the Golden Helmet*, which, whether they were painted by him or not, would have been inconceivable without Rembrandt. It is not the notion of human genius, but the way it manifests itself that deserves attention.

Rembrandt's paintings have long been problematic as far as the question of attribution is concerned. The modern trend has been restrictive: early in this century, Hofstede de Groot estimated his output at about 1,000 paintings; successive scholars have cut it

down to 700, then to 630, to 420; and research currently underway by the Rembrandt Research Project in Amsterdam will cut it down still further.[9] It has long been assumed that Rembrandt was an active teacher. But it is just now being recognized that the growing number of works identified as Rembrandt look-alikes were made by apprentices whom he taught or by artists whom he used as assistants, and who, as such, painted in his manner. (Of course, some others were simply camp followers who took up the manner on their own.) It was common practice at the time for an artist to run his studio as a workshop to produce pictures. Rubens did so, as did Bloemaert, Honthorst, and many others among the Dutch. Rembrandt's idiosyncrasy was that he also treated the painting of a picture as a definitively individual enterprise. He demonstrated that there is no necessary contradiction between running a business and claiming individual pictorial authority. And Rembrandt's paradoxical achievement was that he got other artists to pass themselves off as him. One result is that some of the Rembrandtesque works—*The Polish Rider* and *David and Saul*, for example—are among the most impressive paintings made in Holland at the time. Another result is the anxiety about their attribution.[10]

Responsibility for the problem of attribution raised in the case of a work like *The Man with the Golden Helmet* can be laid at Rembrandt's own door. Rather than insisting on the authenticity of this or that painting, or assuming that Rembrandt had less authority or was less the individual painter than has been assumed, one might inquire as to how he deployed his authority and how he construed himself in paint. It is not, then, just a matter of coping with the latest news. For it would seem that in the works of this painter who was an inveterate self-portraitist and was also, we now know, the head of a large and productive workshop, the question of identity—which is after all the problem of attribution put in other terms—was already very much in play.

The flurry of questions about attribution has put into the background another common Rembrandt concern. Meaning, in its simplest form—the identity of the subject of a painting—has been as much a problem as has been the identification of the artist's hand. The titles which many Rembrandt paintings go by are a record of evocative yet puzzled attempts at description: "The Man with the Golden Helmet," "The Polish Rider," "The Jewish Bride." It has been argued that it is precisely the uncertainty of the subject that makes for much of the richness of these works. "The painting triumphs over questions of identity. Its implications sink in slowly,

like a line of brilliant verse," a recent critic wrote of the so-called *Polish Rider*.[11] One is reminded of the terms in which Jacob Rosenberg praised *The Man with the Golden Helmet*. How do titles (and, incidentally, terms of praise) like these come about?

Let us take, for an example, the painting now in Amsterdam of a richly garbed couple, the man with one hand on the woman's shoulder and the other resting on her breast (fig. 1.1). In 1834, its then owner, John Smith, described it as "The Birthday Salutation" of what he took to be a sixty-year-old man to a woman whom the next owner, an Amsterdam collector, described as a Jewish bride being ornamented by her father (!) with a necklace. The nineteenth century seems to have thought it was a double portrait, which it well might be. But they tried to displace a certain embarrassment about the hand on the woman's breast by referring to the man as the woman's father.[12]

What the art market treats as the problem of a subject or title is a problem of interpretation to scholars. The pursuit of the meaning of this work has continued, though now in biblical terms: are these perhaps Tobias and Sarah, Boas and Ruth, Jacob and Rachel, Judah and Tamar, or Isaac and Rebecca? And how might we decide which? There have been both limiting and expansive answers to the question. One proposal is that Rembrandt extracts or selects his figures from the narrative settings he found in a common stock of illustrations. To pin down the subject, then, one need only identify the source. In this instance, a Rembrandt drawing and an engraving after a composition of Raphael's lead to Isaac, Abraham's son, and his wife Rebecca in the land of the Philistines when they were passing as brother and sister and were spied upon by King Abimelech who discovered them instead to be a loving couple. Opposed to this recipe for finding the subject is the view that Rembrandt, particularly in his late works, did not care about specific subjects, but only about general or encompassing human themes—marital love, perhaps, in this instance. In this view, Rembrandt is a sort of universalist, and his works rise above the particularity of any single subject. But what do we then do with the particularized description of the couple's faces? Is this perhaps a couple whom Rembrandt painted representing a scene or a theme?[13]

It could be. It was fashionable at the time for Dutch couples to want to be portrayed as historical men and women. This was one way to fashion social identities or to chart manners in a swiftly changing society. But if we compare *The Jewish Bride* to a work by

Jan de Bray in which a Dutch couple appear in the guise of Ulysses and Penelope, the differences are striking (figs. 1.1, 1.2). The very crispness of the painted surface and the awkwardness of their gestures make De Bray's couple look as if they stuck their heads through one of those flats at a fair where you step up to have your picture taken. If *The Jewish Bride* is a portrait, Rembrandt, by contrast, succeeds in representing his contemporaries so that they suggest another time and place. The couple's material presence and individually described features make a puzzling—though for Rembrandt a quite characteristic—fit with the indeterminacy of dress, setting, thoughts. As far as interpretation goes, we are left uncertain as to where reality ends and fiction begins, and even precisely what, if any, the fiction might be. We find ourselves uncomfortably close to the evocative vein of writing that has been thought appropriate for Rembrandt. But on what basis and to what end was this pictorial appeal produced? How and why was the painting made to look like this?

The problem of who and what is depicted in any work is raised partly because of Rembrandt's penchant for eccentric subjects. The host of drawings from his studio featuring biblical narratives that had never, or at least not commonly, been depicted before, magnifies this basic problem. Further, there is a formidable lack of any clear sign of dress, other accoutrements, or, particularly in the later paintings, action or gesture, which could make clear who, or what event, is depicted. In keeping with current exasperation at the nineteenth-century view of the master, it has recently been suggested that instead of being universal, Rembrandt was intentionally vague.[14] His meaning as well as his authority is under threat. But as in the case of "disattribution," need this be couched in the form of an accusation against or a diminution of Rembrandt? Can it not be used to help us to explain the characteristic manner of his art in more appropriate terms?

Rembrandt was an artist who, from the beginning, called attention to his often laborious working of the paint. *The Jewish Bride* is but one example among many. In this respect, as in his notorious reworking of etchings through a number of states, he called attention to invention as a process. It is most appropriate, then, to ask what that process of invention entailed. How were the couple known as *The Jewish Bride* made to look in such a way as to raise the question of meaning in the first place? Much can be gained by recalling, to adapt a famous phrase of Gombrich's, that making comes before

meaning. At least in Rembrandt's case, attention to the making of his works may be a precondition to understanding the nature of their meaning.

This book aims to locate Rembrandt's idiosyncrasy and his strength in his artistic production, by which I mean in aspects of his studio practice and his relationship to the market that reveal themselves in, or even as, his works. The first chapter looks at Rembrandt's working of his paint and, with a digression on his representation of hands, proposes one explanation for the remarkable substantiality of his paint and painted surfaces. Turning our eyes from his handling of paint to his models, chapter 2, drawing on self-portraits, studio lore, and the language of Rembrandt and of some of his critics, argues that he treats his models in theatrical terms, thus calling attention to the performative nature of life in art. Chapter 3 takes up Rembrandt's career, in order to show that at its center was the studio, which he treated as a world in which life had to be reenacted under his direction; it concludes with the suggestion that the *effect* of individuality that is given off by his late works is dependent on this master's domination of the world he brought into his studio. The final chapter follows Rembrandt and his works out of the studio and into the marketplace. It describes Rembrandt as *pictor economicus* and returns to points made about his career and his production that were previously couched in studio terms—relation to patrons, handling of paint, relationship to tradition, and depiction of self—to frame them, as he did himself, in terms of the marketplace.

I started this study by taking issue with the presentation of Rembrandt in my earlier *The Art of Describing*. There, in a kind of reworking of an established nineteenth-century view, I saw him as an outsider, a loner even, in relationship to the Dutch visual culture. Here I propose to see him not outside but inside his culture, and I do this by considering the circumstances of his shop and the making and the marketing of his art. The Netherlands was, after all, not only a leader in lenses and maps, but also in banking, commerce, and the conduct of trade. Instead of concentrating on questions concerning sight and knowledge of the world seen, which assimilate pictures to the production of natural knowledge, this study concentrates on making and marketing, which assimilate pictures to the production of value. A persistent but minor theme is that Rembrandt avoids, in his production of art, the confirmation of either familial or court values. The chapters can be read as a sequence moving from paint, to model, to studio and artist in that studio, to

artist in the marketplace, or as moving from Rembrandt painting, to Rembrandt as actor, to Rembrandt as director, to Rembrandt as entrepreneur. In either case, I hope that it will succeed in making clear what led me to title this book as I have.

II

THE RECENT CHALLENGE to accepted attributions is the kind of event that unites the interests of the public and the more specialized interests of the scholar. But it is the result of art historical research, which is in turn based on certain attitudes toward historic art, its explanation in general, and Rembrandt in particular. It might be of use to locate this book in relation to some recent publications on Rembrandt. This is appropriate, furthermore, because I shall gratefully be making use of research on Rembrandt's production—from his laying on of the paint to his studio practice—as well as of readings of early texts about his life and work that are prominently featured in Rembrandt studies today.

The acknowledged founding father of current Rembrandt studies was the late Jan Emmens. In 1964, this Dutch scholar published his *Rembrandt en de regels van de kunst* (Rembrandt and the rules of art), which aimed to free Rembrandt once and for all from what Emmens considered to be the anachronistic nineteenth-century image of a misunderstood and lonely genius whose works turned inward in midcareer because of his rejection and misunderstanding by his patrons and viewers.[15] The "rules of art" of the title refers to the codified, classicist theory of art on the basis of which the first critique of Rembrandt was mounted in the 1670s. And it is Emmens's well-grounded argument that the nineteenth century went on to embrace the very Rembrandt that this classicist theory had created in order to denounce. Much of his book is concerned with the reading of early critical texts, with the aim of pointing out the theoretical assumptions (or biases, in his view) on which they were based. Emmens also raises a second argument against the nineteenth-century myth of Rembrandt: far from singling out Rembrandt as a unique, lone genius, the classicistic writers had considered Rembrandt to be the representative Dutch artist of the preclassical age. On this account, he was singled out for criticism by reason of his *similarity* to other artists of his time, not because of his *difference*. Among Emmens's admirers there are a number who take it that Rembrandt's status as a genius, as well as his status as a loner, were rightly called into question in this book.

By disclosing later writing on Rembrandt to be the display of

parti pris positions that did not understand him in terms relevant to his own life and time, Emmens hoped to clear the ground for the production of a dispassionate and historically valid account of Rembrandt's art. Curiously, Emmens did not make much headway on this project himself. As far as Rembrandt is concerned, his book ends on an inconclusive note. Part of Emmens's honesty, and part of the complexity of this interesting book, is that he effectively admitted that his method—the appeal to an historically relevant body of theory to offer verbal access to the artist and his works—simply did not work with Rembrandt. On Emmens's account, practice and inborn talent, rather than art theory, define the art of Rembrandt and that of his age. Emmens sought to base this distinction on contemporary applications of what he refers to as an Aristotelian triad: in the preclassicist age *exercitatio* and *ingenium* took precedence over *ars*. This appeal to making and to the individual talent suggests a useful approach to the viewing and the study of Rembrandt's art. And yet to Emmens this approach seemed hopelessly vague and untrustworthy. The very tool—the verbal theory—that he thought was necessary to do the job was lacking, since the artist in the preclassicist age did not work on the basis of a body of theory about art.

There were a few reviews of Emmens's book protesting sharply on behalf of Rembrandt's art.[16] But the direction that Rembrandt studies have taken is largely due to successors or followers who have programatically applied Emmens's techniques to Rembrandt and his time as Emmens himself did not. One of the two major directions being taken today in Rembrandt research can be traced back to this book. This is the attempt, notable in the work of Hessel Miedema, to supply the viable art theory contemporary with Rembrandt that Emmens was unable to find. What is at issue here is not the finding of new texts, but the rereading of familiar ones such as Karel van Mander's *Het Schilderboek* . . . (1604) and Philips Angel's *Lof der schilder-konst* (1642).[17] In the work of Miedema, the very texts that Emmens had dubbed as preclassicist and lacking in theoretical rigor are found to offer a conceptual rigor *in nuce*, as it were. This divergence from Emmens has been conducted in terms of a kind of reading that Emmens himself encouraged in his book. But in the work of the followers, the kind of reading that originally proved so useful in clearing the ground has been misleading.

Miedema follows Emmens's example when he makes a sharp distinction between an authentic fact and a topos deployed to make a conventional point about a notion of an artist or of art. Reading done in this manner is intent on exposing the notion of art that in-

forms a text. But the distinction between fact and topos is not what Emmens claims it to be. He fails to see that writers deploy topoi in order to characterize particular pictures or the careers of particular artists. Reading intentionally, with an eye on the artists and the art at issue, one finds that even the classicizing critics of Rembrandt offer evidence about the nature and the character of his art. The variety and agility in the use of anecdote and language that is part of the tradition of writing on art that follows Vasari's great *Lives of the Painters* has been ignored on misleading grounds. The aim of suggesting the character of the individual artist and his works that is native to this tradition is under suspicion in post-Emmens work. Emmens's view of the nature of art history is operative here: in the name of truth, it is argued, the *historical* task should be entirely separated from inherently biased *critical* considerations, and the former and not the latter belong within the purview of the scholarly enterprise.[18]

If one branch of work on Rembrandt heads for texts, with a certain overconfidence in their unambiguous clarity, another branch has headed, with a comparable overconfidence, for the paintings. Here, too, the aim has been what some of the scholars involved refer to as purification. If the textual people want to clear away the verbal cobwebs that have prevented a clear understanding of Rembrandt, the painting people want to do the same for the paintings themselves. Since 1969, the Rembrandt Research Project, a team of Dutch scholars, has been trying to determine Rembrandt's oeuvre once and for all with the help of the newest technical means. In their first two published volumes, the exhaustive analysis and description of each painting offers a remarkable verbal record of close viewing of pictures. It is fitting that such close attention be paid to the works of a painter who made such an elaborate display of the laying on of his paint. However, a surprising number of works are proving to be not by Rembrandt's hand, but instead by those of students, assistants, and imitators. It is the diffusion and the spread of the Rembrandt mode of painting that is documented by the project. Rembrandt, it appears, is not reducible to his autographic oeuvre.[19]

Evidence suggests that Rembrandt was the most representative artist of his age—to recall Emmens's formulation—because he was responsible for making so much painting of the age look as it does! His authority (and his uniqueness) seem to be slipping in by the back door! However, this is not quite legitimate in the judgment of the Rembrandt team, as far as one can make out. For example, insofar as they offer an *explanation* (as distinct from a *description*) of

Rembrandt's painting technique—the thickness of his pigments or the visibility of his brushstrokes—they do so only in the terms in which it was dealt with in texts at the time. His particular paint-handling is thus understood within the general context of preclassicist painting. Despite their careful descriptions of Rembrandt's paint surface, his practice is understood, in keeping with Emmens's lead, as representative of, in the sense of common to, his age.

The sharp division between a trust to texts on the one hand and to the painted surfaces on the other that characterizes much of Rembrandt studies today is not unique. It is a version of the basic problem facing any historian of art who must use words to deal with objects made out of paint. A third consideration has now been introduced into Rembrandt studies—a reconsideration of his life. A recent book by Gary Schwartz marshals much evidence about what he calls the social dynamics of Rembrandt's world, as a way of providing access to the works: his dwelling places and those of friends, patrons, and contacts are marked on maps of the two towns where he lived; charts clarify the history of the Rembrandt family or the social position, religion, and relationships of patrons both actual and potential; those writers he had contact with are noted and discussed; and, finally, every document that has been found touching in any way on Rembrandt and his paintings is deployed to fill out the picture. The effect is a welcome breaking of the mold of Rembrandt studies by the sheer intrusion of so many names and so much new material.[20] But the book has a point of view: the thrust of this account is that Rembrandt was a mean-spirited man with a taste for the theater and for literary friends, who was frustrated in his worldly ambitions and outdistanced in his career by his contemporaries and his students. Schwartz's tendency to deny Rembrandt the benefit of the doubt, and hence to give a negative reading to each and every event in his life—passing reference to Rembrandt as "a Latin-school drop-out" suggests the tone—is noticeable in the book. But the major cause of its surprisingly negative conclusion is the premise that public reception of a particular kind is the standard by which the artist is judged.

In an endnote Schwartz admits that if he had had the nerve he would have liked to call his book (after Emmens) *Rembrandt and the Rules of the Game*. But is he on to the game as Rembrandt played it? Is Rembrandt, as Schwartz suggests, a failed Govert Flinck, or, better, a failed Rubens or Van Dyck? The point that Rembrandt's rebarbative relationship to potential patrons and his dependency on the market is testimony to failed ambitions (that failure being the

phenomenon that dominates this study) is assumed, not argued. In this presentation, the paintings are made hostages to fortune narrowly conceived in terms of a painter's social success. But what is a painter's fortune if it is not the fate of his works? And if Rembrandt is seen to this day as having been supremely successful as a maker of paintings (as well as of etchings and of drawings, which are notable by their absence from Schwartz's book), then to measure his success in social terms is surely to give only part of the picture. The virtue of the book is that it makes us seriously consider Rembrandt's career. But there is no compelling reason not to consider the practice and production of art as part of his career.

If the gap between texts, paint surface, and now the public face of the career, is being closed, this seems to me to be happening in work which approaches Rembrandt through his practice, as, for example, in the fine catalogues by Peter Schatborn on Rembrandt as a teacher or on the drawings attributed to him in the Rijksmuseum.[21] The belief that attention to his practice can give us access to his intentions is perhaps a bias of our time. But it is of particular interest in the case of Rembrandt, who in a remarkable manner and to a remarkable degree achieved his ambitions, which, I shall argue, were mastery in the studio and the establishment of value in the marketplace.

I

THE MASTER'S

TOUCH

ONE OF THE MOST distinctive and identifying aspects of Rembrandt's paintings is the way he applies his paint. Rather than striving to craft a representation of the world seen, as does Vermeer in *The Art of Painting,* for example, Rembrandt in his use of paint appears to obscure it, drawing our attention to the paint itself rather than to the objects it represents. Look at the sleeve of the late *Lucretia* in Minneapolis (pl. 9). The cuff of the garment that discloses the hand summoning witnesses to her suicide is tawny, worked over in a complex pattern of yellow and white brushstrokes applied with a loaded brush. We find a similar handling of the paint in *The Oath of Claudius Civilis* (pl. 4, fig. 1.3). The central part is all that remains of a much larger painting that Rembrandt was asked to do for the great new Amsterdam Town Hall. It represents the pledge given to the leader Claudius Civilis preceding the rebellion of the Batavians, the early inhabitants of Holland, against their Roman rulers. We can compare it with the way another Dutch painter painted a historical scene (fig. 1.4). In his depiction of the thirteenth century, Caesar van Everdingen accounts for every visible detail of the world, even down to the fringe on the foreground rug. We are made eyewitnesses to the people and accoutrements of thirteenth-century history as if they were objects depicted in a still-life. Time is effectively effaced and robbed of a sense of history. Rembrandt, on the other hand, obscures the surface of both people and objects. His painting is hard to make out at first—the figures and objects, which appear to emerge into light from the obscured, darker surroundings, are bound in an extraordinary way to the paint surface. The visual presence of the paint interferes with, or replaces, the implicit access to the surfaces of the world. Everything, from the firmness of

hand grasps to the diverse richness of a garment, is urged upon us as the display of different qualities of pigment that is not only colored, but worked and shaped. The oath taken by the Batavian revolutionaries is celebrated in the very material of the paint.

In early accounts of Rembrandt, the thickness of his pigment consistently draws comment: paint an inch thick; a portrait painted so that the canvas could be lifted by the sitter's painted nose; jewels and pearls which seem to have been done in relief. Houbraken makes a story out of it: he tells how in order to maximize the effect of a single pearl, Rembrandt painted out the figure of Cleopatra.[1] All of these comments speak to Rembrandt's handling of the paint, but also to his using it to attempt to represent objects by recreating them in paint. Thus a compelling reason for having seen *The Man with the Golden Helmet* (pl. 12) as a canonical Rembrandt is the impasto of the worked metal of the helmet. Though among recent critics at least one found the impasto of the helmet overly substantial and hence not attributable to the master's hand, the evidence is that, since Rembrandt's own day, a substantiating impasto has been seen as a characteristic of Rembrandt's production.[2]

These old observations have been confirmed by recent technical research, which suggests certain constancies in Rembrandt's extremely various and continuously experimental manner. If one could point to a single major discovery—one which signals a change in the understanding of Rembrandt's way of painting—it is that the laying on of glazes in the Venetian manner is not basic to his technique. A glaze is a pigment made transparent by a high admixture of resin. Titian and the other Venetians dragged one such thin, transparent layer or veil of dark paint over an underlying layer of lighter paint to create an optical play of color on a rough-woven canvas. Rembrandt, on the other hand, tended to build up a solid structure out of opaque pigments. Having blocked the figures onto his prepared ground. Rembrandt characteristically laid in thickly, in high impasto, the highest lit areas of the picture, sometimes working the paint with the palette knife or even with his fingers rather than with the brush. It looks as if on occasion Rembrandt even used a glaze in a contrary way to heighten the solidity effect: the shoulder of the man in red raising his musket to right of center in *The Nightwatch* appears to be a patch of red lake glaze put on top of some red ochre. It is not used to describe a particular fabric or costume, but to call attention to solidity and also visual richness for its own sake.[3] When asked about the materiality of Rembrandt's paint, one conservator I talked to referred to the white lead (with its

admixture of chalk) structure as the skeleton or armature of the picture, while another spoke of Rembrandt's works as having the solidity and the appearance of being wrought that we associate with metal. (Originally these effects would have been stronger. Conservators point out that as the result of restoration procedures which used to involve "ironing" the canvas in the course of relining, few Rembrandts today retain their original impasto.) The raised areas of paint are built up so that they can reflect natural light and cast shadows as would real, substantial objects (pl. 7). A paradoxical effect of this handling is to make the highest-lit areas of the painted world not the most ephemeral, with light erasing form as it so often does in Western painting, but precisely among the most substantial.

Rembrandt was a slow rather than a fast painter. Layers of paint testify to what we know about the length of time it took him to complete and deliver works. (It is also possible that he was one of those artists who was loath to let a work go. And many who have studied Rembrandt comment that he got not more but less certain as time went on.) Baldinucci, who comments on the reluctance of prospective clients who knew how long it would take to sit for Rembrandt, puts it well when he wonders how, with such quick brushstrokes, Rembrandt worked so slowly and painstakingly.[4] For all his accomplishment, Rembrandt was not notably decisive or economical as a painter. He contrasts in this with the actual speed and the effect of speed given off by the brush of Hals. Though the paint of Rembrandt and that of Hals is often compared, there is little similarity between their modes of painting besides the visibility of the brushwork. Indeed, with the exception of those who followed Rembrandt's example, it is hard to find other Dutch artists whose paint surface is comparable to his in this regard. One might cite the slowly worked and built-up surfaces of certain animal painters—I have in mind some cows by Cuyp or the coarse flank of Potter's famous *Bull*. But these are descriptively imitative of the surfaces of things as Rembrandt's worked paint is not.

One of the reasons that the thickness of Rembrandt's paint was commented on in his own time is that it fitted into an established way of describing pictures. Writers, invoking ancient precedent, commonly distinguished between two modes of painting—a smooth and a rough one, or a finished and a less finished, loose, or free one. This was related to the distinction between those paintings appropriately viewed close up and those appropriately viewed from farther away, which was instanced by Horace when he came up with his long-lived phrase "ut pictura poesis," though Horace did not

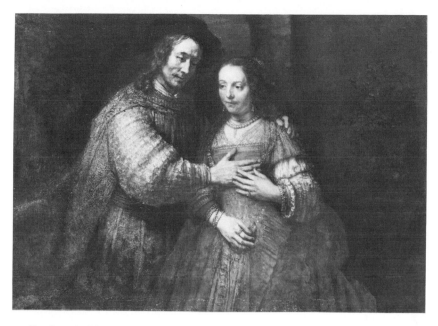

1.1. Rembrandt, *The Jewish Bride*. By courtesy of the Rijksmuseum-Stichting, Amsterdam.

1.2. Jan de Bray, *A Couple Represented as Ulysses and Penelope*, 1668. Collection of the J. B. Speed Art Museum, Louisville, Kentucky.

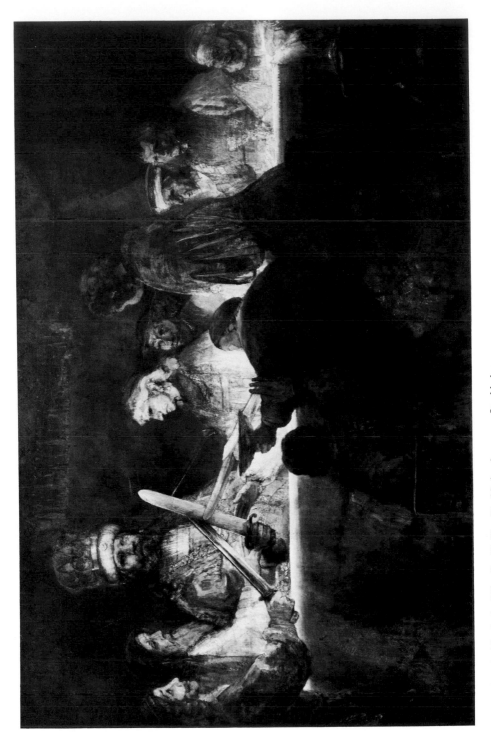

1.3. Rembrandt, *The Oath of Claudius Civilis*, 1661. Nationalmuseum, Stockholm.

1.4. Caesar van Everdingen, *Duke Willem II Granting Privileges to the High Office of the Dike-Reeve of Rijnland in 1255*, 1655. Collection of Hoogheemraadschap van Rijnland, Leiden. Photo Lichtbeelden Instituut, Amsterdam.

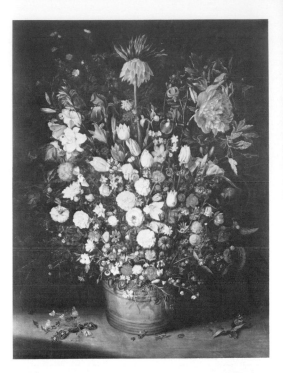

1.5. Jan Bruegel the Elder, *Flowerpiece*. Alte Pinakothek, Munich.

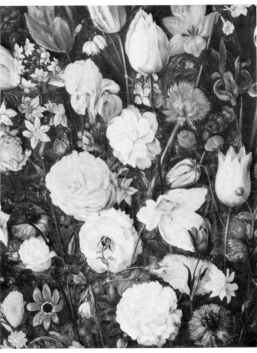

1.6. Jan Bruegel the Elder, *Flowerpiece*, detail. Alte Pinakothek, Munich.

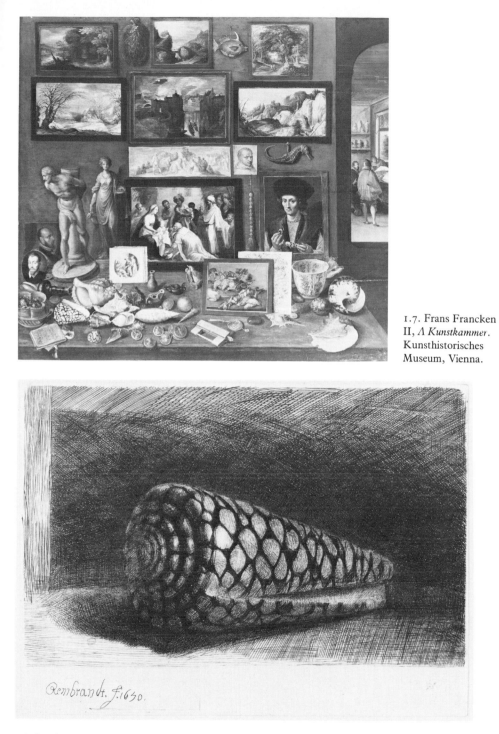

1.7. Frans Francken II, *A Kunstkammer*. Kunsthistorisches Museum, Vienna.

Rembrandt. f. 1650.

1.8. Rembrandt, *The Shell*, 1650; etching with drypoint and burin, B. 159, II. By courtesy of the Trustees of the British Museum, London.

prenent leur origine. Car cette fituation fe changeant
tant foit peu , à chafque fois que fe change celle des
membres , où ces nerfs font inferés, eft inftituée de la
nature , pour faire, non feulement que l'ame cognoif-
fe , en quel endroit eft chafque partie du cors qu'elle
anime , au refpect de toutes les autres ; mais auffy qu'el-
le puiffe transferer de là fon attention , à tous les lieux
contenus dans les lignes droites, qu'on peut imagi-
ner eftre tirées de l'extremité de chacune de ces par-
ties , & prolongées a l'infini. Comme lors que l'A-
ueugle , dont nous auons defia tant parlé cy deffus,
tourne fa main A, vers E, ou C, auffy vers E , les nerfs

inferés en cette main , caufent vn
certain changement en fon cer-
ueau , qui donne moyen à fon ame
de connoiftre , non feulement le
lieu A, ou C, mais auffy tous les au-
tres qui font en la ligne droite
A E, ou C E, en forte qu'elle peut
porter fon attention iufques aux obiets B & D, & deter-
miner les lieux où ils font, fans connoiftre pour cela ny
penfer aucunement à ceux où font fes deux mains. Et
ainfi lors que noftre œil, ou noftre tefte, fe tournent
vers quelque cofté , noftre ame en eft auertie par le
changement, que les nerfs inferés dans les mufcles, qui
feruent à ces mouuemens, caufent en noftre cerueau.
Comme icy en l'œil R S T , il faut penfer que la fitua-
tion, du petit filet du nerf optique, qui eft au point R, ou
S, ou T; eft fuiuie d'vne autre certaine fituation, de la
partie du cerueau 7, ou 8, ou 9, qui fait que l'ame peut
connoiftre

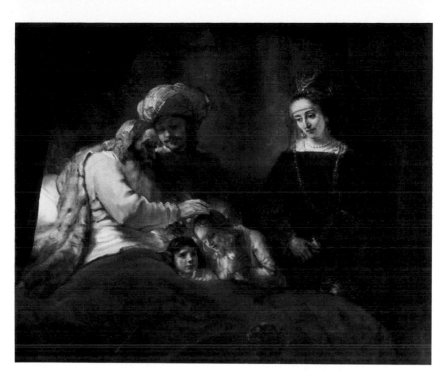

1.10. Rembrandt, *Jacob Blessing the Children of Joseph*, 1656. Gemäldegalerie, Staatliche Kunstsammlungen, Kassel.

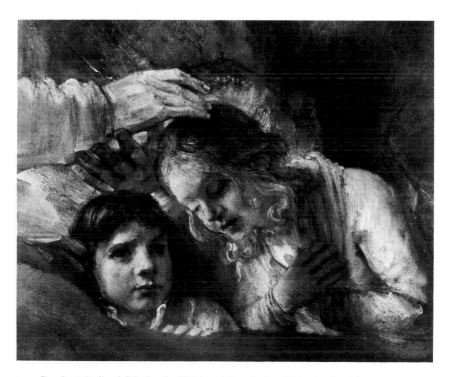

1.11. Rembrandt, *Jacob Blessing the Children of Joseph*, detail (blessing hands). Gemäldegalerie, Staatliche Kunstsammlungen, Kassel.

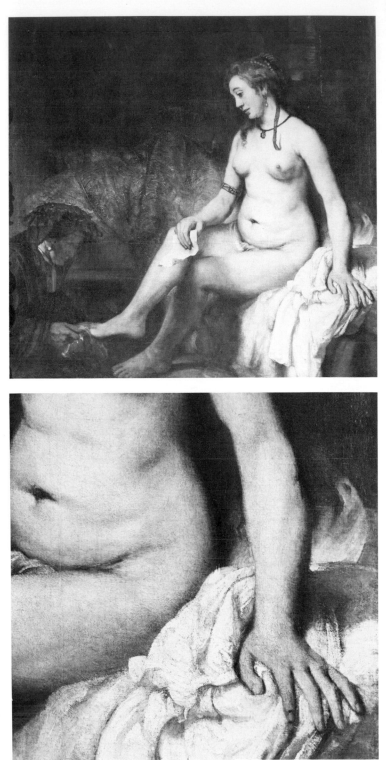

1.12. Rembrandt,
Bathsheba, 1654.
Louvre, Paris. Photo
Musées Nationaux.

1.13. Rembrandt,
Bathsheba, detail (her
left hand). Louvre,
Paris. Photo Musées
Nationaux.

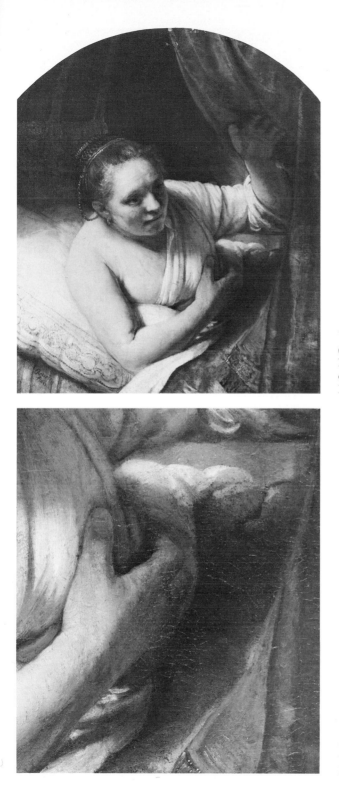

1.14. Rembrandt, *A Woman in Bed (Geertge as Sarah?)*. National Gallery of Scotland, Edinburgh.

1.15. Rembrandt, *A Woman in Bed*, detail (hand). National Gallery of Scotland, Edinburgh.

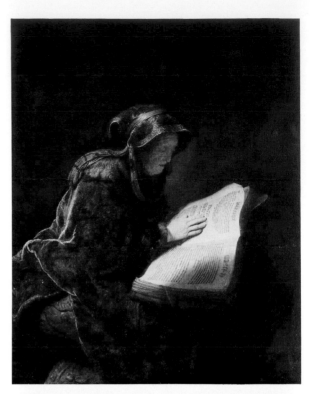

1.16. Rembrandt,
An Old Woman. By
courtesy of the
Rijksmuseum-
Stichting, Amsterdam.

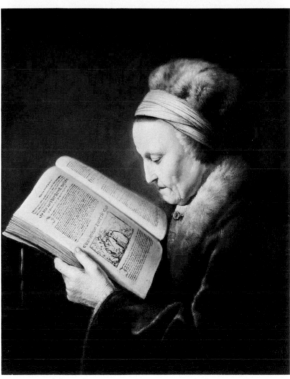

1.17. Gerard Dou,
Rembrandt's Mother.
By courtesy of the
Rijksmuseum-
Stichting, Amsterdam.

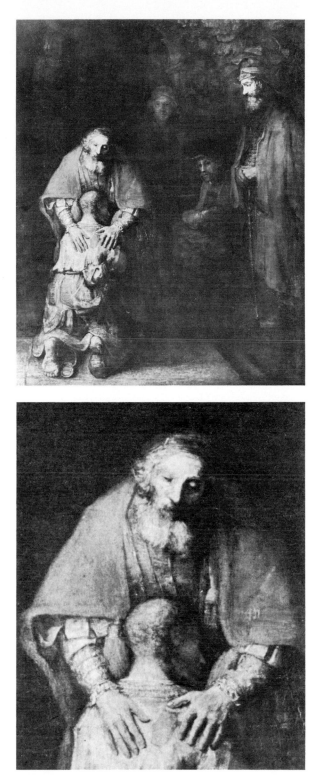

1.18. Rembrandt, *The Return of the Prodigal Son*. The Hermitage, Leningrad.

1.19. Rembrandt, *The Return of the Prodigal Son*, detail (father's head and hands). The Hermitage, Leningrad.

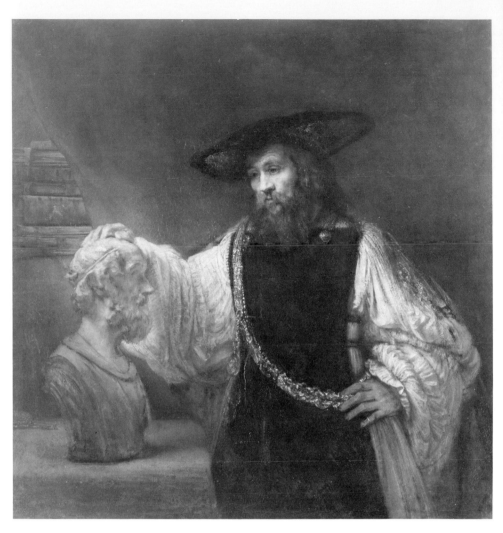

1.20. Rembrandt, *Aristotle Contemplating the Bust of Homer*, 1653. Metropolitan Museum of Art, New York. Purchased with special funds and gifts of friends of the Museum, 1961 (61.198).

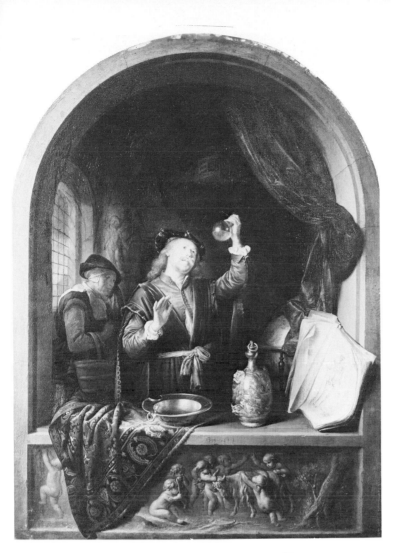

1.21. Gerard Dou, *The Doctor*. Kunsthistorisches Museum, Vienna.

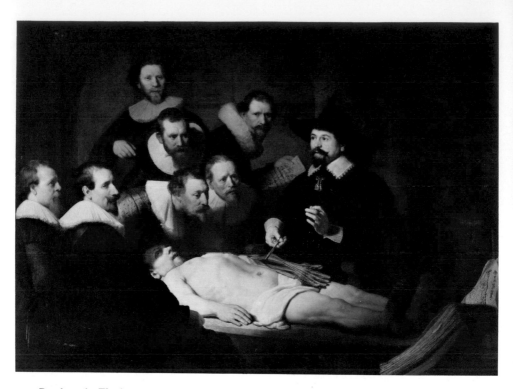

1.22. Rembrandt, *The Anatomy Lesson of Dr. Nicolaes Tulp*, 1632. Mauritshuis, The Hague.

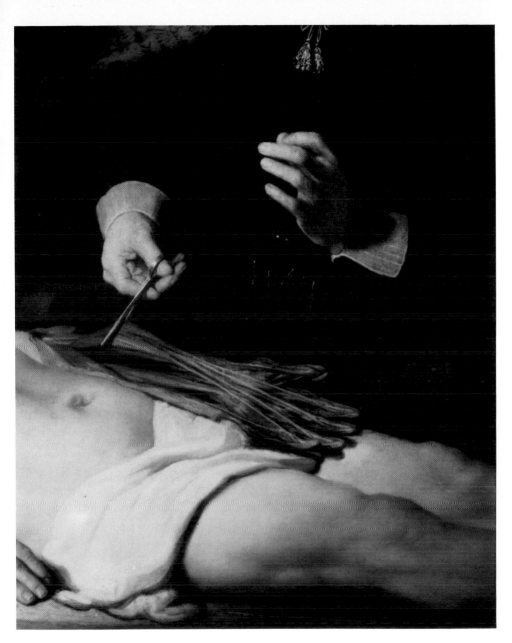

1.23. Rembrandt, *The Anatomy Lesson of Dr. Nicolaes Tulp*, detail (his hands). Mauritshuis, The Hague.

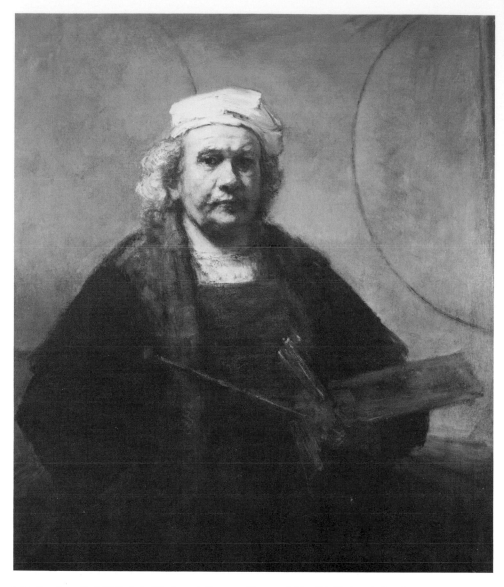

I.24. Rembrandt, *Self-Portrait*. The Iveagh Bequest, Kenwood (English Heritage), London.

1.25. Rembrandt, *Self-Portrait*, detail (hand). The Iveagh Bequest, Kenwood (English Heritage), London.

1.26. Rembrandt, *The Goldsmith*, 1655; etching with drypoint; B. 123, II (actual size). By courtesy of the Trustees of the British Museum, London.

1.27. Adriaen van der Werff, *Self-Portrait with His Wife and Daughter*, 1699. By courtesy of the Rijksmuseum-Stichting, Amsterdam.

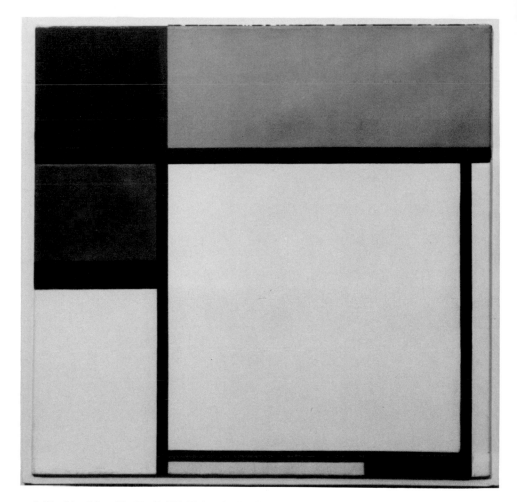

1.28. Piet Mondrian, *Fox Trot B*. Yale University Art Gallery, New Haven. Gift of Société Anonyme.

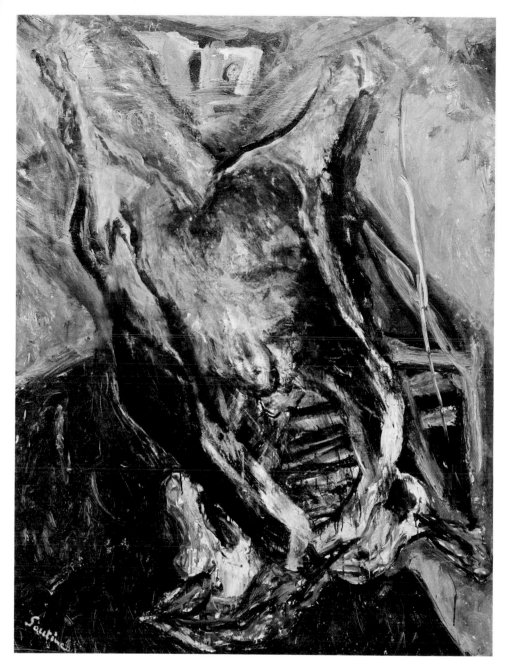

1.29. Soutine, *Slaughtered Ox*. Albright-Knox Art Gallery, Buffalo, New York. Room of Contemporary Art Fund, 1939.

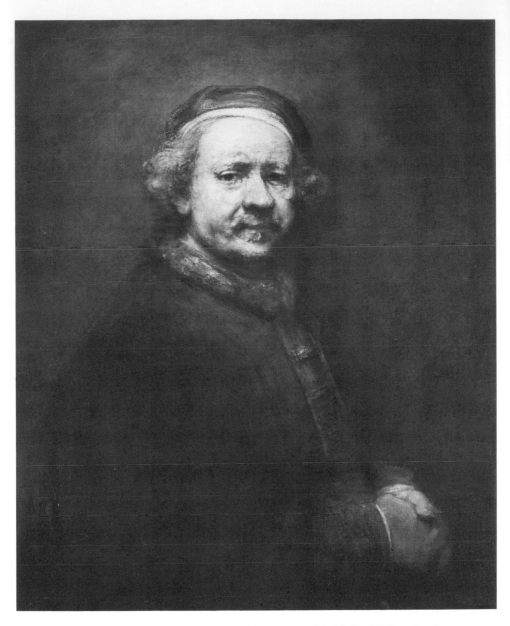

1.30. Rembrandt, *Self-Portrait*, 1669. By courtesy of the Trustees of the National Gallery, London.

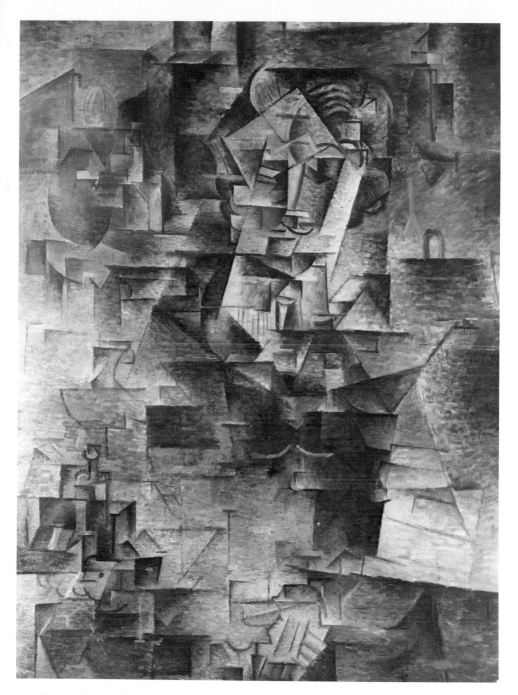

1.31. Picasso, *Portrait of Daniel-Henry Kahnweiler*, 1910. © The Art Institute of Chicago. All Rights Reserved. Gift of Mrs. Gilbert Chapman in memory of Charles B. Goodspeed (1948.561).

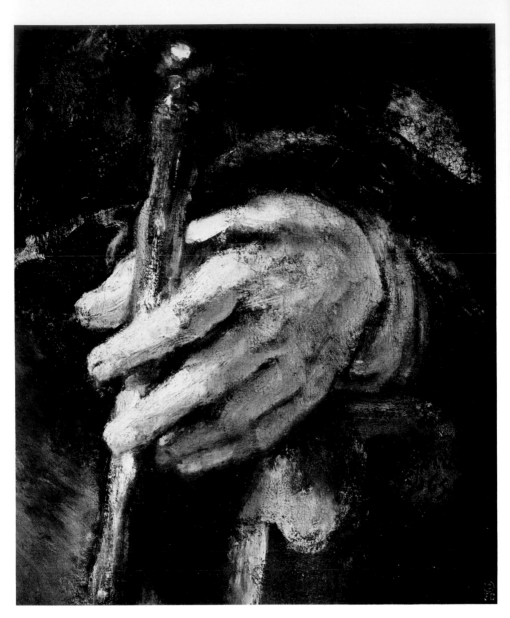

1.32. Rembrandt, *Self-Portrait*, 1658, detail (hand holding maulstick). © The Frick Collection, New York.

introduce the rough/smooth distinction.[5] Certain social and artistic values came to be attached to the difference between the two manners. In Vasari's account the rough or unfinished manner of Donatello or of Titian offered a display of imagination over and above mere manual skills and, as such, appealed to connoisseurs, who enjoyed knowing how to fill in what the artist's quick and brilliant brush suggested to their sophisticated eyes and imaginations.[6] The rough style, then, in the Italian account at least, was the virtuoso's art for the knowing courtier. Karel van Mander, the northern writer and artist often referred to as the Dutch Vasari, picked up the Italian distinction and repeated it (his terms are *"net"* and *"rouw"*), with a warning, for the benefit of the northern artists, that they would do well to start smooth.

In the Netherlands, it will come as no surprise, Rembrandt and Hals were among those called rough, and Dou and Van Dyck smooth. By 1650, Rembrandt and Van Dyck were spoken of as the paradigmatic artists in the two respective modes, and we have accounts of artists at that time who felt they had to make a choice between the two.[7]

Today the rough/smooth distinction with its attendant values is offered not only as a description of, but implicitly also as an explanation for, Rembrandt's paint. On this account, Rembrandt's handling of the paint was a suggestive device directed toward the sophisticated viewer. There is an anecdote told by Houbraken about Rembrandt's studio that fits the model of the refined viewing skills assumed by the rough manner: the painter advised visitors to his studio to stand back lest they be poisoned by the smell of paint. This is perhaps reiterated in the postscript to the letter to Constantijn Huygens in which Rembrandt instructs his patron to hang a gift painting in strong light and to view it at a distance.[8] Further, it is true that several of the early writers, among them Félibien and de Piles, recommend a distant view as appropriate to Rembrandt's brushwork in terms which fit this sense of the distinction rough/smooth. This was, after all, the established verbal manner in which to give a positive account of the rough mode at the time. But does it offer a just account of Rembrandt's practice?

In the north by 1650, the balance of taste for the two manners was the reverse of the account just given. Let us take first take up the issue of how the two styles were received: contemporary accounts offer evidence of what was involved for Jan de Baen, one of Rembrandt's pupils, in choosing the proper artistic path to follow in the Netherlands about 1650. It was the smooth style associated with

Van Dyck, rather than the rough one, that was perceived as appropriate to the court, and historically it was seen as the new fashion replacing the old style of Rembrandt (figs. 1.27, 3.24).[9] Instead of appealing to a knowing and imaginative courtier, the rough style was seen as passé and, in the case of Rembrandt at least, as being tainted with the marks of the studio. On this view, to call attention to one's paint was not the refined thing to do. This is one way of understanding the early accounts of Rembrandt's life, which report that he was too openly messing about with his paints. Baldinucci, for example, reports that he cleaned his brushes on his clothes, and a persistent theme in Houbraken's life is the relationship between Rembrandt's uncouth manners and his rough manner of painting. (Rembrandt's recorded public behavior, which we shall consider in chapters 3 and 4, does not contradict these reports.)

Why should the attitude toward rough and smooth in the north be so different at this time from that in the established tradition of writing about pictures? It might be a sign that the north was historically in the vanguard of European taste in embracing a new neoclassical finish—that it was so to speak "beyond the rough." This is how De Baen's choice has been understood by modern scholars. But I suspect that the turning away from Rembrandt's rough handling is also a reaction against the old cultural status or location of art in the north. Even in Rembrandt's time much art-making in the Netherlands was still bound to the craft world of guild and workshop rather than to a privileged and literate society beyond. The smooth style was seen as marking a break with this. There was a certain justness about the criticisms of Rembrandt's paint. In painting in the manner that he did, despite the growing popularity of the smooth manner, Rembrandt called attention to his craft by effectively presenting his performance as that of a maker in the studio. In effect, he transformed rough painting negatively viewed into a newly positive practice.[10]

We have considered various descriptions of Rembrandt's paint, but if we want to explain what Rembrandt was doing, we might put the question in terms of production: does his insistence on the thickness or materiality of his paint, to return to a feature noted by contemporary commentators, challenge craft in the name of suggestiveness? Or does it rather call attention to craft in a new sense by the production of a substantial, as distinguished from a suggestive, pictorial presence?

We might consider the nature of the paint surface in Netherlandish art in somewhat different terms. Rembrandt was not the first art-

ist in the north to associate the visible display of the handling of the paint with what I have called craft. But he did this with a difference, and to clarify this point it will be useful to play him off against a particular craft tradition. Like Rembrandt's works, this tradition cannot be described in terms of the rough/smooth distinction as that came to be understood. It did not offer lack of finish as an enticement for the connoisseur, but instead made a certain kind of pictorial craftsmanship the basis of a claim about the nature or value of art. I am referring to the tradition of painters who were often involved with some form of still-life, and who considered their art to be in competition with Nature herself.

Jan Bruegel, the first great flower painter, strives to make his painted flowers equal to and even finer than those made by Nature (figs. 1.5, 1.6).[11] His paintings are a display of artistic virtuosity, and it is for that reason Bruegel intends us to see his brushstrokes at work as well as the panel which supports them. To appreciate the art in this art, one does not stand back but comes close. Although paintings of this kind are often described as reminders of mortality, there is evidence that they were produced as a display of human craft and to satisfy a desire for the possession of knowledge. They were included in those curious encyclopedic collections, the first museums, that were assembled by European princes to be a microcosm of the world and, in turn, recorded in yet further pictures. Such a collection might include sculpture, painting, jewels, coins, shells, a sea horse, and also flowers in paintings as a way to preserve them (fig. 1.7). But besides presenting themselves as a display of human artistry, Jan Bruegel's pictures supply (or flirt with supplying) value in more ways than one: the specimens are painted so as to fool our eyes into thinking they are the real thing; they are chosen for their rarity; the materials were chosen with an eye to their cost— copper as a support frequently, lapis lazuli as a pigment, gold for certain frames. It was because of these values, among others, that the paintings were priced more highly than the special specimens and objects represented in them.

A similar claim to value was made in Holland during Rembrandt's lifetime by a painter of still-lifes such as Kalf. In choosing to devote his attention to a rare piece of china, to silver and fine glassware rather than to flowers, Kalf seems to have been competing with other human craftsmen rather than with nature. His works make the claim that he could with his paint craft a finer silver plate or glass goblet than the silversmith or glass blower could make. We watch in slow motion the working of the paint by which he is able to

represent the smooth surface of a gleaming glass, or the fuzzy sur-
face of a peach. Such a painter lays claim to being supreme among
human craftsmen. And he paints his pictures for wealthy Dutch mer-
chants who are buying expensive illusions of expensive possessions.

My reason for bringing up Jan Bruegel's handling of paint is to
break through the simple reception theory engaged in the discus-
sion of rough and smooth and to introduce, instead, questions of
the production of painterly value, with which Rembrandt was also
concerned. But it is Rembrandt's difference from Bruegel within
this scheme of things that I hope to demonstrate, and to that end let
us consider the one work in which Rembrandt might be said to have
taken up the Bruegel mode (fig. 1.8). His etching of a shell is the
only "pure" still-life—by which I mean a work without the added
presence of any human figures—that we have from Rembrandt's
hand in any medium. (And Rembrandt seems to have discouraged
artists in his studio who had such talent.)[12] Rembrandt's shell re-
minds us of Jan Bruegel, who often painted shells lying beneath a
vase of his flowers. In representing a shell, Rembrandt turned to an
object that fascinated collectors at the time, because shells were
thought to occupy a separate category on the borderline between art
and nature. The shell was an example of natural artifice, of Nature
acting like an artist. Put a bit differently, it is Nature reproducing
something that looks as if it were crafted by man. (The point is
rather like our delight when we bring a shell or piece of drift-wood
home from the beach and display it on a shelf because it seems to
mimic the work of a human artist.)[13] But unlike Bruegel's shells or
flowers, there is no possibility of illusion on the part of Rembrandt's
shell. The value of Rembrandt's etched shell is distinguished from,
rather than associated with, other kinds of values.

By making the remarkable decision to etch the shell, transform-
ing its pale colors, its curved and glossy surface, into lines (and
dots) of black on white, Rembrandt intentionally calls attention to
the difference between what the shell is made of and a picture of it,
and between the look and the value of the object and the look and
the value of an image.[14] Rembrandt was himself a collector and most
probably owned this shell. But in etching it, and doing that not only
once but reworking it in three successive states, he was not display-
ing a taste for natural knowledge, nor a taste for the possession
of a rare and expensive shell, nor a taste for fine materials (all the
recorded impressions of the shell are on an ordinary paper), but
rather what one might call a taste for representation. The shell from
his collection is transformed and multiplied by his handiwork in the

studio for circulation on the market as a number of collectible Rembrandts. And it is notable that Rembrandt signed and dated the etched shell starting with the first state.

The etched shell offers a particularly rich example of how Rembrandt established representational values by shunning the multiple values courted by Bruegel's paintings. As an etching of a shell it is of course a special case, a negative example, both in choice of subject and choice of medium. Let us now ask how we might describe the values claimed by Rembrandt's paintings. What is the nature of his production of painterly value?

Rembrandt chose to study with a group of Amsterdam painters of small, narrative pictures who called little attention to their paint.[15] They are not memorable for their surfaces. For them it was the story, not the paint with which it was executed, that mattered. The option of rough or smooth seems not to apply. But early in his career we find Rembrandt, in a painting done when he was about twenty years old, carving into the wet paint surface with the end of his paint brush or with his maulstick (the wooden stick on which the painter steadies his brush when he paints) (pl. 1). He already treats his medium as something to be worked in, as if material to be modeled, though in the early years this handling was often focused on the underlayers of paint. It is the paint's capacity to be so worked, not its beauty or value as material substance, that Rembrandt prizes from the start. Other painters at the time made on occasion a display of particularly valuable pigments: Velázquez used ultramarine or azurite for a sky, and Frans van Mieris, himself a goldsmith's son, gilded a copper plate to achieve a gemlike luster on the painted surface. It is remarkable that Rembrandt was, apparently, the only other Dutch painter at the time to have used gold. We should recall in this connection the unexpected use of expensive red lake glaze to build up the shoulder of the musketeer in *The Nightwatch*. Rembrandt's continual experimentation with the handling of pigments did not involve the display of their value as such. On the four occasions when he (or his workshop, if the works are not all by him) used gold as ground or, in the Los Angeles *Raising of Lazarus*, as part of the paint surface itself, it is less for the purpose of luster than in the interest of the three-dimensionality of the pictorial form.[16] His paintings display the gold *effect*, as in the chain of *Aristotle*, not the thing itself. (One should add that this—displaying *effect* rather than valuable materials—could not be said of the production of etchings, in which Rembrandt's interest in rare and diverse kinds of paper is justly renowned.)

There is another dimension, which is superficially like another sense, that is engaged by Rembrandt's paint surface. In the mature paintings, paint is worked to engage our sense of touch as it is mediated through our sense of sight. Rembrandt lays the paint on with his brush and often shapes it with his palette knife or fingers so thickly that it looks as if one could lay one's hand on it. Notice the raised ridges of pigment that define the chain (or is it meant as a ring?) which loops over the little finger of the *Aristotle* in New York (pl. 3). It is true that painters were praised at the time for their ability to recreate texture in paint. Jan Bruegel, whose flowers we just looked at, was nicknamed Velvet Bruegel for that very reason. He could, as the name suggested, depict velvet and other surfaces like the petals of a flower so that one could, so to speak, *see the texture* of their surfaces. Rembrandt did not display his craft as a painter by rendering those visible properties—the illusory surface effects of look and texture—that were captured with the brush of Bruegel or Kalf. In a painted passage such as Aristotle's chain, Rembrandt makes the materiality of the paint itself representational. Qualities that we know by touch—the weight and pressure, the substantiality of things—we are made instead to see.

Rembrandt does not expect us to actually touch a painting, as Constable is reported to have wished.[17] But by appealing to the physical activity of touch he is able to suggest that seeing is also an activity: vision, so the analogy proposed by his paint goes, is a kind of touch. In *La Dioptrique* (1637), Descartes illustrated vision (the way we see, as distinguished from the mechanism of the eye) with a reference to a blind man probing with a stick. The eye, he argued, is affected by light carried by the air just as the hand is affected by a stick. "Seeing with sticks" was the notion of seeing proposed by Descartes's text and by the illustrations which accompanied it (fig. 1.9). One does not assume that Rembrandt espoused any particular theory of vision. But his paint surface, as well as the subject of some works, shows that he shared an interest in blindness and in touch with those pursuing natural knowledge and in some measure for the same paradoxical reason—as a condition of attending to the nature of seeing. It is not the eye as an image-making mechanism, but the activity of seeing, that his paintings call attention to. His laying on of substantial paint can be described as making something that is visible in this sense.[18]

Rembrandt's building up of paint and of objects in paint helps explain the curiously flat or even absent space of his mature works. There is the awkwardly foreshortened or truncated bed in the Kassel

Jacob Blessing (fig. 1.10) or the characteristic peripheral fading-out and lack of spatial definition around the major single figures. The absence of the illusion of depth in Rembrandt's late paintings is not due to the fact that he painted before the introduction of perspective theory into the Netherlands (as Jan Emmens suggested in *Rembrandt en de regels van de kunst*), but rather because he considers both the objects in his paintings and the paint itself to be thick or solid substances. In his etchings and drawings, when he is not using paint, Rembrandt, by telling contrast, does depict space persuasively. (A number of artists, among them Hoogstraten and Nicolaes Maes, who were his students in the 1640s, pursued the interest of perspective in paint that Rembrandt eschewed.) There is a kinship here with that combination of substantiality of paint and notorious difficulty in depicting space that we find in an artist like Manet. To such a material sense of pigments and of the objects in view, space is registered negatively, as an absence of substance.

Before we go any further, we might do well to distinguish between three forms in which this availability to touch is manifest in Rembrandt's paintings: the facture or thickness of the paint, the implied solidity of objects represented within the paintings, and the painting itself as an object. It is the overlay or overlapping between these different but related claims that produces the distinctive appearance and the nature of his paintings: they can be accommodated neither to the Italian model of the window on the world nor to the Dutch model of the mirror or map of the world, for they are produced instead as new objects in the world.[19] There is, finally, one further manifestation of touch in Rembrandt's works which is related to, but distinct from, those just noted: the prominence and activity of the painted hands. We are turning our attention now from the deployment of paint to its thematization in Rembrandt's paintings.

The hands of *Bathsheba* in the Louvre (figs. 1.12, 1.13) and those of the woman possibly representing Sarah, in Edinburgh (figs. 1.14, 1.15), are exaggerated, almost grotesque in size. In the Edinburgh painting Rembrandt has gone out of his way not to observe that rule of sight that Gombrich illustrated with the bingo-ball effect: namely that we depend on certain constancies of knowledge to "correct" the huge appearance of objects, such as hands, thrust towards us.[20] But there is another factor. Our hands are large in relationship to our bodies, and painters normally reduce their size to make their appearance less awkward or overbearing. As Bathsheba's large left hand resting on the cloth beside her makes clear, Rem-

brandt refuses to make this adjustment. Why this emphasis on prominent hands? First, because in Rembrandt's paintings to touch with the hand gives access to understanding. Here is an early portrayal of an old woman reading a book (fig. 1.16). This is perhaps the artist's mother, and it might be intended as a picture of the prophetess Hanna. It is not the identity of the woman that is our interest, but the way Rembrandt depicts her reading. She does not look at the book in front of her as much as she absorbs it through her touch, almost as a blind woman today might move her hand across a page printed in the raised type of braille. The difference between this and a contemporary painting by Rembrandt's first pupil Dou is telling (fig. 1.17). Dou's woman looks, as we are invited to look with her, at both text and picture. Unlike Rembrandt's book, Dou's is there to be looked at. Rembrandt intentionally leaves the text, which is unillustrated, illegible. Hard as we look, we cannot make out a word. And what lies between us and the text is the finely worked hand. It is as if the hands, rather than the eyes, were the instruments with which the woman reads. Houbraken complained about Rembrandt's lack of care with hands, adding that in portraits he either hid them in shadows or put in the wrinkled hands of old women. There is a contradiction here, because the depiction of wrinkled skin was one form that Rembrandt's attention to hands took.[21]

Human understanding as well as textual understanding is prominently marked in Rembrandt by the laying on of hands. One understands why the biblical passage in which the old Jacob picks the grandson he wishes to bless by touching his hand to the head proved so fascinating to Rembrandt (fig. 1.11). Love between man and woman in *The Jewish Bride* is demonstrated through a complex overlaying of very large hands (pl. 7). It is as if the hands had grown to these unusual dimensions in order to be sufficient to their task. And hands are pivotal in the welcome offered to the returning prodigal son in the painting in Leningrad (figs. 1.18, 1.19). The father faces his son and the viewer, but it is his hands resting in greeting on the rough cloth of the son's garment which bind the forgiving father to the penitent child. In works such as these, touch answers to the desire for the demonstration of love between people. Ordinarily, sight is necessarily out of touch because to see one must be at a certain distance from what one views. Touch is more immediate than the distanced eye. The attendant figures who, in contrast to the father, are looking on at the right demonstrate this difference

(even if, as some experts believe, they were not executed by Rembrandt's hand).[22]

Rembrandt investigates blindness or its symptoms in order to heighten our sense of the activity of perception. The father's eyes appear to be drained of sight, as if they were literally dimmed in respect to the immediate contact offered by the laying on of hands. One could say the same thing about Rembrandt's fascination with the blessings bestowed by the blind Jacob or Isaac. Blindness is not invoked with reference to a higher spiritual insight, but to call attention to the activity of touch in our experience of the world. Rembrandt represents touch as the embodiment of sight: seeing done with hands instead of with Descartes's sticks. And it is relevant to recall that the analogy between sight and touch had its technical counterpart in Rembrandt's handling of the paint: his exploitation of the reflection of natural light off high relief to intensify highlights and cast shadows unites the visible and the substantial.

To propose a rule about a single aspect of Rembrandt's varied practice is of course to invite exceptions. But we might consider how often the prominent hands in Rembrandt's paintings are not deployed in expressive gestures, nor described—as Van Dyck's attenuated and useless aristocratic ones are, for example—as a sign of social class. How often are hands instead depicted as the instrument with which we touch or grasp. Sometimes this is achieved by indirection as in *The Nightwatch*, where Captain Banning Cocq's raised hand stains, with a commanding shadow, the lemon yellow jacket of his lieutenant (fig. 2.1).

We are so used to the familiar title of *Aristotle Contemplating the Bust of Homer* that we tend to ignore the fact that Rembrandt makes the philosopher's relationship to that great writer he so admired a matter of touch (pl. 2, fig. 1.20). While one oversized hand rests on his hip, fingering his heavy gold chain, the other rests on, in order to feel and thus to know, the marble bust. (The bust, like the shell, was an item from Rembrandt's own collection he put to studio use.) The right hand takes on the creamy color of that bust it probes, while the other hand retains what is established, by contrast, as the ruddier appearance of flesh. We happen to have evidence that this particular gesture was noticed when the painting was new. The work had been ordered by an Italian collector who also wanted some other paintings similar in kind to hang along side of it in his collection. He sent a drawing made after Rembrandt's painting to Guercino to order a companion piece. The Italian artist responded

by suggesting that he supply a portrait of a cosmographer (a portrait of a man with his hand on a globe) to accompany what he took to be Rembrandt's portrait of a physiognomist (one who studies human nature through a study of human features). Guercino, in other words, was struck by the gesture of the hand on the bust and furthermore read it as having to do with a particular form of knowledge—physiognomy.

It has been suggested that Rembrandt's *Aristotle* is related to those familiar types of contemporary portraits which depict a man with part of his valued collection or perhaps a scholar or an artist with a bust of an admired intellectual or artistic model.[23] But we might consider the *Aristotle* as Rembrandt's version of a picture like Dou's *Doctor* (fig. 1.21), which, as it happens, was also painted in 1653. It is, in other words, a picture concerned with knowledge or with the means by which we apprehend the world. In taking the *Aristotle* to be a physiognomist, Guercino saw it in such terms. Whatever one might take the nature of such knowledge to be, on Rembrandt's account, a salient point is that apprehension of the world is actively sought through touch. Aristotle's eyes, shaded in a characteristic Rembrandt manner, are not fixed on anything in the external world. Lost in thought, perhaps, he is taken up with touch.[24] Dou's doctor is portrayed as a man who understands the human condition through sight alone. In this instance, he directs his eyes to the contents of a urine bottle—a substance whose appearance was taken then, as it is today, as offering a visual symptom of the body's health. Glancing away from the bottle, as Dou's doctor will do, we are also invited to look at the illustrated anatomy book by Vesalius—a visible and legible volume which contrasts with the pile of characteristically substantial but unreadable texts which Rembrandt has piled at the left in his *Aristotle*. The very execution of Dou's painting—the clear surface not marred by a single visible brushstroke—trusts to the look of visible things just as the doctor in the painting does. The alternative that Rembrandt's painting offers with its pitted and raised paint and the thoughtful and touching Aristotle is decisive.

But Rembrandt's appeal to the hand and to touch is motivated by more than a desire for physical activity and contact, strong though that is. The hand, after all, is the instrument of his profession; it is with the hand that a painter paints. Much has been written about Rembrandt's first important public commission in Amsterdam, his depiction of Dr. Nicholaes Tulp, praelector or lecturer in anatomy to the Amsterdam guild of surgeons, to whom he is offering an ana-

tomical demonstration (fig. 1.22).[25] We know the name of each of the men portrayed, even that of the convict whose corpse was used on this occasion. The extraordinary veracity with which Rembrandt conveys the pallor of death is matched by his care in depicting the dissection. He follows the model of the portrait of Vesalius which served as the frontispiece to his famous illustrated anatomical text. Tulp, like Vesalius, is depicted dissecting the muscle and tendons in the forearm which serve to flex the fingers. It has only recently been pointed out that while the doctor's right hand exposes the muscles and tendons, his left hand is raised in a gesture which demonstrates their use. Tulp's left hand is not raised in a rhetorical gesture to accompany speech but to demonstrate that flexing of the fingers which enables us to hold or grasp objects. He is in effect demonstrating how we use our hand (fig. 1.23).

Why is Tulp in this painting demonstrating the function of the hand?[26] I am going to suggest that in this painting Rembrandt is concerned with the essential instrument of the painter. But though I think that is true, it is rushing things a bit to say it. For surely it was Tulp, not Rembrandt alone, who thought to have the grasping action of the hand made the center of the portrait of his anatomical demonstration. There was good reason for Tulp to do this, and it has to do not only with the model provided by Vesalius but also with the highly regarded writings of Aristotle. According to Aristotle the human hand was not a specialized instrument like the claw of a predator or the hooves of a herbivore. It was an instrument at a higher level, because it was not one instrument but many. It was an instrument for using instruments. Man, wrote Aristotle, has hands because he is the most intelligent animal. He thought of it as the physical counterpart of human reason, which was the instrument of the soul. For it was with the instrumental use of reason and the hand, particularly in its primary feature—the prehensile element that is demonstrated here—that, according to Aristotle, man had created civilization. If a painter, Rembrandt, for example, had wanted to define his particular profession, a profession that, because it was manual, had traditionally needed defense against the higher claims made for the intellectual liberal arts, what better way than focus upon the hand in Aristotle's terms as the instrumental sign of man's intelligence?

There was, then, a mutuality of interest between Tulp, a doctor, and Rembrandt, a painter, in the invention of this portrait which, I believe, led to the pictorial innovation of the prominent "demonstrating" grasp of Tulp's left hand.

If Rembrandt had specifically thought of the painter's hand in this instrumental way, did he ever attempt to paint it? Perhaps he did. And this could explain a particular feature of his *Self-Portrait* in Kenwood (fig. 1.24). There has been much discussion about how we might explain the two great circles that appear behind Rembrandt on the wall.[27] I do not propose to add anything to that discussion, but I do want to call attention to the painter's hand—or to what replaces his hand (fig. 1.25). It is an assemblage which, as a medical friend remarked, looks almost like a prosthetic device. It was in 1660, at the age of fifty-four, that Rembrandt, who was a committed self-portraitist, first painted his self-portrait as a painter. (I am ignoring the early painting in Boston which is less clearly a case of self-portraiture.) Rembrandt wears a painter's smock and rough, white cap. His right hand, the hand he actually painted with, is hidden, it is true, but his left hand has been replaced with a palette, brushes, and a maul stick. (X-rays show a certain amount of repainting, and they suggest that Rembrandt first put his materials in the hand to the left, the hand in which they would have appeared if viewed in a mirror.) It is, in fact, as if Rembrandt had constructed his hand out of the instruments that it employed for painting. The hand of the painter is represented in what, following Aristotle's definition, we might call its instrumental use. Let us read Aristotle: "Take the hand, this is as good as a talon, a claw, or a horn, or again a spear or a sword, or any other weapon or tool: it can be all of these, because it can seize and hold them all," to which Rembrandt the painter has now added it can be a palette, maulstick, and brushes, and he has painted it as such.[28]

Leo Steinberg has written something remarkably close to this about Picasso fashioning hands in the *Three Musicians* in Philadelphia: "He knows, or knew in 1921, that a man's hand may manifest itself as a rake or mallet, pincer, vise or broom; as cantilever or as decorative fringe. . . ."[29] We are accustomed to what we consider to be bodily distortions in the work of a painter of our own century like Picasso, and, indeed, in the medium of sculpture he produced assemblages of a similar type. Rembrandt also reconstructed the body and shared a common purpose—to represent a particular function. The point is less to claim Rembrandt for the moderns, than to argue the old-fashioned nature of the reconstructive art of Picasso. But the comparison to Picasso works both ways, since I mean to suggest by it that many things that have been taken as pictorial devices intended to achieve expressive effects in Rembrandt's

art—the deployment of light or the late brushwork—are construc-
tive in nature.

To summarize: we have seen that Rembrandt's substantial (or
"rough") paint calls attention to itself as work done in the studio;
that touch is appealed to by the paint surface to represent the active
apprehension of the world; that touch is enacted by the size and ac-
tion of the hands in his paintings. Touch supplements sight as the
primary vehicle of human contact, understanding, and love, and, in
particular with the *Anatomy Lesson of Dr. Tulp* and the Kenwood
Self-Portrait (but it is probably a more general phenomenon), Rem-
brandt's fascination with the hand is related to the instrumental role
of the artist's hand in the making of pictures. It is, finally, just pos-
sible that in the curious etching known as *The Goldsmith* we can see
how Rembrandt conjoined the hand's two roles—loving and paint-
ing—in an image of the artist at his work (fig. 1.26).

The tiny etching of 1655 depicts a goldsmith in his shop just put-
ting the finishing touches to a figural group representing a woman
(Charity, or Caritas) with two children. While his right hand works
with the hammer to fasten the metal to its base, the artist lovingly
embraces the woman with a huge left hand. His fingers press up
against her thigh. Lest we doubt that this is meant as a gesture of
embrace, note the way the goldsmith's cheek is bent to meet hers.
The embrace could be called familial. This could be the portrayal of
a man, his wife, and their children. But all the love and tenderness
of the man, his embrace of the woman within the grip and caress of
his hand, is bestowed on the statue he made. As an artist he bestows
his love not on a real family, but on a surrogate one of his own
making.

It was a topos of the time that the artist's engagement with his art
was like the love of a man for his muse, his mistress, or, in some
versions, his wife. In poems and paintings alike, this gives a certain
authority to the painter or writer in love. The analogy was often
made a matter of substitution: the artist's love of art replaces the
love of other women in his life. And this was extended to a com-
parison between the making of a work of art and the engendering of
a child. In response to a priest who told Michelangelo it was a pity
that he had not married so as to leave the fruit of his labors to his
children, Vasari has Michelangelo reply that his art is already a wife
too many and that his works are his children. The story found its
way into the north by way of Van Mander (who ends his life of
Spranger with it), and it was repeated by Hoogstraten.[30]

In Dutch paintings, artists commonly worked the analogy art-wife to precisely the opposite end. It is one thing to say one's muse is like or even replaces a wife, and quite another thing to consider one's wife to be one's muse. But the Dutch artist often depicts his wife, sometimes even with his children, as such. There is a practical basis for this—family members served the artist as models. But in addition to overlapping with this practice, self-portraits in the company of "real" or depicted wife and/or family also engage certain notions of art. The topos as we have it from Vasari and Michelangelo does not anticipate that domestication of art that we find in self-portraits with family members by Dou, Metsu, Mieris, Jan de Baen, and others. Adriaen van der Werff even manages to extend this domestic representation of art into the artistocratic sphere. Bedecked with the gold chain awarded him for royal service, he includes a painting of his wife and daughter as Pictura and a Genius (?) in his *Self-Portrait* of 1699, a second version of one he made for the Medici collection of artists' self-portraits (fig. 1.27). For all the aura and imagery of the court, this painting is as much a tribute to his wife and children, who seem all but alive despite their pictorial state, as to his art. There is a difference between art being related to love, and painting being bound up with and confirming marriage and the household. One need not argue the point further, since Rembrandt makes this difference clear.[31]

The smock the goldsmith wears while he is working is like the one Rembrandt wears in his Kenwood *Self-Portrait* (and also, incidentally, like that worn by Aristotle). But this etching is not a self-portrait. Unlike many other Dutch artists, Rembrandt never depicted himself with wife and child. The closest he comes to it is in this etching where he displaces love of family onto love of his own art. It is unusual to find any acknowledgment of the misogynist potential of the topos: that art can serve an artist in place of a mistress and that he (rather than she!) can then give birth to works of art. In embracing the woman and her children as offspring of his own making, Rembrandt illustrates the misogynist desire as it was so frankly uttered by Montaigne in his essay *On the Affection of Fathers for their Children*, "I do not know whether I would not like much better to have produced one perfectly formed child by intercourse with the muses than by intercourse with my wife."[32] Eros, as we find it in the Pygmalion myth (to which this work might also be related), is transformed into an exercise of male generativity. Art so represented is not coextensive with the household and domestic life, but distin-

guished from it. This was a determining aspect of Rembrandt's studio operation. We shall return to it again in the chapters to follow.

There was, as far as we know, no group of this size cast in metal in Holland at this date. (Rembrandt probably fashioned the Caritas after a Beham engraving.) Why then did Rembrandt invent one? Because it presents in miniature an image of what Rembrandt conceived his art as being. Painters and sculptors in Europe had traditionally vied with each other for praise. Painters, for their part, had tried to equal sculptors by making figures within their paintings that were as solid and convincing as the three-dimensional works of the sculptor. In northern Europe this took the special form of the painted replication of sculpture that we find on the exterior of altarpieces from Van Eyck to Rubens. The painters effectively transformed sculpture so that it served their aim of deceiving the eyes of the beholder by representing the world in color and design on a flat surface. Don't be sculptural, be painterly and lifelike, was the message of Rubens's brief treatise on the painter's imitation of ancient statues.[33] Rembrandt, rather uniquely, tried instead to make something relieflike and solid out of painting. In the figure of the goldsmith with his statue he has accomplished his iconic aim. He is something of a sculptor manqué, like Picasso. (This might account for some of the satisfactions he found as a printmaker in working or "sculpting" the plates.) The statue that Rembrandt invents for the artist to embrace in this etching is the answer to his desire, or, if not the answer, a most explicit acknowledgment of it.

It is somewhat eccentric to attribute to a painter the desire to make a real object out of a painting. But we have the evidence of another Dutchman, Mondrian, who is on record as having said that he wanted his paintings to have a "real existence." He tried to achieve this by bringing the picture forward from the frame, mounting the painting on the frame so as to push it out into the viewer's space (fig. 1.28).[34] It is not inconsistent with the desire for this kind of objective presence, that Mondrian's paintings sacrificed the traditional pictorial illusion of both surface representation and depth. The distinctive format and facture of Rembrandt's late paintings—the life-size three-quarter-length frontally viewed figures worked up in thick pigments—can also be described as a record of a sacrifice. Considering the phenomenon in historical terms, one could say that Rembrandt's sculptural ambition plays back, or replays backwards, the account offered by Sixten Ringbom of the emergence of narrative scenes in northern painting out of icons or sculpted reliefs.[35]

My aim has been to direct attention to the distinctive manner of Rembrandt's touch. Basing our account on one feature of his way with his paint, we have teased out certain things about the formal and thematic presence of his paintings. Since the last century, a taste for Rembrandt has been a taste for the mysterious and the evocative—the romantic legend of his life has been extended to a romantic viewing of the art. Artists such as Soutine have been attracted to Rembrandt. But the viewing of the Dutch master's works that we see in Soutine's *Flayed Ox* separates the expressive from the constructive aspects of the painted surface as Rembrandt never did (fig. 1.29). The result is that while it might be thought that such paintings look Rembrandt-like, Rembrandt in fact does not apply the paint in this loose, expressive manner in any of his works. I used the word "constructive" on purpose. For I think the idiosyncratic invention of Rembrandt's late works is comparable to what Picasso did in 1907–10 (figs. 1.30, 1.31).

Rembrandt's final *Self-portrait* and Picasso's 1910 *Portrait of Daniel-Henry Kahnweiler* offer a common frontality. The image confronts the viewer immediately and head-on. The darkness surrounding the figure in Rembrandt's late portraits is similar to the well-known fading-out around a cubist image such as this. As Picasso was to do after him, Rembrandt moved away from depicting actions to offer the act of painting itself as the performance we view. In Picasso's case, this is a turn from depicting performers to understanding that he himself is the performer. A similar account could be given of Rembrandt. In the works of both these artists, when the narrative frame is sacrificed, so is the organizing authority of the actual picture frame. Both artists assemble their images from the center out and therefore have a certain problem at the four corners. Both aim to capture the substance of the model before them. As painters they are both sculptors manqué. But while Picasso tried to subdue the sculptor in his painting and, post cubism, made it a separate and even a hidden enterprise, Rembrandt continued to press sculptural ambitions on his painting.[36]

The parallel with the cubist Picasso is unexpected, not only because of the time gap, but also because Rembrandt's pictorial invention, though of this order, did not get taken up, as did aspects of Picasso's cubism, to become the dominant style in the age to follow. But despite the idiosyncracy of Rembrandt's painting, it would be misleading to conclude that he lacked for understanding in his time. The spread of his style—which is marked in the number of paint-

ings attributed to Rembrandt that we now know to have been done instead by others under his impress—is remarkable testimony to the contrary. If Rembrandt's manner of painting hardly outlived his presence, the isolate self that he invented in paint did. The idiosyncratic look of Rembrandt's paint with which we have been concerned entailed a claim to be distinguished, to stand apart, to be himself and, in the format of the mature paintings, to even constitute a self. This self was not forced on Rembrandt by the world around him—as the romantic view of the lonely, rejected artist would have it—but was very much his own invention. The place where Rembrandt staged its invention was in the studio.

2

THE THEATRICAL

MODEL

NEAR THE END of the last chapter, I said that in the course of his career as a painter, Rembrandt moved away from the depiction of actions to offer the action of painting itself as the performance that we view. That was at the conclusion of a discussion devoted primarily to certain aspects of Rembrandt's handling of his paint. I want now to take issue with that statement, not because I think it is wrong, but because I think it is misleading in two respects: first, because it maintains the idea of a clear break, the insistence on a kind of before and after in Rembrandt's career as a painter, and second, because it minimizes the abiding nature of Rembrandt's interest in performance. These attitudes—commonly combined into a notion of a break in his career which involved turning from the depiction of outward action to inward feelings—became cornerstones of modern commentary on Rembrandt. It is partly in response to them, but also as a way to turn our attention from the *medium* of his paintings—the paint—to their *subject*—human lives—that I am taking up Rembrandt and the theater.

I am hardly the first to consider this as a proper topic for Rembrandt studies. There is an ample literature which attempts to document Rembrandt's social and pictorial relationship to the theater in Amsterdam. The bare bones of the case are constituted by his 1633 portrait of the playwright and theater-founder Krul, a group of drawings generally considered to be of actors (fig. 2.2), his illustration for the printed text of Jan Six's play *Medea*, and a few further works possibly related in subject to scenes from particular plays. To these we might add his fondness for costumes known as "*à l'antique*," which were commonly used in stage productions at the time. Further, the suggestion has been made that *The Night-Watch* repre-

sented a scene, perhaps even a tableau (*vertooning*) from a historical drama by Vondel, *Gysbrecht van Amstel,* or (to my mind much more convincingly) the festivities staged on the occasion of triumphal or joyous entries into Amsterdam (fig. 2.1).[1]

Whether one accepts this last suggestion or not, the pictorial evidence that prompted it remains of interest, and it is to that particular aspect of Rembrandt and the theater that I want to turn first. It was the fact that the figures were presented as if they were part of a staged or enacted scene—the gestures of certain individuals as well as the action of the group as a whole, the interest in the display of costumes and the prominent setting all adding up to an intriguing but elusive subject—that led to the appeal to a performance as an explanation of *The Night-Watch.*[2] What seemed "theatrical" in this view was the heightened or distinctive gestures, the curious dress, and perhaps also the effect of light. These are not unique to this painting, but are characteristics of a number of Rembrandt's paintings, particularly, it has been argued, in the 1620s and 1630s—the first half of his career. "Theatrical" used in this sense has referred, then, to an interest in outward display—of feelings and of dress. These are not things that modern viewers have associated with Rembrandt's mature works. For indeed, in such theatrical terms, a standard account of his career tells how Rembrandt overcame his theatrical impulses or a theatrical view of the world. The implication—as in the standard comparison of the early and late depictions of *David and Saul* (figs. 2.3, 2.4)—is that the mature painter discarded the superficiality, falseness even, of heightened gestures and fancy get-ups in order to disclose or lay bare inner human truths.

But did Rembrandt really take years to understand the nature of figural gestures—did he not, perhaps, know about their falseness and yet embrace them from the start? A good test case is the well-known *Judas Returning the Pieces of Silver* (fig. 2.5). The work is well known not because it has been seen by many people, but because it is the first painting to be singled out for high and specific praise by an early admirer, Constantijn Huygens, secretary to the Stadholder. The passage in his manuscript autobiography in which he praises Rembrandt and another young Leiden painter, Lievens, has been repeatedly probed by Rembrandt scholars. Huygens's description of the work praises it specifically for the expressiveness of the body and clothes of Judas: ". . . wild face, torn hair, rent raiment, contorted arms, hands so clasped as to check the flow of blood, thrown to his knees by heedless vehemence, his whole body twisted by the pitiful fierceness of feeling. . . ." Commen-

tators on Rembrandt have followed Huygens by singling out the fig-
ure of Judas as a paradigmatic example of Rembrandt's early ges-
tural manner. But Huygens introduces this verbal evocation by
calling attention to the fact that even here Judas—this highly ex-
pressive painted figure—is in a sense putting on a show: ". . . a
Judas, I say, frantic, howling, entreating forgiveness yet feeling no
hope of it, nor having in his looks any trace of hope. . . ."[3] It is
likely that Huygens's comment follows from the commentary of
Calvin who understood Judas's repentance as essentially flawed.
Calvin interpreted it as an example of a false, Papist repentance, for
it offers the outward sign of a man without any inner conviction,
who is cut off from the grace of God: "Iudas was touched with re-
pentance: not that he repented . . . Iudas therefore conceiued a
lothsomnes & a horror, not that he might turn himself unto God,
but rather that he being overwhelmed with dispaire, might be an
example of a man wholly forsaken of the grace of God."[4] As in the
frequently depicted scene of the kiss, Judas is performing an emo-
tion (here contrition, there love). Here, however, the basis of the
performance is less deceit than serving as an example, with the
knowledge of doing something—repenting—in which even as you
do it you know you fail. Built in to Rembrandt's choice of the ges-
tural display of Judas is, as it were, a prior admission of its per-
formed nature.[5]

Among the etchings that Jan Joris van Vliet did after Rembrandt's
works, there is one of the head of Judas which was subsequently
referred to as a "grieving man" or an "afflicted man" (fig. 2.6). The
abbreviated title, like the etching itself, is in fact a reductive or sim-
plified way of taking Rembrandt's Judas. I mean by this that the
"acting" aspect of the figure has been removed—he is what he ap-
pears to be. The final step was made in Wenzel Hollar's etching after
Van Vliet in which he assimilates the enacted contrition of Rem-
brandt's Judas into the "real" weeping of Heraclitus in the pairing
with Democritus (fig. 2.7).

For corroboration of the phenomenon of performance in Rem-
brandt's early work, we can turn to a painting of a decade or so later,
The Wedding of Samson, which was, curiously, the other painting to
have been given extensive textual attention by a contemporary of
Rembrandt (fig. 2.8). Once again, Rembrandt has selected an eccen-
tric event, in the sense that it is one that was seldom if ever depicted
in painting—the banquet on the occasion of Samson's wedding with
the Philistine woman. To the one side we see Samson posing his
riddle to the Philistines, while just off center, behind the festive

board, is the self-conscious, stiffly posed figure of his new wife, identified in the Bible only as the woman from Timnah. It is she who will betray Samson to her people after tricking him to tell her the answer to his riddle. Posed in the posture of a bride (her similarity to the Bruegel tradition has been noted), she is a woman who will contradict her appearance as a newly wedded wife by doing her husband in. Once again, at the center of his picture, Rembrandt has focused in on a betrayer—on one whose appearance or actions must be understood as being a performance. And this fact is underlined here by the compositional echo of Leonardo's *Last Supper,* in which Rembrandt placed Samson's wife, his betrayer, in the place of Christ.

On the evidence of these two works, I would argue that Rembrandt was well aware of, and interested in, the falseness of outward gestures early in his career. But it is perhaps more appropriate to say that he was interested in gestures as performed or acted, rather than as simply "false." What he chose to consider in his depiction of Judas, and then the woman from Timnah, were the performances of two consummate actors.

It might seem morally contrary to posit Rembrandt's fascination with two such perfidious performers—theatrically contrary too, for we are used to criticism of the "theatricality" of figures in his early works (indeed the theatricality of art in general), on the basis of an assumed distinction between falsehood and sincerity or truth. This is to consider the performance from the point of view of an observer—an observer, furthermore, who feels he can finally (as we have thought Rembrandt did) dismiss the player in the interests of the truth. But let us think of the performance quite differently, for a moment, from the point of view of the actor whose interest in it is to play a role, for whom taking the part of another, miming and speaking his feelings and situation, is the measure of success. This, I want to suggest, is indeed how Rembrandt thought of it, and the single-mindedness and purpose with which he pursued this sense of art affected his entire practice and production.

Consider, first, one of his earliest self-portraits (pl. 1). It is recognized that a number of these works served Rembrandt as studies in expression. By looking at his own face in a mirror he could practice expression which might be of use in rendering figures in narrative works. The operative device, we commonly assume, is the mirror. In effect, then, we could say that these portraits are instances of the artist copying a mirrored image. The skill they display, the practice they engage, is that of pictorial imitation. But have we not overlooked another element? As a prior condition to making

the copy, Rembrandt has had to become an actor: to get at the expression he wishes to depict, he must experience or at least play at experiencing it himself.

Samuel van Hoogstraten was a student of Rembrandt's, and subsequently an artist and a teacher in his own right, who, in the course of a lengthy treatise on the making of art, reflected on his experiences in the Rembrandt studio. We are probably not far off the mark if we take Hoogstraten's account of his own practice as a teacher to inform us about that of his master. He recommends the use of the mirror to the artist wishing to learn the depiction of passions in just such theatrical terms: "so that you may be both performer and spectator at the same time." Driving the point home, Hoogstraten writes, "If one wants to win honor in this the most noble part of art [by which he means history painting] one must completely transform oneself into an actor."[6] But let us consider the situation, the more common one of course, when no mirror is handy. How then would such an artist-actor proceed? Is one expected to be an actor even without a spectator or without the substitute for a spectator a mirror provides? Hoogstraten had an answer to this, too.

In a fascinating passage in his account of Hoogstraten's life, Houbraken (who was, in turn, Hoogstraten's student and thus a "grandson" of the Rembrandt studio) tells a story of the theatrical doings in Hoogstraten's studio, where his students were encouraged to act. At issue is the critique of a student's weekly narrative drawing— done perhaps after a biblical text. In an effort to get the student to perfect the "proper movements of the figure," Hoogstraten first asks him to read the text, and then asks him to act out the speaker's role. In desperation at the student's inability to act, he says, "Is that supposed to be the figure who is speaking that? Imagine that I am the other person to whom you must say that and say it to me." Hoogstraten finally gets up and acts it out for the student himself. The moral of the tale is that the student is advised to actually act out a speaking figure's part in order to be able to perfect his own drawing of it.[7]

There were, of course, hallowed precedents for proposing the actor as a model for the artist, in particular for the poet. Aristotle had advised the playwright to mime the part he was to write, and Horace offered the actor's sympathy with the feelings of weeping or laughing people he plays as a model for the poet's persuasive diction.[8] What was good for the poet, so Renaissance writers argued, was also good for the artist, and it was, furthermore, a way for him to improve his intellectual standing and social lot. There is reason,

then, for modern commentators on Dutch art to assume that the in-
vocation of the actor on the part of Dutch artists and commentaries
on art was an attempt to enhance the status of artists by relating
them to poets through a kinship with actors.[9] Hoogstraten would
seem quite traditional in his views. But was he so in his practice?

As a footnote to the tale about acting, Houbraken reports that, in
order to help his students learn a pictorially appropriate way to rep-
resent bodily gestures and movements, Hoogstraten used the attic
of his Dordrecht house as a theater where his artist-students per-
formed plays, some of which he wrote himself. On occasion, friends
and relatives were even invited to attend.[10] We can perhaps get some
idea of what this looked like from the illustration Hoogstraten offers
us of a theatrical performance put on in his studio for the study of
perspective foreshortening and shadow projection (fig. 2.9). The
performance by artists of a play is, on balance, an extraordinarily
literal way to take the injunction to the poet—and by extension to
the artist—to be like an actor. As studio practice it seems to be
completely without precedent.[11] Perhaps it was an invention on the
part of Hoogstraten's teacher Rembrandt. The practice produces a
very curious model of the theater as well as of the making of art. As
a theater it is designed with actors but (normally) with no viewers or
audience in mind. And the artist-actor is meant to learn from a
model, that of his own body, which he himself can never see—ex-
cept, that is, if he turns, as Rembrandt was (therefore?) to turn so
often, to make a portrait of himself using a mirror.

When Rembrandt makes repeated self-portraits, he is working at
what one might call the logical heart of such a model of art: pursu-
ing, attending to, and presenting himself as a model in the theatrical
mode. We have considered the ways in which Rembrandt's applica-
tion of paint calls attention to the process of making a painting. He
is a painter who delights in displaying his delight in the laying on of
paint. In self-portraiture, his performance of the artist as model is
matched to the performance of his brush. The early Amsterdam
Self-Portrait (pl. 1, fig. 2.11) is a splendid case in point: like a num-
ber of the earliest self-portraits in all media, this is most likely an
instance of Rembrandt using himself as a model for a study of ex-
pression and light. We note the dazzling showmanship of the work:
the confident line of the cheek marked against the lighter paint of
the wall (a tour de force like the dark man fixed in the light doorway
at the back of *Las Meninas*); the unruly curls of hair which are made
concrete by being scratched down through the paint to reveal the
ground beneath; the brilliant pink of the ear, the lobe of which is

marked at the bottom with pure red. The eyes, with which the artist studied himself, are hidden by shadow. The element of performance as painter and as model reinforce each other. And already in this early self-portrayal, Rembrandt's calling attention to the paint as paint is intuitively linked to his calling attention to himself.

There has been a certain amount of discussion of Rembrandt's appearance, sometimes even twice over, in some of his early history paintings. When he appears in subsidiary roles in the early Leiden history paintings, the artist, one might say, wears this technique of pictorial inventing—that is, invention by the artist as actor within the scene—on his sleeve (fig. 2.10). In some instances the strong interpretation has been to see a specifiable moral meaning: as when Rembrandt presses up against the flesh of Christ's stomach as His body is lowered from the cross, or when he balances Saskia on his knee, sword at his waist, glass raised, the very image, as has been pointed out, of the Prodigal Son (fig. 2.12). There was a tradition of the artist's self-portrayal as Nicodemus or Joseph of Arimathea, and at least one other Dutch contemporary, Mieris, also held his wife on his knee, possibly as a kind of enactment of the Prodigal Son. But Rembrandt's performance in the Dresden painting seems forced, hard-pressed, or overplayed. It is overplayed if we think, by contrast to his performance here, of the economic ambitions that Rembrandt had but recently realized in his marriage: his was the successful union of a Dutch artist marrying up. Saskia, the young woman who serves as a model for the tart on his knee, was a burgomaster's daughter. A certain tension between the two is involved in the picture, as Rembrandt without Saskia's clear consent, plays down the well-made marriage. (X-rays show that Rembrandt removed a third carousing figure he had originally painted between the pair. The change had the effect of emphasizing the couple and hence, perhaps, of a marital reference.) He shows us an early example of his capacity for playing a part—a talent certainly not foreign to one fascinated by the perfidy of a Judas. He exhibits extravagance in both a sexual and an economic sense rather than the economy expected of a good marriage. The sword with which he is conspicuously armed is not an emblem of the painter's prowess, as armor was to be in other self-portraits, but rather a sign of the gay blade. But the picture is a profligate display of pictorial talent.[12]

We can contrast Rembrandt's social and pictorial disruptiveness here to Rubens's evident pride in the public confirmation of the married role in his famous marriage piece (fig. 2.13). Perhaps Rembrandt hides behind, as much as he reveals himself through, the

role of the prodigal son. In every work in which he plays a role by serving as his own model, it is a matter of judgment whether a reference to himself in that role is intended and what the force of the reference is. The same could be said of those studies of heads and faces in which Rembrandt features himself, though I take it that in his deployment of these theatrical studio practices, Rembrandt allowed such uncertainty about the meaning to come into play in the making of the work. It makes for what I have referred to as the problem of the "subject" of his paintings.

There is a history to be told, as yet only written in pieces, of the relationship of the artist in the Netherlands to the theater. In Antwerp, the painters' Guild of St. Luke was united with the *rederijkers* (rhetoricians) to form a common *kamer* or club which was in existence from 1480 until the foundation of a separate painters' academy in 1663. There artist and poet-playwright were sometimes united in the same person. Karel van Mander—artist, instructor to, and in his writings promoter of, artists in the north—had been in his youthful days in Flanders a writer of farces and a set-designer for a *rederijker* group. The roster of the *rederijkers* from seventeenth-century Haarlem after Van Mander's death (a time of their decline) includes a number of artists—Frans Hals, the de Brays, Esias van de Velde, Jan Wijnants, Brouwer, and more. There were obvious practical reasons for this relationship, since the painters could supply coats of arms, as well as sets and designs for public pageants of various kinds, while the writers could furnish texts and stage effects for artists to depict in their art. Jan Steen—who was not a member, but who painted *rederijkers* at their meetings and pictured themes from their plays—is perhaps the best-known Dutch artist to illustrate the connection in his paintings.[13]

What has not been suggested, and what our view of Rembrandt's works suggests, is that another attraction and interest for the artists might have been acting itself. There is not much published evidence of acting artists among the *rederijker* groups. Jacques de Gheyn II, a student of Van Mander's, played David in a play or a dumb-show during a triumphal entry staged in Amsterdam in 1594. Less relevantly, perhaps, the Amsterdam playwright Bredero was a painter before he became a man of the theater.[14]

But outside of the *rederijker* groups there is striking evidence—though of an eccentric kind—that artists were reputed to be good actors. At least, that is one way to take the anecdotes told by Van Mander in his account of the lives of Pieter Bruegel and the Haarlem printmaker and painter Hendrick Goltzius. Bruegel is reported

to have dressed up as a peasant to visit village festivities unobserved. Goltzius on his study trip to Italy not only liked to exchange roles with his servant but once played a Dutch cheese-seller at the door of fellow artist Jan Sadeler's house in Munich.[15] And Goltzius's masquerading ambitions extended to his art, where he produced, among other things, pseudo-Dürer prints that had even the experts fooled. When Van Mander praises Goltzius for what he refers to as his "Protean ways" (a characteristic commonly connected with actors at the time) he proposes to value the artist who is able to take on different roles. Both for the performing look of his figures and for the frequent role he takes as a performer in his own works, it is Jan Steen who should be placed alongside Rembrandt as the Dutch artist who put this practice to the most notable pictorial use.[16]

In Rembrandt's case, there is another possible relationship to the theater, or at least to acting. His attendance from the age of about nine to about thirteen at the Leiden Latin school has been plumbed for evidence of book-learning—did he know Latin, did the Latin school, despite the few books listed in his bankruptcy inventory, make a reader out of him, or at least expose him to texts enough to last a lifetime?[17] But it is also possible that he was first exposed to the theater, or more particularly to acting, as a student at the Latin school. In the Netherlands, as elsewhere in Europe at the time, one of the established ways to teach students full rhetorical *pronuntiatio* was through the performance of Latin plays. Much more was included in the notion of "pronunciation," of course, than is normal in a language class today. For "pronunciation" included *actio*, visible eloquence which involved not only the voice but also gestures common to the orator and to the actor. A specific exercise in school, one of those based on Aphthonius's *Progymnasmata*, went under the name of *prosopopoeia* or "impersonation"—essentially the composition of dramatic monologues for famous people in particular situations. These were also declaimed as if part of a play.[18] So close were acting and the rhetoric taught at schools that Worp, in his study of the Dutch theater, tells of an Amsterdam actor paid by a poet and professor at the Atheneum to teach him his craft.[19] If the writing of such exercises stressed, among other things, what was technically known as *invention*, the habit of performance extended it through gestures and the inflection of the voice. We know that such theatrical practices took place in the Dutch Latin schools of the time.[20] Although we have no specific evidence of theatrical goings on in the school in Leiden at the moment when Rembrandt attended it, a

letter written by J. J. Scaliger in 1595 comments that "quelques en-fans" in Leiden had performed Beza's *Abraham Sacrifiant*.[21]

What is particularly appealing about the idea of Rembrandt's possible participation in plays at the Latin school is that these provide a model for acting as a method of learning and a tool of teaching—just what seems to have been recreated in Hoogstraten's studio after Rembrandt's example. This type of theater is uniquely relevant to the artist's practice in another respect, for although the record of the Latin schools suggests that an audience was sometimes invited to hear the students (who also sometimes went out to perform), the purpose of the performance was to educate the students. It was a theater designed for the actor, not for the spectator, and was a model for the spectatorless theater in the studio, where the artist was not a spectator, but a performer.

Before we continue, let us consider what pictorial evidence there is that Rembrandt practiced the theatrical habit other than in his self-portraits. We might turn first to one of his distinctive kind of works—the several-figured drawings, often of biblical narratives. These are drawings, incidentally, which recall Hoogstraten's teaching anecdote, in that they frequently feature a conversational exchange. They begin to appear at about the time of Rembrandt's move to Amsterdam, when he begins for the first time to operate as a teacher and member of a large workshop. They are characteristically executed in pen and wash and, curiously, bear no relationship to his own paintings. That is, the drawings are not preparatory for paintings but seem to be produced for purposes of teaching (a point we shall return to in the next chapter) and/or as an end in themselves. As a category of drawing they are quite without precedent before Rembrandt, though they are imitated by, and hence are confusable with, a host of drawings produced by artists who worked in his studio as students or assistants.[22] Looking at them with the hindsight afforded by knowledge of the activities in Hoogstraten's workshop, one might see them as having been drawn after small groups of performing students.[23]

An attempt has been made to substantiate this point on the evidence of a few groups of drawings which appear to show views of one and the same group taken from different positions: two drawings show Isaac blessing Jacob (figs. 2.14, 2.15). Another pair depicts a scene of beheading (figs. 2.16, 2.17); a third pair depicts Nathan admonishing David (figs. 2.18, 2.19). A series (if we may call it that) of such drawings in which Rembrandt or his students

(the particular hand is not an issue) repeats one biblical narrative each time with slight alterations can be seen, then, as a record of a series of performed scenes—akin to the impersonations encouraged in the Latin schools. Two drawings of a similar action could either record one performance viewed from different positions, two different performances or, in some cases, the replaying of or an alteration made to one in progress: "move a bit that way—OK, now start speaking." Rembrandt's many drawings of narrative subjects are as much rehearsals of enacted scenes as they are meditations on particular stories.[24]

We also have evidence in the form of occasional comments in Rembrandt's hand preserved on some drawings—comments addressed to a student or to himself. A number of them seem to resemble directions for the performance of a scene. For example, on Hoogstraten's drawing of the *Rest on the Flight* (fig. 2.20), Rembrandt notes: "It would be better if the ass was placed further back for a change and that a greater accent came on the heads; also that there was more vegetation by the tree. 1. Joseph is straining too hard and too impetuously. Mary must hold the child more loosely, for a tender babe cannot endure to be clasped so firmly . . ."[25] Beneath a drawing of *The Adulterous Woman before Christ* (fig. 2.21), Rembrandt describes the actions of the assembled scribes, "so eager to ensnare Christ in his reply, the scribes could not wait for the answer." An evocation of the tenor of human gestures replaces the spoken words of Christ, which Rembrandt neglects to write on the ground. On a drawing of *The Departure of Rebecca* (fig. 2.22), Rembrandt notes, again probably for his students' benefit, that "this is meant to be provided with many neighbors who observe the departure of this esteemed bride."

Though at the heart of his training the artist was called on to perform as an actor, it is also the case that he was the spectator of the performances of others in the studio. The reference to observers in the last inscription quoted fits in with this. I suspect that it is at least partly because Rembrandt thinks of what is going on as performances that he so often includes viewers or observers within his drawn narratives. Perhaps this was part of the attraction of those incidents from the Bible in which *observed* events take place: the expulsion of Hagar as watched by Sarah and Isaac, or the return of the prodigal son watched by members of the household. In the many drawings in which he returns to these particular biblical narratives, Rembrandt always includes witnesses. And Rembrandt takes advantage of the opportunity to include viewers whenever he can—when

Abraham entertains the angels (Ben. 575, 576, and the etching B. 29), or when the angel departs from the family of Tobias (fig. 2.24). His interest has been termed voyeuristic, but it would be better to call it, in a particular sense, spectatorial. He lacks any interest in that ability of the voyeuristic eye, unseen, to capture something or someone unawares which proved so fascinating to the technological and pictorial culture in which he lived.[26] Rembrandt's witnesses call attention to the observed and, because observed, consciously performed nature of human events. The inclusion of witnesses to an event had been recommended to artists as a compositional principle by Karel van Mander, who referred to them specifically as actors (*fijn Comedianten*). The point has been made that Rembrandt's teacher Lastman used this device in certain of his pictures.[27] But although the use of such a device is perhaps related to this tradition, the theatrical or performative nature of Rembrandt's studio and his pictorial practice is distinct from it.

To establish the centrality of performance in Rembrandt's studio, it is not necessary to believe that every scene represented by Rembrandt and his studio in drawings was actually performed. Hoogstraten suggests that they were not always performed when he recommends that the artist with practice can learn to play such performances out in his mind. Hoogstraten puts it literally (as was his habit!) by comparing the mind of the artist to a stage and suggesting that he pull back the curtain to see a scene played there.[28] When the habit of enactment is played out in the painter's mind, the fiction of performance is maintained. This is an artist's version of closet drama. So well did Rembrandt and his students learn this skill that it seems a hopeless task to try to distinguish between those drawings done, as they would have said, *uyt den geest* (from the mind) from those done *naer het leven* (after life). Indeed, the salient question is perhaps not whether this or that drawing is after life, but what, on the evidence of his artistic practice, Rembrandt considered "life" to be. It made little difference on a particular occasion if he worked after players or imagined a play in the mind, for in either case Rembrandt got at "real" life through attending to the reenactment of it.

Hoogstraten makes his suggestion about playing scenes in the mind in a chapter devoted to what we today would refer to as the composition of a picture (*Hoemen 't ordineeren moet aenvangen*). And indeed there is a respect in which Rembrandt's manner of pictorial composition betrays this theatrical model. It is notable that in working on a composition Rembrandt pays particular attention to the de-

portment and gestures of his figures and to the direction from which they are seen. One way to gauge how he thinks of composition is to consider how he changes it. We might take as an example two depictions of the departure of the angel from the house of Tobias: in the painting in Paris of 1637 we see the action from alongside the house, while in a etching of 1641 and a drawing of about 1652 we look at the house with its doorway and essentially the same figures from a position more to the right (figs. 2.23, 2.24, 2.25). Rembrandt effects a compositional change by proposing that we view the same group of actors, with slight alterations in their gestures, from another position: to compose is to replay an enacted scene.[29] This kind of adjustment of point of view to posited actors may be contrasted to the kind of restructuring of a scene commonly made by Raphael. We can take as an example his drawing for the painting of the Madonna, Christ child, and little St. John known as the *Madonna del Prato*, or *The Madonna in the Meadow* (figs. 2.26, 2.27). For Raphael, to compose involves altering the elements of a composition internally, with reference to itself. In this drawing, the lines of Raphael's pen manipulate the three bodies, their positions, and the directions of their glances on the sheet towards the satisfying resolution of the pattern of the painting.[30] Rembrandt instead makes it appear that he is manipulating human actors in the studio whom he circles around, stopping to look, making suggestions about their gestures as he works. (On those occasions when he does repeat figures on one sheet as in *Three Studies for a Disciple at Emmaus* [Ben. 87], or *Three Studies for a Deposition from the Cross* [fig. 2.28], it is to get the attitude right rather than a question of formal organization.) Of course Raphael, like Rembrandt, employed models in his studio. But he did not represent this situation in his works in the manner that Rembrandt did. Raphael subjected models to certain prior notions of pictorial organization, while Rembrandt's pictorial organization appears in each instance to be due to his view of the attitudes or poses his models took.[31]

There is finally a bit of anecdotal evidence about the theatrical habits of the Rembrandt studio. It is a story told by Houbraken about a slightly scandalous affair. It appears that a pupil was closeted in one of the private cubicles that Rembrandt devised for his assistants, to permit their work to go on undisturbed. With the student was a model, a woman, whom, the weather being hot, he decided to join by also taking off his clothes. "Here we are," said the student to the model, "naked like Adam and Eve in the Garden." The conversation was overheard by the others in the studio and

eventually also by Rembrandt who spied on the pair through a chink in the cubicle wall. At which point, so Houbraken continues, Rembrandt banged on the door with a stick and shouted, "But because you are aware that you are naked you must come out of the Garden of Eden." Houbraken reports the exchange as if it had taken the form of a scene from a play. It is not surprising to find that Adam and Eve had been the subject of a Latin school play performed in 's Hertogenbosch in 1591. After Rembrandt's speech the play (*spel* is the word in Houbraken's Dutch) was over, and the master proceeded to drive the pair, who were hastily trying to get dressed, out into the street. This little performance is almost too good to be true, and whether it happened or not is really not the point. For it offers useful testimony about the atmosphere of a studio where the practice was for its members to put on plays. And there is something that rings true, as we shall see, about Rembrandt playing the role of God. Indeed, his role in this little studio drama is a corrective or perhaps an alternative to the later romantic view—one cultivated in some ways by Rembrandt himself—of a moody, lonely, and retiring genius.[32]

The subject of the "play" that Rembrandt interrupted on Houbraken's account was Adam and Eve. It puts one in mind of the representations of these figures that we find in Rembrandt's drawings. In one, for example, Adam is feeling rather pressed by Eve's insistence that he take the apple (fig. 2.29), and in an etching—which depicts a moment later—it looks as if, against his better judgment, he is about to give way while Eve, grimly? patiently? watches his moves and waits (fig. 2.30). The nature of the gestures in these scenes leads to another point about the drawings that we have been considering—a point that indeed holds true for Rembrandt's works in general. Not only is the type or category of such drawings quite without artistic precedent, but so also are the poses or gestures of the figures within them. It is notable that the movements of the figures in Rembrandt's narrative drawings are not conventional. I mean by this that they cannot (at least not without some strain) be traced back or related to the figures that we find in the large collection of works that Rembrandt owned. They lack "sources," as art historians are used to calling them. They contrast in this respect to the highly conventional gestural vocabulary employed by an artist like Rembrandt's admired contemporary Rubens.[33] Further, there is often something ungainly about Rembrandt's figures—not only the look of the body but also the actions. One can indeed believe that these are studio folk enacting a scene—giving thought, as Hoog-

straten instructed his students, to how they might have behaved as Adam or Eve at this juncture and also conscious that they are being observed. The figures in the drawings are at once lifelike and calculated in the poses that they take. We could appeal to the theatrical practice of this studio instead of to the established conventions of art as the basis for these unprecedented figures.

The nature of the mixture of art and life with which we are concerned was addressed at the time in discussions about acting. There has been much debate as to what acting was actually like at the time. What was the relationship between word and gesture, between oral and visual presence? Or the relationship between art and nature? Did an actor aim to strike an audience as real or as artificial? It is not surprising that the evidence indicates that acting on the stage was conducted according to an accepted body of rules. The actor on this account was not an originator but a performer: "[the] player is like a garment which the Tailor maketh at the direction of the owner: so they frame their action, at the disposing of the Poet." [34] But it is clear that there were tensions within the system—so Hamlet instructs the players to avoid "inexplicable dumb shows and noises" in the interest of "holding the mirror up to nature," and actors were praised for their ability to totally transform themselves into a part. [35]

I do not propose to use Rembrandt's works as evidence of what acting in the Dutch theater was like. Rembrandt's images are evidence that he problematized personification or role-playing to a Shakespearean degree which is not found in the texts of Dutch plays of the time. In attempting to understand Rembrandt's understanding of his inventions, the issue is perhaps less what acting in the theater was like, than how it was talked and written about. At least in English texts of the time, certain terms—in particular "lively" and "natural"—appear repeatedly. Heywood's 1612 *An Apology for Actors* praises "lively and well spirited action . . . as if the Personator were the man Personated." This is repeated the same year by John Brinsley in giving advice on the teaching of *pronuntiatio* to school children in his *Ludus Literarius: Or the Grammar School*. Students should pronounce "distinctly, & naturally" speaking every dialogue "lively, as if they themselves were the persons which did speake in that dialogue," while what they cannot do in Latin they should first do "naturally and lively" in English. Reading such texts while looking at Rembrandt's drawings, one runs the danger of wanting to put words in the artist's mouth—this, one seems to be telling him, is how you did it, this is how the figures look and this the effect you were after. [36]

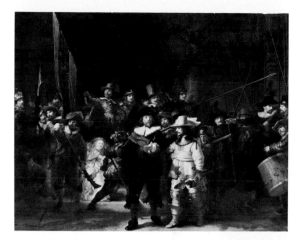

2.1. Rembrandt, *The Night-watch*, 1642. By courtesy of the Rijksmuseum-Stichting, Amsterdam.

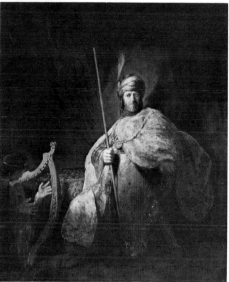

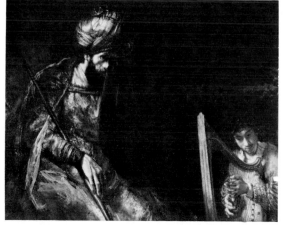

2.2. (Above, left) Rembrandt, *Actor in the Role of Pantalone Engaged in Conversation*, mid-1630's; Ben. 293 verso. Prentenkabinett, Rijksmuseum, Amsterdam.

2.3. (Above) Rembrandt, *David and Saul*, c. 1629/30. Städelsches Kunstinstitut, Frankfurt. Photo Ursula Edelmann.

2.4. "Rembrandt," *David and Saul*. Mauritshuis, The Hague.

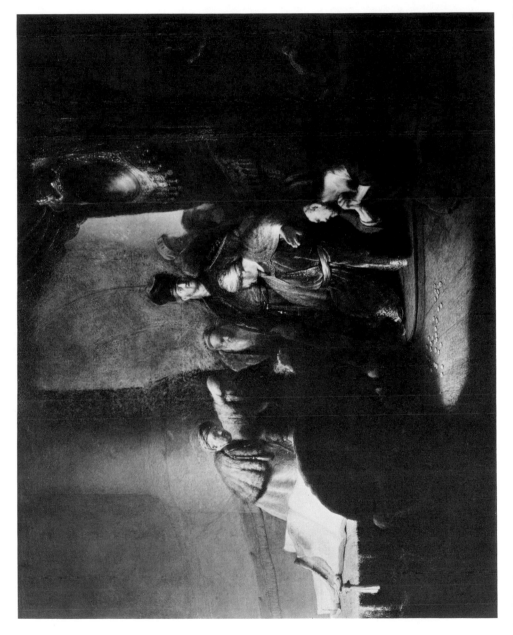

2.6. (Left) Joris van Vliet, after Rembrandt, *Judas*, 1634; etching. Prentenkabinett, Rijksmuseum, Amsterdam.

2.7. (Below) Wenzel Hollar, after Van Vliet after Rembrandt, *Democritus and Heraclitus*; etching.

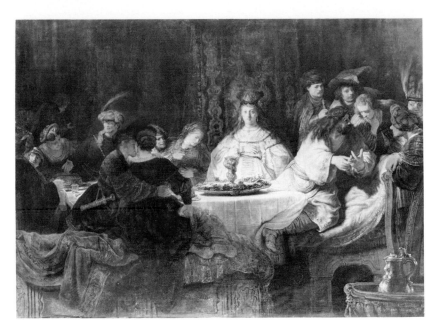

2.8. Rembrandt, *The Wedding of Samson*, 1638. Gemäldegalerie Alte Meister, Staatliche Kunstsammlungen, Dresden.

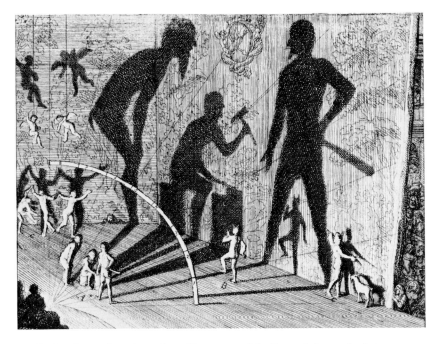

2.9. Shadow theater, from Samuel van Hoogstraten, *Inleyding tot de hooge schoole der schilderkunst*, Rotterdam, 1678, p. 260. Metropolitan Museum of Art, New York. The Elisha Whittelsey Collection, the Elisha Whittelsey Fund, 1948 (48.119).

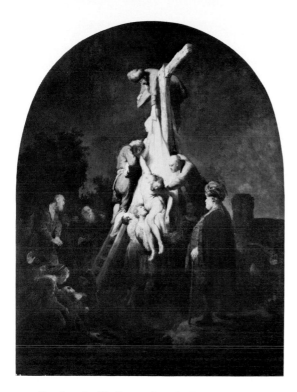

2.10. Rembrandt, *The Descent from the Cross*, 1633. Alte
Pinakothek, Munich.

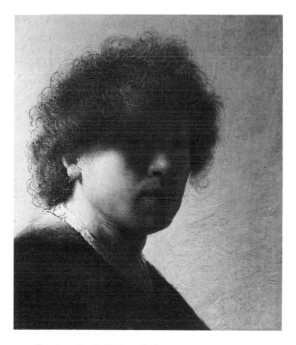

2.11. Rembrandt, *Self-Portrait*. By courtesy of the
Rijksmuseum-Stichting, Amsterdam.

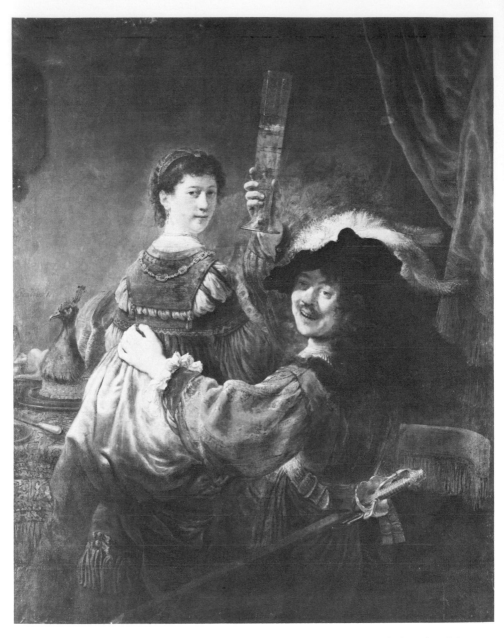

2.12. Rembrandt, *Rembrandt and Saskia* (as the Prodigal Son). Gemäldegalerie Alte Meister, Staatlichen Kunstsammlungen, Dresden.

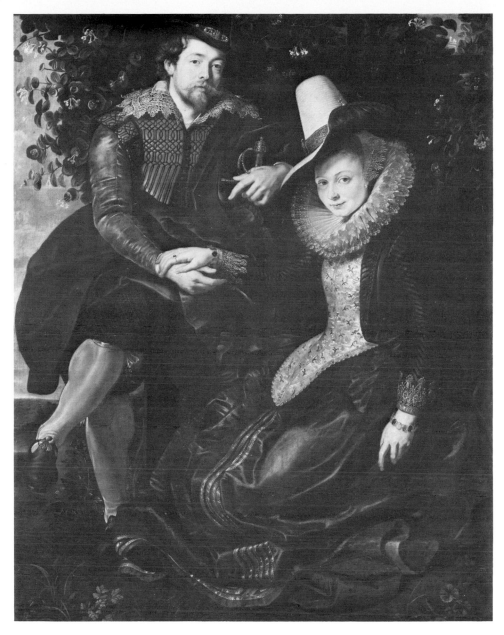

2.13. Rubens, *Rubens and Isabella Brandt*, c. 1609/10. Alte Pinakothek, Munich.

2.14. Rembrandt, *Isaac Blessing Jacob*; Ben. 892. Collection unknown.

2.15. Rembrandt, *Isaac Blessing Jacob*; Ben. 891. Devonshire Collection, Chatsworth. Reproduced by permission of the Chatsworth Settlement Trustees. Photo Courtauld Institute of Art.

2.16. Rembrandt, *Beheading of Prisoners*; Ben. 478. Metropolitan Museum of Art, New York. The Robert Lehman Collection, 1975 (1975.1.791).

2.17. Rembrandt, *Studies for a Beheading*; Ben. 479. By courtesy of the Trustees of the British Museum, London.

2.18. Rembrandt, *Nathan Admonishing David*; Ben. 947. Kupferstichkabinett, Staatliche Museen Preussischer Kulturbesitz, Berlin (West).

2.19. Rembrandt, *Nathan Admonishing David*; Ben. 948. Metropolitan Museum of Art, New York. Bequest of Mrs. H. O. Havemeyer, 1929. The H. O. Havemeyer Collection (29.100.934).

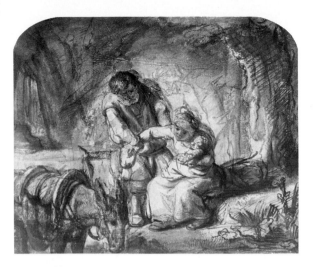

2.20. Samuel van Hoog-
straten? *Rest on the Flight to
Egypt.* Kupferstich-Kabinett,
Staatliche Kunstsammlungen,
Dresden.

2.21. Rembrandt, *The Adul-
terous Woman before Christ*;
Ben. 1047. Staatliche Graph-
ische Sammlung, Munich.

2.22. Rembrandt, *The Departure of Rebecca*; Ben. 147. Staatsgalerie, Stuttgart.

2.23. Rembrandt, *The Departure of the Angel from the Family of Tobit*, 1637. Louvre, Paris. Photo Musées Nationaux.

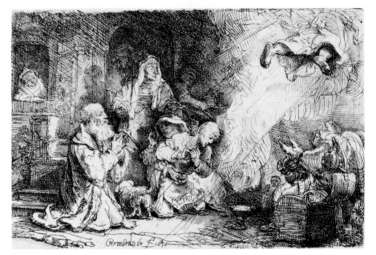

2.24. Rembrandt, *The Departure of the Angel from the Family of Tobit*, 1641; etching; B.43, III. By courtesy of the Trustees of the British Museum, London.

2.25. Rembrandt, *The Departure of the Angel from the Family of Tobit*, c. 1652; Ben. 893. Pierpont Morgan Library, New York.

2.26. Raphael, draw-
ing for *The Madonna
in the Meadow*.
Graphische Sammlung
Albertina, Vienna.

2.27. Raphael, *The
Madonna in the
Meadow*.
Kunsthistorisches
Museum, Vienna.

2.28. Rembrandt, *Three Studies for a Deposition from the Cross*; Ben. 934. Formerly Norton Simon Museum, Pasadena.

2.29. Rembrandt, *Eve Offering the Apple to Adam*; Ben. 163. In the collection of Marcia Riklis Hirschfeld, New York, New York.

2.30. Rembrandt, *Adam and Eve*, 1638; etching; B. 28, II. By courtesy of the Trustees of the British Museum, London.

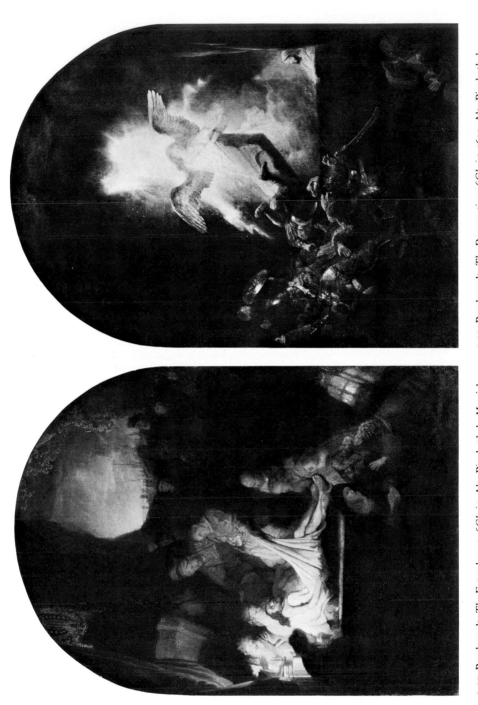

2.31. Rembrandt, *The Entombment of Christ*. Alte Pinakothek, Munich.

2.32. Rembrandt, *The Resurrection of Christ*, 1639. Alte Pinakothek, Munich.

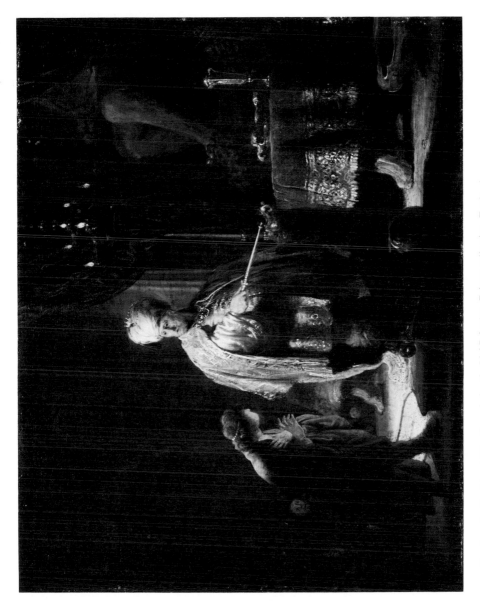

2.33. Rembrandt, *Daniel and King Cyrus before the Idol Bel*, 1633. Private collection, England.

2.34. Rembrandt, *Naked Woman on a Mound*; etching; B. 198, II. By courtesy of the Trustees of the British Museum, London.

2.35. Rembrandt, *Female Nude Seated in Front of a Stove*; Ben. 1142. Prentenkabinett, Rijksmuseum, Amsterdam.

2.36. Rembrandt, *Saskia*. Gemäldegalerie, Staatliche Kunstsammlungen, Kassel.

2.37. Gerard ter Borch, *Woman Spinning*. Museum Boymans-van Beuningen, Rotterdam. Collection Willem van der Vorm Foundation.

2.38. Rembrandt, *Saskia as Flora*. By courtesy of the Trustees of the National Gallery, London.

2.39. Edouard Manet, *Victorine in the Costume of an Espada*. Metropolitan Museum of Art, New York. Bequest of Mrs. H. O. Havemeyer, 1929. The H. O. Havemeyer Collection (29.100.53).

2.40. Edouard Manet, *Olympia*. Musée d'Orsay, Paris. Photo Musées Nationaux.

2.41. Rembrandt, *Saskia Asleep in Bed*; Ben. 281A. Ashmolean Museum, Oxford.

We are lucky to have a few words from Rembrandt's own pen on just this subject—although the luck is somewhat compromised by the vexed discussion the key phrase has produced. The much-discussed phrase occurs in his third letter (12 January 1639) to Constantijn Huygens, by way of offering an explanation for his delay in completing two pictures, an *Entombment* and a *Resurrection* ordered by Huygens's employer, the Stadholder (figs. 2.31, 2.32). His delivery of the pictures was delayed, wrote Rembrandt, because he had worked so hard to introduce the greatest and most natural movement: "die meeste ende die naetuereelste beweechgelickheijt" (fig. on p. 50).[37] The interest of the phrase is that, aside from the few inscriptions on drawings, this is the only surviving written statement that Rembrandt made about his art. Interpretation of the phrase has concentrated on the use and meaning of the word *beweechgelickheijt*, or movement. Does Rembrandt's word refer to something external or something internal? Does it refer to what we would call motion, or emotion? If Rembrandt is referring to these two paintings, for example, to the soldiers kicking up their feet in the course of their effort to escape the risen Christ, then bodily movement might seem to be at issue. The problem is that it has been assumed that in other, mostly later works, it was not the visible surface of the body but the invisible depths of the soul that were of interest to this master.[38] More recent commentary has quite sensibly directed attention to the rhetorical context and usage of the word "movement." So construed, as the rhetorical "moving" of a listener, the distinction between outer and inner has no place. The general conclusion is that on the rhetorical model, Rembrandt intended to refer to devising figures that would move his viewers.[39]

I do not dispute this analysis and indeed do not think that it is necessarily wrong. But I want to call attention to the use of the word "natural" which has in effect been scooped up and absorbed into the rhetorical reading of the phrase. If we read the phrase with the emphasis on *natural*—he is after the greatest and most *natural* movement—we are put in mind of the debates, and some of the language employed, about the performance of actors on the stage. In England, acting and its equivalent in the schools was praised for being "lively" and/or "natural." The two words are used quite interchangeably. It is but a slight adjustment to move from rhetorical usage to the stage—the two were in theory, in training, and in practice so close at the time. Given Rembrandt's studio practice it seems an adjustment that makes sense. We would then be faced in this passage with Rembrandt neither distinguishing between inner and outer move-

Letter by Rembrandt to Constantijn Huygens, 12 January 1639. The Hague, Koninklijk Huisarchief, inv. G 1, no. 18.

ment, nor emphasizing the effect of the work as that of moving the viewer, but instead referring to his figures as one would have at the time to actors by describing their movements as "natural."[40]

Let us recall how we have got to this point. We were considering the enacted basis of Rembrandt's narrative drawings as an element in their invention. Artists were advised to learn gesture and expression by being actors, and groups apparently did this in the studio. And we noted—without, however, yet establishing it as characteristic—that the figures in these drawings were notably independent of previous works of art. To find some way of understanding the nature of their invention, we turned to contemporary actor-talk and ended by arguing that Rembrandt himself was engaged in such (or something related to this) when he defended his delay in delivering two pictures because of his concern to render the greatest and most natural movement of his figures. This gives us a vocabulary for describing the drawn figures as fashioned like actors on a stage or, like actors, engaged in what we might describe as a recreation of the natural.[41]

Rembrandt's figures have been repeatedly described in specifically theatrical terms. In the nineteenth century Baudelaire praised them for their drama; "le drame naturel et vivant" were his words about Rembrandt in the Salon of 1846.[42] Delacroix introduced Rembrandt in the course of criticizing the way in which Poussin used little maquettes and the way Raphael drew each of his figures nude before dressing them, as steps in pictorial composition. Delacroix does not say how he thinks Rembrandt composed. But he is intuitively right in his observation that if Rembrandt had employed studio practices such as these, his works would not have had the effect of pantomime that they do. Predictably, Delacroix concludes by relating such pantomime to nature. "I'l n'aurait ni cette force de pantomime, ni cette force dans l'effet qui rend ses scènes la véritable expression de la nature." Perhaps, concludes Delacroix, we will find that Rembrandt is a much greater painter than Raphael![43] Finally, Hazlitt wrote in his Rembrandt entry for the 1817 *Encyclopaedia Britannica*, "This artist considered painting like the stage, where the characters do not strike unless they are exaggerated.[44]

An interesting gloss on this view is provided by the taste for Rembrandt, among other artists, of a leading English actor in the early eighteenth century. Barton Booth (1681–1733) owned a curious early painting by Rembrandt, *Daniel and King Cyrus before the Idol Bel*, that remains in an English private collection (fig. 2.33).[45] It is one of Rembrandt's small narrative paintings that come close to

the manner of the narrative biblical drawings we have discussed. Booth's reasons for buying a painting such as this are of interest. They were set forth in the biography of Booth written by Theophilus Cibber that appeared shortly after the actor's death. As an actor, Booth was particularly famous for his "attitudes." The term was originally used to describe poses depicted in works of art, but came in the early eighteenth century to apply to the actor's deployment of his body.[46] Booth's attitudes were picturesque. They were quite literally so, for he collected paintings in order to borrow attitudes from them for his own use on the stage. We can read the account in Cibber's own words:

> Mr. Booth's Attitudes were all picturesque.—He had a good Taste for Statuary and Painting, and where he could not come at Original Pictures, he spared no Pains or Expence to get the best Drawings and Prints: These he frequently studied, and sometimes borrowed Attitudes from, which he so judiciously introduced, so finely executed, and fell into them with so easy a Transition, that these Masterpieces of his Art seemed but the Effect of Nature.[47]

Booth's interest in an Attitude which gives off the Effect of Nature sounds like a theatrical reading of Rembrandt's phrase *naetuereelste beweechgelickheijt*." And his interest in Rembrandt's *Cyrus* as providing models for the actor's lifelike art has the effect of placing on the real stage figures which were produced with one in the studio in mind.

The nature-convention debate has a complex history in relationship to the theater, replete with terms such as "life" and "nature," whose shifting references and meanings I shall not take up. The simple point to establish is that Rembrandt's works were looked at and described in this vein. The reactions have not all been positive. Rembrandt's perceived relationship to the theater has been the occasion for blame as well as for praise. The blame emphasized the overly realistic side of the theatrical model. Rembrandt's "realism" in this view is like bad theater. The most famous early attack on the "realism" of Rembrandt's art appears in a verse treatise of 1681 entitled *The Use and Abuse of the Theater*, written by Andries Pels, a poet, playwright, translator of Horace's *Ars Poetica*, and founding member of Nil Volentibus Arduum (1669), an Amsterdam society founded to promote the reform of the arts. Pels's attack has been understood as part of a classicizing literary man's programmatic antagonism to nonclassical art. But the logic and the appropriateness that led to Rembrandt's being attacked in the middle of a *theatrical*

treatise has not been remarked. It is curious that a prominent book on Rembrandt mistakenly refers to Pels's text as "The Use and Abuse of *Painting*" (my italics). What is perhaps a slip of the translator's tongue is telling, since at the time the word *toneel*—meaning stage or scene—was applied to certain types of pictorial images as well as to the theater.[48]

Pels introduces Rembrandt halfway through his poem. He has offered a history of the stage, concluding with an account of its misuse in Amsterdam, and turns to recommendations for the good theater. At this juncture he is arguing for the superiority of the French theater over that of Spain and England, and for art made according to the rules: architecture has its rules, he exhorts the poet, so do plays. Painting also has rules, he implies, but Rembrandt is the notorious example of a painter who did not follow them. It is here that Pels, after praising Rembrandt's great talent, refers to him as a heretic (*ketter*) in art and proceeds to offer a litany of his offenses against the rules. It has been pointed out that the individual elements of Pels's critique—the "natural" rendering of the female nude, disregard of perspective, the historically inappropriate costumes, exercising native talent rather than following the rules of art—were hardly new. They consolidate and restate established criticisms of Rembrandt, most of which were already in print. The attack extends the notion of the vulgar poet to include the vulgar painter.[49] But what is quite new is the context in which this critique takes place, namely a treatise on the theater. How does Rembrandt fit into a contemporary debate about the theater?

Pels's often-cited passage on the realistic, garter-marked body of Rembrandt's early etched nude is not simply an attack on pictorial or artistic realism. It is presented in the course of an attack on a rule-less *theatrical* practice which Pels drives home by instancing the look and deportment of this common woman (fig. 2.34). Antagonism to the common (in the sense of low or indecorous) practice of the public theater was an established feature of what has been called the antitheatrical prejudice. Though it would be going too far to accuse Pels, himself a playwright, of sharing the antitheatrical prejudice, his treatise and his founding membership in Nil Volentibus Arduum reveal him making a sharp distinction between right and wrong, between the good plays and the bad. Much of such discussions of the good theater at the time is about texts, language, composition, and so on. In the name of the perfectly constructed text, the purists want to fend off the trappings and the spectacle of the playhouse itself—the popular audience, the money-making, and

the writing of plays fit for this. Pels is party to such a view, and his poem was addressed to the situation in Amsterdam at the time.[50]

The exemplary object of Pels's wrath was the playwright Jan Vos, who had died in 1667. A glazier turned poet and playwright, Vos wrote popular plays which included a Senecan-type tragedy *Aran and Titus* (1641) and the spectacle-piece *Medea* (1667); he was a designer of festive decorations for the city and for many years had served as one of the heads or regents of the *schouwburg*.[51] For all its popularity, partly because of it, the theater in Amsterdam was under continual pressure, political and religious, particularly after the first public stage was opened in 1637.[52] Performances in the old building were stopped in 1664 and the new building, inaugurated in 1665 just before Vos's death, was closed down for five years between 1672 and 1678 as a result of church pressure. Pels was one of those who wanted to correct the errors of the past, to purify both the texts and the theater. The perennial problem of the theater was exacerbated in Amsterdam because its proceeds benefited charitable organizations (the city orphanage and the almshouse for old men), whose regents were also involved in recommending members for the theater board. The cash success of plays such as those by Jan Vos had a built-in social desirability which angered Pels and his associates. When the *schouwburg* was permitted to reopen in 1677, with Pels as one of its regents, the dependence on the regents of the charitable organizations was broken. He argues in his poem that Vos's plays with their frequent vulgar language, inappropriate stage events and spectacular appeal, as well as the new building which was designed to put on such shows, were examples of what was wrong with the theater. Pels had further reason for anger, because in the preface to his *Medea* of 1667, Vos had come out against the Horatian rules for composing plays, arguing that, unlike architecture (a point disputed by Pels in his *Gebruik*), plays need follow no rules, and saying that it is to the (implicitly) common eyes rather than to the educated ears that a play should make its appeal.[53]

In a poem entitled "The Battle between Death and Nature or the Triumph of Painting" (1654), Vos saluted Rembrandt at the head of a list of Amsterdam painters, and he wrote a poem on a painting by Rembrandt in an Amsterdam collection. But there are no vital links between their lives and no compelling similarities between the plays of Vos and Rembrandt's art.[54] Pels's inclusion of Rembrandt in a treatise on the theater aimed against Vos and his kind involves guilt by association, but it is the association that Pels makes that is of interest. What is on Pels's mind are the rules of art, and it is Rem-

brandt's practice—choosing an ordinary woman as his model, trusting to his eye, and seeking out costumes in the streets of Amsterdam—that he criticizes. It is a case of prejudice against the practice of Vos in the playhouse being extended to Rembrandt in the studio. The problem presented by writing done for the theater gave a particular twist to the classicistic critique. It is on the grounds of the privileging of theatrical *practice*—the unspoken analogy being between the playhouse and the studio—that Rembrandt is invoked in a contemporary debate about the theater.

I have proposed that Rembrandt got at "real" life by attending to the acting of it in the studio. We got to this description of Rembrandt's outlook on the somewhat narrow but specific basis of three types of pictorial examples: the depiction of narrative figures who play roles; the artist as actor in self-portraits; and student-apprentices serving as actors for biblical drawings. Studio lore was cited, and Rembrandt's use of the phrase "natural movement" was read in theatrical terms as bearing out his practice. Later commentators were introduced to show that a theatrical view of Rembrandt had been widely entertained and also to sharpen the issues it raises about his art.

The corollary, the flip side as it were, of the artist acting as a model is the recognition that to model is itself to act—that modeling is itself a performance or a narrative action to record. It is to view the performance not only from the inside, the actor's point of view, but from the outside, from the point of view of the observer—the one who made the drawings that we have been looking at. In saying this we are saying that not only is the artist an actor, but that he looks on others as actors too—as they present themselves, that is, as his models. This includes not only the acting groups, but those individuals—models or sitters—who were depicted in the studio. In a number of drawings and etchings of female models, Rembrandt included their unbuttoned and discarded clothes, or the oven used to keep them warm (fig. 2.35). The Louvre *Bathsheba* can be described as the memorial in paint of what it is to view a woman acting as a nude model.[55]

Let us take a look at a few of the series of paintings that Rembrandt made of Saskia (figs. 2.36, 2.38). She is depicted in a number of stunning costumes, some of which have been identified with particular figures, like Flora. How did these images come about? I am intentionally not asking what they mean. Characteristically (let us call this Rembrandt's practice), we are left in the dark as to whether Flora is a version of Saskia or Saskia, a Flora—or whether

this is a portrait, a history painting, or the compromise, a *portrait historié*. Two very different accounts come to mind. First, perhaps Saskia liked dressing herself up and Rembrandt encouraged her taste. The pearls she wears were most likely his gift to her, later to be a subject of bitter contention with Geertge, who, after Saskia's death, succeeded her in Rembrandt's affections. Second, perhaps this is familial usage—it was normal for artists to use members of their families as models. Ter Borch's sister, for example, played a virtuous housewife at her spindle for her brother to paint (fig. 2.37). In using her as his model, Ter Borch expected his sister to play a role.[56]

Let us consider that in his depictions of Saskia, Rembrandt is drawing out this point, playing with the performative nature of modeling but also reflecting on the enacted or elusive nature of a person so represented. X-rays show that Rembrandt first depicted Saskia as Judith with the head of Holofernes before "transforming" her into this Flora. A second figure behind her has been painted out, and it is possible that her right hand originally held a curved sword. In the biblical story, Judith presented herself first as an available courtesan and then turned into the threatening woman who decapitated Holofernes. Rembrandt has reversed the order of the biblical tale, disarming Saskia by transforming her from an armed and dangerous woman into one who offers only pleasure. The doubts that have been raised about whether or not Rembrandt would have depicted Saskia as Judith seem to be weakened by the discoveries of a dagger-bearing hand beneath the Kassel *Saskia in a Red Hat* and a nude woman beneath the *Bellona* in New York, for which Saskia appears to have been the model.[57]

These pictures remind one of Victorine Meurend acting as the model for Manet (figs. 2.39, 2.40). Given male imaginings of women in the culture, it is not surprising that two of her roles, that of the bullfighter and that of Olympia, correspond closely to the pair taken up by Saskia. But the basis of the similarity in pictorial terms is that for Manet, as for Rembrandt, to serve as a model is necessarily to perform. Like that material sense of pigments which the two artists also shared, this is a phenomenon bound up with a tendency to absorb the world into studio practice, its pigments, and its models, and to acknowledge such studio practice in the making of one's paintings. It is not, then, as surprising as it may seem that a particular line of European painters whom we think of as realists—Velázquez, Hogarth, Courbet, Manet, and, I would add, Rembrandt—

have been fascinated by the playing of roles, be it on the part of models, sitters, or, by extension, professional actors.

It is only when a model is depicted asleep (at rest, or sick), that she does not perform (fig. 2.41, pl. 11). It is this that makes Rembrandt's drawings of Saskia or Hendrickje sleeping exceptional: the play of Rembrandt's hand is free to take over. On these occasions there is an extravagance to the application and to the play of the washes. The figure of the sleeping woman, by contrast, remains but faintly or insubstantially described as if in sleep she had eluded his grasp.

I realize that we have been treating Rembrandt's theatrical model in a certain isolation from the world around it. How is one to place it? To what is it related at the time? Does Rembrandt see all people as necessarily being actors in the presentation of self on a social stage as Erving Goffman has described it? Or could one argue that there is a particular sense in which Rembrandt is responding to, or even is *like* his sitters, who were members of a society where new social identities had to be produced. In this view, Rembrandt's art was contributing to the shaping of new manners and appearances to the social eye. His art might be placed alongside that of Ter Borch, for example, a painter for whom the question and the ambiguity of social performance were very much in pictorial play.

But I wonder if we have to appeal to the world as a stage for an explanation, when Rembrandt so clearly took his studio to be one. It takes no particular stretch of the imagination for an artist in the western tradition to see that to model is to perform. But it is a particular extension of this to see the world in this way. Or perhaps after all it is not an extension but a contraction—of the world into one's studio.

3

A MASTER IN

THE STUDIO

THE LAST chapter was designed in pursuit of a theatrical model. The problem I posed was whether, and if so how, the theatrical character so often attributed to Rembrandt's works is justified. Rather than taking us out into the world, the trail led into the studio. I argued that the theater in Rembrandt's case served as a special way of treating, understanding, and pictorially marking studio practice: in particular, the evidence is that the relationship between artist and model/sitter was theatrically construed. In closing, without offering any evidence, I went on to make the large claim that Rembrandt contrived to see or at least to represent life as if it were a studio event. I want to try to make good this claim.

There are a number of arguments that could be made against the proposition that Rembrandt's life and the life of his art is (largely) a studio matter. For one thing, the human and historical compass of his art is so great. In choosing to be a painter of historical subjects—considered the noblest kind at the time—Rembrandt turned away from the mundane, visible world of the other Dutch painters. The portraitist's task—condemned to copy after nature—was, in this view, perhaps an economic necessity for Rembrandt, a way to make money, but at a remove from the true ambitions of his art. Surely, it could be said, his works evoke and capture the workings of the human imagination rather than the literal concerns and practical arrangements of a working studio. What, moreover, could be further from Rembrandt's recognition of the essential isolation of the human condition than the hustle and bustle of a workshop scene?

But against such a reading of his art we have the evidence—multiplied because of recent research—of Rembrandt's serious invest-

ment of time and energy in being a teacher and the head of a large studio operation. He certainly had over fifty students and/or assistants during the course of his career. And others were attracted to his style. He engendered, nurtured, and sold the Rembrandt mode to the Dutch public. To the established description of Rembrandt as a painter who chose the high road of history painting, we must now add that he also chose the life of the studio. There was a marked self-consciousness about this. Among his works and those of his students and assistants there are probably more images which record the working operations of his studio—the manner, the accoutrements, and surroundings in which models and sitters posed—than there are of any other artist in Europe at the time (figs. 3.1–9).

Rembrandt is seen today as one of a crowd—one of a substantial group of artists (students, assistants, and imitators) a number of whose works, it is argued, have long been mistakenly attributed to him. The authorship of a surprising number of once canonical paintings is under question—from *The Polish Rider* in the Frick Collection, New York, to the Berlin *Man with the Golden Helmet*, to the *David and Saul* in The Hague, to a group of small history paintings from the 1650s. The Rembrandt Research Project, which was established in Amsterdam twenty years ago to ascertain Rembrandt attributions, has produced unexpected results: instead of isolating Rembrandt's manner, the team has called attention to its diffusion or spread. From our new knowledge of his studio entourage, we can conclude that for most of his life Rembrandt was not a lone genius but the setter of a certain (and, for a while, a fashionable) pictorial style (figs. 4.31–38).

This studio habit does not fit our previous notion of the man or of his works.[1] Though studio production was common in Renaissance painting, not all painters were famed, as was Raphael, for example, for being a team-player, or, better, the successful captain of a workshop team. While Raphael and Rubens could work with a team, Leonardo and most notably Michelangelo, could not. At some level this reluctance or inability might well have been a matter of personality. The record of Rembrandt's dealings with possible patrons, and actual mistresses, suggests he was not a man who got on easily with others as Raphael and Rubens did. Rembrandt's pictorial personality makes a clear claim to individuality and even separateness. His idiosyncratic application of the paint calls attention to his own hand. His habit was not to work out his inventions in advance through drawings, but rather to invent paintings in the course

of their execution. Rather than executing his inventions as was
common in other studio workshops, Rembrandt's students had to
make paintings like his. What is curious and stands in need of some
explanation is that Rembrandt lays claim to a singular authority
which he is simultaneously ready to diffuse.

The combination of choosing the high road of history paint-
ing and running an active studio had, of course, great precedents.
Among living masters in northern Europe, it was preeminently
Rubens's way. But unlike Rubens, the world traveler and diplomat,
the confidant of kings, and even unlike Bloemaert, Honthorst, and
Lastman, the more modest masters of studios in the northern Neth-
erlands, Rembrandt stayed home. His studio constituted his world.
For most of his life he was not a lone genius but the setter of a par-
ticular fashion, but that fashion was, by its nature, of the studio
born. Although Rembrandt's ambitions equaled those of any artist
at the time, they were manifested more exclusively in this arena.
Rembrandt contrived to see, or at least to represent, life in the
world as if it were a studio event.

I shall divide the discussion of Rembrandt in the studio into four
parts: first, a brief biographical account to demonstrate the cen-
trality of the workshop to his career and life; second, an evaluation
of the elusive role of artistic tradition in his teaching and making of
art; third, several pictorial examples to illustrate the sense in which
Rembrandt represented life as an event staged in the studio; and fi-
nally, a return to *The Jewish Bride* as an instance of the pictorial
results of Rembrandt's treatment of the studio as his domain.

I

THE OUTLINES of Rembrandt's life have been known for some
time.[2] Born into a Leiden miller's family, the youngest son of eight
surviving children, Rembrandt attended the local Latin school, per-
haps because his parents intended him to move up into the educated
bureaucracy. However, his taste led him instead to study art, first
with a local master, Jacob van Swanenburg. Having completed his
apprenticeship, he went for six months, as a kind of postgraduate
course, to Amsterdam to work with Pieter Lastman, a well-known
history painter. The dates of this Amsterdam sojourn are uncertain;
the estimates range from 1622–23 to 1625–26 when Rembrandt
was going on twenty. Returning to Leiden, Rembrandt worked
there for five to six years, competing, though on no clear evidence

sharing a studio, with Jan Lievens, and also taking on his first students—Van Vliet, Jouderville, and Dou. Rembrandt specialized in small history paintings in the Lastman mode and also in *tronies*—nonportrait studies of heads of a sort which came in eighteenth-century France to be known as *têtes de fantasies*. The competitive relationship between Rembrandt and Lievens, a quite exceptional one in Dutch art at the time, is recorded in their works and also in their pairing in the rave notice the two received in the manuscript autobiographical fragment by Constantijn Huygens, secretary to the Stadholder in The Hague, who praised Lievens for his portraits and Rembrandt for his historical scenes.

Much analysis has been devoted to the production of the two young artists during these years, with a general consensus that Lievens, often working on a large scale and with greater initial ease, was the one who challenged Rembrandt. It was Lievens, not Rembrandt, whom Huygens commissioned to make his own portrait. It is an earlier instance and one quite unique in Dutch art, of the relationship between Braque and Picasso c. 1907–10. And as in that case, it was the artist who proved weaker in the long run who led the way at first. But rather than dwelling on the ins and outs of their Leiden production, I want to consider what each did after, the differing shape of their two careers. Both of these young and ambitious artists chose to leave Leiden to pursue their artistic fortunes. It is notable, particularly given the international scope of their ambitions, that Italy was not on either's itinerary. Other artists, it was remarked at the time, were paid more for their works if they were known to have made the trip. Rembrandt, characteristically, made Italy a matter of the look of his art instead of a matter of an actual journey.[3]

It was probably in 1632, soon after Rembrandt's departure, that Lievens apparently headed for England to find work at court. He seems to have succeeded at this. There is some evidence that he painted the King as well as other members of the royal family.[4] He was apparently also attracted to and taken up by Van Dyck, whose pictorial style and courtly success Lievens took as his model (fig. 3.10). Van Dyck included a portrait of Lievens, but not of Rembrandt, in his series of engraved portraits of princes, scholars, and artists known as the *Iconography*. The Flemish painter returned to Antwerp in the mid-thirties, and Lievens went along too, joined the Antwerp guild, and married there. When he returned to Amsterdam in 1644, Lievens was invited to participate in a number of

major court and civic projects: the Oranjezaal in the Huis ten Bosch, mythological paintings in an Orange castle at Oranienburg, and finally, of course, the Amsterdam Town Hall itself. Though Lievens was no Van Dyck, this was nevertheless the brilliant culmination to an exemplary public career. This was Lievens's own assessment: an English sitter of his wrote home to his son that "he hath so high conceit of himself that he thinks there is none to be compaired with him in all Germany Holland, nor the rest of the 17 provinces."[5] It has been suggested that this was the kind of successful career Rembrandt dreamt of for himself. It was perhaps a dream the two artists had shared in their Leiden days. Rembrandt's ambition, one suspects, was to be not only the best in the north but the best in Europe! Rembrandt succeeded in this, but the evidence for it is found in the work produced in, and the influence of, his studio, rather than in a successful career in the public sphere. His art was fit for the studio and the market, not for aristocratic patrons and kings. It is this that needs explaining.

Rembrandt also catered to the court. Early on he did a portrait of Amalia van Solms (wife of the Stadholder, Frederick Henry) (fig. 3.11) and other works, including the oft-discussed Passion Series, at court behest (figs. 3.12, 2.31, 2.32). A self-portrait of his was in the collection of Charles I of England by 1639 (fig. 3.28). And on the basis of a few later works (the sketch known as *The Union of the Land* [Br. 476], the etching known as *The Phoenix* [B. 110], and the *Claudius Civilis* [fig. 3.60]), Rembrandt has been suspected of having had Orangist or royalist sympathies.[6] But he never went out of his way, by which I mean he never traveled to England or even to The Hague, as far as we know, to pursue court success. Rembrandt's taste for the court came out in his art, instead of in his life, in the courtly personages and accoutrements that are so frankly displayed.[7]

At just about the time that Lievens headed off to seek success at the English court, Rembrandt went to work and live at Uylenburgh's art workshop in the Breestraat in Amsterdam. Along with some others, he invested his talents as well as some money in the production of works arranged for and largely distributed through a business network organized by Hendrick Uylenburgh. It was in these first years that Rembrandt discovered his skills as a portraitist. He probably also served as teacher, supervising the production of copies of works by himself and by others as well. The drop in the number of etchings and history paintings Rembrandt made during these years is deplored in modern studies. But it is clear that it was

during these years, when his time was taken up in the busy and complex operations of this studio-workshop, that Rembrandt learned the methods of producing and merchandising works which he was to employ, and became accustomed to a milieu which he was in some measure to reproduce in his own studio operation in the years to come. Although with a single, ambitious artist at its head, the mixture of teaching and marketing and the nature of the art produced were different in Rembrandt's studio from those at Uylenburgh's establishment.[8]

Certain events in Rembrandt's early life have been seen largely in social terms. But his upward-bound marriage to Saskia, a burgomaster's daughter, and his 1639 purchase of an extravagant and ruinously expensive house were also part of the particular shape of his career. One might put it this way: while Lievens was pursuing the court, Rembrandt married the well-born niece of the gallery owner in whose shop he worked, subsequently went into enormous debt to buy the house right next to his on the Breestraat, and set up his own art shop. Commentary on Rembrandt's style of life has also been couched in social terms, which might be summarized as follows: an old view, dating from shortly after his death, which saw him as a kind of ne'er-do-well was replaced in the nineteenth century by the image of a bohemian; modern scholarship, discovering his motley collections to be encyclopedic and thus worthy of a gentleman's aspirations, saw him instead as a man with social ambitions; most recently, court ambitions have been added to these—with the implication that Rembrandt failed (though not, in this view, for lack of trying) at playing according to the rules of the court and regential game.[9] Each of these characterizations—as squalid, as a gentleman avidly collecting, as a failed courtier—implies an attitude towards the activities of Rembrandt's workshop and towards his art. A link between Rembrandt's life and his art has been assumed which needs sorting out.[10]

If one model of the successful artist's career at the time is provided by Lievens with his court and regential connections, another is provided by Ferdinand Bol (fig. 3.13). The son of a well-to-do family (his father was a master surgeon), Bol was the first of a series of Dordrecht artists who studied or apprenticed with Rembrandt. He enjoyed a great public success in Amsterdam, painted many guild portraits, two major works for the new Town Hall, and, quite unlike Rembrandt, held many public positions, from serving as a governor of the artists' Guild of St. Luke to being sergeant of his

neighborhood's civic guard. The culmination of his career was his second marriage at the age of fifty-three to a very wealthy woman. Bol waited to post the banns until two days after Rembrandt's funeral, perhaps because after this remunerative marriage he intended to stop painting altogether! (If we believe his *Self-Portrait of 1669*, he also swore off sex: the sleeping cupid and the column signify the chastity expected of an older man in remarriage.) Bol's retirement from painting was far from unique at the time: the landscape painter Hobbema stopped painting when he got a well-paid position as one of the wine-gaugers of Amsterdam. One mark of success, then, was for an artist to marry well enough to be able to afford to stop painting altogether.[11]

It is clear that Rembrandt was not averse to treating art as a business. One might say that, in contrast to Bol, the business he was in was art.[12] And after the death of his first, well-born wife, Rembrandt took a very different path from the example offered by Bol. It has been said that Rembrandt did not remarry after Saskia's death because according to the terms of her will he would have had to sacrifice her inheritance if he had done so. But of course a marriage such as Bol's, to an even wealthier woman, would have been another way out for him. I shall not argue that true love versus crass financial opportunism ruled in Rembrandt's relationships with Geertge and then Hendrickje. And I shall not take the time to repeat once again the evidence of Rembrandt's harsh way of disposing of Geertge when he took up with her successor. But one thing seems clear—and on this we have the evidence of his art—that these two women, like Saskia before them, were treated, even used, one might say, by Rembrandt as models for his art. To offer but three examples: it is generally accepted that the woman leaning out of the bed, perhaps Sarah, in a painting in Edinburgh is Geertge (fig. 3.15), and for the Louvre *Bathsheba* and *The Woman Bathing* (figs. 3.16, 3.17) Rembrandt certainly used Hendrickje as his model. Far from thinking of marriage as Bol and others had, as a way out of the studio, Rembrandt took it, as he took so much else, in.

There are points to be considered in judging the studio use to which Rembrandt put the women in his household. It is customary to assume that midcentury painters of genre subjects such as Metsu and Mieris put their wives as well as themselves into their pictures. So far as nudity is concerned, it is surprising but true that women of station, commonly accompanied by their husbands, were portrayed as nude or partially nude figures in commissioned historiated portraits. Though no one has suggested that a wife would have posed

3.1. Rembrandt workshop, *Rembrandt's Studio with Pupils Drawing from the Model*. Hessisches Landesmuseum, Darmstadt.

3.2. Rembrandt workshop, *Studio Interior with Two Sitters*. Cabinet des Dessins, Louvre, Paris. Photo Musées Nationaux.

3.3. Rembrandt,
*Rembrandt's Studio with a
Model*; Ben. 1161. Ash-
molean Museum, Oxford.

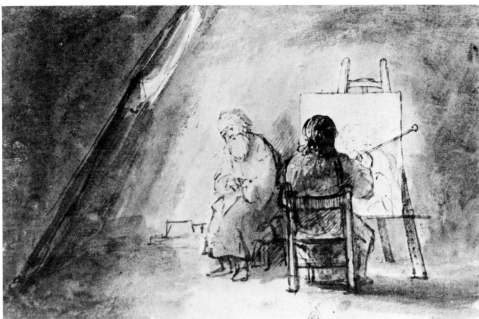

3.4. Rembrandt workshop, *Artist Painting Model*. Fondation Custodia (coll. F. Lugt), Institut Néerlandais,
Paris.

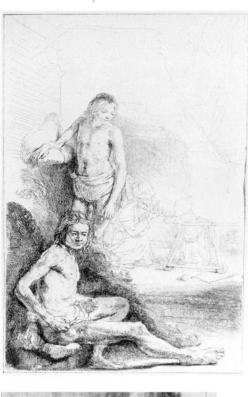

3.5. Rembrandt, *A Male Model Seated and Standing*; etching; B. 194, II. Ashmolean Museum, Oxford.

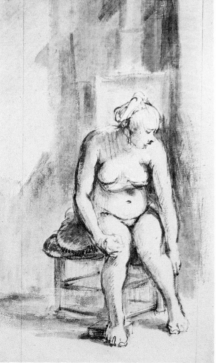

3.6. Rembrandt, *Female Nude Seated in Front of a Stove*, Ben. 1142. Prentenkabinett, Rijksmuseum, Amsterdam.

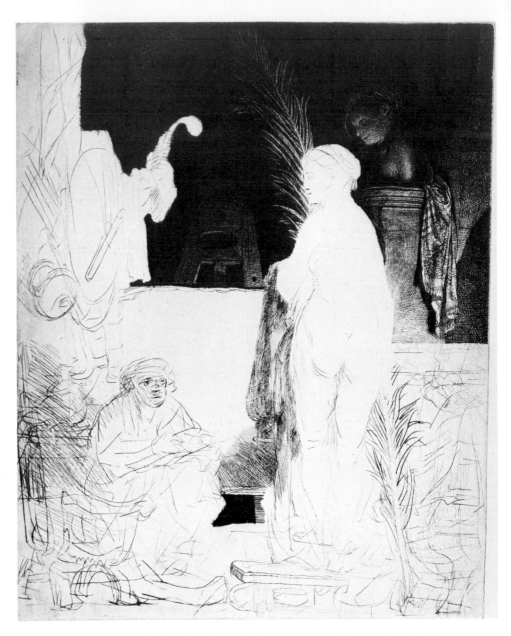

3.7. Rembrandt, *Artist and Model*; etching; B. 192, II. By courtesy of the Trustees of the British Museum, London.

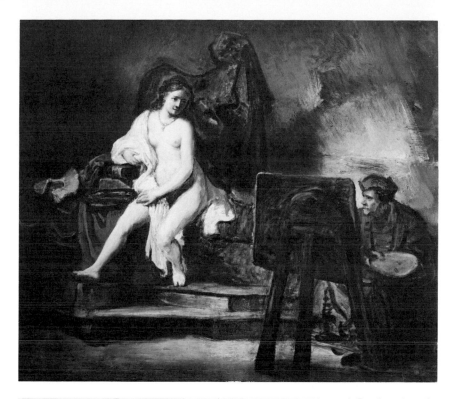

3.8. Rembrandt work-shop, *A Painter and His Model*. Art Gallery and Museum, Glasgow.

3.9. Rembrandt, *An Artist in His Studio*; Ben. 390. By courtesy of the J. Paul Getty Museum, Malibu, Calfornia.

3.10. Jan Lievens, *Self-Portrait*. By courtesy of the Trustees of the National Gallery, London.

3.11. Rembrandt, *Amalia van Solms*, Musée Jacquemart-André, Paris.

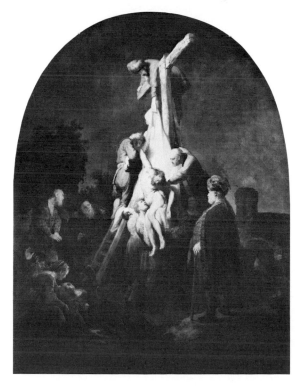

3.12. Rembrandt, *The Descent from the Cross*. Alte Pinakothek, Munich.

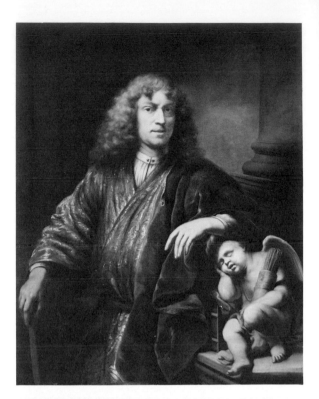

3.13. Ferdinand Bol, *Self-Portrait*. By courtesy of the Rijksmuseum-Stichting, Amsterdam.

3.14. Ferdinand Bol, *Man and Wife as Venus and Paris*, 1656. Dordrechts Museum, Dordrecht, on loan from the Rijksdienst Beeldende Kunst.

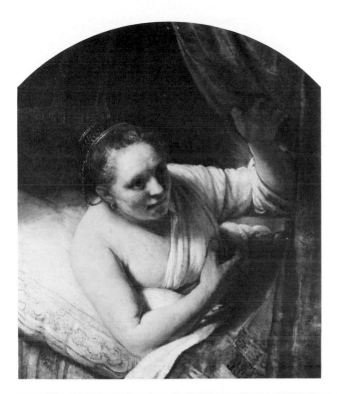

3.15. Rembrandt, *A Woman in Bed* (*Geertge as Sarah?*). National Gallery of Scotland, Edinburgh.

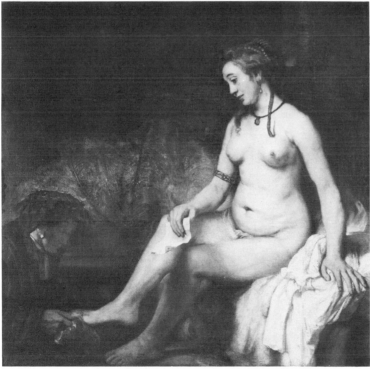

3.16. Rembrandt, *Bathsheba*, 1654. Louvre, Paris. Photo Musées Nationaux.

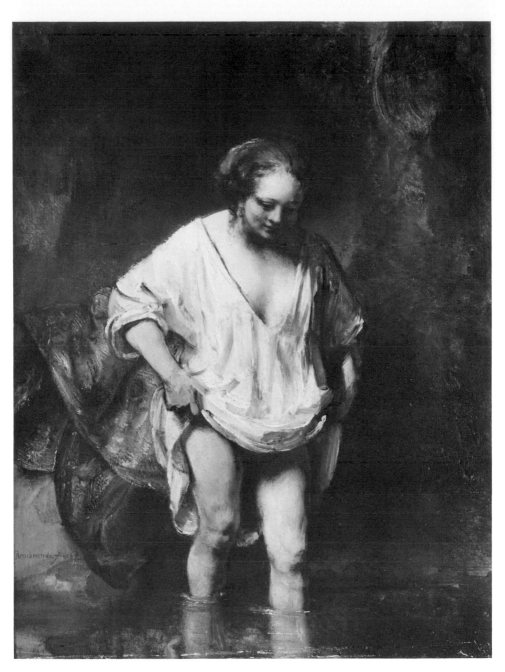

3.17. Rembrandt, *A Woman Bathing* (Hendrickje). By courtesy of the Trustees of the National Gallery, London.

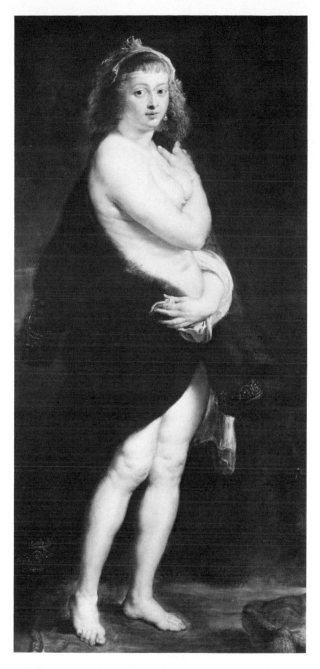

3.18. Peter Paul Rubens, *Helena Fourment: "Het Pelsken."*
Kunsthistorisches Museum, Vienna.

3.19. "Societas Parentalis," in Johann Amos Comenius, *Orbis Sensualium Pictus*, Nürnberg, 1658.

3.20. Otto van Veen, *Self-Portrait with His Family*, 1584. Louvre, Paris. Photo Musées Nationaux.

3.21. Marcus Geeraerts, *The Cares of the Painter*, 1577. Cabinet des Estampes, Bibliothèque Nationale, Paris.

3.22. Abraham Bosse, *Painter's Studio*; engraving.

3.23. Jakob Willemsen Delff, *Self-Portrait with His Wife and Three Sons*. By courtesy of the Rijksmuseum-Stichting, Amsterdam.

3.24. Jan de Baen, *Self-Portrait with His Wife and Child*. Bredius Museum, The Hague.

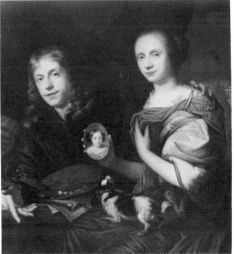

3.25. Adriaen van der Werff, *Self-Portrait with His Wife and Daughter*, 1699. By courtesy of the Rijksmuseum-Stichting, Amsterdam.

3.26. Rembrandt, *Self-Portrait with Saskia*, 1636; etching; B. 19, II (actual size). By courtesy of the Trustees of the British Museum, London.

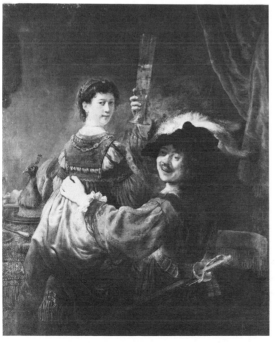

3.27. Rembrandt, *Rembrandt and Saskia* (as the Prodigal Son). Gemäldegalerie Alte Meister, Staatliche Kunstsammlungen, Dresden.

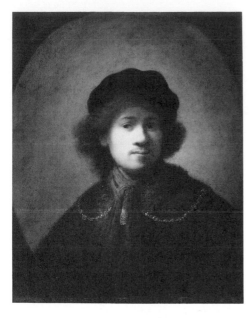

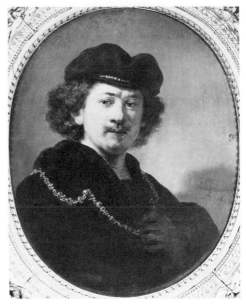

3.28. Rembrandt, *Self-Portrait*. Walker Art Gallery, Liverpool.

3.29. Rembrandt, *Self-Portrait* (above), and its signature (below), 1633. Louvre, Paris. Photo Musées Nationaux.

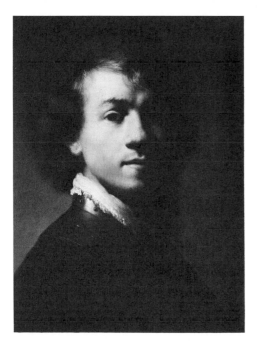

3.30. Rembrandt, *Self-Portrait*. Mauritshuis, The Hague.

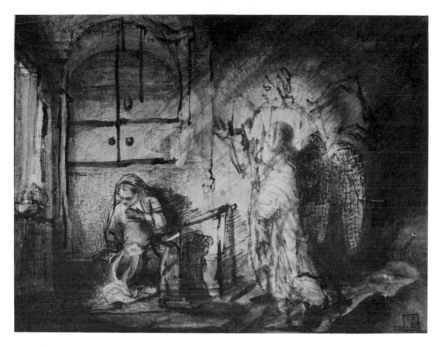

3.31. Constantijn Daniel van Renesse, with corrections by Rembrandt, *The Annunciation.* Kupferstichkabinett, Staatliche Museen Preussischer Kulturbesitz, Berlin (West).

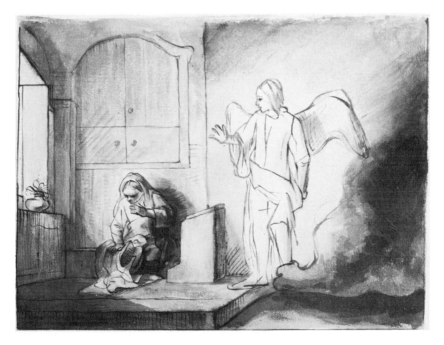

3.32. Anonymous, copy after Renesse drawing with corrections by Rembrandt. Kupferstichkabinett, Herzog Anton Ulrich-Museum, Braunschweig. Photo B. P. Keiser.

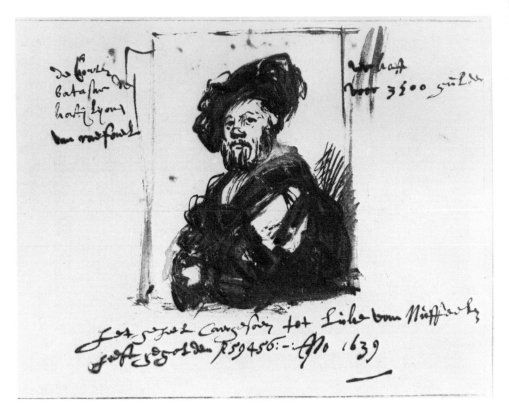

3.33. Rembrandt, *Baldassare Castiglione*, after Raphael, 1639; Ben. 451. Graphische Sammlung Albertina, Vienna.

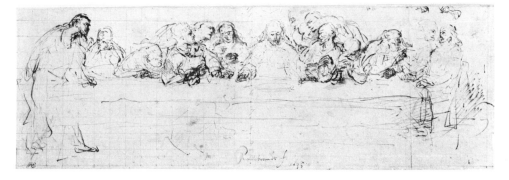

3.34. Rembrandt, *The Last Supper*, after Leonardo, 1635; Ben. 445. Kupferstichkabinett, Staatliche Museen Preussischer Kulturbesitz, Berlin (West).

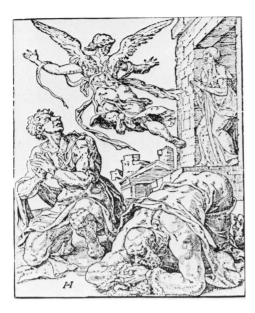

3.35. Maerten van Heemskerck, *The Departure of the Angel from the Family of Tobit*; woodcut.

3.36. Rembrandt, *The Departure of the Angel from the Family of Tobit*, 1637. Louvre, Paris. Photo Musées Nationaux.

3.37. Rembrandt, *The Departure of the Angel from the Family of Tobit*, c. 1652; Ben. 893. Pierpont Morgan Library, New York.

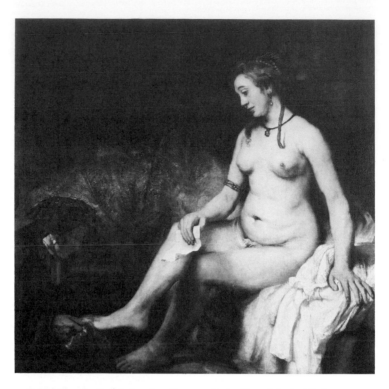

3.38. Rembrandt, *Bathsheba*, 1654. Louvre, Paris. Photo Musées Nationaux.

3.39. "Rembrandt," *Bathsheba*. Metropolitan Museum of Art, New York.
Bequest of Benjamin Altman, 1913 (14.40.651).

3.40. Rembrandt workshop, *A Painter and His Model*. Art Gallery and Museum, Glasgow.

3.41. François Perrier, *Antique Relief*, engraving, in *Icones et Segmenta*, Paris, 1645.

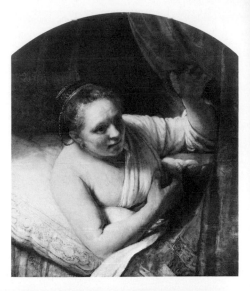

3.42. Rembrandt, *A Woman in Bed (Geertge as Sarah?)*. National Gallery of Scotland, Edinburgh.

3.43. Pieter Lastman, *The Wedding Night of Tobias and Sarah*, 1611. Museum of Fine Arts, Boston. The Juliana Cheney Edwards Collection (62.985).

3.44. Jean-Etienne Liotard, *François Tronchin*, 1757. Cleveland Museum of Art. The John L. Severance Fund.

3.45. Cornelis Cort, after Johannes Stradanus, *The Art Academy*, 1578; engraving. Metropolitan Museum of Art, New York. The Harris Brisbane Dick Fund, 1953 (53.600.509).

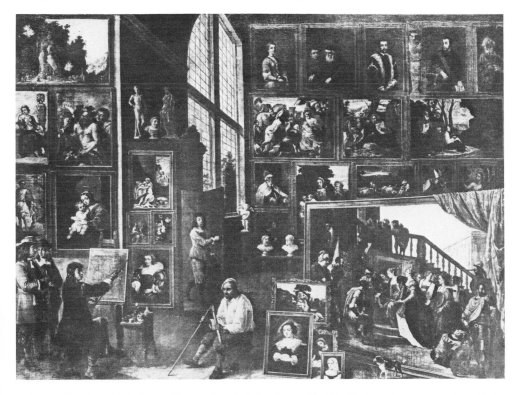

3.46. David Teniers II, *The Picture Gallery*. Schleissheim. Bildarchiv Foto Marburg/Art Resource, New York.

3.47. Rembrandt, *Standing Man with a Pouch*; Ben. 31. Prentenkabinett, Rijksmuseum, Amsterdam.

3.48. Edouard Manet, *Rag-Picker or Beggar*. Norton Simon Museum, Pasadena. The Norton Simon Foundation (F.68.9.P).

3.49. Rembrandt, *Woman Hanging on a Gibbet*;
Ben. 1105. Metropolitan Museum of Art, New
York. Bequest of Mrs. H. O. Havemeyer, 1929. The
H. O. Havemeyer Collection (29.100.937).

3.50. Rembrandt, *Woman Hanging on a Gibbet*;
Ben. 1106. Metropolitan Museum of Art, New
York. The Robert Lehman Collection (1975.1.803).

3.51. Jacques de Gheyn II, *Karel van
Mander (?) on His Deathbed*. Städel-
sches Kunstinstitut, Frankfurt.

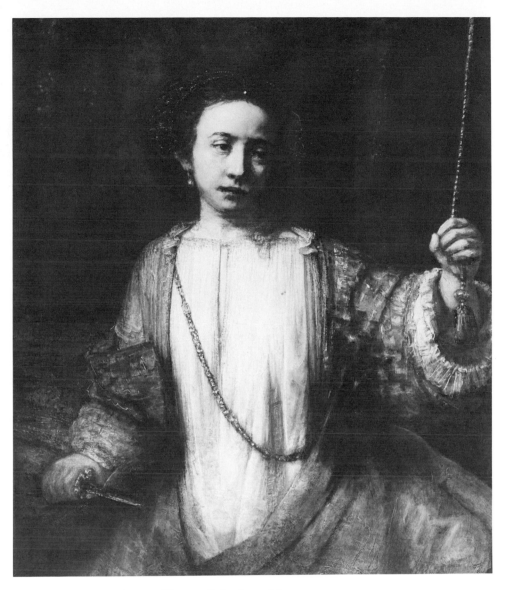

3.52. Rembrandt, *Lucretia*, 1666. Minneapolis Institute of Arts.

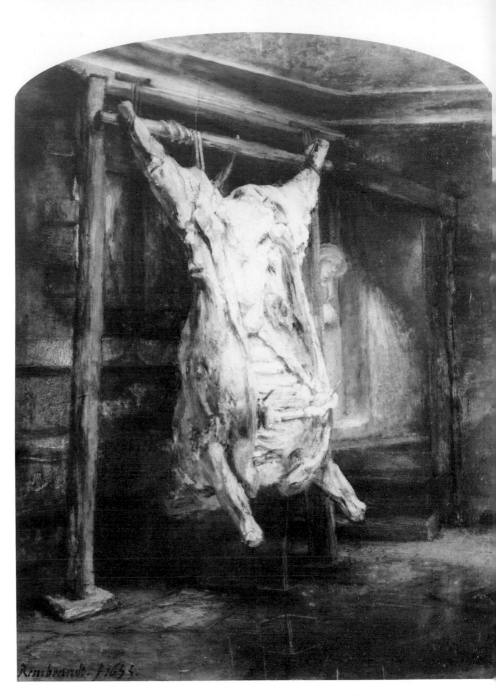

3.53. Rembrandt, *The Slaughtered Ox*, 1655. Louvre, Paris. Photo Musées Nationaux.

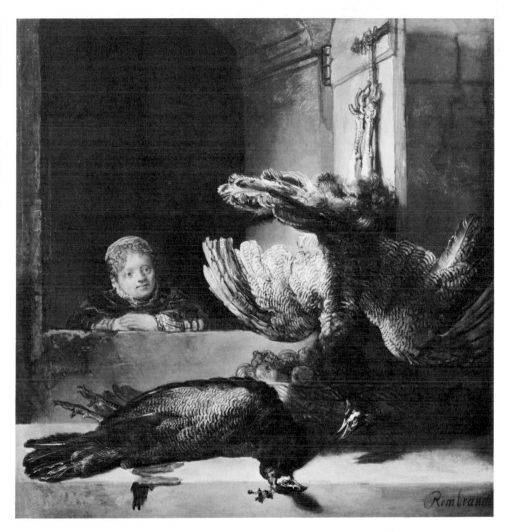

3.54. Rembrandt, *Child with Dead Peacocks*. By courtesy of the Rijksmuseum-Stichting, Amsterdam.

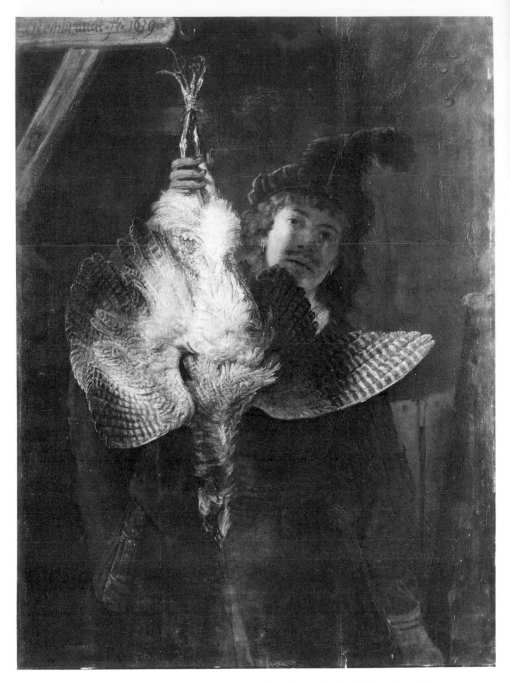

3.55. Rembrandt, *Self-Portrait with Dead Bittern*, 1639. Gemäldegalerie Alte Meister, Staatliche Kunstsammlungen, Dresden.

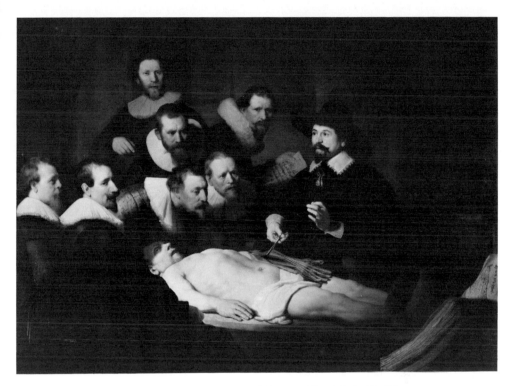

3.56. Rembrandt, *The Anatomy Lesson of Dr. Nicolaes Tulp*, 1632, Mauritshuis, The Hague.

3.57. Engraving after Raphael, *The School of Athens*. Warburg Institute, London. Photo Warburg Institute.

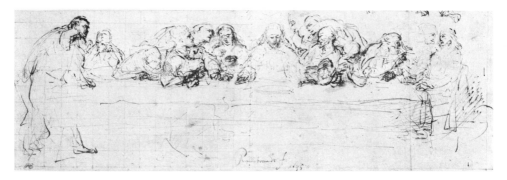

3.58. Rembrandt, *The Last Supper*, after Leonardo, 1635; Ben. 445. Kupferstichkabinett, Staatliche Museen Preussischer Kulturbesitz, Berlin (West).

3.59. Rembrandt, *The Oath of Claudius Civilis*; Ben. 1061. Staatliche Graphische Sammlung, Munich.

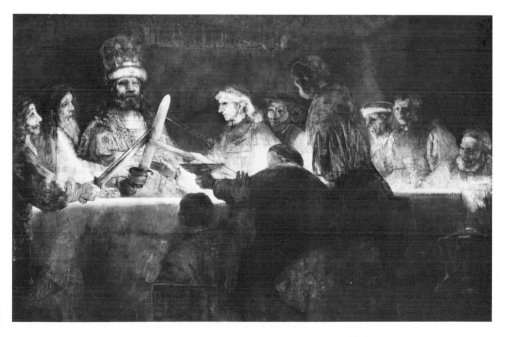

3.60. Rembrandt, *The Oath of Claudius Civilis*, 1661. Nationalmuseum, Stockholm.

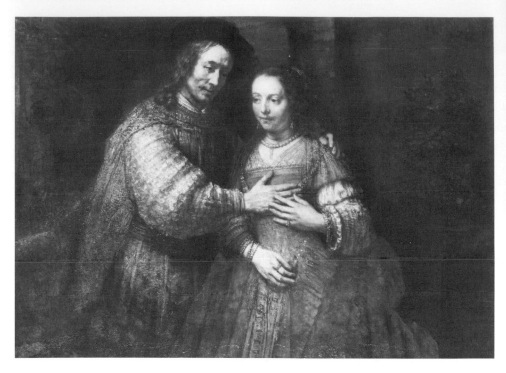

3.61. Rembrandt, *The Jewish Bride*. By courtesy of the Rijksmuseum-Stichting, Amsterdam.

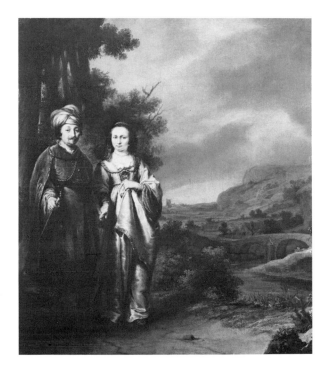

3.62. Ferdinand Bol, *Anna van Erckel and Erasmus Scharlaken as Isaac and Rebecca*. Dordrechts Museum, Dordrecht, on loan from the Rijksdienst Beeldende Kunst.

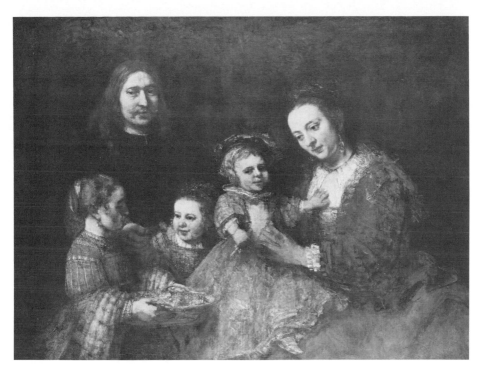

3.63. Rembrandt, *Family Group*. Herzog Anton Ulrich-Museum, Braunschweig. Photo B. P. Keiser.

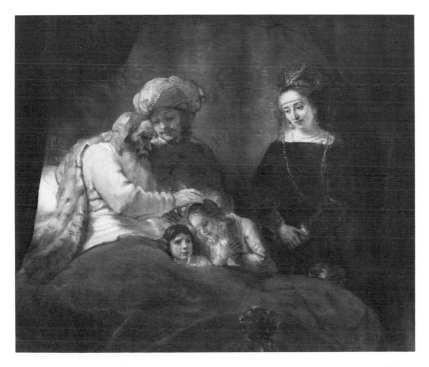

3.64. Rembrandt, *Jacob Blessing the Children of Joseph*, 1656. Gemäldegalerie, Staatliche Kunstsammlungen, Kassel.

3.65. Rembrandt, *Man with a Magnifying Glass*. Metropolitan Museum of Art, New York. Bequest of Benjamin Altman, 1913 (14.40.621).

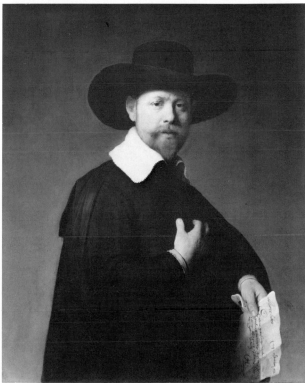

3.67. Rembrandt, *Marten Looten*, 1632. Los Angeles County Museum of Art. Gift of J. Paul Getty.

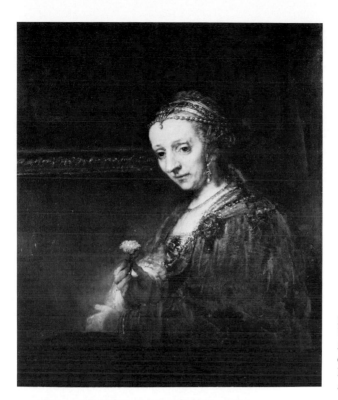

3.66. Rembrandt,
Woman with a Pink.
Metropolitan Museum
of Art, New York.
Bequest of Benjamin
Altman, 1913.

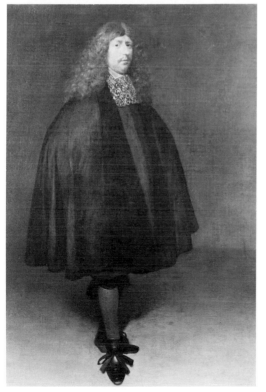

3.68. Gerard ter
Borch, *Self-Portrait*.
Mauritshuis, The
Hague.

3.69. Nicolaes Maes, *Jacob Trip*. Mauritshuis, The Hague.

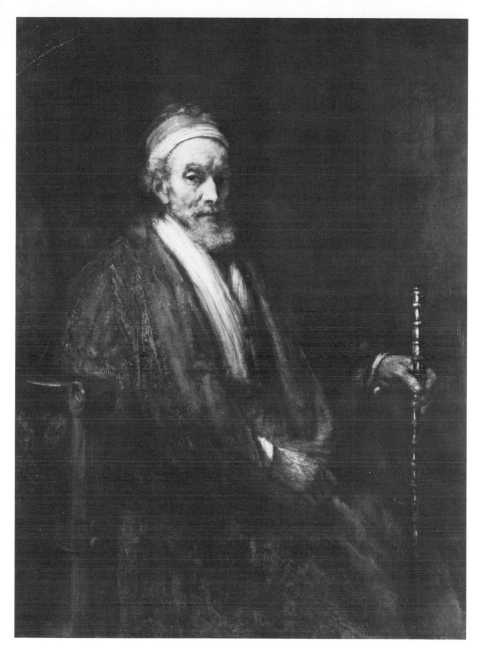

3.70. Rembrandt, *Jacob Trip*. By courtesy of the Trustees of the National Gallery, London.

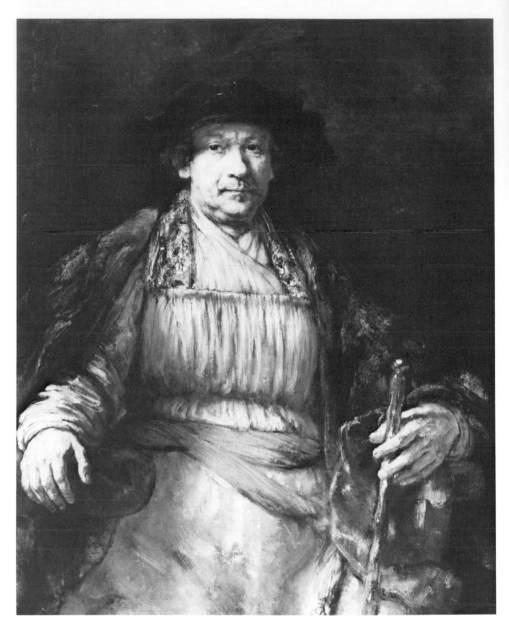

3.71. Rembrandt, *Self-Portrait*, 1658. © The Frick Collection, New York.

for her portrait in the nude, an unidentified Dutch couple were depicted by Bol as Paris offering the apple to a bare-breasted Venus (fig. 3.14). All this occurred within the accepted bounds of marriage and the Dutch family.[13]

Legal documents reveal the not surprising fact that the women who served as artists' models in Holland at the time were prostitutes or at least assumed to be such. This custom had ancient roots. In June 1654, Hendrickje Stoffels, living with though not married to Rembrandt, and five months pregnant with Cornelia (the chosen name was that of Rembrandt's own mother), was called in front of the church council. When she finally made her appearance in July, after a third summons, it was to admit that she had lived with Rembrandt like a whore. It is worth quoting the document in the original Dutch: "Hendrickje Jaghers . . . bekent dat se met Rembrandt de schilder Hoererije heeft gepleecht." The year that Hendrickje admitted to practicing prostitution was also the year Rembrandt painted the *Bathsheba*. Hendrickje was not in any ordinary sense a prostitute, but despite the number of times she was painted by Rembrandt, she does not appear as a family member as did wives of other artists. Her appearance as *Bathsheba* and the *Woman Bathing* fits neither the description of prostitute or wife, though the subject of each—Uriah's wife and a Susanna-like woman, observed after and during a bath—clearly has a sexual aura involving desires pursued outside of the bonds of marriage. Her category was an exceptional one in social as well as in pictorial terms. Hendrickje was celebrated by Rembrandt in what he construed as a separate domain. He entertained his desire for her in the studio and sustained it by capturing her in paint.[14]

There is also a famous painting in which Rubens portrayed his wife nude. His different relationship to her and to painting her can further clarify Rembrandt's practice (fig. 3.18). Rubens's choice of Helena as his second wife tells us something of *his* sense of that profession. The Flemish master told a correspondent that in his widowhood he refused to consider marriage to a court lady who would, in his words, have blushed to see him take up his brush. Despite his success at courts, Rubens did not aspire to live in that world. He chose to remain in Antwerp and picked a middle-class wife. Unlike Rembrandt's common-born mistresses, Helena Fourment (more like Saskia, in fact) was the daughter of a rich silk and tapestry merchant who proved of use in furthering Rubens's career by commissioning tapestry designs from him. Her actual role as her husband's model, in the magnificent nude portrait in the pose of the Venus

Pudica known as *Het Pelsken* was distinctly a private affair. The picture was not intended for sale and was left to Helena in Rubens's will. To use Helena as a model in this manner was an exception to his normal studio practice. Gossip and a certain kind of salesmanship long maintained that all of Rubens's female beauties were his wife. Philip IV of Spain was advised that the beauty of Venus in a Rubens *Judgment of Paris* was that of the artist's wife, and the nineteenth century saw Helena in every woman Rubens painted. Rubens did depict her on a number of occasions in the family context, but with the exception of the painting in Vienna, there is no evidence that Helena ever served Rubens as a model. Though there is much that is similar between these admiring and stunning paintings of nude women by the two artists, each represented in an established female role and each loved by her painter, the conditions of their production were not the same.[15]

Rembrandt created his studio at the expense of an established relationship between the household and art. The common Dutch pattern was coexistence of art and the household. Art in Holland was a cottage industry, a domestic production that was represented as such. The studio was a room in the artist's house, the *schilderkamer*, in which artists often depicted themselves, or perhaps other artists, at work. Vermeer's *Art of Painting*, the most famous picture of this type, can stand for the genre. Members of artists' families served as models, and artists often painted themselves as members of their own families—with wife and children and, on occasion, with parents—making paintings of them, or painting in their midst (figs. 3.20, 3.23, 3.24, 3.25). Seen from this angle, the domestication of the painter's muse as his wife that we took up in chapter 1 bears out the identification between professional and familial well-being.[16]

The familial context of art is illustrated by Comenius in his *Orbis Pictus*, that famous early illustrated schoolbook, where he uses the artist's family to illustrate *the* family (fig. 3.19). The numbered list of objects which are the subject of this pictorial lesson on the parental state opens with the father-artist and concludes with his palette. The legend says that he first begets children and that he works (at his painting) to support them. It may be that Comenius drew on the model of the industrious painter (*nulla dies sine linea*) from Pliny's account of Apelles and that the *tabula rasa* of a child's mind is also invoked. But the naming of such symbolic details still leaves Comenius's choice of the artist's family to depict *the* family unaccounted for. In ideological terms—though just what social and economic

factors contributed remains to be studied—there was at the time in northern Europe a positive and binding relationship assumed between art and the family.[17]

Rembrandt turns away from this. Though he twice depicted himself with Saskia, the images do not fit easily into the domestic category. In the Dresden *Prodigal Son,* as we have seen, Rembrandt directly implicated his art in a disruption of the married state.[18] And his etching of himself drawing (or perhaps etching) in which Saskia, diminished in size but brilliantly lit, is awkwardly displaced beyond Rembrandt's looming, shadowed face, acknowledges the relationship between art and the married state only to suggest some tension that cannot be spoken (figs. 3.26, 3.27).[19] Rembrandt never painted himself with Hendrickje, never with wife and child, and never in a clearly domestic space.

There was, finally, also a practical manifestation of the separation of his studio from the household. For a number of years, according to Houbraken, Rembrandt rented warehouse space away from his house in which his assistants could work. Furthermore, Houbraken reports Rembrandt to have set up partitions there to create separate cubicles in which students and assistants could work alone. (The "play" of Adam and Eve was played out in one of these.) Perhaps when he was no longer renting a warehouse, Rembrandt had such cubicles reconstructed in his own house. A document records that in 1658, when the Breestraat house was being sold to pay off his creditors, Rembrandt was required "to take with him two tile stoves and several partitions in the attic placed there for apprentices." Whatever the purpose of these cubicles—Houbraken said privacy, modern commentators have suggested independence, and nineteenth-century analogues suggest increased productivity—Rembrandt by this device effectively defined studio space as something separate from the household. It is a definition that is borne out by his works.[20]

How does Rembrandt manifest his ambition in terms of the studio? One obvious pictorial sign of Rembrandt's worldly ambitions is found in the portrait heads—mostly early self-portraits—bedecked with a golden chain (figs. 3.28, 3.29). Since antiquity, a chain of gold had been the sign of royal favor. And in the Renaissance, with new claims being made for art, and with the high honor and even urgency with which it was received at court, artists also became the recipients of chains. They were an accepted mark of royal favor and were sought after, won, and then often displayed by artists in their

self-portraits. Titian, Vasari, Rubens (who received at least three), Van Dyck, and Goltzius were among the artists so rewarded. Rembrandt was not, nor did he seek this reward. There has been some difference of opinion about the precise way in which to interpret his depiction of the chain: is it a claim the imaginary nature of which testifies to an awareness of the constraining and hence suspect nature of actual royal favor, or does it perhaps call attention to the chain's symbolic force—an attribute in that case of the honor of art and of the artist rather than a tribute to worldly ambition and success. Regardless of its exact meaning, we can say that the reward that was sought by others in the world is displaced by Rembrandt onto what is obviously a studio trapping. These pictures are not fed by the desire "if I only had a gold chain" but are a studio enactment of the award with Rembrandt playing the artist's role.[21] The same thing might be said about those self-portraits in which Rembrandt dons a bit of armor, in this case quite clearly a studio accoutrement, which, curiously, in the Netherlands had a complex of established textual connections with painting (fig. 3.30).[22]

Such studio dress-up with gold chains and armor offer a minor but revealing record of Rembrandt's serious ambitions as an artist. Emblems of any kind are conspicuous by their absence from Rembrandt's works. If we compare Rembrandt's self-portraits to those by his student Dou, which are frequently piled high with significant accoutrements, we see how minor a role they play. An added appeal of gold chains and armor was that they are dress in its most material form and were readily worked to that pictorial effect of substance to which he was so attracted. Bol and Hoogstraten, among Rembrandt's other students, imitated his use of the golden chain. But Hoogstraten traveled to Italy and to Vienna where to his great satisfaction he succeeded in actually being awarded a gold chain by the emperor. When he depicts this chain in a late portrait, it is as a real trophy of real life (akin to the *trompe l'oeil* illusion of the real offered by so many of his paintings) rather than an invention of art. Hoogstraten played out in public and confirmed in a picture what in his master's work was a pictorial effect, a display of ambition in the studio.[23]

There is also the matter of Rembrandt's signature, the distinctive form of which he arrived at about 1633, not long after he moved to Amsterdam (fig. 3.29). An Italian trip was not on the horizon. And very shortly Rembrandt was to begin the major purchases of prints that made good his claim, as reported by Huygens, that plenty of Italian art was available in the Netherlands. He had settled into the

life, into the neighborhood even, in which he was to spend almost all of his days. And it was then and there, before almost anyone could have seen it in his art, that Rembrandt made it known simply by the way he chose to sign his name (a studio move if there ever was one) that his ambition was to rank with those great Italians— Leonardo, Raphael, Michelangelo, and Titian—who were known only by their forenames. It was as if Lievens had chosen to be known as Jan. Rembrandt's first name stuck. And one should add that, questions of its form or authenticity on any one occasion aside, Rembrandt liked his name affixed to his works, and even to works made by others in his studio.[24]

II

I W A N T now to turn from the centrality of the studio in Rembrandt's life and in his career to consider certain aspects of the training that went on there. In considering Rembrandt as a teacher, scholars in the past emphasized his influence on the works of presumed students and followers; today they are considering Rembrandt's training of apprentices as assistants, and the emphasis is on the way art was made in his workshop. A new sort of concreteness, the setting and the habits of the workplace, is being introduced. What can we say about the notion of art exemplified by this particular workshop enterprise?[25]

Compared to the standard procedures and strategies in the instruction of artists in the Netherlands at the time, Rembrandt's practices seem distinctive, even idiosyncratic. (But one could also use these adjectives to describe the look of the works produced by Rembrandt and his assistants.) We can describe a normal course of training from the drawing handbooks of the time and from the uniquely preserved documentation of the Ter Borch family atelier. A young artist, of course, learned to draw before he learned to paint. The major object of his attention was the human body. He copied it from prints, from the drawings of other masters, and finally from paintings. From such "flat" models the artist in training graduated to casts after statues and finally to the live model. The handling of composition was also learned from copying previous works of art.[26]

Despite this accepted practice of learning through copying, Rembrandt does not seem to have used the impressive collection of prints and other works in his own collection in the teaching process. There are, as far as I know, almost no extant copies by his students

after any work in the collection.[27] It has been generally assumed, on the basis of teaching practices of the time, the size of Rembrandt's own collection, and the historical aura given off by his own works, that examples were provided by the art of the past. In fact, that rule of art does not seem to have been practiced in Rembrandt's studio. His students and assistants, it is true, did an amazing amount of copying, but it was after works—drawings mostly—produced by Rembrandt or corrected by Rembrandt or else by those following Rembrandt within the studio.[28] Many of Rembrandt's students or assistants came to him at about the age when they might have opted for an Italian trip to finish their training. Rembrandt's practice as a teacher suggests that he encouraged these young artists to see his studio as an alternative to Italy, but it was not designed as an equivalent to it: the major example that Rembrandt put forth in his studio seems to have been his own way or practice itself.[29]

Aside from setting his students the task of drawing from the live nude model, Rembrandt's major teaching effort went into encouraging and correcting drawings principally of the narrative sort. I pointed out in the previous chapter that as a type this kind of drawing is quite without precedent in format, or technique, or function as a tool of teaching. It has been proposed that Rembrandt produced them for use in his teaching. The evidence for this is largely that they are connected to no further work in Rembrandt's own oeuvre. Drawings such as these were not, in other words, used by Rembrandt himself as preparatory studies for anything else. Like so many other aspects of his teaching operation, however, such drawings seem to reflect something about Rembrandt's own practice as much as they do his practice as a teacher.[30]

It is an identifying feature of some of the greatest painters of the seventeenth century, that they composed, albeit employing a variety of different techniques, directly on the canvas. X-rays have confirmed that it is for this the reason that we lack preparatory drawings by Caravaggio, Velázquez, or Vermeer. Rembrandt was one of these as far as his painting is concerned, but unlike the others he was also a major draftsman. But a condition of his drawing was that it remained quite separate from his painting. After his early years it was only under unusual circumstances that Rembrandt ever made drawings in preparation for his paintings. It is generally true that in those cases where there is a connection between a painting and a drawing in the Rembrandt manner, this is good reason to have doubts about assigning the authorship of both to the master himself. If the barrier between the two media is crossed, we have reason

to think that both works were done by a student's hand or perhaps that a copyist was involved. (This contrasts with the normal situation in which it is assumed that a painting related to a compositional drawing is by the same artist who did the drawing.)[31]

In Rembrandt's shop it was the students who made their narrative drawings (and in some cases Rembrandt's own) into paintings. The Rembrandt shop appears to have produced an entire category of small history paintings based on drawings of this type. A number of works from the fifties and sixties which are probably only marginally related to Rembrandt's hand, the *Christ and the Samaritan Woman* in New York and in Berlin, for example (fig. 4.33), fall into this category.

One of the remarkable things about Rembrandt's production as an artist is the almost total separation that he maintained between the three media in which he worked—drawing, painting, and etching.[32] One is rarely worked as preparation for the other, and etching remained Rembrandt's own private preserve. He appears to have taught it regularly to no one: there were few Rembrandt followers and no assistants in etching as there were in painting.[33] Rembrandt's interest in the narrative groups of the drawings continued to find an outlet in his etchings. But as time went on, he concentrated his own energies as a painter on a format which was never drawn either by his hand or by his students. This undrawn format, by which term one could describe half- or three-quarter-length figural portrayals like *The Jewish Bride,* was produced only in paint. It came to be what painting was for Rembrandt. Life in the studio played its part here, too, as we shall see shortly.[34]

Rembrandt was apparently a most demanding teacher. We see the manner in which he bore down on the drawings of his students and assistants with corrective erasures in white, the reworking in pen and brush, and the verbal instructions with which he sometimes marked their attempts. Rubens had the distinctive habit of retouching drawings in his collection by artists who were dead. Rembrandt did the same to the work of the living. We can gauge the hard-pressed students' reactions to these demands from the multiplication of copies they made after drawings that had been corrected by Rembrandt (figs. 3.31, 3.32). These confirm the students' anxiety to follow his lead. Hoogstraten reports having been driven to tears and even going without food or drink on at least one occasion while he tried to correct what Rembrandt had marked as an error in his work.[35]

Students and assistants were normally worked hard. Vasari

praised Raphael as an exception for manifesting towards his students the kind of love which is generally not lavished on craftsmen but on one's own sons. Any studio operated by practical examples—the tales are rife of artists refusing to put into words what they could demonstrate in practice. But part of Raphael's effectiveness as a father figure was, one imagines, that he could appeal beyond the example of his own practice to certain accepted standards of picture making. By 1510 in Italy the tradition of painting had an institutional authority of its own. But this kind of appeal to the external authority of tradition was absent in Rembrandt's case. When we ask what examples Rembrandt expected his students to follow in their drawings we are hard put to give an answer. Perhaps this explains the opaque or evasive response Hoogstraten got when he pestered Rembrandt with questions about how to proceed. Rather than telling him to follow this or that master or rule, Rembrandt's advice was to proceed from what he already knew.[36] This must have presented a problem for Rembrandt's students.

The practice he established for his students and assistants was one he honored himself. Among the large number of drawings by Rembrandt known today, actual copies after older works of art are extremely rare. They total perhaps fifteen or so. The five commemorative drawings that Rembrandt did after Lastman paintings in the thirties, the three drawings after an engraving of Leonardo's *Last Supper* (fig. 3.34), the quick salesroom *ricordo* of Raphael's *Castiglione* (fig. 3.33), a drawing after a bust of Galba, the copy of Mantegna's *Calumny of Apelles*, and the famous group after Indian miniatures make up the entire lot in Rembrandt's hand.[37] Even allowing for losses over time, copying after older art was not a habit that Rembrandt cultivated or one that he handed on to his students. The traditional complaints about Rembrandt's failure to show an interest in his art collection has some justification.[38]

But how did Rembrandt relate in practice to the art of the past? What can we make of Rembrandt's attitude towards artistic tradition? About Rembrandt's attitude, in general terms, there can certainly be little doubt: he is one of the few Dutch artists who thought of his art as taking its place in and belonging to the larger European artistic field. This is the aura that Lord Clark evoked in his book on Rembrandt and the Italian Renaissance.[39] But despite our sense that Rembrandt, like Rubens, who was the exemplary artist in this respect, wanted to take his place in the European tradition, copying the art of the past was not central to the operation of his studio. The lack of copies after other works, the lack, in other words, of the

practice of imitation, is compounded by the fact that it is often very hard to put one's finger on the particular source in earlier art of many of his figures or compositional arrangements. There are, of course, exceptions to this, and they have been much studied. Some early paintings such as *Balaam and His Ass*, for example, follow closely after works by his teacher Lastman. The painting of the *Deposition* commissioned by the Stadholder (fig. 2.10) echoes a print after Rubens's altarpiece, and in his 1640 *Self-Portrait* in London, Rembrandt commemorates (or perhaps even celebrates) Rubens's death that year by presenting himself in the manner and mode of great Italian predecessors, Raphael and Titian (fig. 4.20). His repeated use of the table motif of Leonardo's *Last Supper*, from the early *Wedding of Samson* (fig. 2.8) to the late *Claudius Civilis* (fig. 3.60), is for him an exceptional case of taking up a canonical invention as a tribute to, and assuming of, a heritage.[40] These could be dubbed *emulations*, using a rhetorical term of the time, as E. de Jongh has proposed. The viewer is meant to recognize the source and perhaps even see Rembrandt's use of it in a competitive vein. His aim is to honor and to offer a challenge to a predecessor.[41]

The normal, working assumption of the historian of Renaissance art who looks for sources is that through them one traces a mode of picture-making and a tradition. It is by imitating artists before him that an artist such as Rubens claimed his place in the tradition. Allowance is even made, and an explanation offered, for imitation working through the artist's memory rather than through the making of actual copies. But it is imitation, nonetheless, and it is a general characteristic of art historians—as of Renaissance artists as they view them—that they offer no alternative to what we might call the law of imitation. An inheritance or filiation and artistic continuity is confirmed, and a certain canon of works is taken up in the process.[42]

But a large number of the sources that have been cited for works by Rembrandt are not compelling, not because Rembrandt did not look at earlier art, but because he did not declare or reveal his models. The specific models Rembrandt drew on for such ambitious works as the *Danae*, *Jacob Blessing the Sons of Joseph*, or the late *Return of the Prodigal Son* remain unidentified. By virtue of subject and of scale, these paintings claim their place in the tradition, but their specific relationship to it has proved difficult to chart. The evidence is hard to assess because Rembrandt has not proclaimed his sources in the mode of emulation.[43]

Adopting other terms that have been proposed for distinguishing

modes of imitation, could one say that Rembrandt was practicing imitation as *transformation* and as *dissimulation*—the artist effectively hiding his sources by absorbing them into his works? There was a Dutch proverb at the time which was used to explain borrowings of this sort: "Well-cooked turnips make good stew." The operative word was *rapen*, which means "turnips," but also "pickings" or stolen goods (from the verb *rapen*).[44] The thrust was that making a painting, like cooking a dish, could not be done without collecting ingredients or borrowing elements from other works and combining them together so well that they were no longer distinguishable as such. The proverb promotes a particular version of image-making. Applied to Rembrandt, it has led to a renewed effort to recoup the borrowings or sources he is supposed to have hidden. What if an artist, beyond wanting to transform or to hide his sources, had reasons to want to pretend to an absence of them all together? It is a position not dreamed of in the Renaissance philosophy of imitation.[45]

Rembrandt's common tactic was to turn to obscure images which were not recognizably part of the canon. The viewer was not expected to recognize the model behind a figure but instead to look at the figure. While Rubens invoked known figural models for the expressive power they had accumulated within the tradition (*Pathosformel* was Aby Warburg's term for this), Rembrandt avoided them. He used images to supply something very much akin to what he looked for in the studio performances of his students and sitters: models which enabled him to avoid what he would have viewed as stereotypes.[46] Take as an example the painting of *The Angel Leaving the Family of Tobias*, which is generally, and I think in this case correctly, said to have its "source" in a print by Heemskerck (figs. 3.35, 3.36). In this case Rembrandt took over major elements of the composition. The angel (who, however, glows with green and gold in the Louvre) is a startling copy. But Rembrandt uses this work like a crutch, absorbing it to serve him as a scaffolding. His intention was not that it be recognized as such.[47] When, in a later drawing of the same scene, Rembrandt returns to the Heemskerck, it is to view it as he might have viewed a group of players in the studio from another point of view (fig. 3.37).

The *Bathsheba* in the Louvre is exemplary of the elusive nature of Rembrandt's relationship to tradition (fig. 3.38). There can be no question that in this picture Rembrandt was taking on a central concern of European easel painting—the nude female figure. The secondary interplay between the servant and her mistress was also tra-

ditional. But having established the type of image that Rembrandt was producing, we find that there is no particular canonical painting, and no engraving after a canonical painting, to which he turned. The source for the figure which has been cited is an engraving by François Perrier after an antique relief published in a popular book, though not a book that we know Rembrandt to have owned (fig. 3.41). The objection to citing this source is not based on the availability of the book, but rather the necessity of assuming any specific model at all. It may be granted that the pedicure is shared in kind, and perhaps the woman's left arm and her hand as well. It is no accident, given Rembrandt's own sculptural ambitions at this time, that a painting of his should approximate an engraving after a sculpted relief. But is it really necessary for us to posit Perrier's engraving as what we call a source? Is it not possible for us to imagine Rembrandt inventing this Bathsheba without turning to a specific model in previous art? We would, after all, be less likely to press this question about a painting by Rembrandt's teacher Lastman. We do so in the case of Rembrandt, I think, because we assimilate Rembrandt's works to a canon including "classical" works and, in doing so, assume that his works are linked to other works in the canon in the way that the works of many other artists are linked to each other.

If it is hard for us to think there might be no specific source, we must try to imagine what it was for an artist like Rembrandt to make a painting without one. An unattributed Rembrandtesque painting in Glasgow in which a woman, her right arm resting on a pile of books, is posing for an artist, suggests more accurately the manner in which the *Bathsheba* was made than does an appeal to Perrier's print (fig. 3.40). The Glasgow painting is, in turn, related to the *Toilet of Bathsheba* in New York, in which a model is shown preparing, as it were, to play the role of Bathsheba (fig. 3.39). The extraordinary weight, the unusual gravity of flesh, conveyed by the image of the female body in the *Bathsheba* results from Rembrandt's treatment of the tradition of the monumental nude as reembodied and reenacted in a particular woman modeling for the artist in his studio. Bathsheba's story was elided with Hendrickje's situation. Houbraken was not wrong when he wrote that, like Caravaggio, Rembrandt followed the living model before his eyes. What he neglected to say was that for Rembrandt, in practice, models presented themselves in a theatricalized studio.[48]

This formulation is confirmed in other instances in which life in the studio replaced the art of the past. Recognizing the fragmented character of Rembrandt's pictures (by which is meant that a part,

which is therefore hard to identify, stands for the whole of a narrative action), a scholar has suggested that Rembrandt composed by extracting single figures from the works of previous artists.[49] On this account, the Edinburgh *Sarah* is an extraction from a painting by Lastman (figs. 3.42, 3.43). Rembrandt took out Sarah and left Tobit and the bedroom setting behind. But this ignores an important step in the production of the painting. For what Rembrandt did (or what the picture makes us think he did) was to bring the figure into the studio in the form of a woman posing before his eyes. (Hence the appropriateness of Liotard's portrait in which an eighteenth-century owner of the painting, who is exchanging gestures with the woman in the picture, reenacts the original studio event [fig. 3.44]). If the narrative drawings of master and pupils suggest small acting companies, a painting such as this concentrates on a single actor. The device known as "extraction" is formal and iconographic. As a compositional mode it favors a concentrated narrative crux. But Rembrandt's pictorial practice adds the studio on to this. He accommodated narrative, as we have seen he accommodated tradition, to his practice of focusing on a model/sitter performing in the studio. Perhaps in the case of the *Sarah*, Rembrandt felt that he was redoing Lastman after life, to paraphrase Cézanne's remark about his master, Poussin.

There is, finally, also a tension, a darker side, to Rembrandt's relationship to tradition. It is commonly agreed that one reason that Rembrandt chose the Amsterdam painter Lastman for his postgraduate or finishing course in painting was his ambitions as a history-painter. There is much pictorial evidence that Rembrandt felt closely involved with the older painter. Aside from Leonardo, Lastman was the single artist whom Rembrandt imitated most directly, encouraging his own students to do so.[50] He confirmed his bond late in life when, though deep in bankruptcy, he managed to buy yet another of his teacher's paintings. Rembrandt's early paintings display a clear dependence on Lastman: subject, gestures, compositional devices, fancy "historical" costumes, even some of Rembrandt's earliest use of color is indebted to him. (A good place to see the similarity in blues and pinks is in the Los Angeles County Museum, where Lastman's *Hagar and the Angel* hangs beside Rembrandt's *Raising of Lazarus*.) Yet if we look beyond the obvious copies and certain effects it is surprising, particularly given Rembrandt's elaborate devotion to Lastman, how little his work as a whole owes to him. Indeed, the most persistent and unique features of Rembrandt's work as an artist, the kinds of subjects and modes to which

he devoted himself, had no interest at all for his admired teacher. I am referring here to Rembrandt's pen and wash teaching drawings, his nudes, his etchings, and his self-portraits as part of a larger interest in the human face and in portraiture. It would appear that part of the appeal that Lastman continued to have for Rembrandt, what enabled him to keep up the relationship as long as he did, was his weakness, rather than his strength, vis-à-vis Rembrandt's art. He was a mentor who posed no threat, and as such he could be openly treated as canonical. Behind Rembrandt's behavior lies a resistance to acknowledging the authority of tradition. This is in part an anxiety about its power in relation to his own. If Rembrandt had not been his follower, the world would have taken little notice of Lastman at all.

Rembrandt did not simply hide his sources. He resisted the lure of authority offered by a canonical work in order to show that he was making it on his own. We have ample evidence, from his "teaching" drawings to the great majority of his late paintings, that it was the model in the studio, not the art of the past, that Rembrandt wanted before his eyes.

The characteristic format of his late paintings—the single, half- or three-quarter-length figure which we referred to as undrawn—is also a sign of Rembrandt's resistance to canonical works of art. These paintings make the claim of being originating: their fiction is that life in the studio replaces the art of the past. They can be distinguished in this regard from the works of the other artist of the time who was notorious for painting after the live model. Caravaggio, unlike Rembrandt, flaunted canonical poses taken from the recognized Renaissance masters. Though Rembrandt knew and learned from previous artists, there is something Protestant in his unwillingness to acknowledge any authority outside of himself.[51]

III

THIS CHAPTER has aimed to show the way in which an account of Rembrandt's life leads one into his studio, and that, within his studio, work curiously revolves back on life itself. At the heart of the entire operation are the painter and his model(s). In Rembrandt's case this was a capacious category. Take a drawing of a beggar, for example (fig. 3.47).[52] The question we are accustomed to ask of such an image is whether or not it was drawn after life, by which we mean was the figure before Rembrandt's eyes when he drew it? This has been taken to mean, "did Rembrandt go out into

the streets and draw beggars?" The general conclusion is that he did not, that he was, instead (as a pair of his etchings [B. 177, 178] after Beham demonstrates) drawing from a repertory of works of art and bringing them to a new appearance of life. But what if another possibility is that the beggar was actually brought into his studio? If this were so, a beggar "after life" would, in effect, mean working after a studio model. This seems to me to have been a normal working procedure for Rembrandt: the appearance of "after life" occurs at a characteristic introduction of life into the studio. But just how would this have occurred?

Hoogstraten recounts an amusing incident, repeated by Houbraken, that took place when he and his brother were in Vienna, that offers a possible answer to this question. It seems that his brother wanted to make a picture of the denial of Peter, and he needed a plebian model for his saint. He headed out to the marketplace to find a beggar whom he could persuade to come along with him. The beggar, probably expecting a small handout, followed along without realizing what he was getting into. He arrived at the studio only to get into a terrible state over what he saw. (The engraving of an art academy by Stradanus, although exaggerated in its depiction, can serve to suggest something of what he found [fig. 3.45].) The skulls and some headless lay figures, the normal accoutrements of the painter's trade, terrified him. He thought he had been brought into the presence of Death and the Devil himself. He pleaded to be released, and it was only after much cajolery (and promise of cash) that he agreed to stay. The poor man remained, however, in a very shaken state. And so it was that he continued to display his fear and dismay when he came to serve the painter as the model for St. Peter. Hoogstraten includes this true-to-life story in his chapter on how to represent human feelings in art. And he ends his account by remarking that the frightened beggar was the perfect model: as fearful and dismayed as St. Peter himself.[53]

I take it that the beggar in Rembrandt's fine chalk drawing is one who instead firmly stood his ground. From the swagger of his stance one would gather that he refused to be put off by the new and curious surroundings into which he was brought. His appearance is different; it is a representation of life enacted in the studio.

We took up the beggar's case with the art historian's question: is he drawn after life or not? But the nature of Rembrandt's practice, the beggar serving as a model, reveals an unexpected complexity. For it is indisputable that the "life" here being drawn after is an enacted life. So the problem would seem to be not whether we con-

sider this drawing to be after life, but what Rembrandt, on the evidence of his practice considered "life" to be. And the evidence is that Rembrandt got at "real" life through attending to the acting of it in the studio.[54]

The custom has had a long life. We can compare Rembrandt's beggar to Manet's, who, far from being brought to life in the studio, was treated by Manet as an object to paint (fig. 3.48). It is precisely the full or positive sense of an individual caught performing in the studio that is absent. A similar fixity characterizes the violinist in Manet's *Old Musician*. We know that the model was the most famous gypsy in Paris, who was also well known as an artist's model. Here the suspension of life is due to Manet's casting the gypsy in a pose taken from Velázquez's *Bacchus*. Though he shared Rembrandt's affinity for the studio, Manet in such cases could be described as working against the theatricalized model. The role-playing he encouraged otherwise, gives way to painting. Historically, he was at the other end of the studio tradition: while Rembrandt in the studio held out against the established taste for art, Manet held out against the modern taste for the disorderly world outside.[55]

There is one instance which allows us to compare the way Rembrandt depicted life inside and life outside the studio. It can help to establish the point that his work normally revolved back on life as it is staged in the studio. Aside from his well-documented excursions around Amsterdam and into the countryside near-by, his depiction of some exotic animals, and the images of women and children who filled an album of his drawings, Rembrandt seldom depicted life outside his studio. A singular exception is a pair of drawings recording the lifeless body of Elsje Christiaens, suspended from a scaffolding on the Volewijk, the gallows field of Amsterdam (figs. 3.49, 3.50).[56] The judicial execution and the display of the young woman's body that followed were intended to stand as an example to the public. But Rembrandt treated it as a matter of private interest. He disregarded the landscape and the other bodies on view nearby in order to focus in and close up. He noted with extreme care the manner in which the body was suspended from the scaffold, the cut of her dress, the raised and extended right hand, perhaps the one that wielded the ax with which Elsje slew her landlady, and the weapon itself hung to one side. Having drawn her body once, he moved to the right and drew it over again. These drawings look different from other drawings by Rembrandt. They display the kind of descriptive ambition that we find in Pieter Saenredam or Jacques de Gheyn II (fig. 3.51). The object in view is still and observed. Both in leaving

the studio and in his manner of execution, Rembrandt went out of his normal artistic way to make them.

Elsje Christiaens was executed and displayed on her post early in the month of May 1664. She was the first woman to have been executed in Amsterdam in over twenty years. Given the apparently fresh state of the body, Rembrandt must have drawn Elsje within a few days of her execution. Back in his studio, Rembrandt made a painting of a fabled woman who had made a public display of her own death. There is little similarity, of course, between the two women's tales. But the *Lucretia* is evidence of what happened in the studio to Rembrandt's interest in the violent death of a woman (fig. 3.52). Lucretia is enveloped and supported, as on a broad plinth, by her voluminous gown. But for the blood which stains the pleated cloth over her breast red, the three-quarter format and figural authority is characteristic of Rembrandt's later works. The act of a person representing herself and the artist's view of this performance are the subject of the work. Indeed, it has been pointed out that the rope Lucretia pulls might be the sling used by the model in the studio to assist her in holding a pose.[57] But this is a startling painting. Rembrandt's accustomed means of theatrical disclosure, the presence of the figure and the distinctive inflection of head and hands, which in other works confirm an individual's *life* are employed to convey death. In his studio, death becomes an event: description (of Elsje) is replaced by enactment (on the part of Lucretia). It is relevant to Rembrandt's engagement with the deaths of these two women that the drawings and the painting we have been looking at were all made in the years just after Hendrickje Stoffel's death.

Recalling the case of the frightened beggar, one might ask what it took for the artist to elicit a performance such as this. I am not about to suggest that Rembrandt staged a death in the studio in order to paint it. But the painting of Lucretia sustains a fiction of enactment. This pertains as much to our sense of the viewer as it does to our sense of the action viewed. The painted Lucretia differs from the drawing of Elsje in respect to the quality of its engagement with what is seen. And the artist implicates himself in what we are given to see. It is not only in the self-portrait done in the mirror that the artist, to recall Hoogstraten's words, is performer and spectator as well. This might be said of any picture in which the labor of applying the paint is exposed as it is here. Painting itself is part of the performance that we view. But this case reveals a deeper involvement. For it was the painter's hand that stained Lucretia's breast

with blood so that he, and we, could see her dying. Her fictional suicide was the painter's act (pl. 8).

The relation revealed between painting and the mortality of the flesh is not limited to this work, nor was it Rembrandt's discovery alone. His paintings of a *Slaughtered Ox* (fig. 3.53, pl. 10), the *Child with Dead Peacocks* (fig. 3.54), the *Self-Portrait with Dead Bittern* (fig. 3.55), and the anatomies of Dr. Tulp (fig. 3.56) and Dr. Deyman (Br. 414) all relate the bodily concern basic to western Renaissance painting with death. Like Titian in the *Flaying of Marsyas* and Thomas Eakins in the *Gross Clinic*, Rembrandt in these paintings identifies the painter with the role of one—butcher, hunter, surgeon—whose hand cuts and delves into the body.[58] The juxtaposition of the man (or woman) with the lavishly displayed ruptured flesh or splayed feathers of beast or bird in the *Self-Portrait with Dead Bittern* or the *Slaughtered Ox* suggests that Rembrandt identified with both the slayer and the slain. It is further a general feature of Rembrandt's rough painting mode that it calls attention to the kinship between pigment and human flesh. A number of his later works such as the *Slaughtered Ox* and the *Civilis*, and most particularly the memorable faces in portraits and self-portraits alike, convey the specific sense that what is built up out of pigment so handled is simultaneously in a state of decay (pls. 4, 10). It is the dark side of the master's touch.

In Spain at the time, passages of rough paint were referred to with the word *borrón* (meaning roughly "blotch" or "blot"—*borrar* meant to erase, a *borrador* is a rough draft of a text). The overtones were of something messy that was, if so applied, a blot or blemish on the honor of a person or on the beauty of a painting. In a play of Lope de Vega's, a married woman, desired by a King, burns her flesh prior to their assignation. As the King approaches, she discards her clothes to reveal her disfigured flesh and he exclaims, "Oh sweet hiding of the sinister event! O image by the skillful painter, that from up close is a *borrón*." Rembrandt can be described as one of those painters who did not seek to hide the sinister event. His later paintings bring out the blemish (violation?) inherent in an image of human flesh formed out of nonrepresentational and nonrational marks of paint.[59]

The characteristic look and format favored by Rembrandt in his later works was well known and remarked on by his death. Abraham Bruegel, a late member of the famous Flemish family of painters, acted as an agent for Ruffo, the Sicilian collector who had ordered the *Aristotle* from Rembrandt. In a letter written in 1670 he

described Rembrandt to his employer as a painter of half-length, curiously garbed figures lit only at the tip of the nose and otherwise lost in shadows.[60] This is a good if unsympathetic account. But rather than being produced as willful rejections of accepted artistic norms, such works are Rembrandt's representations of his studio practice.

In the first chapter I considered the tangible, painted presence of Rembrandt's figures as the product of a desire to create a substantial object out of paint. But there is more to their making than that. Though it is common parlance to describe Rembrandt's late figures as emerging from shadows, the reverse was probably more true. Rembrandt's focus of attention was evidently on the face and collar (and to a lesser extent the hands) of his sitters. This is what the eye on his account focuses on and takes in during a concentrated glance; what is peripheral to this is left indistinct. It is the figure, not the space around it, that is his prime concern. What began within a more traditional form of portraiture in the 1630s came to characterize all his works by the 1650s.[61] It is a record of a certain kind of attention. Ruskin once recommended that the ideal shape for a painting would be round—not because of the perfection of the circle, but because it comes closest to the compass of a gaze.[62] For Ruskin as for Rembrandt, the frame was not a window, or a ground-plan for a composition, but a marker located in relationship to the limits of the gaze. The peripheral area—be it the undefined surface around Trip, or the grotto suggested behind the wading woman in the National Gallery, the cloth behind Bathsheba, or the wall hung with painting behind the paired portraits in New York—is secondary (figs. 3.65, 3.66). The scale of Rembrandt's later works, the fact that the figures are life-size or just under, is essential to their visual effect. The act of a person representing himself and the artist's view of this self-presentation are made the subject of each work.

In an etching of c. 1639 known as *The Artist Drawing from a Model,* we are shown the interior of the studio (fig. 3.7). The disarray of the workplace is evident: clothing, armor, furniture, and a bit of sculpture crowd a scene in the midst of which artist and model are face to face. The clutter of objects is uncharacteristic of Rembrandt's works, and our view—an unusual one from behind the model looking back to the artist doubled over at his task—emphasizes what normally was kept invisible. The blank canvas behind the artist and the uneven finish of the plate call attention in different ways to that concentration and transformation necessary to the making of an image. The neutral, undefined surroundings repre-

sented by the tell-tale fade-out around the figure in Rembrandt's late paintings distance the sitter from the real activity of the studio and transform it into a place for the presentation of his act.

Nineteenth-century photographic practice is evidence that Rembrandt continued to be understood in this way. Rembrandt's absent but nevertheless implicit studio setting—removed from the world and concentrating on the individual portrayed—had a great appeal for portrait photographers of the nineteenth century. With this description, I think we can see the practical as well as the visual appeal that Rembrandt had. The "look" of his works was all the rage, and all manner of equipment and effects were dubbed with his name: the Rembrandt portrait; Rembrandt lighting; the Rembrandt process (of printing); Rembrandt accessories of all kinds. And his chiaroscuro technique was recommended as a prime compositional device for a medium with only a limited means at its disposal to hold the viewer's eye. But it is also the staging procedures that led up to the taking of the picture that put one in mind of Rembrandt. The problem was how to get mood into a mechanical image made directly after life. Photographers staged their portraits: sitters were led through reception rooms hung with photographs of past sitters, and finally entered what was known as the operating room, where the portrait was made. Photographers orchestrated the staging of life that was implicit in Rembrandt's studio.[63]

All painting in the seventeenth century was a studio affair. Every painting was a studio production. This in itself was nothing new. But it was at this time that painters addressed themselves to the situation: the relationship between the painter and his model(s) in an interior space was made a subject of art. Though we have a good number of drawings by both Rembrandt and his assistants recording work in the studio, and a number of self-portraits in various media of the artist at work, Rembrandt never made a major painting on the order of Vermeer's *Art of Painting* or Velázquez's *Las Meninas*. Instead, the studio situation is present in the form and in the manner of his late paintings. While Velázquez played host to his royal patrons in the palace, and Vermeer entertained a young woman in domestic surroundings as part of a rich and elusive visible world, Rembrandt painted as if he were the director of his own theater company. His late works are the equivalent of closet drama rendered in the medium of paint.

IV

WE HAVE CONSIDERED the studio as enabling images of a certain kind. But one of the ways in which the studio was enabling for Rembrandt is that in it life, and art, could be brought under his control. It was the domain where he exercised rule. The *Claudius Civilis* is an interesting case in point (figs. 3.59, 3.60). Modern scholars have generally mourned the destruction of this major commission. The implication is that when the huge painting was removed from the new Town Hall, Rembrandt and we, his public, lost the great, international, monumental work that he had it in him to make. (Originally nineteen feet square, what remains of the work today is six by ten feet.)[64] Rembrandt's commission had been pictorially to stage the oath given by the Batavians to follow their leader Civilis in a revolt against the Romans. In its original state, as we know it in a small drawing, the Raphaelesque setting evoked an art which claimed to reflect an order inherent in nature as well as in society (figs. 3.57, 3.59). In Raphael's *School of Athens*, Plato and Aristotle laid claim to knowledge of heaven and of earth in an architectural setting like this. But what did Rembrandt's reworking involve? By eliminating the setting surrounding the figures, cutting down to the table and concentrating on the men participating in the oath, Rembrandt made the *Civilis* more like his other paintings in format and in conception. The dimension of public order—in the state as in art—was disposed of. It was cut away with the stripping away of the setting. (He had earlier—and to similar effect—trimmed Leonardo's *Last Supper*, in copying an engraving after it, down to a crowded scene at table [fig. 3.58].) We can imagine Rembrandt directing the performance of this reduced scene by the studio company of actors we have spoken of. There is no question that removed from the lunette, and thus no longer high above the viewer, the painting had a new kind of visibility. In cutting and reworking the work as he did, Rembrandt replaced the embodiment of the state with the body of the painting itself. The work of the artist in the studio replaced the affairs of state. And the mutilated work, its laboriously reworked pigments obvious at close view, was one that was back under Rembrandt's control (pl. 4).[65]

Rembrandt extended this control over the studio as his domain even to those who sat to him for their portraits. As we saw in the case of *The Jewish Bride* (fig. 3.61), Rembrandt's characteristic handling blurs the distinction between the portrayal of his contemporaries and the representation of historical figures. But we might put

this in different terms and say that Rembrandt blurs the distinction between those who pay to sit and those models who are paid. This sharpens our sense of Rembrandt's exercise of authority in the studio. Let us say that in the case of *The Jewish Bride* we cannot tell the nature of the contract: were this couple paid to serve as Rembrandt's models or did they pay him to paint them? One way of putting the difference between Rembrandt's works, particularly the late ones, and those by other Dutch artists, is that Rembrandt withholds this information. Historians of art have tended to think of Rembrandt as blurring genres with the effect of "elevating," in the sense of making more significant or universal, the couple in *The Jewish Bride*. He makes a portrait more than a portrait by elevating the genre. But this *effect* of universality is achieved by masking or hiding the economic and social basis of the transaction between the painter and his sitters. What we have come to treat as a problem in interpretation was rooted in Rembrandt's practice.

Compare this pair to another: the formal stance, carefully described features, and position in the landscape make clear that despite their exotic dress the couple in a painting by Bol are a Dutch couple posing for their portrait (fig. 3.62). In fact, they are Bol's future second wife and her first husband, who were identified in the inventory of her possessions as appearing here in the guise of the biblical couple Isaac and Rebecca.[66] The comparison with Rembrandt's *Jewish Bride* is an apt one. It is clear that this couple paid Bol to paint them. They sit, or stand, but are not made to perform. Many of Rembrandt's late works share a common evocativeness, a kind of painted immediacy combined with a calculated indeterminacy of clothing and setting—one thinks of the *Family Group* in Braunschweig (fig. 3.63) or the *Man with a Magnifying Glass* and the *Lady with a Pink* in New York (figs. 3.65, 3.66). Dress, gesture, and often the absence of any distinctive designation of class are combined with the effect that the sitters do not look as if they came and paid Rembrandt to paint their portraits. They do not look as if they were his or any other painter's patrons. One might say that rather than serving them, Rembrandt exercises his authority over them.

It was not only in the look of his works, but in the nature of his studio that Rembrandt was distinctive. The interest is in how these two fit together. Other artists besides Rembrandt boasted of distinctive styles—both the format and the finish of the portraits by Ter Borch fit this description (fig. 3.68). But what distinguishes Rembrandt is that rather than accommodating to his patrons' life-style, as Ter Borch's self-portrait shows that he did, Rembrandt saw to it

by the end that his patrons accommodated to his studio practices. And there is one further point: not only do his works deny his economic interest in his sitters, the image in which he casts his sitters is his own.

Let us consider the look of Rembrandt's late figures. If we compare Bol's couple once more to Rembrandt's *Jewish Bride,* or Nicolaes Maes's portrait of Jacob Trip to Rembrandt's (figs. 3.69, 3.70), who is to say that the student is not more skillful than the teacher in showing us how particular sitters looked? Rembrandt did this, too, on occasion, most particularly in a number of portraits in the 1630s (fig. 3.67). But we think of Rembrandt as being true to the inner nature of his sitters: something there was within them that he found out and revealed. Though in each instance we think of it as unique, the individuality is something that his late portrayals have in common. One might say that it is a uniqueness shared. But is this aura, this suggestion of individuality, something that Rembrandt found in his sitters or something that he imposed on them? We have seen that they are treated just as his models are. They leave behind, outside the studio, their social position and are transformed. We might consider the *Aristotle* in these terms. If we did not have the evidence we have about the commissioning of this painting and, further, that this man served repeatedly as a model in Rembrandt's studio, we might well take it as a portrait in the studio mode of *The Jewish Bride.*[67] There is no compelling evidence to suggest that the Kassel *Jacob Blessing* is a family portrait, but here, too, the aura of the work is consistent with Rembrandt's representation of his sitters (fig. 3.64).[68] Though they pay Rembrandt for his services, Rembrandt treats his sitters as he treats his models, which is to say that he treats them as he came to treat himself.[69]

For surely Rembrandt, particularly as we see him in his late self-portraits, also has a part in the uniqueness shared. Indeed there is a sense in which his sitters are extensions of himself, or extensions of his pictorial positing of an autonomous self. The scale and format of the *Self-Portrait* in the Frick Collection, three-quarters, almost life-size, as well as the dress, make it indistinguishable from Rembrandt's portraits of others at the time: compare Rembrandt to Jacob Trip, or Trip to Rembrandt (figs. 3.70, 3.71). The *Self-Portrait* is paradigmatic in this.[70]

The effect of singularity and of individuality given off by Rembrandt's works is a product of this master's domination of the world he brought into the studio. Retirement to rule, and the delight mixed with the horror in the discovery that the self alone is what

one rules, is a familiar scenario from Prospero on his island to Monet in his garden. To these examples I would add Rembrandt in his studio. The nineteenth century credited Rembrandt with being uniquely in touch with something true about the individual human state. I would put it differently. It is something stranger and more unsettling. Rembrandt was not the discoverer, but one of the inventors of that individual state. And so his late works became a touchstone for what western culture, from his day until our own, has taken as the irreducible uniqueness of the individual.

4

"FREEDOM, ART,

AND MONEY"

IN PREVIOUS chapters we have considered Rembrandt's manner of painting, of representing the model, and of conducting his career, all within the confines of his studio walls. My argument has been that the distinctive works which Rembrandt came to produce were related to his sense of and deployment of life within the studio. But the art he made and the life he pursued also took him outside the studio, and I want now to suggest a larger context for Rembrandt's studio operation and for his life. He was not only a man of the studio but also a man of the market. He had a "propensity to truck, barter and exhange," in Adam Smith's famous phrase, and to make works suitable to such transactions. As a master in the studio he made himself a free individual, not beholden to patrons. But he was beholden instead to the market—or more specifically to the identification that he made between two representations of value, art and money. Descamps put it well when he wrote of Rembrandt that he loved only three things: his freedom, art, and money.[1] The relationship or, given the complexity of the mix, the relationships among the three seem self-evident because they are so basic to our culture. But my interest lies in showing that the distinctiveness of Rembrandt's artistic production lies in his originating investment in this system.

This chapter will consider three points: evidence as to Rembrandt's behavior; the market as the frame; the extent to which this gives a new edge to our viewing of the paintings. It will treat the market economy historically—as providing conditions for the painter's activities—and analogically—as the painter took it to offer models or definitions of self and art. There is, in the three sections to follow, an overlap among these points.

I

A CONVENIENT starting place is the relationship between artist and model/sitter represented by the kind of painting with which we ended the last chapter (fig. 4.1). In a work such as *The Jewish Bride*, Rembrandt blurred the distinction between sitter and model, and was not agreeing to serve his patrons. Rembrandt imposed his own image of self—his distinctive facture and tone—on those who sat to him. This, I concluded, was the exercise of the authority that Rembrandt claimed for himself as an individual in the studio. But now let us follow the evidence in another direction and consider the sense in which in the manner of his paintings, as well as in the manner of treating sitters, Rembrandt was in fact refusing to cater to the patronage system.

The status of the artist and his art was a lively social and economic issue in Holland around midcentury. Professional status was very much on the mind of Dutch artists at just this time. Sociologists would call what was happening "professionalization."[2] One aspect of the professionalization of a vocation is the institutionalization of bonds between practitioners, the claim to certain common skills, and the upholding of standards of competence. Academies of various kinds were one means by which professionalization was achieved by (or for) artists in Renaissance Europe. There was much activity towards this end in the Netherlands during Rembrandt's lifetime: a short-lived Brotherhood of Painters brought artists and writers together in Amsterdam in 1653; a confrerie of artists replaced the Guild of St. Luke in The Hague in the 1650s, with Jan Lievens, Rembrandt's old friend, as one of its founding members; this was matched in the literary sphere by the founding of the classicizing association, Nil Volentibus Arduum, in Amsterdam in 1669. Art historians have usually considered such professionalization to be a means of achieving freedom for the artist and his art, freedom from the restrictions of craft guilds. Much attention has been paid to the artistic ideals of such groups. But these changes were not accompanied by more power in their relationship to clients. The type of patronage in which the patron/buyer encouraged the professional to identify with him and hence serve him socially characteristically flourished in Europe along with the new academies. Vasari, for example, a founder of the artists' academy in Florence, had favored an artist on the model of the educated courtier. Wives and the household, which had played such a central role in Dutch art, were not part of this scheme. Vasari warns artists not to be distracted or

driven by wives, who on a number of occasions in the *Lives* are ac-
cused of ruining a husband's career. We can see marks of the social
identification of the artist with the patron-buyer by comparing Bol's
Self-Portrait with his portrayal of other sitters: he clearly fashioned
his own image after theirs (figs. 4.2, 4.3). And the stance taken in
his art was confirmed in his rich marriage, which ended his profes-
sional career as a painter.

Rembrandt was not a joiner by nature. But his absence from the
two banquets of the short-lived Amsterdam Brotherhood of Paint-
ing in 1653 and 1654, where artists hobnobbed with powerful men
from the city, is worth noting. The fact that Rembrandt seems to
have had no interest in the new organizations that, as one of their
effects, elevated the artist into the patrons' society, is consistent
with his unwillingness to identify with his well-born sitters. We
might contrast him in this with another former student, Govert
Flinck. Flinck did attend the banquet, got on well with prominent
patrons, including, on occasion, royalty, and just before his early
death was rewarded with the commission for seven major works in
the Town Hall. Even the design of Flinck's house took into account
the necessity of entertaining patrons in their accustomed style. In
the manner of Rubens, he built a sky-lit studio (a new-fashioned
"*schilderzaal*"!) on to his house, in which a collection of objects
very much like Rembrandt's was displayed for the delectation of vis-
iting patrons. Objects which Rembrandt accumulated for studio use
and for dealing on the market, Flinck used to his social advantage.[3]

The only "academy" which Rembrandt ever had anything to do
with was Uylenburgh's workshop, whose only claim to the name was
Baldinucci's reference to it as the "famosa Accademia di Eeulen-
borg."[4] It was, as we noted earlier, a teaching studio and a shop
combined. Uylenburgh's operation was looked down on at the time
as being what today would be called a sweat shop. Time spent work-
ing there was referred to on at least one occasion as time spent "in
the galleys" (the reference being to the ships manned by convicts
that sailed out of Marseille).[5] In its production of art and in its frank
interest in merchandising (and above all in its mixture of the two),
Uylenburgh's academy had nothing to do with the upwardly mobile
social ambition that marked the various new professional associa-
tions of artists. Flinck followed Rembrandt at Uylenburgh's, but his
later career shows, as Rembrandt's does not, that he saw it as some-
thing to rise above. It has been noted that Rembrandt's production
of paintings was at its highest level at two times in his career: in
1634, when still contracted to Uylenburgh, and again in 1661 after

declaring bankruptcy, when for legal reasons he was employed in a business run by his common-law wife and son. One suspects that producing for Uylenburgh, or as he did later in the family business for the market, was for Rembrandt a welcome freedom from dealing directly with patrons. He was most productive, in other words, when he could not deal with patrons.[6]

There is rich anecdotal testimony, and in recent years clearer archival evidence, that Rembrandt got on badly with patrons. Houbraken suggests that there was a willful element in his behavior when he describes the difficult situation of clients: "one must beg him and still add money."[7] It is as if Rembrandt wanted to bring prospective patrons to their knees as part of his payment. The incidents can be grouped under three main headings. (1) He required unacceptably long hours from sitters: Baldinucci reports that this made people hestitate in coming to him (though Houbraken attributes delays to the number of clients!). (2) He delayed in finishing works: Prince Frederick Henry waited six years for the completion of the Passion Series, which Rembrandt finished only when he needed money to buy his house; Herman Becker was in court over the long-undelivered *Juno*. (3) He delivered works that were found unacceptable either because they were not likenesses of the sitter (legal action was mounted against Rembrandt about a portrait of a girl by one d'Andrada on this account) or were imperfect in other ways: the Burgomaster of Amsterdam returned the *Claudius Civilis* for reworking; the Burgomaster de Graeff is reported to have refused to pay for his portrait; Ruffo, the Rembrandt enthusiast in Sicily who commissioned the *Aristotle,* returned an *Alexander* as being put together out of disparate pieces of canvas, and Rembrandt never responded to his request for designs for an additional six paintings.[8]

Rembrandt's pictorial reflection on the role of the client or interested viewer is the subject of a drawing now in New York (fig. 4.5). It differs from those images of the time which were designed to put a client's or patron's attention to art in a favorable light. A characteristic format depicted the artist at his easel in the studio entertaining an admiring visitor. In an engraving by Abraham Bosse, the situation of the noble court artist is played off against that of the vulgar artist, who, in an engraving held up by the assistant at the right, is depicted working to support his family (fig. 4.4). Noble art practiced at court replaces drudgery at home. The court and the family are themes, and the choice between them a stance, that Rembrandt did not take up either in his life or in his art. Rather than courting

patrons, as other artists did, Rembrandt took to castigating them: the painting in view in his drawing is surrounded by people listening to the ass-eared man with pipe at the left. (Could the man ostentatiously shitting and wiping his seat at the right—a traditional figure from peasant *kermis* scenes—be a joke against those who compared Rembrandt's paint to dung?) Instead of being a counterattack by a man on the defense as Schwartz has suggested, Rembrandt's drawing enthusiastically enters the fray.[9]

In the case of Jan Six there is a unique pictorial record of Rembrandt's relationship with a client (figs. 4.6, 4.7, 4.8). Rembrandt's first contact with the young merchant, erstwhile writer, patron of the arts, and future burgomaster, must have been about 1647 when he etched his portrait. In the following year, Rembrandt etched an illustration for the printed edition of Six's play *Medea* (B. 112—the etching is, it has been noted, of a scene which is not in the text), which was directed in performance by another Rembrandt supporter, the playwright Jan Vos. In 1652 Rembrandt entered two drawings (of Homer and Minerva) into the Six family album and in the following year contracted to sell Six three of his paintings from the thirties, one of which was the *Saskia* now in Kassel (fig. 2.36). Six loaned Rembrandt one thousand guilders in 1653, and in 1654 Rembrandt painted the portrait which still hangs today in the collection of the Six family in Amsterdam. The portrait seems to have marked the end of the friendship. When Six married in 1656, he asked Flinck, not Rembrandt, to paint his bride, and in the same year, as a further break in their relationship, he transferred Rembrandt's debt to another party. The friendship and the patronage were over.[10] Descamps writes that Six tried in vain to get Rembrandt out into society.[11] This impression of Rembrandt is correct. Again there is the contrast between Rembrandt and Govert Flinck, to whom Six subsequently turned and whom he must have considered to be satisfactory in this worldly respect.

But if Rembrandt was intransigent, he seems to have met his match in Six. Surviving drawings reveal that the etched portrait of Six in his study began as an informal scene—Six by a window, his dog leaping up at his side—and ended with the image of the contemplative scholar, turned away from the window, lost in his reading (figs. 4.6, 4.7). Rembrandt was in the habit of reworking his etched portraits through a number of states. But this record of changes made even prior to beginning to etch is unusual. Was it perhaps Six who insisted on them? (And was it Six's insistence that led Rembrandt, when he had finished, to hand over to him the etched plate along

with the etching? At any rate, the plate for the etched portrait of Six in the possession of the Six family today is one of the few plates that Rembrandt relinquished in his lifetime.)[12] We don't know the answer. But Six's intransigence in the face of Rembrandt's demands is made powerfully visible, and indeed played a determining role, in Rembrandt's painted portrait of him, which is an anomaly among his later portraits (fig. 4.8). For all its power, it looks different from the rest. It is executed with a brilliance of brushwork achieved with an unaccustomed economy which must betoken an unaccustomed speed of completion. A sign of this is the consistent thinness of the paint surface. The series of horizontal brushstrokes which mark the fastenings of the coat are rendered in an almost transparent yellow ochre with a bit of pigment concentrated along an edge. Even the area which combines the most concentrated action and painterly attention—the hand which, having pulled on one glove, is gripping the other—lacks the characteristic thickness of paint build-up. Six appears in a favorite outfit of his. (We see it again, though not to the same advantage, in the small portrait of him attributed to Ter Borch that hangs next to Rembrandt's in the Six Collection in Amsterdam.) He turns away slightly. His coat is slung over his shoulder and with a certain purposefulness he is putting on his gloves to go. Let us suppose that he was unwilling to give the time necessary to sit for Rembrandt. His tilted head and his shadowed eyes could suggest inwardness or withdrawal. But this being Rembrandt's studio, I think they register rather that this is a sitter who is unwilling to play the part assigned, who is unwilling to do what is required to serve as Rembrandt's model. Six refused to be made over in Rembrandt's image. The speed of painterly execution and the imminent departure of the sitter dressed in his own street clothes represent Six as a sitter who got away. But in an important sense he did not. Rembrandt recorded him in the very act, remarkably adapting his manner to that of Six. Though Six tried to make his escape, it is Rembrandt's representation of him by which he is known.[13]

How are we to assess Rembrandt's behavior? Gary Schwartz's account is one of great opportunities lost: how a young painter, with connections to the court and then to Amsterdam's powerful and wealthy, went wrong after the 1630s. But that is to privilege the possibility of a particular kind of career at the expense of art. There came to be a method in what has appeared to be Rembrandt's madness or bad behavior. And to get at that, we can try to describe Rembrandt's behavior in terms of the marketplace. Let us begin by considering what kinds of marketing options were available to artists at

the time. We shall take up some materials from the previous chapter, but here with an emphasis on the marketing of art rather than the career of the artist.

It has long been said—our sources go back to the seventeenth century itself—that what was remarkable about the Dutch taste for paintings is that the production and demand were so large and marketing so widespread. Producing for the open market was the rule rather than exception for the great majority of Dutch artists in Rembrandt's day. Lacking land, wrote one traveler, everyone in the Netherlands invested in pictures and (somewhat contradictorily for their status as a commodity) pictures were cheap. They were marketed at fairs (though also by painters directly), so that the butcher, the baker, and the peasant could own them. Inventories of households, both urban and peasant, commonly list paintings valued at well under ten guilders and bear out the point about cheapness and popularity, though not, given the low cost, the point about investment. If we look to the legacy of Dutch paintings that survive, their sheer numbers and their production by a host of specialists in specific types (peasant, landscape, still-life, and so on) fit this account of a general market for pictures—though we are justly astounded at the distinction of some of the works turned out in such mass market conditions.[14]

We know there were exceptions to this common production and marketing situation. There were paintings ordered, for example, by the court, by burgomasters for town halls, and by regents of various organizations for their buildings. Families ordered portraits for their domestic walls. Artists found alternatives to producing for the open market. Lievens, Bol, and Flinck each worked himself into a circle of moderately dependable patrons. It appears also that a number of artists avoided the open market by contracting the right of first refusal with a single buyer over works by their hand. This is the recipe for success recommended by Hoogstraten, who counseled the painter that, whatever the merit of his work, he must still seek Maecenases, and through them get the attention of princes, kings, and prosperous merchants.[15] Rembrandt's first pupil, Gerard Dou (1613–75), had an agreement with Pieter Spiering Silvercron, a Swedish representative in The Hague, who paid him 1,000 guilders for the right of first refusal and then, in addition, paid him the extraordinary price of between 600 and 1,000 guilders for each work he chose to send home to Queen Christina. After Spiering's departure, Dou picked up a home-town Maecenas who publicly exhibited the twenty-seven Dous in his own collection. Though Dou's

works eventually fetched enormous prices from European princes (30,000 guilders is the reported price for one), he still calculated the fees for his meticulously worked paintings in the established guild manner, by hours of work; and he is reported to have refused an English court post when it was offered him (fig. 1.21). Dou's leading student, Frans Mieris (1635–81), had a similar career: he refused a court post in Vienna with a retainer of 2,500 guilders per year when it was offered to him, though he did accept a commission for a self-portrait from the Medici Grand-Duke. He also was taken up by a local patron whom Houbraken refers to as his Maecenas. He took an active part in the running of the Leiden Guild of St. Luke. A significant difference from Dou's case was Mieris's lack of economic success: he never owned his own house, and like a number of Dutch painters he ended his life in debt and apparently in drink. With the recent discovery that Jan Vermeer also had a wealthy home-town Maecenas who bought up a good number of his works, we seem to have an alternative to producing for the market, on the one hand, and for a series of individual patrons and commissions on the one other.[16]

The culmination of this kind of production for a Maecenas is to be found in the career of Adriaen van der Werff (1659–1722), who, in the year before his death, was hailed by Houbraken as the greatest of all Dutch painters (fig. 4.16). Although he remained in his home town of Rotterdam, Van der Werff, unlike his predecessors, did accept a court post when it was offered him by the Elector Johann Wilhelm von der Pfalz of Düsseldorf. He eventually received a gold chain, was awarded the title of Chevalier, and changed the form of his signature to mark the honor. Due to the preservation of the artist's papers which include detailed studio records, we have exceptional access to many details about his production and his sales. During his employment by the Düsseldorf prince from 1697 until 1716, Van der Werff was paid a base stipend of 4,000 guilders for the six months of each year he worked for the court. An additional fee was paid for each painting, the cost of which was figured on the traditional basis of the time Van der Werff spent at work on it. Though he adjusted subject matter to the taste of the court (portraits are phased out in favor of history paintings), the court had a taste for Van der Werff's "*fijn*" Dutch manner. Studio documents list the cost assessed for paintings by the number of weeks that Adriaen, assisted by his brother, spent on each. The per diem pay was high (forty-five guilders), the time spent on each picture long (ten to nineteen weeks was not unusual for one work), and the out-

put small (six paintings was the most in a year). Van der Werff completed only 38 paintings for the Kurfürst between 1697 and 1716, and only 156 of his works are known today. Like his *Self-Portrait*, Van der Werff's life and art exemplify the meeting of bourgeoisie and court in the minds and in the taste of the time.[17]

We need pursue the evidence no further to say that Rembrandt did not conduct himself in this manner. A minor but highly indicative point is that though Rembrandt was an ambitious artist with a large workshop, he could not have kept the kind of record of specific works produced, paid for according to time spent, and delivered to a patron, that we have from the studio of Adriaen van der Werff. While he turned against the patronage system, he did not embrace the market in its traditional form but rather felt his way towards finding a place for art in the operations of the developing capitalist marketplace. Rembrandt's is a story of debts undertaken and loans extended, which circulated as pieces of paper representing the works of art or the money in question. He was always in want of money and willing to offer the promise of paintings or etchings as payment of his debt. In a note on the back of one of his drawings (fig. 4.15), Rembrandt considers offering to finish up two works for Christoffel Thysz, presumably against the outstanding portion of the debt he owed him for his house; while still not free of this debt, in December 1655 when he is holding the first sale of his possessions (perhaps to pay it off), Rembrandt started negotiations to buy another house with the promise of payment in cash as well as in paintings and etchings (including an etched portrait equal to the quality of that of Jan Six) to one Van Cattenburgh, who had been himself in debt to Rembrandt but two years before.[18]

Some clients apparently concluded that one way to assure delivery was to put Rembrandt in their debt. There was therefore what can be described as a small but lively market in Rembrandt's promissory notes, which, given the uncertainty of payment and availability of a painting by Rembrandt, involved the same speculative spirit which the Dutch exhibited in, say, tulips or the Amsterdam bourse.[19] In 1656, Jan Six, for example, at the end of their friendship, ceded Rembrandt's 1,000-guilder debt to him to one Gerbrand Ornia, who, at the time of Rembrandt's declaration of bankruptcy, got the painter and art dealer Lodewijk van Ludick, a guarantor of the original Six loan, to take it over. By then interest had increased the original value of the loan to 1,200 guilders. Rembrandt promised van Ludick one-quarter of what he would receive from the *Claudius Civilis* and in addition one-quarter of what he would

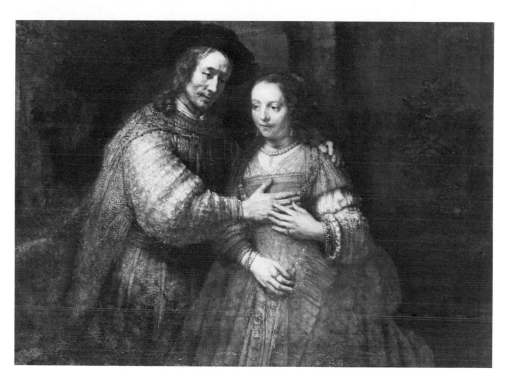

4.1. Rembrandt, *The Jewish Bride*. By courtesy of the Rijksmuseum-Stichting, Amsterdam.

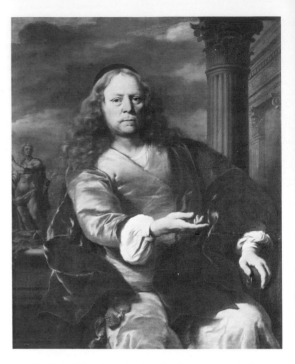

4.2. Ferdinand Bol, *Portrait of a Man*. By courtesy of the
Rijksmuseum-Stichting, Amsterdam.

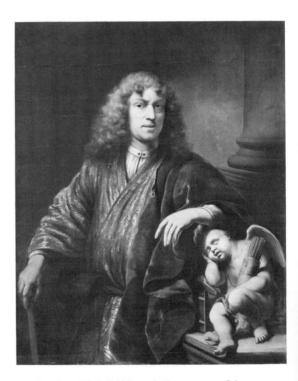

4.3. Ferdinand Bol, *Self-Portrait*. By courtesy of the
Rijksmuseum-Stichting, Amsterdam.

4.4. Abraham Bosse, *The Painter's Studio*; engraving.

4.5. Rembrandt, *Satire on Art Criticism*; Ben. A35a. Metropolitan Museum of Art, New York.
The Robert Lehman Collection, 1975 (1975.1.799).

4.6. Rembrandt, *Jan Six*; Ben. 767. Collection Six, Amsterdam.

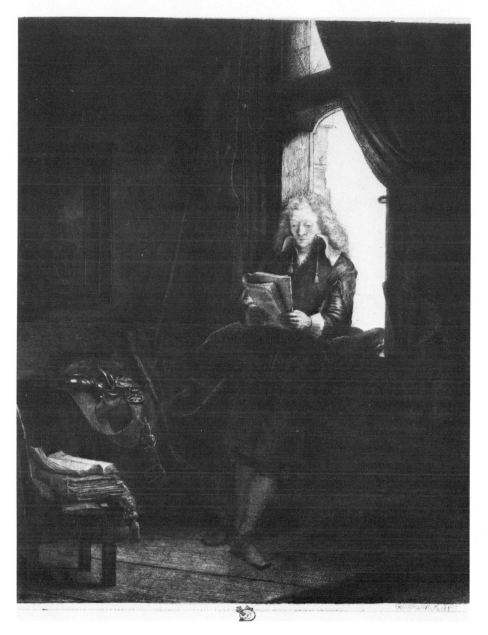

4.7. Rembrandt, *Jan Six*, 1647; etching; B. 285, II. By courtesy of the Trustees of the British Museum, London.

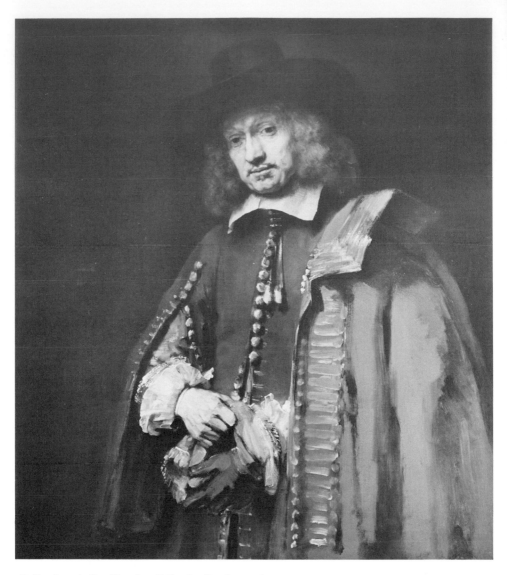

4.8. Rembrandt, *Jan Six*, 1654. Collection Six, Amsterdam.

4.9. Rembrandt, *Baldassare Castiglione*, after Raphael, 1639; Ben. 451. Graphische Sammlung Albertina, Vienna.

4.10. Rembrandt, *Christ Preaching* ("The hundred-guilder print"); B. 74, I. By courtesy of the Trustees of the British Museum, London.

4.11. Rembrandt, *The Holy Family*, 1646. Gemäldegalerie, Staatliche Kunstsammlungen, Kassel.

4.12. Rembrandt, *The Money-Changer* (The Rich Man?), 1627. Gemäldegalerie, Staatliche Museen Preussischer Kulturbesitz, Berlin (West).

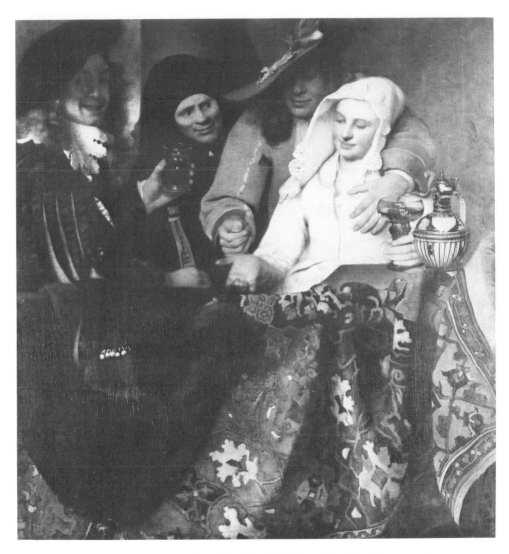

4.13. Jan Vermeer, *The Procuress*, 1656. Gemäldegalerie Alte Meister, Staatliche Kunstsammlungen, Dresden.

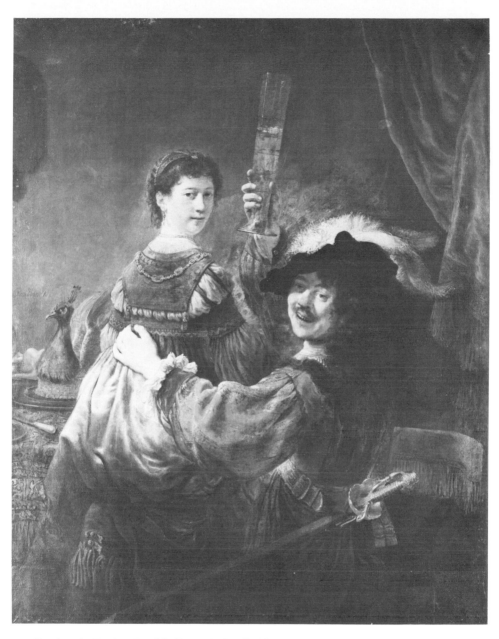

4.14. Rembrandt, *Rembrandt and Saskia* (as the Prodigal Son). Gemäldegalerie Alte Meister, Staatliche Kunstsammlungen, Dresden.

4.15. Rembrandt, *A Child Being Taught to Walk*; Ben. 1169. By courtesy of the Trustees of the British Museum, London.

4.16. Adriaen van der Werff, *Self-Portrait with His Wife and Daughter*, 1699. By courtesy of the Rijksmuseum-Stichting, Amsterdam.

4.17. Rembrandt, *Self-Portrait Drawing by a Window*, 1648; B. 22, II (actual size). By courtesy of the British Museum, London.

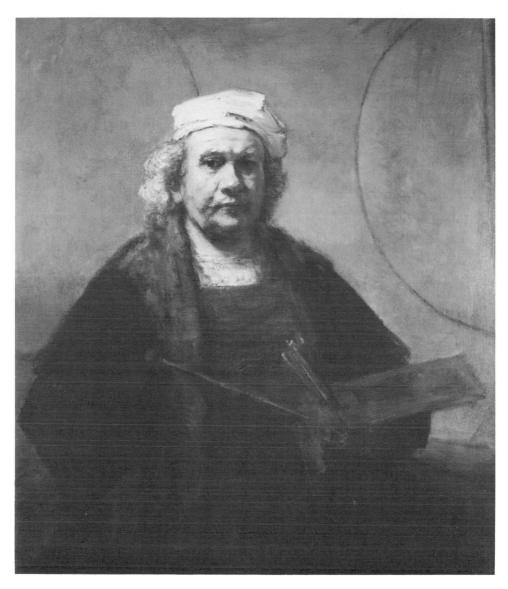

4.18. Rembrandt, *Self-Portrait*. The Iveagh Bequest, Kenwood (English Heritage), London.

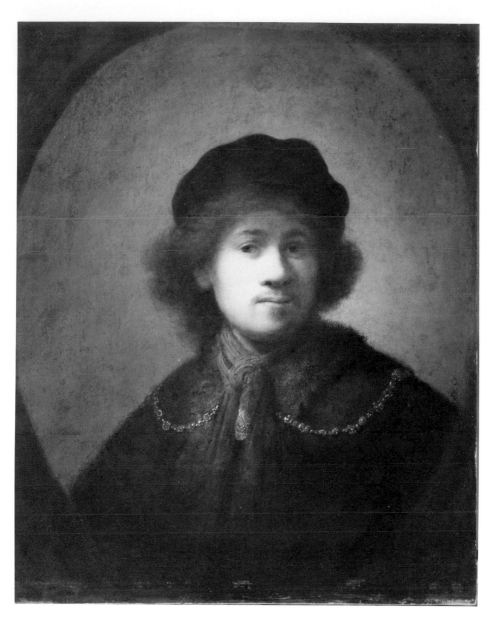

4.19. Rembrandt, *Self-Portrait*. Walker Art Gallery, Liverpool.

4.20. Rembrandt, *Self-Portrait*, 1640. By courtesy of the Trustees of the National Gallery, London.

4.21. Jan Lievens, *Rembrandt*. Rijksmuseum, Amsterdam, on loan from Daanm Cevat.

4.22. Govert Flinck, *Rembrandt*. By courtesy of the Rijksmuseum-Stichting, Amsterdam.

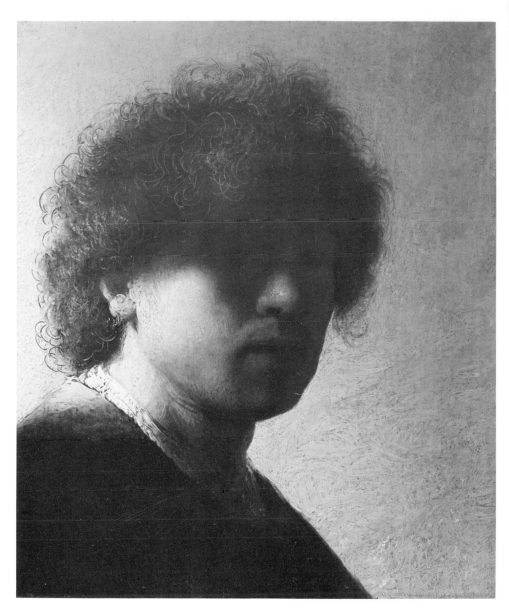

4.23. Rembrandt, *Self-Portrait*. By courtesy of the Rijksmuseum-Stichting, Amsterdam.

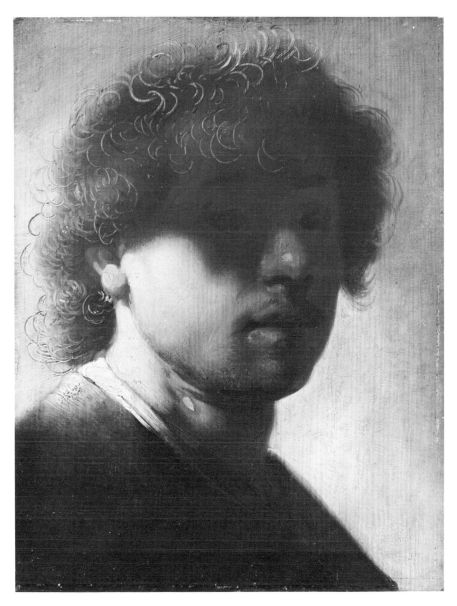

4.24. Anonymous, copy after Rembrandt, *Self-Portrait*. Gemäldegalerie, Staatliche Kunstsammlungen, Kassel.

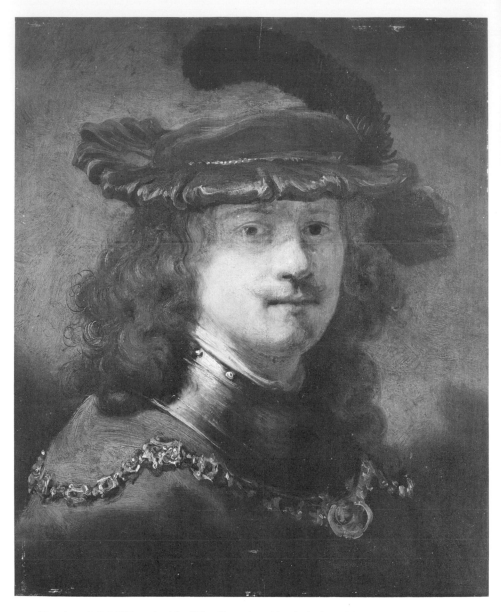

4.25. "Rembrandt," *Self-Portrait with a Velvet Beret*. Gemäldegalerie, Staatliche Museen Preussischer Kulturbesitz, Berlin (West).

4.26. "Rembrandt" (or eigh-
teenth-century fraud?), *Self-
Portrait*. National Gallery of
Art, Washington. The Widener
Collection (1942.9.70).

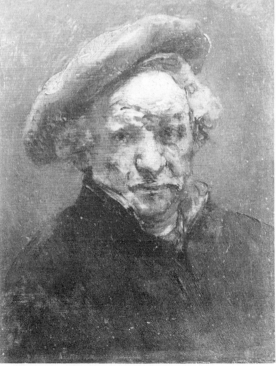

4.27. "Rembrandt" (or fraud?),
Self-Portrait. Musée Granet,
Palais de Malte, Aix-en-
Provence. Photo Bernard
Terlay.

4.28. Sir Joshua Reynolds, *Self-Portrait Shading the Eyes*. National Portrait Gallery, London.

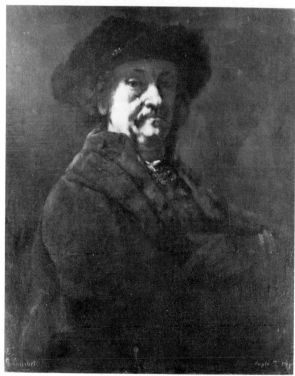

4.29. Gustave Courbet, *Copy of a Self-Portrait by Rembrandt*. Musée des Beaux-Arts et d'Archéologie, Besançon.

4.30. Picasso, *The Young Painter*, 14 April 1972. Musée Picasso, Paris. Photo Musées Nationaux.

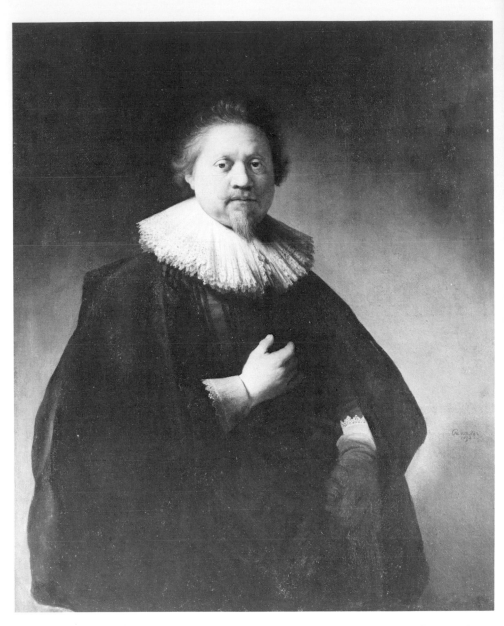

4.31. "Rembrandt," *Portrait of a Man*. Metropolitan Museum of Art, New York. Bequest of Mrs. H. O. Havemeyer, 1929. The H. O. Havemeyer Collection (29.100.3).

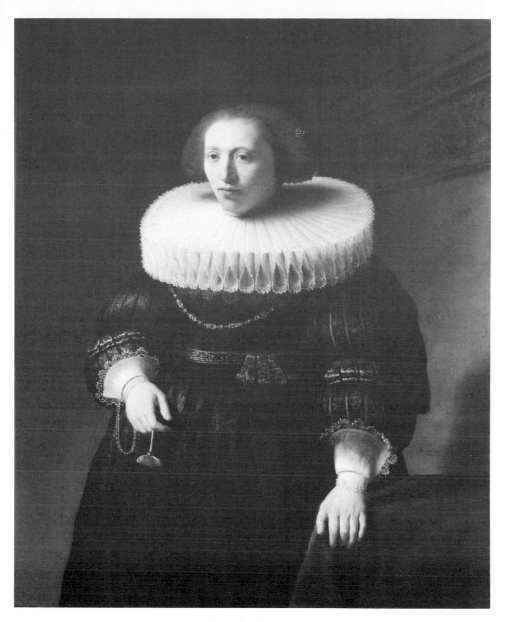

4.32. "Rembrandt," *Portrait of a Woman*. Metropolitan Museum of Art, New York. Bequest of Mrs. H. O. Havemeyer, 1929. The H. O. Havemeyer Collection (29.100.4).

4.33. "Rembrandt," *Christ and the Samaritan Woman.* Gemäldegalerie, Staatliche Museen Preussischer Kulturbesitz, Berlin (West).

4.34. "Rembrandt," *The Centurion Cornelius.* Reproduced by permission of the Trustees of the Wallace Collection, London.

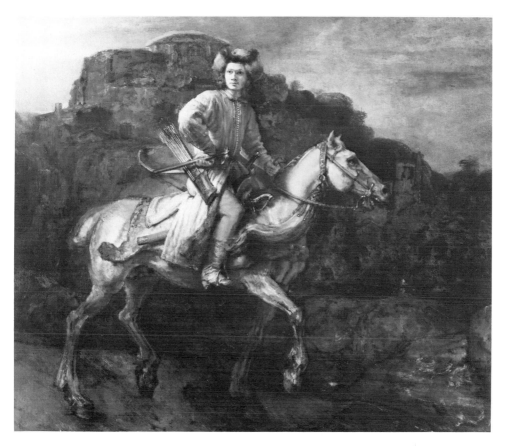

4.35. "Rembrandt," *The Polish Rider*. © The Frick Collection, New York.

4.36. "Rembrandt," *David and Saul*. Mauritshuis, The Hague.

4.37. "Rembrandt," *An Old Man in an Armchair*. By courtesy of the Trustees of the National Gallery, London.

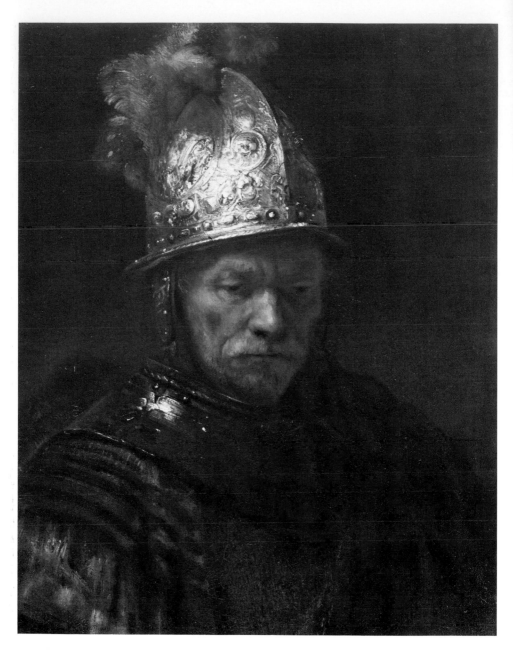

4.38. "Rembrandt," *The Man with the Golden Helmet*. Gemäldegalerie, Staatliche Museen Preussischer Kulturbesitz, Berlin (West).

receive for retouching that work. Ludick finally, in turn, sold the debt to Herman Becker, who was already involved in negotiations to get Rembrandt to complete a promised *Juno* in payment of yet another debt. The tale has even more complexities, but the inventory of Becker's estate—he died some nine years after Rembrandt—lists at least thirteen paintings by, and one painting after, Rembrandt. His strategy paid off and he ended up with the paintings.

This is not the first time the story of this loan has been told. One version has it that it shows Rembrandt to have been profoundly independent and Becker a persistent admirer of his art, and another that Rembrandt was a bad risk and it was rare for a person who had dealings with him not to lose his money in the end.[20] I tell it not to put Rembrandt in either a favorable or unfavorable light, but to call attention to the way in which he conducted his affairs. An economy of money and the marketplace, rather than the obligation to patrons with its attendant notion of service, characterized his relationship to clients. Rembrandt was evidently more comfortable circulating his paintings by conducting negotiations with creditors than by serving patrons.

A word is in order at this point on the subject of Rembrandt's bankruptcy. We speak of Rembrandt as "going bankrupt," but the evidence is that he declared himself to be insolvent (technically known as *cessio bonorum*) in order to limit the extent of the claims that could be made against him. This is not unknown in financial dealings in our own day. Though he may well have preferred to avoid bankruptcy, features of the way he managed it served him well: he ended up employed in a business run by others (Hendrickje and his son Titus), and his future dealings were with a market to a great extent made up of those to whom he was indebted. It was under these conditions that Rembrandt painted some of his most self-assured and impressive works.[21]

Paintings, like other valued objects, had of course been used as credit before. Nicholas Jongelinck of Antwerp in 1565 offered his painting collection, which included among other things sixteen paintings by Pieter Bruegel, to the city of Antwerp as collateral for the tax arrears of a friend.[22] But the record of Rembrandt and the market is that of an isolated instance such as this transformed into an entire practice. It is a practice which has had a long life. When, in the years just after the crash of 1929, an advertising man named Erickson returned Rembrandt's *Aristotle* to the art dealer Duveen for a substantial loan, only to buy it back and then repeat this exchange twice over again, the painting was circulating as Rembrandt

himself circulated art in the marketplace system of exchange. The value of a painting is a function of exchange; only when its progress finally stops in a museum can it be described as priceless.

If Van Ludick or Becker or De Renialme had acted in the way that dealers came to act in the later nineteenth century, Rembrandt's experience would have been somewhat different. The dealer replaced the patron as the person whom the painter served. Advance payments were forthcoming, though still on a manual day-work basis as they had been for Dou, Mieris, or Van der Werff from the Maecenases of old. The French artist in the nineteenth century who sought freedom from the Academy and the State in the dealer system became involved in a new kind of dependency. It was a dependency constituted from within what Rembrandt had taken to be the freedom of the marketplace.[23]

We have considered certain fits and misfits between artists and their patron/clients, but what did this have to do with the nature of the art produced? It is traditional to focus on the subject-matter and the use of paintings as functions of the patronage relationship. But we can also discern a relationship between the basis of the payment and the look or manner of paintings. Returning to Dou, Mieris, and Van der Werff with this question in mind, two things strike one. First, these men all made what was called *fijnschilderij*, or highly finished works. We noted in the first chapter that after the midcentury the smooth style was generally perceived as the preferred manner in which to paint. Which came first on this occasion—the manner or the commanding taste for it—is not clear. But the relationship was established. The care with which Dou tried to protect his surfaces both in the making (with umbrellas against dust) and in the exhibiting (sometimes fitting paintings with wooden shutters) is well documented. Though their execution and subjects differ from Dou's, the finish of Mieris and Adriaen van der Werff is similar.[24]

The production of works like this took skill and time. Payment was made, value assessed, according to the time spent. But there was, in addition, a second sense in which finish was valued: that look of perfection given off by a painting that looks completed. We have this on the evidence of a member of the Elector's court, who wrote that Van der Werff's works looked as if he had worked at them for years at the cost of his health and even of his eyesight. Van der Werff's paintings, he concluded, are like most precious jewels. The passage holds in balance two notions of finish which imply two contradictory concepts of value: on the one hand it is a display of hu-

man labor and on the other it is a display of that perfection we asso-
ciate largely with Nature, as in a jewel.[25]

With this account in place, let us return to Rembrandt's making
and marketing. Rembrandt was not only unwilling to play the social
game with patrons, he was also unwilling to produce works that
could be paid for, and hence valued, in the accustomed ways. What
we described in an earlier chapter as Rembrandt's "rough" studio
mode can also be described in market terms. Contemporary remarks
and complaints about the lack of finish of Rembrandt's paintings tes-
tify to the challenge he offered to the normal ways of calculating
painterly value. Though clearly made by his hand, his works did
not display the artist's labor in an expected and accepted sense. Rem-
brandt's characteristic working and reworking of the paint meant
that the amount of time he spent was incalculable and the achieve-
ment of completion impossible to judge. Value in both senses in
which the paintings by Van der Werff were judged—time spent and
perfection like that of Nature—was rejected by Rembrandt.

Because Rembrandt made paintings in the manner he did, the
question of when a work was finished was open to dispute. It was all
very well for him to say that a painting was finished when his inten-
tion was realized, as Houbraken reports, but that left judgment of
finish, and hence the calculation of value, solely in the hands of the
artist. A law suit taken up against him in 1654 shows the problems
raised: a client named d'Andrada complained that Rembrandt's por-
trait of a young woman was not a likeness and demanded that he
change it, or else return his advance of seventy-five guilders with
interest. Rembrandt, unwilling as always to give an inch when chal-
lenged, replied as follows: he would not put his hand to the painting
or finish it until he was paid the remainder of what was due; when it
was finished, judgment as to the likeness would be left to the board
of the Guild of St. Luke; if it must be changed again and still did
not suit the client he would take it back, finish it in the course of
time and sell it (presumably for a second, additional payment) the
next time he held a sale of his paintings. From what we know of
Rembrandt's manner of painting, d'Andrada's complaint could have
had its source either in his refashioning of the girl in his manner or
in his idiosyncratic handling of the brush.[26]

It was normal workshop practice for a master to keep a number
of unfinished or partially finished works in the studio for finishing
to order. But Rembrandt worked this system to this own painterly
and market ends. There were occasions on which Rembrandt told a

client that if he did not think a work were finished it could be re-
turned and he would, for a fee, paint at it some more. There is at
least one occasion (the case of the *Civilis*) on which Rembrandt
must have calculated that he would be able to get more money by
retouching a painting. A legal document records that one quarter of
the payment, plus one quarter of the additional money he would be
paid for retouching it, were destined for Van Ludick, the dealer/
creditor we mentioned before. It would appear that the (to us) prob-
lematic return of the Town Hall painting to Rembrandt for more
work was anticipated, even desired, by the artist. (In the same com-
plicated notarial document, Rembrandt is obliged to repaint and
improve the circumciser in a painting of the Circumcision, also at
issue between him and Van Ludick.) A less clear case is that of the
Homer, which Rembrandt shipped to Ruffo in Sicily along with an
Alexander. Ruffo liked the work but, referring to it as "*mezzo finito*"
and disputing the price asked by the artist (which he pointed out
was four times the price per head or per half-figure in Italy), he
shipped it back to Rembrandt. Rembrandt, in response, held firm
on the five-hundred-guilder price for the painting, which he re-
ferred to (in the Italian version which is all that we have of his letter)
as "*il schizzo di Humerio*" [sic]. One wonders if Rembrandt had not
hoped to get by with the *Homer* in the condition in which he sent it
to Italy in the first place, and, failing that, counted on the fact that
he could insist on the five-hundred-guilder fee when he put in some
more work.[27]

What seems odd in his practice as a painter is what brought Rem-
brandt fame and money as an etcher. His repeated reworkings of his
plates and the resulting series of states were deployed as a marketing
device which gained him great success. In Houbraken's words,
"Thanks to his method of putting in slight changes or small addi-
tions so that his prints could be sold as new . . . no true connoisseur
could be without the *Juno* . . . with or without the crown—or
Joseph with his head in the light and with his head in shadow. . . ."
In the case of his etchings, Rembrandt's long-drawn-out working
procedure was made to pay off at each of several stages along the
way in the working of a plate. By creating a demand for his works in
progress, Rembrandt as an etcher established a remarkably success-
ful marketing operation. It was preeminently through the sale and
wide distribution of his etchings that Rembrandt's European repu-
tation was made in his lifetime. He transformed a medium whose
great distinction in other hands was its replicative nature into the
most personal and individualized as well as the most widely circu-

lated of commodities. What he treated as his most private preserve or property (in the sense that his assistants did not also etch), one that was labor-intensive, replicative in nature, and generally patron-free, was his most successful mode of production.[28]

What did Rembrandt have in mind in place of the patronage system? It seems to have been something a bit old but also rather new: a craftsman selling his products replaced by an entrepreneur, of sorts, working the market with pictures distinctive in manner or mode. Two terms deserve attention here: entrepreneur and market. I say "an entrepreneur of sorts." As far as production went, it was Rubens and not Rembrandt who was the prime innovator in the north of Europe at the time. Though Rembrandt's obsession with the intricacies of the market system permeated his life and his work, the organization of his shop—a master surrounded by student-assistants each eventually producing paintings on their own for sale—was an established one. It was Rubens, by contrast, who promoted a division of labor. He developed a painting factory: assistants specialized in certain skills—landscapes, animals, and so on—and the master devised a mode of invention employing a clever combination of oil sketches and drawings. These permitted his inventions to be executed by others, sometimes with final touches to hands or faces by the master himself. It is in keeping with the logic of this factory procedure that Rubens, unlike Rembrandt, did not sign the works that were sold from his studio. Only five of the thousands of works produced were signed. On occasion, when challenged or pressed, Rubens agreed to make distinctions between hands. But the claim that all the works issuing forth from his studio were his was a claim about a commodity whose value was distinguishable from his own hand and which was capable of proliferation and replication. Rubens confirmed this expansive notion of authenticity and authentication when he sought and received copyright protection against the pirating of the engravings which his studio was in the business of producing after his paintings. Rembrandt imitated this mode in a brief experiment with essentially replicative etchings in the thirties, but he then gave it up.[29] Modern attempts to separate works by Rubens's hand from those by others in the studio, and the taste for his *eigenhändig* oil sketches, intrude a notion of value inappropriate to his mode of production and to the commodity he produced. Though he was himself a brilliant wielder of both brush and pen, Rubens was a pioneer in encouraging the distribution and sales of his inventions through means that have come, in our age, to be called mechanical reproduction. For all its moder-

nity in these terms, it did not prove to be a lasting model for art in our culture.[30]

While Rubens's interest was in the work of art as a commodity distinct from himself personally, Rembrandt, despite the diffusion of his manner in his studio, was unwilling to make this separation. So far as we know he almost never collaborated on paintings with assistants.[31] His merging of invention with execution, his distinctive handling of the paint (or of the etched line), his invention and use of his signature presented his works and those of his studio as an extension of himself. Related to this is the fact that, while Rubens's works benefited from and frankly displayed the fact that they did cleave to pictorial tradition, Rembrandt's, as we have seen, did not. But this was where Rembrandt's peculiarity and innovation lay. It was the commodity—the *Rembrandt*—that Rembrandt made that was new. And it is he, not Rubens, who invented the work of art most characteristic of our culture—a commodity distinguished among others by not being factory produced, but produced in limited numbers and creating its market, whose special claim to the aura of individuality and to high market value binds it to basic aspects of an entrepreneurial (capitalist) enterprise.[32]

While other ambitious artists were defecting from the open market to patrons, Rembrandt maintained his freedom by choosing to make art for the new markets.[33] This helps to explain certain accusations mounted against him in early lives. The charge that he chose to hobnob with the lower classes might well have been a reaction to Rembrandt's rejection of the social behavior or adaptation that the patronage system assumed. He was also said to have been overly interested in money: he was criticized for having charged stiff fees to his students and for making money from the sale of their work, though neither practice was at all unusual at the time. Since making money was not considered reprehensible in other artists— on the contrary it was one of the desiderata of the profession—some reflection must be being cast on the unacceptable way in which Rembrandt went about it. If one puts together the apparent contradiction between charges of hobnobbing with the poor on the one hand, and money-grubbing on the other, the common denominator would seem to be that of a man out for gain in a socially unacceptable, or what was considered a déclassé, way. The marketplace, not the dwelling places of the rich, they were saying, was his beat.[34]

But was it simply gain or profit that drove Rembrandt? An anecdote suggests that love of money was indeed an element. Houbraken tells us of occasions when Rembrandt's students painted coins on

the floor and of a gullible Rembrandt trying to grab them. Lest we mistake the point, Houbraken adds that this was not done out of greed, and that Rembrandt was not embarrassed by being fooled, but took it in good fun. He concludes his account of Rembrandt and money with the general wisdom that having money does not appease the desire for it. Perhaps it was not love of money but love of possessing (of which the desire for money is a common emblem) that drove him? His aim was less to get rich quick than to feed the mania for collecting or hoarding that he displayed throughout his life. Having frequented auctions starting in the mid-thirties, sometimes buying multiple copies of prints (eight copies of Dürer's *Life of the Virgin,* for example), he built up the huge collection of paintings (over seventy), works on paper (ninety albums), shells, statuary, and armor, only a part of which was inventoried when the famous bankruptcy sale was held. After having officially declared bankruptcy, Rembrandt began to collect again.[35]

It appears that collecting came naturally to Rembrandt, but one must remember that this was a cultural phenomenon. I mean this not only in the sense that artists needed material for study in the studio, or that they were dealers on the side, or that the encyclopedic collection was the mark of the cultivated gentleman merchant at the time, but also in the sense that the storing up of goods, as assets for future dealings, was a remarkable and celebrated practice in the Amsterdam commercial and trading world. A feature of Amsterdam was the huge warehouses built to store grain, spices, wines, furs, sugar, cocoa—any goods the world wanted—in unprecedented quantities. This great abundance of goods was backed up by a banking system which assured sufficient credit for the most flexible possible scheduling of payments. The bulging depots were as fabled in the public world of commerce as the encyclopedic collections were in the private sphere, though they were not discussed in the same texts. Economic tracts by jealous trading competitors focus on the warehouses, and the journals of professional travelers marvel at the private collections. The warehouses were not depicted by painters, though they appear in engravings accompanying celebratory texts. Warehouses and encyclopedic collections alike are evidence of an accumulating instinct endemic to a capitalist economy predicated on the existence of markets. Rembrandt was part of this.[36]

Rembrandt entertained a number of different interests when he ventured forth to bid at auctions in Amsterdam. First, as we have seen, he was building up his own collection. But it appears that,

contrary to what one would expect, Rembrandt was not necessarily after bargains. He bid excessively high prices (breaking all previous records, as one would say today) for certain works. The extravagant price of 179 guilders which he paid for a single copy of the so-called *Eulenspiegel* print of Lucas van Leyden was commented on at the time.[37] One can chalk such extravagance up to artistic admiration as well as to scarcity: there is no question that Lucas was an artist for whose works Rembrandt had an affinity. But something else is also in play here, and Baldinucci recognized it when he explained that Rembrandt bid up the prices of works of art on the market in order to add credit to his profession, *per mettere in credito la professione*. The word *credito* has just the right historical inflection, since like the English "credit," *credito* engaged both reputation/belief and the commercial/economic meaning which were conjoined in Rembrandt's market behavior on behalf of art. While other Dutch artists added to the esteem of their profession by forming clubs or academies to replace the craftsman's guild, and by serving courts and wealthy patrons, Rembrandt chose to do so by attending to the value of art on the market. For Rembrandt this was clearly an alternative way. He did not wish to establish value by personal association with those who had status or power through a taste in letters or through money, but rather in "free" market terms.[38]

It is against this background that we should note the words "sold for 3,500 guilders" that Rembrandt jotted next to his quick, salesroom copy after Raphael's *Baldassare Castiglione* (the words beneath the drawing record that the entire estate of which the Raphael was part went for 59,456 guilders) (fig. 4.9). And this explains the story of how the Rembrandt etching known as "the hundred-guilder print" got its name (fig. 4.10). The eighteenth-century collector and amateur of the arts, Mariette, said that it was Rembrandt himself who bought up at a sale an impression of his *Christ Preaching* for this excessive price. It was not, Mariette wrote, that Rembrandt needed it. Not only had he kept the plate, but he had already bought up at any price he could every impression of it that he could find. What he wanted to do was to make his works rare, in order, the implication is, to add to their value. The specific value once established by reference to a print worth a hundred guilders has long since worn off—as has even the magic of the 2.3 million dollars paid for the *Aristotle*, when such paintings as a modest portrait of a woman certified to be by Rembrandt's hand are sold today for four times that amount. But the aura of the sobriquet "one-hundred-guilder print," like that of the 2.3-million-dollar *Aristotle*, has stuck.

It records not just a price, but a manner of indicating the worth of a work of art that has lasted.[39]

From the point of view of the person who is doing the buying, Rembrandt's tactics were not money-making. If Rembrandt made it a practice to bid up and buy goods at high prices in order to establish their value on the market, it was a recipe for eventual bankruptcy. He took risks. But he was not as talented at making money as he was at making value in painting. Once again, as in most of his dealings (he was a true Amsterdam trader in this), it was less money in the bank than the promise of future returns that he was after. Rembrandt was using the marketplace to add honor to art. The term *honor* is not offered lightly. The nature of Rembrandt's dealings in the marketplace suggest a context in which to read the famous phrase "*eer voor goet*," or honor before goods or possessions, that he inscribed in the *album amicorum* of Burchard Grossman in 1634 on the eve of his marriage to Saskia.[40]

Previous scholars have, not incorrectly, related Rembrandt's phrase to a set of interlocking *topoi* often invoked at the time to define the aims of the artist: pursuit of honor and profit, or honor, fame, and profit; or love of art, wealth, and fame. A gold chain awarded for royal service was considered a sign of honor in this system. Honor was attributed to the artist's person and set against goods or wealth, or profit on the market.[41] But Rembrandt behaved in a way that upset this system of values and the distinctions it strove to preserve: he pursued honor not in the sense of honors that

others could confer, but in the sense of what art itself could confer, the value that his art itself brought into being, and this was registered in the money values of the market. This was the way the world paid tribute to art, the way the artist exacted its tribute—the ambiguity of the word, again here, not offered lightly.

The concept of honor has a complicated history, but one constant has been that honor was set against the pursuit of riches in trade. In the sixteenth century, Calvinists, taking up an established humanist position, addressed the phrase as a warning to merchants. As an admonition, it called attention to the difference between the material things of the world (gold, possessions) and a superior moral goal or sphere (honor). But the notion of honor was complicated by the fact that though considered to be a man's possession, it was a possession bestowed by others: you had to, in other words, gain it. With the domination of the marketplace in seventeenth-century Holland and in England, it is not surprising that a prophet of the market economy like Hobbes, in his *Leviathan* of 1651, should collapse the distinction between honor and the market and see the first in terms of the second: it is in the marketplace that honor is gained, or in Hobbes's words, "The *Value,* or WORTH of a man, is as of all other things, his Price," and, "The manifestation of the Value we set on one another, is that which is commonly called Honouring and Dishonouring." We have no way of telling precisely what Rembrandt intended by the phrase he inscribed in Grossman's book in 1634. But the nature of his dealings on the art market, and the way those dealings were narrated by his near contemporaries Baldinucci, Houbraken, and Mariette, provide sufficient evidence to suggest that it was in this new sense of market worth that Rembrandt pursued honor for art.[42]

II

WE HAVE BEEN considering some of the evidence about Rembrandt's behavior in relationship to the marketplace—the first point being that he treated it as an alternative to the patronage system for securing the economic well-being of his art. The marketplace has been invoked not only as a locus for his life, but also because the economic system to which it was central offers an appropriate model to use in understanding Rembrandt and his art. It was a model that Rembrandt himself can be said to have taken up: in remarkable ways he internalized into his practice this system of which he was part. He did this in a manner that was at once canny and naive:

canny in that he devised representations so adequate to its values, naive in that in the very devising of the representations he never lost his faith either in them or in the system of which they were part. The description of Rembrandt as *pictor economicus* is a construction, then, but it was a construction he put on himself.

The prospect of being free from patrons was part of Rembrandt's market motivation. In the economic sphere, he was in good company in this at the time. Whatever the actual conditions of market dealings in art or in other commodities were at the time, there is no question that freedom, or *vrijheid*, was repeatedly invoked (as it is to this day) to define optimum market conditions. The textile entrepreneur Pieter de la Court, born in Leiden some twelve years after Rembrandt, made freedom from intervention or control the basis of his definition of the "interest" or economic well-being first of Leiden and then of the republic itself. He is usefully compared to Rembrandt in that, whether running his prosperous cloth business or advising his town or his country how to run their business, it was not reform in the organization of production but the free flow of goods and capital in the marketplace with which he was primarily concerned. In his *Prosperity of Leiden* (1659) and his *The True Interest and Political Maxims of the Republic of Holland* (1662), de la Court advised his readers to trust to commerce freely pursued without intereference or regulation from guilds, from the ruler of the state, or from any religious orthodoxy, as the path to economic well-being: the word *vrijheid* echoes through his pages.[43]

It was largely in reaction to the astonishing and unprecedented economic success of de la Court's Holland that some Englishmen, writing in the seventeenth and eighteenth centuries, formulated the first notion of an independent market economy. Exchange was said to characterize relations between men, whose nature was defined by an interest in the acquisition of goods (wealth). A human equalizer, the market economy so defined freed men from the social bonds or hierarchy of the previous society, where property had taken the immovable form of land, where men produced only what they needed to subsist, and where the order was social (man to man), rather than economic (man to goods). On the open market men could deal with other men through the impersonal and highly flexible medium of credit and the system of exchange.[44]

The system so described was to Rembrandt's taste. If it seems paradoxical that a man whose works are so consistently concerned with human relationships should take to the impersonality of the market exchange, I would say that the paradox contains its own ex-

planation. It was in a world conceived in this way that human en-
counters and relationships came to be staged in the artist's studio.
Though we have considered the studio as a form of standing apart
from the world, it is equally important to recognize it as being in a
reciprocal relationship to, and hence still part of, the world from
which it stood apart. The sharp demarcation between the studio
and the world, and the resulting distinctiveness assumed for the life
in art, was itself part of the social and economic arrangements of the
society.

But if Rembrandt sought to establish the value of his paintings on
the marketplace, we must establish what value on the marketplace
means. Market value is admittedly a very slippery, an economist to-
day might say a contradictory, notion, since value is tantamount to
market price. In effect, all prior or intrinsic notions of value are re-
placed by a system in which value is absorbed into that relative
worth established in the exchange between goods; value is simply
the amount for which a thing can be exchanged, the market price.
Value is considered to be a social or a human construct produced in
a relational system activated by human desires. It is man-made
rather than inherent in the nature of things. The economic notion of
value has had a long and much debated history. Classical economic
thought distinguished value in exchange (diamonds) from value in
use (water). The standard examples originated with Adam Smith.
Smith himself somewhat softened the status of exchange value by
going on to distinguish the natural or just price—that is, a notion of
value which took into account input of labor and so on—from the
actual price in market exchange. In economic thought as it devel-
oped, price or exchange value held sway. Marx's notion of surplus
value was yet another attempt to get away from price in the market-
place exchange by distinguishing value—created, at least in part, by
unrewarded labor—from price. But by attempting to locate value
outside the system which they are committed to explain, all such pro-
posals effectively acknowledge the independence and self-sufficiency
of the exchange system itself. The marketplace that Rembrandt
chose over the patronage system was not simply a different locus for
the establishment of value or worth, but a different manner of con-
struing or constructing these terms.[45]

What did entering the market system involve for Rembrandt? It
was a chancy move; since its boom in seventeenth-century Amster-
dam, the modern marketplace has been perceived as destabilizing
in nature. Seventeenth-century observers were astonished at the
ease with which payment could be assigned by bank credit, "nothing

being more real than ingots of gold, bars of silver, piasteres, ducats, ducatons and suchlike, but the method of payment in bank, as it is called, has not the same reality. One could, on the contrary, call it a veritable illusion; since for the gold and silver taken to the bank it gives only a line of writing in a book. This line may be transferred to another, and this second transfers it to a third, . . . and this can go on, so to speak, to infinity." Speculative trading in commodities and in commodity values at the Amsterdam bourse produced even more uncertainty: "The seller, so to speak, sells nothing but wind and the buyer receives only wind."[46] *Confusion de Confusiones* was, appropriately, the title chosen for the first book written on the operation of any stock exchange.[47]

What struck observers was that the entire market operation called for a belief in mere representations—credit stands for the commands and demands of the individuals playing the market game. (In his *Confusion de Confusiones*, de la Vega specifically compared the Amsterdam exchange to a theater with the speculators as the actors.)[48] If, understood one way, the market is an emptying out, understood another way it marks the establishment of a system of representation.[49] (The fact that economic thought has characteristically accommodated the order of the marketplace to the natural order does not belie it as a human invention. It relates it to claims made about other representational systems invented at the time, such as "natural knowledge.") It is not the ideology of the system, which is the object of much attention now, but the fact that it was a system of representation that is our interest. Rembrandt was also a maker of representations: hence the appropriateness of his making art into a commodity to be exchanged in a marketplace so perceived. One can say of this artist what Adam Smith said of mankind, "Every man thus lives by exchanging or becomes in some measure a merchant."[50]

Let us consider Rembrandt's paintings as commodities and try to give a generic description of them as such. Only rarely did they fool the eye to present an illusion of something else—they do not fit the model of a mirror of, or a window on, the world. (The illusionistic painted frame and curtain of the Kassel *Holy Family* call attention, as Wolfgang Kemp has shown, to the picture as an object suitable for hanging on a collector's wall (fig. 4.11). The illusionism was directed beyond the imitation of the visible world to the fabrication of an object belonging to the world of commodities.) They displayed no intrinsic value: they could not be mistaken for an object of value as were the painted flowers or jewels of Jan Bruegel; they were not

fashioned out of expensive materials; the craftsmanship that went into their making could not be esteemed in established terms. There was an emphasis on the working of the pigments out of which a substantial object was produced. In the last years they presented human figures, of uncertain identity, in three-quarter-length format, which avoided a generic category, such as history painting, with its attendant values. By stripping away inherent or conventional values and by insisting on the sheer materiality and the ugliness of his medium (one early writer described it as like dung), Rembrandt made art of an unprecedented kind, which he commodified. He exploited the nature of paintings as durable goods to promote them in the market. And his paintings shared with money—a piece of metal or of paper, marked with certain symbols—a quality which economists refer to as abstract: though nothing in itself, it is accepted as the representation of value.[51]

Rembrandt's attraction to paint was akin to his attraction to money. (Recall Houbraken's story about his reaching, without greed, for painted coins!) If this seems odd, let us consider how much of what we say about money we also assume about works of art. How easy it is to substitute art for the references to money in the following: it has no inherent value in itself; it has no practical use except as the means for storing up value and for expressing value in its function in exchange, which is "a world apart in which the objects are classified and arranged according to particular norms which are not inherent in the objects . . . [it] is the expression and the agent of the relationship that makes the satisfaction of one person always mutually dependent upon another person"; it is a value created in its sharing, a shared value, one might say; but it can also be of satisfaction to a lone person, the recluse or the miser; "it can provide a sense of power that is far enough removed from specific empirical objects that it does not come up against the limitations of ownership;" the miser gains "satisfaction from having fully acquired potentialities without ever conceiving of their actual realizations"; its potential is its value and it gives to "consciousness that free scope, that ominous self-extension through an unresistant medium . . . all of which are part of any aesthetic enjoyment."

The preceding mosaic of quotations is assembled from Georg Simmel's *Philosophy of Money* (*Philosophie des Geldes*) published in 1900.[52] The book's inclusion here needs some explanation. It is one of a number of impressive works to be written in Germany after Marx—by Tönnies and Weber as well as by Simmel—which attempted to conceptualize the transition to a capitalist society and

its effects on human relationships. Though they wrote at a historical distance from seventeenth-century Holland, the subject dealt with by these earliest sociologists is relevant to Rembrandt's world. Weber's hypothesis of a relationship between the spirit of capitalism and Christian asceticism has dominated much subsequent historically oriented discussion. But for those with an interest in the making of art, there is much to learn from Simmel, whose starting point is not the notion of a vocational calling involving certain ideals of behavior, but the relationship of men to a (purported) thing, money. Simmel can be said to have aestheticized money: he had the wit to see that our society's engagement with things aesthetic is related to its engagement with money. Though his book is frequently invoked because it concludes with deep misgivings about a society so constituted, Simmel devotes the greater part to its virtues. A Jew who was long denied a professorial chair in Germany, an outsider, without status, dependent as a *privat dozent* on his brains and money payment from his students, fascinated with things aesthetic, Simmel can serve as a kind of native informant, *après la lettre*, about Rembrandt.[53]

Scholars have been quick to pass judgment on the old man inspecting a coin by candlelight whom Rembrandt depicted surrounded by money-bags, and papers in a darkened interior (fig. 4.12, pl. 5). This, it has been remarked, is not the Christian way to behave and, with reference to the biblical parable of the Rich Man, the moral point has been taken as the meaning of the painting. There is a Bloemaert engraving labeled Avarice which shows a woman inspecting a coin by candlelight, and it does not seem wrong to relate Rembrandt's distinctive handling of the hidden flame to the works of Utrecht painters such as Bloemart and his followers. But the painting differs significantly from its possible antecedents.[54]

From the point of view of dealing with money, let us consider for a moment what Rembrandt did not choose to take up. Other artists of the time who took up the mode of Utrecht painters (Vermeer, for example, in his *Procuress*), were attracted by venal love—that relationship between money and sex which was the subject of many works by Ter Borch and Mieris (fig. 4.13). Rembrandt's one artistic foray into the realm of commerce with women is an exception which proves the rule. When Rembrandt performs the prodigal son to Saskia's whore in the Dresden *Prodigal Son*, it is he, rather than the distinctly uncomplicitous Saskia, who delights in and takes responsibility for this upending of the marital economy (fig. 4.14). For all its brilliance, the painting is disjunctive and curiously empty at its

psychological core, because Rembrandt has little feeling for the version of female temptation—whether depicted as brazen display or as ambiguous pose—with which other artists, from Baburen to Ter Borch, registered women's threat to the domestic economy. And it is no accident that while spending, both sexual and economic, is clearly in play, money is notably left out of Rembrandt's sexual scene.[55]

Unlike many Dutch artists, Rembrandt is singularly uninterested in and insensitive to the tension between the household and the world. One result of this is that *his* domestic scenes, the large group of drawings he grouped together in an album as the lives of women and children, evade the morals of the household economy as it is represented by other Dutch artists (figs. 2.41, 4.15).[56] This explains the "modern" look of Rembrandt's children learning to walk or women reading or resting in bed, in contrast to the virtuous women of the household caring for their children or their linens as they were depicted by De Hooch, Nicolaes Maes, and others (fig. 2.37). Rembrandt depicts women and children independent of the ideal of the household, as well as apart from the theatrical conditions of his studio.

Money itself is not a major subject within Rembrandt's works, but when it does appear it is in a decisively public context: *Judas Returning the Pieces of Silver, Christ Driving the Money-Changers out of the Temple, The Tribute Money* (not thought to be by Rembrandt's hand), *The Parable of the Laborers in the Vineyard,* the etched portrait of the tax-collector Uytenbogaert, and, by implication, perhaps, the group portrait of the Syndics. The substitution of light for the traditional shower of gold coins in Jupiter's appearance to Danae in the Leningrad painting, might be a case of avoiding the sex-money link. To put this in economic terms: the single phenomenon of the market replaces the distinction, which goes back to Aristotle, between the economy of the household (*oikonomike*) and the accumulation of wealth that belongs to the world of commerce (*chrematistike*).

What, then, was Rembrandt's interest in the so-called *Money-Changer*? Though one coin is held up against the light and more are scattered by the scale on the table before the man, coins are but a small part of the visual array of the painting in Berlin. Accumulation, and a certain security obtained through it, are suggested by the enclosure constructed out of the illuminated semicircle of books within the darkened room. The bespectacled old man's preoccupation with money and the assembled mass of books recalls the type of

Antwerp banking paintings from the sixteenth century made by Reymerswaele. But what distinguishes Rembrandt's painting from its predecessors is the way its design and execution sustain and extend an aura of contemplation. In seventeenth-century Amsterdam, as in sixteenth-century Antwerp, commercial practices contradicted received religious wisdom. Hoarding, as Simmel among others has noted, is the mark of the capitalist. "Accumulate, accumulate! That is Moses and the Prophets. . . . Accumulation for the sake of accumulation, production for the sake of production," wrote Marx, and he continued in words we might append to Rembrandt's *Money-Changer*, "Only as a personification of capital is the capitalist respectable. As such, he shares with the miser an absolute drive for self-enrichment."[57] Though the painting in Berlin dates from his Leiden days, it records Rembrandt's fascination with hoarding before he clearly exercised the taste in his own collections and in his art. The painting deals with satisfactions which Rembrandt shared.

Rembrandt associated hoarding not only with the traffic in money (gold), but also with a loving and lavish traffic in paint. In passages of certain paintings—the chain of honor in the *Aristotle* or the helmet in the *Man with the Golden Helmet*—the two are made one. Avarice and extravagance, as Simmel evoked the aestheticized love of money, are combined.[58] We might judge the taste for money and for paint alike to be a taste for something ultimately insubstantial, but they feed a kind of contemplation on the part of the old man, and on his part for the viewer, that we have come to call aesthetic. In *The Money-Changer*, Rembrandt draws attention to this connection.

III

THE EVIDENCE is that Rembrandt took to the new marketplace economy not only because he wanted freedom from patrons, but also because he wanted freedom for himself. This was very much at the heart of the matter for him as well as for the economic system of which he was part. As far as human *relationships* in the studio are concerned, they were concentrated in the "enacted" pen and wash drawings or in etchings, and were only executed as paintings by others working in the studio. In paint, at least in his later years, Rembrandt concentrated on the half- or three-quarter-length single-figure format: his most charcteristic images are of individuals alone. We have interpreted the accusation that he hobnobbed with the lower classes as a reaction to Rembrandt's rejection of the kind of

decorous social behavior that the patronage system assumed. But Rembrandt himself is reported to have offered another explanation. He explained his behavior in terms of his desire for freedom.

Roger de Piles, followed by Houbraken, wrote that Rembrandt explained his frequenting the common people by saying that it was not honor that he sought, but freedom: "Quand je veux délasser mon esprit . . . ce n'est pas l'honneur que je cherche, c'est la liberté," or "Als ik myn geest uitspanninge wil geven, dan is het niet eer die ik zoek, maar vryheid," in Houbraken's Dutch.[59] The final phrase has been understood as referring to what we continue to think of as the freedom of the individual. But this phrase, and its claim for individual freedom over honor, is related through the word "honor" to the topos "honor over goods" or "*eer voor goet*," which the young Rembrandt, as we have seen, had inscribed in Grossman's book. Honor which was privileged over goods in the first phrase is itself eclipsed by the freedom of the individual in the second. The terms concern issues that in Rembrandt's day took on new interest in relationship to the marketplace. Two different but reciprocal values—that established in the marketplace and that of the individual suited to that market—are juxtaposed. Taken together, they constitute that ideology of the free market and the free individual that modern society has inherited in great part from the example of Rembrandt's Holland.

Rembrandt and individualism (or Rembrandt and the individual) has become a commonplace in the literature on him. Here, for example, is Julius Held: "Rembrandt himself never yielded his personal independence. The greatness of his art, in the last analysis, is due to this fact: that it is the work of a man who never compromised, who never permitted himself to be burdened with a chain of honor, and fiercely maintained both the integrity of his art and his freedom as a man."[60] This is not wrong, but the terms which are brought together here are unexamined. How is it that art should have come to be so identified with what are called the freedom and the self of the artist? Historically, the argument for the self, the definition of the sense in which a person is considered, or considers himself or herself to be, an individual, has taken many different forms. In Rembrandt's case alone, religion, philosophy, and the poets have all been appealed to on one occasion or other.[61] In the previous chapter I proposed that the invention of the individuality "effect" of his works was a function of the authority Rembrandt exercised in the studio. But I want now to add that it was also a function of the economic system in which he lived and in which he

played such an active part. It was in Rembrandt's time that the individual came to be defined in what were then new, economic terms. Those familiar words from the American declaration of human rights, "life, liberty, and the pursuit of happiness," are a reworking of Locke's "life, liberty and estate" which constituted his definition of property: "By Property I must be understood . . . to mean that Property which Men have in their Persons as well as Goods." On this view, to be an individual is defined by the right to property. And the most essential property right of each man, and hence the grounding of this notion of the individual, curious though it might sound put in this form, is the right to property in one's own person. Freedom, then, is defined as proprietorship in and of one's own person and capacities. It is the proprietorial quality of this notion of the individual to which I wish to call attention. It was Rembrandt who made this the center of his art—the center, even, of Art.[62]

The paradigmatic manifestation of this is Rembrandt's production of self-portraits—not as they started out, but particularly as they came to be produced after the hiatus between 1640 and 1648. The later self-portraits no longer serve as studies of expressive heads, lighting, and costume. Even the few studio accoutrements of the earlier works—gold chains, feathered hats, armor—are absent, as Rembrandt appears to concentrate harder, to zero in, on himself. We speak of these late works as having or displaying depth, as if their difference is determined by Rembrandt looking deeper into himself. But it is instead a matter of surface, in the sense that he dwells on himself in paint. It is not that Rembrandt looks deeper into himself, but that he closes in—identifying self, himself, with his painting. The embodiment characteristic of many of the later works—not only the thickness of the paint but the congruence between paint and flesh as we see it in the *Lucretia* (pls. 8, 9), the *Claudius Civilis* (pl. 4), *The Slaughtered Ox* (pl. 10), and the *Self-Portrait with Dead Bittern* (fig. 3.55)—comes to be the rooting of identity in the painting itself.

One could put Rembrandt's representation of himself into words: I paint (or I am painting), therefore I am. When Rembrandt returned to self-portrayal in 1648 after a break of eight years, it was by etching himself as an artist, drawing (perhaps etching) by a window (fig. 4.17). After 1648 almost all of his self-portraits were executed in paint. And in the Kenwood (fig. 4.18), Louvre, and Cologne paintings, Rembrandt for the first time *paints* himself as the artist at work, dressed in studio garb. Occurring when it does in his production of self-portraits, this is less a matter of taking up an es-

tablished subgenre of portraiture, or taking on yet another "role," that of the artist, than a matter of taking himself up in a definitive compound with paint. He is not defining himself professionally as a painter, but defining the self in paint.[63]

Portraits of artists—made both by or of them—proliferated in the Netherlands. Although they account for only a small percentage of such works, the paintings commissioned by kings and princes were in many respects exemplary of the type, and the Medicis' famous gallery of artist's self-portraits is representative of the interest in them that princes had. Their requests might specify, as the Medici agent did to Mieris, that the artist paint himself in the process of painting or holding some small work with figures by the painter's hand. In self-portraits of this type, the established order was defined and confirmed: the servant of the prince delivered an image of himself which served a certain social order and a certain notion of art (fig. 4.16). This stance also informs other artists' portraits: self-portraits that were done for patrons other than princes; portraits of the artist at work, such as the Dutch pictures which show the artist by his easel with a musical instrument (these are not necessarily self-portraits); and those artists' self-portraits which make no reference to the profession, but accommodate to other social institutions such as the family. Rubens, who painted himself most unwillingly, did so only for a king, in friendship, or in marriage. Even when a self-portrait was done out of friendship, as witness Poussin's self-portraits for Pointel and Chantelou, it entertained the ambition to offer a definition of Art and of the status of the artist. On this point iconographic studies are correct. It is less the diverse notions of the artist and of art than the fact that such notions were generally in play to which I wish to call attention.[64]

Though one of Rembrandt's self-portraits found its way into King Charles I of England's collection of artists' portraits, he never painted himself at a ruler's behest (fig. 4.19). Baldinucci's remark that the foremost monarch would not be granted an audience while Rembrandt was painting, registers, by opposition, the established norm of artists serving kings.[65] When Rembrandt sports armor or a gold chain, it is as a performance within the studio. Even the 1640 *Self-Portrait* in London, which is exceptional by virtue of its openly declared relationship to artistic tradition, would seem to be a studio version of the self-portrait of the artist with public intent (fig. 4.20). Though it appears to be addressed to a patron's world, it does not appear to have been done at a patron's behest. The painting in Liverpool from the collection of Charles I is one of only two self-portraits which

are inventoried as such in collections during Rembrandt's lifetime—
the other was owned by the dealer De Renialme. King and dealer:
they represent the old patronage world and the new market for self-
portraits.[66]

Rembrandt first painted self-portraits for the studio, then for
himself and the market. The last two were options he treated as
one. Because his self-portrayal began as studio practice instead of as
a presentation of the artist to the world, Rembrandt was able to
transform self-portraiture into a new image of self.[67] To paint him-
self painting and to devise this in the name of himself was an origi-
nating act. The point needs stressing. Knowing the works of Van
Gogh and Cézanne as we do, we are accustomed to thinking of self-
portraiture of this type as central to the painter's art, and we are
likely to conclude that it did not require inventing.

A few years back a debate took place between Meyer Schapiro
and Jacques Derrida over Martin Heidegger's comments on the na-
ture of Van Gogh's paintings of shoes. The debate bears on the rela-
tionship of the painter to his work. Put briefly: to Heidegger's de-
scription of the shoes as objects made for use, and of the painting as
the essence of their (and its) instrumentality, "the disclosure of what
equipment . . . *is* in truth," Schapiro replied that the shoes are not an
instrument of use but "a portion of the [artist's] self . . . the artist's
presence in the work . . . a piece from a self-portrait," against which
Derrida argued that they were neither shoes, nor self-portraiture,
because a painting marked the absence of both the shoes and the
painter: "Donc un oeuvre comme le tableau aux chaussures exhibe
ce qui manque à quelque chose pour être une oeuvre, elle exhibe—
en chaussures—le manque d'elle-même, on pourrait presque dire
son propre manque." From a useful object in paint, to the artist
painting his shoes as self-portrayal, to just a painting. As far as ab-
sence is concerned, Derrida could as well have been speaking as he
has done elsewhere of the nature of texts, but what Heidegger says
about objects and Schapiro about the self help us to attend to things
peculiar to paintings (and I specifically mean easel paintings as dis-
tinguished from images in general) in our tradition.[68]

For there is an added curiosity about "I paint, therefore I am":
the painter, unlike the writer, defines or knows himself in or as a
material object—in Rembrandt's case, as we have seen, the very
substantiality of the paint emphasized this condition.[69] There are
then two senses in which Rembrandt can be said to dwell on himself
in paint: in the act of painting, and as, or in the form of, a painting.
The sliver of canvas just visible along the right edge of the Ken-

wood self-portrait (so slight that it is often cropped in reproductions) to which he does not turn or lift a brush is Rembrandt's anti-illusionistic way of calling attention to the painter's condition (fig. 4.18). In its distinctive abbreviation, the depiction of the canvas matches that of the hand constructed, as we saw earlier, out of the instruments of painting. It is on canvas, and in paint—note the thick white lead building up the simple painter's cap, the red touch of paint as the tip of nose—and by means of maulstick, palette, and brush, that Rembrandt knows himself. It is more appropriate to describe such knowledge as self-possession than as self-consciousness. The late self-portraits offer a concrete instance of an individual representing himself as possessing, and hence having property in, himself. The paradox is that the self as possession, the self possessed, in the instance of Rembrandt's self-portraits is marketable in a literal sense. We have come full circle, then, as Rembrandt did: his works are commodities distinguished from others by being identified as his; and in making them, he in turn commodifies himself. He loved only his freedom, art, and money, to recall the words of Descamps. Or, put differently, so as to bring out connections between the terms, Rembrandt was an entrepreneur of the self.

In the course of considering Rembrandt as *pictor economicus,* we have been reconsidering his practice as set forth in the previous chapters—his obsessive working of the pigment, the framing of the studio as the domain where life is reenacted under direction, the desire for freedom from the patronage system, and the claim to individuality. The question of his relationship to tradition can also be put in the frame of his relationship to the market. The superficial evidence of his practice as artist and as teacher shows that it is hard to demonstrate Rembrandt's sources. His practice as a teacher reflects on his own practice: Rembrandt was uneasy about admitting to any authority outside of himself. One could give a number of different accounts of this phenomenon, of which I will suggest two. A religious consideration might argue that there is something particularly Protestant about such a stance (in constrast, for example, to the Catholic convert Rubens who celebrated and was at ease with authority both artistic and political). Since any question of pictorial generation and succession involves questions of filiation, the phenomenon also lends itself to treatment in psychological terms. A thematic profile of Rembrandt's works would note that he focuses repeatedly on the troubled relationship between generations of men: the father and his prodigal son, Abraham and Ishmael, Jacob and the sons of Joseph. The Old Testament, in the history of the

Jewish tribes, and the New Testament, in God and His Son, make questions of authority and succession central. But Rembrandt's attention to fathers and sons is particularly concentrated and exceedingly fraught. The condition of succession is marked by the injuries sustained by fathers and by others in authority: Saul in disarray before David, the blind Tobit succoured by Tobias, the blind Jacob blessing his grandson, the one-eyed Claudius Civilis joined by his followers. And there is the conclusive appropriateness of two paintings that Rembrandt appears to have left unfinished at his death— the Prodigal son presenting a troubled version, the Presentation to Simon in the Temple a benign one, of generational succession.

An artist's relationship to tradition bears an analogy to a relationship to the authority of God or to the familial father. In general terms, the two accounts of Rembrandt and tradition I have just offered are not wrong. But their appeal is to something external to the works—to a relationship with God or to an anxiety about the father—and they do not offer an account of Rembrandt's particular practice. If to Rembrandt his pictures are his property, then his anxiety about tradition could also be an anxiety about this: his need, as we have seen it manifested in so many other aspects of his art, is to demonstrate that his works are his.

It has often been said that the Renaissance had a different notion of art and of the artist than we ourselves inherited from the nineteenth century—imitation of tradition, emulation rather than originality, characterized their practice. This is the historical rationale behind the art historical agenda to "find the sources," and source-hunting is often accompanied by cautionary words against making anachronistic claims for originality or new inventions. Rembrandt relates to artistic tradition neither in the name of imitation, nor of originality, but in the name of self-possession. We have need for a third term; perhaps *property* will do. Rembrandt registers an uneasiness about taking up an inheritance because he wants assets that he can call his own.

Why is it, then, to return to those questions of authenticity and attribution with which we began this book, that this sense of property in self does not preclude that replication of self which we find in every area of Rembrandt's work—in his repeated self-portrayal, in his own incessant reworkings and reprinting of his etched plates, in the myriad paintings and drawings in his manner by studio assistants. Why does it not preclude his encouraging other artists to pass themselves off as himself? For there is another account to be given of Rembrandt's self-portraits, which bears not on the qualities

of each as a pictorial object, but rather on the extension of the type, on their multiplication. Rembrandt was not the only Dutch painter who painted himself repeatedly. Rembrandt's student Dou and, in turn, his student Mieris—three generations of painters—did so also. And the interest in the multiplication of images of oneself was not confined to painters: their merchant-patrons also shared the taste for the representation and the replication of themselves in paint. Jacob Trip and his wife appear in at least ten different pictures (and that is perhaps simply all that remains of even more paintings that they ordered made of themselves) (figs. 3.69, 3.70). A large family wanting images of parents for their homes has been offered as an explanation, but it also suggests a certain anxiety about the definition of the real person. It was a society in which an interest in the representation of self went hand-in-hand with its repetition, and its replication. The example of Rembrandt focuses the general issue.[70]

Rembrandt depicted himself more often than other painters of the time—approximately fifty times in paint, twenty in etching, and about ten times in surviving drawings. At least when he was young, he also sat to other painters: a portrait by Lievens and one by Flinck (one of a pair with Saskia) are unsettling, since, for all their variety, we are accustomed to believe Rembrandt's views of Rembrandt, not someone else's view of him (figs. 4.21, 4.22). Here, though, at least in works clearly attributed to others, the authority is clear: this is Rembrandt according to Lievens, or Rembrandt according to Flinck. But what do we make of Rembrandt's habit early on of having his studio do copies of his own self-portraits? It is very possible that in the Kassel painting we have a copy painted and taken home by a student after the Rembrandt *Self-Portrait* now in Amsterdam (figs. 4.23, 4.24). Perhaps the looser—previously seen by experts as bolder—laying on of paint in the Kassel version can be ascribed to the absence of the model. As if in compensation for his absence, the copyist reveals more of the eyes—eyes that in this instance did not in fact see.

Rembrandt encouraged a student painter to copy his self-portrait, itself a study work using himself as a model. What kind of a work is a self-portrait by another hand? How can there be a copy of a self-portrait? Can one still call it a self-portrait or is it now a portrait, like that by Lievens? Perhaps it is a nonautographic self-portrait and the interesting question is not really philosophical at all, but rather about the diffusion of self. To a work like that in Kassel we must add works which are described today as copies after lost Rem-

brandt self-portraits, composite works that are made up after several of his self-portraits, or portraits done in the manner of Rembrandt self-portraits (fig. 4.25). The proliferation of self-portraits by later artists working in the Rembrandt manner is a kind of logical extension of Rembrandt's own production. When Courbet copied a non-autograph Rembrandt self-portrait, or, stretching things a bit, when Reynolds's self-portrait mimics Rembrandt's in lighting and in expression, or when Picasso portrays himself Rembrandt-like but as a child, they are playing the game according to his rules (figs. 4.28, 4.29, 4.30).[71] His investment in himself continues to pay off—but just what are the returns? It is disturbing when the authenticity of a once much admired work, such as the *Self-Portrait* in Aix-en-Provence, is challenged, or when one in Washington's National Gallery is said to be a (perhaps eighteenth-century) forgery, particularly so when the painting like that in Aix has been the occasion for probing commentary on Rembrandt (figs. 4.26, 4.27).[72] But Rembrandt virtually promoted these mistakes and deceptions himself. At the core of his own work were his self-portraits, and Rembrandt appeared to have been willing, even anxious, to encourage others to pass themselves off as himself.

Rembrandt displays and extends his authority in a manner that calls authenticity into question. This despite the fact that authenticity as a marketing feature was laid down in his own practice. Speaking of the Rembrandts that they had studied, a member of the Rembrandt Research Project complained: "In a number of cases it is all but impossible to decide whether the Rembrandtesque aspect is due to a deliberate or even a fraudulent intention, or to Rembrandt's direct influence on a pupil or a follower."[73] In Rembrandt's lifetime, inventories already listed works as done "after" Rembrandt, and the number of these actually decreased over the years not because the rate of production decreased, but because fraudulent claims ("What I have is an original") multiplied. The notion of individual pictorial identity embodied in Rembrandt's painting was threatened by the very proliferation in which his studio—and others—engaged.[74]

We have come full circle. Rembrandt was in good measure responsible for the questions that have been raised about the authenticity of *The Man with the Golden Helmet* (pl. 12). Let us look again at that aging man in his great golden helmet: worked gold caps the flesh of a face worn by time. Attention is paid to pitted flesh and to gold fabricated out of paint. The painting constitutes an individual who is not identified. The bust-length format might not be the most

characteristic one, but the values invoked and juxtaposed—human, aesthetic, and economic—are almost too good to be true. The painting is a fitting conclusion to this extended gloss on Descamps's dictum that Rembrandt loved only three things: his freedom, art, and money. It is no wonder that *The Man with the Golden Helmet* has been taken to be an essential or canonical Rembrandt. And it is nonetheless so if its authenticity is in question. The painting may not be by his hand, but the old man is an individual of the tribe of Rembrandt—an artist whose enterprise is not reducible to his autographic oeuvre (figs. 4.31–38).

NOTES

INTRODUCTION

1. Heading of article in the *Sunday Times*, 7 September 1986, p. 1.

2. Jacob Rosenberg, *Rembrandt*, 2 vols. (Cambridge: Harvard University Press, 1948), 1:58–59.

3. A statement attributed to Jan Kelch, curator at the Berlin Museum, by UPI in an article entitled, "A 'Rembrandt' Isn't, Experts Say," *New York Times*, 19 November 1985, p. C21. Since then the museum has published a report on the findings about the painting, *Bilder im Blickpunkt: Der Mann mit dem Goldhelm*, ed. Jan Kelch (Berlin: Staatliche Museen, 1986).

4. The sources of the quotations are the following: advertisement for the Stanhope Hotel, *Wall Street Journal*, 1 May 1986, p. 12; Stephen Farber in the television section of the *San Francisco Chronicle Datebook*, Sunday, 27 May 1984, p. 43; Michael Taylor, *San Francisco Chronice*, 17 June 1986, p. 94; Ray Ratto, *San Francisco Chronicle*, 6 October 1986, p. 59.

5. See David Robinson, *Chaplin: His Life and Art* (New York: McGraw Hill, 1985).

6. Egbert Haverkamp-Begemann, as quoted by Michael Brenson in a column entitled "Scholars Re-examining Rembrandt Attributions," *New York Times*, 25 November 1985, p. 61.

7. Gary Schwartz, *Rembrandt: His Life, His Paintings* (New York: Viking, 1986), p. 10.

8. Otto Friedrich, *Time Magazine*, 16 December 1985, p. 100.

9. In order, the books referred to are C. Hofstede de Groot, *Catalogue raisonné of the works of the Dutch . . . Painters*, vol. 6 (London, 1916); W. R. Valentiner, *Wiedergefundene Gemälde (Klassiker der Kunst)* (Stuttgart-Berlin, 1921); A. Bredius, *Rembrandt Gemälde* (Vienna: Phaidon, 1935); A. Bredius, *Rembrandt: The Complete Paintings*, ed. H. Gerson (London: Phaidon, 1969). For a different account of the history and status of Rembrandt attributions, see Horst Gerson in *Rembrandt after Three Hundred Years: A Symposium* (Chicago: The Art Institute, 1974), pp. 19–29.

10. Lord Clark wasn't wrong when he wrote that "Rembrandt was the most inspiring teacher that had ever lived. . . . Thus mediocrities could paint master-

pieces," *Bulletin van het Rijksmuseum* 71 (1969), p. 116. But I would describe Rembrandt as exercising authority as head of a studio rather than as an inspirational teacher. For reattributions of paintings to members of Rembrandt's studio, see J. Bruyn's review of W. Sumowski, *Gemälde der Rembrandt-Schüler*, in *Oud Holland* 98 (1984): 146–59. Bruyn proposed that a number of Rembrandtesque works, including *The Polish Rider*, were painted by Willem Drost.

11. Kay Larsen, *New York Magazine*, 23–30 December 1985, p. 73.

12. John Smith, *A Catalogue Raisonné of the Works of the Most Eminent Dutch, Flemish and French Painters*, 8 vols. (London: Smith and Son, 1829–37), vol. 7, no. 430. For the description by the Dutch collector, see Bob Haak, *Rembrandt: His Life, His Work, His Times* (New York: Harry N. Abrams, 1969), p. 321.

13. For a summary of the many studies of the painting, see R. H. Fuchs, "Het zogenaamde *Joodse Bruidje* en het probleem van de 'voordracht' in Rembrandts werk," *Tijdschrift voor Geschiedenis*, 82 (1969): 482–93. The principle of *"Herauslösung,"* or selection, was introduced by Christian Tümpel, and Jan Bialostocki proposed the notion of encompassing themes. For a discussion of Rembrandt's iconography, see the 1969 symposium led by Bialostocki, in *Rembrandt after Three Hundred Years: A Symposium* (Chicago: Art Institute of Chicago, 1974), pp. 67–82. The basic study of the genre known as *portrait historié* is Rose Wishnevsky, *Studien zum "portrait historié" in den Niederlanden* (Munich, 1967).

14. "Like so many Dutch *Mona Lisa*s, Rembrandt's half-lengths combine the attractions of inscrutability and unassailable artistic reputation. They provide the viewer with a flatteringly fuzzy mirror for his own most profound reflections on the meaning of life. . . ." Gary Schwartz, *Rembrandt*, p. 305.

15. J. A. Emmens, *Rembrandt en de regels van de kunst* (Utrecht: Haentjens Dekker and Gumbert, 1968); reprinted as vol. 2 of J. A. Emmens, *Verzameld werk*, 4 vols. (Amsterdam: G. A. van Oorschot, 1979).

16. One review was disturbed by the absence of any new "picture" of Rembrandt to replace the debunked views of the nineteenth century; see Vitale Bloch, "Recent Rembrandt Literature," *Burlington Magazine* 108 (1966): 527. Another complained about the limitations of Emmens's "theoretical" approach in dealing with the practice of making, and the interest in viewing, pictures; see R. H. Fuchs, "Reconstructing Rembrandt's Ideas about Art," *Simiolus* 4 (1970): 54–57.

17. Miedema suggested the direction that work with texts should take in his review of Emmens in *Oud Holland* 84 (1969): 249–256. He has since produced, among other things, a translation into modern Dutch and a commentary on Karel van Mander, *Den grondt der edel vry schilder-const* (Utrecht: Haentjens Dekker & Gumpert, 1973); a study of Van Mander's recasting of Vasari's *Lives* of the Italian painters, *Karel van Manders "Leven der Moderne, oft Dees-Tijtsche Doorluchtighe Italieaensche Schilders en hun bron." Een vergelijking tussen van Mander en Vasari* (Alphen aan den Rijn: Canaletto, 1984); and a commentary on Angel in *Proef*, 1973.

18. Emmens, *Rembrandt*, pp. 91–92, identifies Horace as the source of an account of Rembrandt's greedy attempting to pick up some coins painted on the floor by his assistants. Whether or not the account by Houbraken is indebted to Horace's miser who tried to pick up coins soldered to a crossroad, the tale as it is told suggests things about the relationship between Rembrandt, art, and money that distinguish it from a general classicistic critique. For the identification of the

discipline of art history with a classicistic concept of art, see Emmens, ibid., pp. 175–76.

19. *A Corpus of Rembrandt Paintings* (The Hague, Boston, London: 1982–): volume 1 was published in 1982, volume 2 in 1986. It is clear within the volumes themselves, as well as in the scholarly response they have received, that scientific or technological means such as dendrochonology (the dating of wood used for a panel), x-rays, infrared photography, or the new autoradiography (the activation of the underlying layers of paint by a beam of neutrons to illuminate the painting's substructure) assist, but do not replace, connoisseurship or the judgment of the trained eye. A pair of portraits in the Metropolitan Museum (figs. 4.31, 4.32) that have been disattributed by the Research Project had shortly before been approved as Rembrandts on the basis of autoradiographs! See Ainsworth et al., *Art and Autoradiography* (New York: Metropolitan Museum of Art, 1982), p. 29, and *Corpus*, vol. 2, C 58 and C 59, pp. 740–59. The Metropolitan itself (understandably) waffled on this matter. In the *New York Times* of 30 September 1986 (section C, p. 13) an article appeared entitled "Met. to Relabel Two of Its Rembrandts," and on 15 November 1986 (p. 12) an article entitled "Met. Museum Postpones Relabeling of Rembrandts." A meeting of American and Dutch experts, convened in Boston in February 1987 to discuss these and three other "problematic" Rembrandts in American collections, apparently ended in a stalemate: the Americans for, the Dutch against, the attributions to Rembrandt. See John Russell, "The Cordial Conflict on Rembrandt Continues," *New York Times* (Western edition), 19 Feb. 1987, p. 1.

The case of Rembrandt makes it particularly clear that the question of attribution is not the same as the question of originality or of invention. Where, then, does "quality" lie? That individuality claimed by Rembrandt's mode of painting, an individuality which, however, is produced in a workshop situation, presents the problem in a particularly complex way. For the determining criteria of attribution, see Ernst van de Wetering, "Studies in the Workshop Practice of the Early Rembrandt," (Academisch Proefschrift, Amsterdam, 1986), introduction, p. xi (published preface to Ph.D. thesis).

It has been suggested that "Rembrandtesque" paintings made under Rembrandt's direction are of three types: (1) study heads taken home by pupils, (2) copies after Rembrandt, and (3) paintings by the assistants sometimes perhaps even signed and sold as Rembrandts. See Ben Broos, "Fame Shared Is Fame Doubled," in *Rembrandt: Impact of a Genius* (Amsterdam, 1983), p. 41.

While the Amsterdam project is trying to distinguish Rembrandt's paintings from those of his assistants and followers, another ongoing publication has been attempting to identify and to illustrate all the paintings by artists presumed to have been Rembrandt's students; see Werner Sumowski, *Gemälde der Rembrandt-Schüler*, 4 vols. (Landau/Pfalz, 1983–), three volumes in print to date. This follows on Werner Sumowski, *The Drawings of the Rembrandt School*, 4 vols. (New York: Abaris, 1981–84).

20. Gary Schwartz, *Rembrandt: His Life, His Painting* (New York: Viking, 1986).

21. *Bij Rembrandt in de Leer: Rembrandt as Teacher* (Amsterdam: Museum het Rembrandthuis, 1985); *Tekeningen van Rembrandt in het Rijksmuseum: Drawings by Rembrandt in the Rijksmuseum* (The Hague: Staatsuitgeverij, 1985). Rembrandt's

drawings are undergoing an investigation paralleling that of the paintings, with similar results. Like the Bredius catalogue of 630 paintings, it appears that the Benesch catalogue of approximately 1,300 drawings represents "Rembrandt, his anonymous pupils and followers," to quote the subtitle of Schatborn's catalogue of the Rijksmuseum drawings.

CHAPTER I

1. "Talvolta alzava sopra tal luogo il colore poco meno di mezzo dito," Baldinucci, p. 79; "Hy eens een pourtret geschildert heeft daar de verw zoodanig dik op lag, datmen de schildery by de neus van de grond konde opligten. Dus zietmen ook gesteente en paerlen, op Borstcieraden en Tulbanden door hem zoo verheven geschildert al even of ze geboetseerd waren"; "Om eene enkele parel kragt te doen hebben, een schoone Kleopatra zou hebben overtaant," Houbraken, 1:269, 259. "Painted out" is not quite the correct translation for the Dutch *overtaant*, which means to varnish something over—but the effect of obliterating Cleopatra remains.

A modern conservator has written of the earthenware vessel in the Kassel *Holy Family* (fig. 4.11), "A plaster cast could be taken of this vessel." A. J. P. Laurie, *The Brushwork of Rembrandt and His School* (Oxford: Oxford University Press, 1932), p. 8.

2. For the disputing of the attribution of "*The Man with the Golden Helmet*" because of the impasto, see Keith Roberts in the *Burlington Magazine*, 118 (1976): 784.

3. I owe this suggestion about *The Night-Watch* to Gridley McKim-Smith. It is the kind of minutia of practice that one hopes will be clarified in the course of current investigations of Rembrandt's paint surface. For the major evidence altering previous notions of Rembrandt's technique, see the "Summary Report on the Results of the Technical Examination of Rembrandt's *Nightwatch*," *Rijksmuseum Bulletin* (1976–77): 68–98. The presence of red glaze in a middle layer of paint from Banning Cocq's scarf (p. 93) might confirm Rembrandt's sometimes profligate and idiosyncratic use of materials. (It is, however, very difficult to explain the use of paint: the report on *The Night-Watch* suggests that the red glaze might have been used as the top layer of paint elsewhere on the scarf; apparently Venetian painters on occasion did use red lake for underdrawing.) Though wary of generalizing on the basis of one painting, the authors suggest that what was found in the case of *The Night Watch* has general relevance to Rembrandt's practice. Rembrandt's habit, apparently not unusual in the northern Netherlands at the time, of working up a painting from background (or top) to foreground would have necessitated paint layers thick enough to cover the previous layer—though this of course would not account for the particular thickness of Rembrandt's paint. For an exposition of this working method, with additional comments on Rembrandt's handling of the paint, see *Corpus*, 1:25–31. A useful selected bibliography of commentary on Rembrandt's manner of painting is in *Rembrandt after Three Hundred Years: A Symposium*, Chicago: Art Institute of Chicago, 1974, pp. 96–101. Technical studies have multiplied since then. Later publications are listed in *Corpus*, 1:11 n. 1.

To say that a painter did not paint in the Venetian manner is not necessarily to say that he did not want to convey the look of Venetian paintings. Although Velázquez, as Gridley McKim-Smith argues in *Examining Velázquez*, did not employ glazes as Titian did, he seems to have wanted his remarkably insubstantially

painted pictures to appear from a certain distance like ones structured in the complex Titian manner. See Gridley McKim-Smith, with Greta Andersen-Bergdoll and Richard Newman, *Examining Velázquez* (New Haven: Yale University Press, 1988). Though it is indisputable that Rembrandt shared Titian's love of paint, in my judgment he did not want to convey a Venetian effect, whatever the viewer's distance. It is notable that aside from a remark by Roger de Piles, Rembrandt, unlike Velázquez, was not repeatedly compared to Titian by the early commentators. For a more positive assessment of Rembrandt's indebtedness to Titian, see Amy Golahny, "Rembrandt's Paintings and the Venetian Tradition" (Ph.D. diss., Columbia University, 1984).

The account offered by A. P. Laurie, *The Brushwork of Rembrandt and His School*, still holds up, though I disagree with his notion of what he calls "Rembrandt's drawing with the brush."

4. "E quel che si rende quasi impossibile a capire si è, come potesse essere, ch'egli col far di colpi operasse si adagio, e con tanta lunghezza." Baldinucci, p. 79. In the face of the enormous amount of technical information that is now being generated about Rembrandt's materials and his handling of them, we should not forget how much of the process of laying on the paint he exposed to the viewer's eye. His blocking in of figures on the ground—misleadingly referred to as drawing—that is exposed by autoradiography reveals traces that Rembrandt successfully managed to hide. See Maryan Wynn Ainsworth, John Brealey et al., *Art and Autoradiography: Insights into the Genesis of Paintings by Rembrandt, Van Dyck, and Vermeer* (New York: Metropolitan Museum of Art, 1982).

5. See Horace, *Ars Poetica*, ll. 361–65. Rensselaer Lee is misleading on this point. Horace does not distinguish between two modes of execution, but between two modes of viewing. And he prefers the work viewed near, which sustains repeated viewing, to the work viewed from afar, which satisfies only once. See Lee, *Ut Pictura Poesis: The Humanistic Theory of Painting* (New York: W. W. Norton & Company), pp. 5–6, and, for a correction to this reading, C. O. Brink, *Horace on Poetry: The "Ars Poetica"* (Cambridge: Cambridge University Press, 1971), pp. 368–72.

6. For the *locus classicus* among modern accounts of the phenomenon, see E. H. Gombrich, *Art and Illusion* (New York: Pantheon Books), pp. 191–202.

7. For a discussion of the relevant seventeenth-century texts and modern commentaries, see the review by B. P. J. Broos of Seymour Slive, *Frans Hals*, in *Simiolus* 10 (1978–79): 121–23.

8. For the studio anecdote see Houbraken, 1:269: "Waarom hy de menschen, als zy op zyn schilderkamer kwamen, en zyn werk van digteby wilden bekyken terug trok, zeggende: *de reuk van de verf zou u verveelen.*" That Houbraken himself assumed a relationship between rough paint and distance, smooth and proximity, is clear from his comments on the paint of Rembrandt's student Aert de Gelder, Houbraken 3:206. For Rembrandt's letter to Huygens, see *Documents*, no. 1639/4, p. 167, "Mijn heer hangt dit stuck op een starck licht en date men daer wijt ken afstaen soo salt best voncken." Contrary to Horace, who recommended bright light as a suitable accompaniment to the close-up view, Rembrandt recommended light and distance.

9. Jan de Baen is the standard example cited in modern accounts of the seventeenth-century literature on the choice between rough and smooth; see Houbraken, 2:305. See also Broos, review of *Frans Hals*, p. 123.

10. In the current literature on Rembrandt, the marked roughness of his paint surface has been understood in two ways: as addressed to the sophisticated viewer or as simply involved with practice. Contemporary textual evidence exists for each description, but they are in contradiction and incommensurate both with regard to the system of discourse from which they come (Horace and Vasari et al. versus Aristotle and followers) and in their conclusions (one describing Rembrandt as appealing "up" in a sophisticated way, the other as working with no rules). If pressed to place my analysis in relationship to these, I am reframing in intentionalist terms the description of practice put forth in Aristotelian categories by Emmens (see the Introduction, above).

11. This discussion of Jan Bruegel is much indebted to the unpublished research of Anita Joplin.

12. Albert Blankert has made this suggestion about the unexercised still-life potential of Ferdinand Bol, whose only still-life, formerly attributed to Rembrandt himself, hangs today in the Hermitage. See Albert Blankert, *Ferdinand Bol* (Doornspijk: Davaco, 1982), pp. 30, 70.

13. I owe this example as well as much of my consideration of the value of illusion to the work of Walter Benn Michaels. See his "The Gold Standard and the Logic of Naturalism," *Representations* 9 (1985): 105-32.

14. A traditional view is that Rembrandt was inspired by the series of etchings of shells by Wenzel Hollar. This does not change the thrust of my argument.

15. This is a hard thing to prove. But my judgment is borne out by a remark of the conservator Ben Johnson about Rembrandt's early *Raising of Lazarus*, "He has completely freed himself from the restraints of Lastman's teachings and allowed his response to the paint substance to dominate." See Ben B. Johnson, "Examination and Treatment of Rembrandt's 'Raising of Lazarus,'" *Bulletin of the Los Angeles County Museum* 20 (1974): 28.

16. Velázquez's use of expensive pigments is discussed in McKim-Smith's *Examining Velázquez;* for Van Mieris, see Otto Naumann, *Frans van Mieris,* 2 vols. (Doornspijk: Davaco, 1981) 1:48-49; for Rembrandt, see W. Froentjes, "Schilderde Rembrandt op goud," *Oud Holland* 84 (1969): 233-37. The conservation report on *The Raising of Lazarus* considers the paint structure across the entire surface of the work and tries to match words to artistic intent as it is revealed in the very material of the painting. See Ben B. Johnson, "Examination and Treatment of Rembrandt's 'Raising of Lazarus,'" *The Los Angeles County Museum Bulletin* 20 (1974): 18-35. The discussion in *Corpus,* 1:296, notes that this picture underwent significant changes in the course of its painting and suggests that the complex paint layers are hardly characteristic of Rembrandt's working method.

17. I am referring to a manuscript by Henry Vaughan cited by Charles S. Rhyne in an unpublished lecture. Vaughan was looking at the *Hay Wain* with Constable's close friend Charles Leslie one day and reports that Leslie "examined the picture very closely, closed his eyes and passed the points of his fingers over the picture in order, as he said, to trace the forms of the impasto touches of the painter."

18. The notion of seeing as an activity contrasts with the interest of the Dutch (be they painters or investigators in natural knowledge such as Leeuwenhoek) in the eye as a picture-making mechanism. For an exposition of the picture-making

model of sight and the mode of art adapted to it, see my *The Art of Describing: Dutch Art in the Seventeenth Century* (Chicago: University of Chicago Press, 1983). There I mistakenly argued that Rembrandt offered touch as an alternative to sight. The phrase "seeing with sticks" is taken from Diderot's *Lettre sur les aveugles à l'usage de ceux qui voient* (1749), "Open the *Dioptrique* of Descartes, and you will find there the phenomena of vision related to those of touch, and illustrations full of men occupied in seeing with sticks. Neither Descartes nor those who have followed him have been able to give a clearer conception of vision." It is translated and discussed by Michael J. Morgan, *Molyneux's Question: Vision, Touch and the Philosophy of Perception* (Cambridge: Cambridge University Press, 1977), p. 34.

19. The painter Philip Guston has written, "In Rembrandt the plane of art is removed. It is not a painting, but a real person—a substitute, a golem. He is really the only painter in the world!" "Faith, Hope and Impossibility," *The Art News Annual* 31 (1966): 153. To which one might add Picasso's confirmation, "Every painter takes himself for Rembrandt," attributed to Picasso in Françoise Gilot and Carlton Lake, *Life with Picasso* (New York: Avon Books, 1981), p. 45.

20. See E. H. Gombrich, *Art and Illusion* (New York: Pantheon, 1960), fig. 246.

21. "Zietmen een goede hand van hem 't is zeldzaam, wyl hy dezelve, inzonderheid by zyn pourtretten, in de schaduw wegdommelt. Of het mogt een hand zyn van een oude berimpelde Bes," Houbraken 1:261. See *Corpus* 1:351, for a modern description of the "elaborately painted hand" of Rembrandt's old woman in Amsterdam.

22. For the question about who executed the attendant figures, see Bob Haak, *Rembrandt: His Life, His Work, His Times* (New York: Harry Adams, n.d.), p. 328.

23. For these comparisons and for a careful study of the painting, including the circumstances of the commission, see Julius S. Held, *Rembrandt's Aristotle and Other Rembrandt Studies* (Princeton: Princeton University Press), pp. 3–44.

24. A recent study argues the philosophical significance of the golden chain and proposes that in this picture Rembrandt is affirming that the contemplation of art is a philosophical activity. This suggests to me that the touching of the chain with the left hand might be as notable as the touching of the bust with the right. See Margaret Deutsch Carroll, "Rembrandt's *Aristotle:* Exemplary Beholder," *Artibus et Historiae* 10 (1984): 35–56.

25. See William S. Heckscher, *Rembrandt's "Anatomy of Dr. Nicolaes Tulp"* (New York: New York University Press, 1958), and William Schupbach, *The Paradox of Rembrandt's "Anatomy of Dr. Tulp"* (London: Welcome Institute for the History of Medicine, 1982).

26. Schupbach, *Paradox*, p. 8, has convincingly demonstrated that the gesture of Tulp's hand illustrates the working of the muscles displayed in the corpse and the relevance to this of Aristotle's description of the hand in *De partibus animalium* 4.10.687a5–b24. But in pursuit of what he calls (p. 41) "the picture's precise meaning"—which he defines as the paradoxical juxtaposition of two established lessons drawn from anatomy, "*cognitio sui*" and "*cognitio Dei*"—Schupbach risks passing right by Rembrandt's vested interest in the represented hand.

27. See B. P. J. Broos, "The 'O' of Rembrandt," *Simiolus* 4 (1971): 150–84, which gives references to the literature.

28. Aristotle, *Parts of Animals*, trans. E. S. Forster (Cambridge: Harvard Uni-

versity Press, The Loeb Classical Library), 4.10.687b4. Reynolds, perhaps the earliest commentator on this painting, took particular, and critical, note of the hand: "Rembrandt's portrait, by himself, half length, when he was old, in a very unfinished manner, but admirable for its colour and effect: his pallet and pencils and mahlstick are in his hand, if it may be so called; for it is so slightly touched, that it can scarce be made out to be a hand." Sir Joshua Reynolds, *A Journey to Flanders and Holland in the Year 1781*, in *The Works*, ed. Edmond Malone, 3 vols. (London: Cadell & Davies, 1809), 2:266.

29. Leo Steinberg, "The Eye Is a Part of the Mind," in *Other Criteria* (New York: Oxford, 1972), p. 302.

30. Giorgio Vasari, *Le vite de' piu eccelenti pittori, scultori ed architetti*, in Le Opere, ed. G. Milanesi, 9 vols. (Florence: Sansoni, 1878–85), 7:281. I profited in these matters from Hans-Joachim Raupp, *Untersuchungen zu Künstlerbildnis und Künstlerdarstellung in den Niederlanden im 17. Jahrhundert* (Hildesheim, Zurich, New York: Georg Olms Verlag, 1984). The various depictions of art in the family context which I consider as a group here, and again in chapter 3, are discussed by Raupp under a number of different typological categories (artists as virtuosi, or the motif of the genial turn of the head, for example), which do not bring out the domestic continuity they share.

31. For further examples of the genre of the artist with wife and family, see the exhibition catalogue *Maler und Modell* (Baden-Baden, Staatliche Kunsthalle, 1969), and E. de Jongh, *Portretten van echt en trouw: Huwelijk en gezin in de Nederlandse kunst van de zeventiende eeuw* (Zwolle: Waanders BV, 1986), pp. 270–78. In the introduction (pp. 55–57) De Jongh suggests that the Dutch artist in the family applies a humanist topos about the creative powers of love to the art of painting and the Dutch marital situation. The commonplace under which he groups such works is "Liefde baart kunst"—roughly, love gives birth to art. Is the family just another form of love giving birth to art? To answer this question, the conditions of this domesticated representation of art need to be examined in terms of the political, the economic, and the social status of family and household and their relationship to the practice of art.

32. *The Complete Essays of Montaigne*, trans. Donald M. Frame (Stanford: Stanford University Press, 1965), p. 293.

33. Rubens's *De Imitatione Statuarum* was printed and translated in Roger de Piles, *Cours de Peinture par Principes* (Paris: Estienne, 1708), pp. 139–48.

34. My thanks to Yves-Alain Bois who, hearing me try to describe Rembrandt's paintings, suggested that I take a look at Mondrian's practice. See Piet Mondrian, *Bulletin of the Museum of Modern Art* 13 (1946): 35–36. The desire to make a painting a new object, separate from, yet marked as the product of, the artist might be described as the polar opposite of those absorptive desires and pictorial strategies studied by Michael Fried.

35. Sixten Ringbom, *Icon to Narrative: The Rise of the Dramatic Close-up in Fifteenth-Century Devotional Painting* (Doornspijk: Davaco, 1984 [originally published in 1965]).

36. The similarity between cubist Picasso and Rembrandt says something also about Picasso: it was not only in his last years that he had a taste for the Dutch artist; see Janie L. Cohen, "Picasso's Exploration of Rembrandt's Art, 1967–1972," *Arts Magazine* 58 (1983): 119–26.

CHAPTER 2

1. Some basic material on Rembrandt and the theater is assembled by Ben Albach, "Rembrandt en het toneel," *De kroniek van het Rembrandthuis* 31 (1972): 2:32; on the fashion for stage costumes off the stage, see S. A. C. Dudok van Heel, "Enkele portretten 'à l'antique' door Rembrandt, Bol, Flinck, en Backer," *De kroniek van het Rembrandthuis* 32 (1980): 2–9; for a nuanced account of the possible relationship between *The Nightwatch* and civic entries, see Margaret Deutsch Carroll, "Rembrandt's *Nightwatch* and the Iconological Traditions of Militia Company Portraiture in Amsterdam," (Ph.D. diss., Harvard University, 1976). The identification of the Kassel portrait (Br. 171) as the playwright Krul has been denied in *Corpus*, 2:A81. Though he is correct to point to Rembrandt's taste for the company of certain writers of his time, Gary Schwartz's attempt in his *Rembrandt* to reidentify the subjects of a number of his paintings with reference to scenes in particular plays is not convincing. For an argument against the textual correspondences, see Marijke Meijer Drees, "Rembrandt en het toneel in Amsterdam," *De nieuwe taalgids* (1985): 23–30.

2. A succinct account of this sense of the "theatrical" character of Rembrandt's art was given by Kurt Bauch, *Der frühe Rembrandt und seine Zeit* (Berlin: Gebr. Mann, 1960), pp. 192–95. Even a study which rejects the overt references to specific performances proposed by other scholars refers to *The Nightwatch* as a "role-portrait"; see Egbert Haverkamp-Begemann, *Rembrandt: The Nightwach* (Princeton: Princeton University Press, 1982).

3. The entire passage under discussion reads: " . . . unius, inquam, Judae furentis, eiulantis, deprecantis veniam, nec sperantis tamen, aut spem vultu servantis, faciem horridam, laniatos crines, scissam vestem, intorta brachia, manus ad sanguinem compressas, genu temero impetu prostratum, corpus omne miserandâ, atrocitate convolutum. . . ." The Latin text was published by J. A. Worp, "Fragment eener Autobiographie van Constantijn Huygens," *Bijdragen en Medeelingen van het historisch Genootschap* (Utrecht) 18 (1897): 78. The translation is my own.

4. The passage is taken from Calvin's commentary on Matthew 27:3: "And he saith that Iudas was touched with repentance: not that he repented, but that hee was displeased with the heinous offence, which he had committed: as god doth oftentimes open the eies of the reprobate, so that they beginne to feele their sins, and to abhor them. For, they which do ernestly sorrow, so that they do repent, are not said only *Metamenein*, but also *Metanoein*, and thereof also *Metanoia*, which is a true conversion of man unto god. Iudas therefore conceiued a lothsomnes & a horror, not that he might turn himself unto God, but rather that he being ouerwhelmed with dispaire, might be an example of a man wholly forsaken of the grace of God. . . . But if the Papists taught truly in their schooles of repentance, then there is nothing wanting in Iudas, for in him may be founde theyr whol definition. For here is to be seene both contrition of heart, and confession of mo[u]th, & satisfaction of work as they speak. Whereby wee doe gather that they but snatch at the bark: because they do omitte that, which was the chief, the conversion of man to God, whil the sinner broken with shame and feare renounceth himself, that he may yeeld hymself to obey righteousness." John Calvin, *A Harmonie upon the Three Evangelists, Matthew, Mark, & Luke with the Commentaire, translated from the Latine by E.P.* . . . (London: 1584), pp. 727.3 and 728.3. I have chosen to quote an English translation of Calvin's commentary which is very close to a Dutch translation

of 1582 which says of Judas, "een exempel is gheweest van een mensche die gant-schelick van Gods genade berooft is." *Harmonia, dat is een tsamenstemminghe gemaect met de drie evangelisten* . . . (Antwerp: Niclaes Soolmans, 1582), p. 425.

I profited on some points about the *Judas* from the master's thesis of Ann Mclean, "A Study of External Display in Rembrandt's *Judas Repentant* and *Samson's Wedding Feast*" (University of California, Berkeley, 1985).

5. This is not to suggest that Rembrandt necessarily agreed with Calvin's view of Judas's repentance. Given his propensity to accept man as a performer, Rembrandt might well have tended more toward the view of Arminius, who found the Calvinist notion of sin too absolute and repentance less problematic. For a different account of what Rembrandt had invested in Judas, see Jan Bialostocki, "Der Sünder als tragischer Held bei Rembrandt," *Neue Beiträge zur Rembrandt-Forschung*, ed. Otto von Simson and Jan Kelch (Berlin: Gebr. Mann, 1973), pp. 137–50.

6. Hoogstraten, pp. 110, 109: "Om te gelijk vertooner en aenschouwer te zijn"; "Zoo moetmen zich zelven geheel in een toneelspeeler hervormen." The relevance of Hoogstraten to Rembrandt in these passages has been noted by Pieter Schatborn in his catalogue of the exhibition *Dutch Figure Drawings from the Seventeenth Century* (Amsterdam: Meijer Wormerveer, 1981), pp. 11–12. I am indebted to the work and friendship of Celeste Brusati in my reading of Hoogstraten. See Celeste Anne Brusati, "The Nature and Status of Pictorial Representation in the Art and Theoretical Writing of Samuel van Hoogstraten" (Ph.D. diss., University of California, Berkeley, 1984).

7. Hoogstraten is reported to have said to the student, "Lees den Text. . . . Wil dat nu het Beeld wezen dat zulks zeit? . . . Verbeeld u eens dat ik die andere Persoon ben, daar gy zulks tegen moet zeggen; zeg het tegens my. . . ." Houbraken, 2:162.

8. Aristotle recommends that the poet act out his story with the gestures of the participants on the grounds that truthful portrayal is produced by one who feels the emotions involved at the moment. He concludes that therefore the poet is either one of great gift or one with a touch of madness in him. This view entered humanist thinking about the visual arts in Italy with Chyrsoloras's proposal that a practicing and acting artist, to quote Baxandall's felicitous phrase, is "a kind of gymnast of the sentiments." See Michael Baxandall, *Giotto and the Orators* (Oxford: Oxford University Press, 1971), p. 83. See Aristotle, *Poetics*, 17.1455a, and Horace, *Ars Poetica*, 101–7.

9. For a consideration of the artist-actor-poet link, with reference to types of artist portraits and their relationship to contemporary texts on art, see Hans-Joachim Raupp, *Untersuchungen zu Künstlerbildnis und Künstlerdarstellung in den Niederlanden im 17. Jahrhundert (Hildesheim: Georg Olms, 1984)*, pp. 221–41.

10. Houbraken, 2:163.

11. I do not mean to suggest that artists had not served each other as models in studios before. Hoogstraten, in recommending what he refers to as a *"kamerspel"* or chamber-play in the studio, says that many great artists had made use of it; Hoogstraten, p. 192. We can assume that this happened in Italian workshops, and we have evidence in the nineteenth century such as that written by a student of Gleyre's, "We worked out together the movements of our compositions; writing them down before starting to draw. They were generally Biblical subjects. We posed ourselves for the compositional arrangement; one would draw and the others would criticize . . .", quoted in Albert Boime, *The Academy and French Painting in the Nineteenth Century* (London: Phaidon Press, 1971), p. 60. It seems that in the

Gleyre studio students were also fond of putting on amateur theatricals, which a recent scholar describes as among their "non-artistic" activities. See William Hauptman, "Delaroche's and Gleyre's Teaching Atelier and Their Group Portraits," *Studies in the History of Art* 18 (National Gallery, Washington) p. 87. What seems distinctive in Hoogstraten's case is not only the performance of entire plays, but that the artist was supposed to learn not from watching but from acting himself.

12. For the interpretation of the Dresden painting as a moral allegory, see I. Bergstrom "Rembrandt's Double-Portrait of Himself and Saskia at the Dresden Gallery," *Nederlands Kunsthistorisch Jaarboek*, 17 (1966): 143–69; for the x-ray, see Anneliese Mayer-Meintschel's "Rembrandt und Saskia im Gleichnis vom verloren Sohn," *Jahrbuch Staatliche Kunstsammlungen, Dresden* (1970–71): 44–54.

13. The basic article on the subject is still Albert Heppner, "The Popular Theatre of the Rederijkers in the Work of Jan Steen and His Contemporaries," *The Journal of the Warburg and Courtauld Institutes* 3 (1939–40): 22–48; see also the translation and reprint of S. J. Gudlaugsson, *The Comedians in the Work of Jan Steen and His Contemporaries* (Soest: Davaco, 1975; original ed. 1945); also see Walter S. Gibson, "Artists and *Rederijkers* in the Age of Bruegel," *The Art Bulletin* 63 (1981): 426–46.

14. For the acting of Jacques de Gheyn II, see I. Q. van Regteren Altena, *Jacques de Gheyn: Three Generations*, 3 vols. (The Hague: Martinus Nijhoff, 1982), 1:37.

15. See Karel van Mander, *Het Schilderboek* . . . (Haarlem, 1604; reprint Utrecht: Davaco, 1969) 233r (Bruegel); 282v, 283 (Goltzius). A translation of Van Mander's life of Bruegel is available in *Northern Renaissance Art 1400–1600*, ed. Wolfgang Stechow (Englewood Cliffs, N.J.: Prentice Hall, 1966), pp. 37–41.

16. The wearing of a feathered hat or a particular form of dress and the turn of the head in portraits of Dutch artists have all been explained as indicating that these artists identified their inspiration (*ingenium*) with that of poets. But perhaps these are also due to artists' affinity for acting. See Raupp, *Untersuchungen*, pp. 167–241, passim. One might consider in the case of each artist whether acting involved a disappearing act (Goltzius) or an appearing one (Steen, perhaps, and certainly Rembrandt).

17. W. R. Valentiner, "Rembrandt auf der Lateinschule," *Jahrbuch der preussischen Kunstsammlungen* 27 (1906): 118–28 links the subjects of certain paintings to texts that might have been read at school.

18. John Bulwer's *Chirologia* and *Chironomia* (London, 1644) with their extensive illustrations of the gestures used in rhetorical delivery have often been invoked to explain gestures in Dutch paintings. But my interest is to map out the identity between artist and actor assumed in Rembrandt's studio practice. For an account of the relationship between rhetoric and acting as taught and practiced at English schools at the time, see B. L. Joseph, *Elizabethan Acting* (Oxford: Oxford University Press, 1951), pp. 1–18; Donald Leman Clark, *John Milton at St. Paul's School* (New York: Columbia University Press, 1948; reprint 1964).

19. J. A. Worp, *Geschiedenis van het drama en vat het toneel in Nederland*, 2 vols. (Groningen: J. B. Wolters, 1904–8), 1:30.

20. They are discussed in some detail by Worp, *Geschiedenis*, 1:193–239, and P. N. M. Bot, "Humanisme en Onderwijs in Nederland," Ph.D. diss. University of Nijmegen, 1955, pp. 129–33.

21. For Scaliger's letter and the curious coincidence that Constantijn Huygens while at school had performed in the same play, see the fine bit of detective work of Julius S. Held in "Rembrandt and the Book of Tobit," in *Rembrandt's Artistotle and Other Essays* (Princeton: Princeton University Press, 1969), pp. 122-23 n. 29. For the history of the Leiden school, see L. Knappert, "Uit de geschiedenis der Latijnische School te Leiden," *Jaarboek voor de geschiedenis en oudheidkunde van Leiden en Rijnland* 1 (1904): 93-137 and 2 (1905): 14-148.

22. On the basis of the proliferation of such biblical drawings in the studio, Peter Schatborn has concluded that they were probably made especially for Rembrandt's students; see *Drawings by Rembrandt in the Rijksmuseum* (The Hague: Staatsuitgeverij, 1985), p. 93.

23. In illustrating my point with a selection of drawings of this type which were produced over a number of years by Rembrandt and the artists working in his studio, I am not taking up questions of attribution or of date.

24. Houbraken acknowledges Rembrandt's multiplication of such enacted narrative scenes in his remark that he knew of no other artist who had introduced so many variations and so many different aspects of one and the same story; Houbraken, 1:258, "En niemant weet ik dat zoo menige verandering in afschetzingen van een en't zelve voorwerp gemaakt heeft." The first two pairs of drawings discussed in my text were previously singled out as evidence that Rembrandt drew after models in the studio rather than from his imagination. The argument was extended to posit that mirrors were used in the studio to multiply the number of views. Though no theatrical conclusions were drawn, the evidence of the drawings was used to argue that Rembrandt preferred the visual stimulus of figures in his studio. See Nigel Konstam, "Rembrandt's Use of Models and Mirrors," *The Burlington Magazine* 99 (1977): 94-98, which also appeared in Dutch, "Over het gebruik van modellen en spiegels bij Rembrandt," *De kroniek van het Rembrandthuis* (1978): 25-32.

25. The inscription has been published as evidence of Rembrandt's practice as a teacher of drawing by B. P. J. Broos in his review of the *Documents*, in *Simiolus* 12 (1981-82): 258.

26. An exception whose uniqueness, however, proves this rule is the etching of the *Virgin and Child with the Cat and Snake* (B 63) in which Joseph, unseen, is peering in at the group through a window. See Julius S. Held's passing remark about "themes of voyeurism" in Rembrandt in "Rembrandt and the Classical World," in *Rembrandt after Three Hundred Years: A Symposium* (Chicago: Art Institute, 1974), p. 61.

27. A type of narrative image with witnesses was described by Van Mander as a display on many levels, like that of a stallholder at the market setting out his wares. This has been discussed by B. P. J. Broos, "Rembrandt and Lastman's *Coriolanus*: the History Piece in Seventeenth-Century Theory and Practice," *Simiolus* 8 (1975/76), pp. 202-3. I owe the translation of the inscription on the Rebecca drawing to Broos in this article, p. 213.

28. "Uit ons zelven vaeren, of, om beter te zeggen, in ons zelven de gordijn opschuiven, en in ons gemoed de geschiede daet eerst afschilderen," Hoogstraten, p. 178.

29. This procedure should be distinguished from the practice of drawing several views of a model or an object from different sides with the aim of capturing the entire object on the surface of a sheet of paper. One could cite Rubens's drawing

combining several views of a sculptured copy after Michelangelo's figure of *Night* (G. Glück and F. M. Haberditzl, *Die Handzeichnungen von Peter Paul Rubens* [Berlin: Julius Bard, 1928], no. 22).

30. For the classic exposition of this compositional and pictorial mode, see E. H. Gombrich, "Raphael's 'Madonna della Sedia,'" in *Norm and Form* (London: Phaidon, 1966), pp. 64–80.

31. Rembrandt's drawing practice assumes that any single narrative is made up of an infinite number of scenes or, to tease out the theatrical analogy, performances to be drawn. In keeping with this, Hoogstraten noted that the painter is freer than the writer because he can start as he pleases, at the beginning, the middle, or the end of a story, while the writer must deal with things from the ground up. See Hoogstraten, p. 178: "Want de verkiezing eens Schilders is vryer, als die van een History schrijver, zijnde deze verbonden de dingen van den grond op te verhandelen, daer een konstenaer plotselijk of in het begin, in het midden, of wel in het eynde der Historie valt, nae zijn lust en goetdunken."

32. For the studio incident, see Houbraken, 1:257. Emmens treated this as a topos about decorum, repeated by Van Mander and Hoogstraten, with its origins in Vasari's account of a sculpted Adam and Eve of Bandinelli who were said by a critic to deserve being driven out of the church even as Adam and Eve had been out of Paradise. I am not persuaded by the connection. Houbraken presents the anecdote as a comment about studio practice, not about a work of art. And even if it does engage a topos, that does not contradict Houbraken's use of it to convey something about the Rembrandt studio. See J. A. Emmens, *Rembrandt en de regels van de kunst* (Utrecht: Hentjens Dekker & Gumbert, 1968), pp. 87–88. Referred to as "het spel van Adam en Eva," the school play has been identified as *Adamus* by Macropedius (1475–1558); see J. A. Worp, *Geschiedenis van het drama en van het toneel in Nederland* (Groningen: J. B. Wolters, 1904–8), 1:236.

33. It was traditional for models to pose to be drawn in a position determined by past art. The nature of the art-life mixture is easier to describe in such a procedure than it is in Rembrandt's practice.

34. Quoted from T. Gainsford, *The Rich Cabinet*, 1616, by B. L. Joseph, *Elizabethan Acting*, (Oxford: Oxford University Press, 1951) p. 153. It has been said that Van Campen's 1637 Amsterdam *schouwburg* was a poet's theater in the sense that the architecture was not illusionistic, and the actors, in the tradition of the *rederijkers*, recited rather than enacted the poets' texts; see B. Hunningher, "De Amsterdamse schouwburg van 1637: Type en character," *Nederlands Kunsthistorisch Jaarboek* 9 (1958): 109–71.

35. Modern assessments of what acting at the time was actually like vary enormously, as instanced by the difference between the first and second editions of Joseph's *Elizabethan Acting:* in 1951 he described acting as rhetorical, in 1964 as realistic. I have reluctantly depended on English sources, which are more numerous than the Dutch. Worp lamented that while there was much written *for* the stage in the seventeenth century in the Seven Provinces, there was almost nothing written *about* it.

36. For the quotations from Heywood and Brinsley see Joseph, *Elizabethan Acting,* 1951, pp. 153, 11, 12; for a discussion of the rhetorical assumptions about acting "naturally" in Hamlet's speech to the players and elsewhere at the time, see pp. 146–53.

37. The surrounding passage reads, "Want deesen twe sijnt daer die meeste

ende die naetuereelste beweechgelickheijt in geopserveert is dat oock de grooste oorsaeck is dat die selvijge soo lang onder handen sij geweest." Rembrandt's letters to Huygens are available in a modern, annotated edition, with translation, *Seven Letters by Rembrandt,* ed. Horst Gerson, transcription I. H. van Eeghen, tr. Yda Ovinck. (The Hague: L. J. C. Boucher, 1961). The phrase appears on p. 34. See also *Documents,* no. 1639/2, p. 161.

38. H. E. van Gelder in *Oud Holland* 60 (1943): 148–51 argued that Rembrandt referred to inner movement, and Jacob Rosenberg, in *Rembrandt,* 2 vols. (Cambridge: Harvard University Press, 1948), 1:116, saw it as outward, "Baroque" movement, which was seconded by Wolfgang Stechow in his review in *The Art Bulletin* 32 (1950): 253 n. 1. Seymour Slive in *Rembrandt and His Critics* (The Hague: Martinus Nijhoff, 1953), p. 24, thought both motion and emotion were referred to, on the basis of an Albertian notion of outward gesture expressing inward emotion.

39. A "soft" version of this reading argues on the evidence of contemporary usage that it is the unity of inward emotions and outward gestures that stir the viewer's emotions; see Lydia de Pauw-de Veen, "Over de betekenis van het woord 'beweeglijkheid' in de zeventiende eeuw," *Oud Holland* 74 (1959): 202–12, and John Gage, *Burlington Magazine* 111 (1969): 381. A "hard" version disputes the distinction between outer movement and inner emotion in a picture as being unjustified on historical grounds and offers the rhetorical Rembrandt as the historically correct alternative; see Jan Emmens, *Oud Holland* 78 (1963): 79–82.

40. There are several occasions in the century following Rembrandt's death when the word "natural" was used by others to describe aspects of figures or faces in his works. Houbraken praised the *St. John Preaching* for "the *natural* rendering of the listening faces" ("verwonderlyk om de natuurlyke verbeeldingen der toeluisterende wezenstrekken") and the painting of *Christ on the Sea of Galilee* for the figures and faces which are rendered "as *naturally* as can be imagined after the situation of the moment" ("Want de werking der beelden, en wezens trekken zyn daar zoo natuurlyk naar de gesteltheid van het geval uitgedrukt als te bedenken is. . . ."), Houbraken, 1:261, 260. The Amsterdam collector Gerrit Braancamp also praises *Christ on the Sea of Galilee* in a 1750 catalogue of his collection, "It is certain that no more touching and at the same time more *natural* Painting than this can be found, on account of the expression and the contrast of the passions, and the handling of light and dark" ("'T is vast, dat er geen aandoenlyker en tevens natuurlyker Schildery, dan dit te vinden is, zoo wegens de uitdrukking als tegenoverstelling der Hartstochten, en de werking van Licht en Donker"), Clara Bille, *De tempel der kunst of het kabinet van der Heer Braancamp,* 2 vols. (Amsterdam, 1961), 1:42

41. I have tried without much success to find out whether "natural" and "lively" were employed in Dutch discussions of acting as they were in the English. My thanks to Dr. Maria A. Schenkeveld-van der Dussen, who told me that the first instance she found of the phrase *natuurlijk speelen* is in a 1766 translation of Remond de Sainte Albine, *Le Comedien* (1743), *Aenleidung tot de uiterlijke welsprekendheid,* chapter 11, "Van 't natuurlijk speelen." The playwright Jan Vos, who wrote admiringly about Rembrandt, appeals to Nature as a model and uses the term *leevendig* but not *natuurlijk* when talking about the theater. Despite the absence of a definitive explanation, Rembrandt's phrase read in a theatrical sense can be of descriptive use in understanding his painting.

42. "Chacun des anciens maîtres a son royaume, son apanage. . . . Une portion de l'empire restait, où Rembrandt seul avait fait quelques excursions,—le drame,—le drame naturel et vivant, le drame terrible et mélancolique, exprimé souvent par la couleur mais toujours par le geste." Charles Baudelaire, "Salon de 1846," in *Ecrits sur l'Art* (Paris: Gallimard, 1971), pp. 176–77. Quite another Rembrandt is evoked by Baudelaire in "Les Phares," "triste hôpital tout rempli de murmures. . . ." *Les Fleurs du Mal* (Paris: Editions Garnier, 1961), p. 15.

43. "He would not have either that force of pantomime nor that force in their effect which gives to his scenes the true expression of nature." Eugène Delacroix, *Journal 1822–1863* (Paris: Plon, 1980), p. 280.

44. *Encyclopedia Britannica* 17 (Edinburgh: Encyclopedia Press, 1917), s.v. "Rembrandt".

45. For a description of the painting and its unusual subject, see J. G. van Gelder, "Een Rembrandt van 1633," *Oud Holland* 75 (1960): 73–78. It is interesting that a Cyrus by Rembrandt is the object of criticism in Pels's poem quoted below, n. 48.

46. *Oxford English Dictionary*, s.v. "attitude." In the 1787 French translation of the treatise by De Lairesse, *Groot Schilderboek*, the Dutch word *beweegelykheid* is rendered as *attitude*. The passage, which concerns the proper way to make a good portrait, is cited by Lydia de Pauw-de Veen, "Over de betekenis," p. 206.

47. Theophilus Cibber, *The Life and Character of That Excellent Actor Barton Booth Esq.* (London, 1753), p. 51, cited in *Corpus*, 2 : 301.

48. There is a modern edition with introduction and notes by Dr. Maria A. Schenkeveld-van der Dussen: A. Pels, *Gebruik én misbruik des tooneels* (Culemborg: Tjeenk Willink/Noorduijn, 1978). The passage dealing with Rembrandt, lines 1093–1132, has not, to my knowledge, been translated into English in its entirety. It might be useful to print a literal, line-by-line translation followed by the original text. I want to thank Dr. Schenkeveld-van der Dussen and Mark Meadow for their help in this task.

You err very grossly, if you would lose the beaten path,
If you would, despairingly, choose one more dangerous;
1095 And, content with perishable praise, do just like
The great Rembrandt, who feared that with neither Titian, Van Dyck,
Nor Michelangelo, nor Raphael he could compare,
And therefore rather chose to err illustriously,
To become the first heretic of the Art of Painting,
1100 And to lure many novices to his line,
Than to sharpen himself through following those experienced,
And to subject his celebrated brush to the rules.
He, though not yielding to any one of these masters
In design, nor being weaker in the strength of coloring,
1105 When he a naked woman, as it sometimes happened,
Would paint, chose no Greek Venus as a model,
But sooner a washerwoman, or a peat-treader from a barn,
Calling his error imitation of Nature,
Everything else vain invention. Sagging breasts,
1110 Wrenched hands, even the pinch of the sausages [the marks of the
 pinches]

Of the stays on the stomach, or the garter on the leg,
It must all be followed, or nature would not be satisfied;
That is to say his own [nature], that neither rules nor *ratio*
Of proportionality endured in human limbs,
1115 And perspective, no more weighed, than the distance between things,
Nor measured with the art, but with the appearance to the eye.
[His nature] that through the entire city, on bridges and on corners,
At the Nieuwe- and the Noordermarket most zealously went to seek
Cuirasses, helmets, Japanese daggers, furs,
1120 And ruffled collars which he found picturesque,
And often fitted on the Roman body of a Scipio,
Or with which he overloaded the noble limbs of a Cyrus.
And nevertheless it seemed, though he to his advantage took
Whatever from the world's four quarters came to him,
1125 That much was wanting towards excellency of adornment
When he dressed his subjects in clothing.
What a loss it is for art that so brave
A hand did not better from her infused gift
Serve itself! Who would have striven past him in painting?
1130 But alas! the nobler the spirit, the more it shall grow wild
If it does not bind itself to a foundation, and by rope of rules,
But attempts to know everything by itself!

 Gy mist zeer gróf, wilt gy 't gebaande pad verliezen,
Wilt ge, als wanhoopende, een gevaarelyker kiezen;
1095 En, met onduurzaam lóf te vréden, doen, gelyk
De groote Rémbrand, die 't by Titiaan, van Dyk,
Nóch Michiel Angelo, nóch Rafel zag te haalen,
En daarom liever koos doorluchtiglyk te dwaalen,
Om de eerste kétter in de Schilderkunst te zyn,
1100 En ménig nieuweling te lókken aan zyn' lyn;
Dan zich door 't vólgen van érvaarene te schérpen,
En zyn vermaard pénseel den rég'len te onderwérpen.
Die, schoon hy voor niet één' van all' die meesters week
In houding, nóch in kracht van koloryt bezweek,
1105 Als hy een' naakte vrouw, gelyk 't somtyds gebeurde,
Zou schild'ren, tót modél geen Grieksche Vénus keurde;
Maar eer een' waschter, óf turftreedster uit een' schuur,
Zyn' dwaaling noemende navölging van Natuur,
Al 't ander ydele verziering. Slappe borsten,
1110 Verwrongen' handen, ja de neepen van de worsten
Des ryglyfs in de buik, des kousebands om 't been,
't Moest al gevölgd zyn, óf natuur was niet te vréên;
Ten minsten zyne, die geen régels nóch geen réden
Van évenmaatigheid gedoogde in 's ménschen léden;
1115 En doorzigt alzo min, als tusschenwydte, woog,
Nóch wikte mét de kunst, maar op de schyn van 't oog.
Die door de gansche Stad op bruggen, én op hoeken,
Op Nieuwe, én Noordermarkt zeer yv'rig op ging zoeken
Harnassen, Moriljons, Japonsche Ponjerts, bont,
1120 En rafelkraagen, die hy schilderachtig vond,
En vaak een' Scipio aan 't Roomsche lichchaam paste,

Of de éd'le léden van een Cyrus méê vermaste.
En échter scheen hém, schoon hy tót zyn voordeel nam,
Wat ooit uit 's waerelds vier gedeelten hérwaarts kwam,
1125 Tót ongemeenheid van optooisel veel te ontbreeken,
Als hy zyn' beelden in de kleederen zou steeken.
Wat is 't een' schade voor de kunst, dat zich zo braaf
Een' hand niet béter van haare ingestorte gaaf
Gediend heeft! Wie had hém voorby gestreefd in 't schild'ren?
1130 Maar óch! hoe éd'ler geest, hoe meer zy zal verwild'ren,
Zo zy zich aan geen grond, én snoer van régels bindt,
Maar alles uit zich zélf te weeten onderwindt!

49. For an exposition of Pels on Rembrandt in these terms, see J. A. Emmens, *Rembrandt en de regels van de kunst*, pp. 73–77.

50. For a historical and critical consideration of Western hostility to the theater, see Jonas A. Barish, *The Anti-Theatrical Prejudice* (Berkeley: University of California Press, 1981.)

51. For Vos's life and works, see the introduction to *Jan Vos toneelweerken: Aran en Titus, Oene, Medea*, ed. W. J. C. Buitendijk (Assen-Amsterdam: Van Gorcum, 1975), pp. 6–27. Pels's disagreements with Vos and their relationship to the interesting politics of the *schouwburg* are discussed by Dr. Maria A. Schenkeveld-van der Dussen, in Pels, *Gebruik*, pp. 16–25.

52. *Histrio-mastix, the Players Scourge . . .* , William Prynne's infamous tract against the theater, was published in Dutch in Leiden in 1639.

53. In the fiery and argumentative preface to his *Medea* (itself of course, a traditional subject for the playwright), Vos argued that Dutch playwrights had no reason to follow an ancient philosopher (Aristotle) or poet (Horace), that though architecture had its rules, plays were different—"De speelen zijn van een anderen aart dan de gebouwen"—and, in defense of such things as death enacted on the stage, that "het zien gaat voor 't zeggen"—or, roughly, sight before speech. See the preface to *Medea* in Buitendijk, *Jan Vos toneelweerken*, pp. 357, 356, 354.

54. For an ambitious attempt to document a relationship between Rembrandt and Vos, see Gary Schwartz, *Rembrandt: His Life, His Paintings* (New York: Viking, 1985).

55. For what he calls the "drama of undressing" in Rembrandt's work, see Simon Schama, "Rembrandt and Women," *Bulletin of the American Academy of Arts and Sciences* 38 (1985): 33.

56. "As in the theater, they [family members] were given a variety of roles to play in paintings," notes Pieter Schatborn in the exhibition catalogue, *Dutch Figure Drawings* (The Hague: Government Printing Office, 1981), p. 22.

57. For the report on the x-ray of the London painting, see Christopher Brown, "Rembrandt's 'Saskia as Flora' X-Rayed," *Essays in Northern European Art Presented to Egbert Haverkamp-Begemann on His Sixtieth Birthday* (Doornspijk: Davaco, 1983), pp. 49–51; for the Kassel painting, see Keith Roberts in *The Burlington Magazine* 121 (1979): 125; for the *Bellona*, see Bob Haak, *Rembrandt: His Life, His Work, His Time* (New York: Harry Abrams, n.d.), p. 101. The dagger in the Kassel painting is dismissed in *Corpus*, 2:A85. The x-ray evidence about the *Bellona* has since been challenged on the basis of autoradiography, M. Ainsworth et al., *Art and Autoradiography* (New York: Metropolitan Museum of Art, 1982), p. 46, and it is not mentioned in the discussion of the picture in *Corpus*, 2:A70.

CHAPTER 3

1. For a clarifying description of Rembrandt as the head of a studio, which offers a balanced view of what this means for problems of attribution and does so without calling his greatness into question, see E. H. Gombrich's review, "Rembrandt Now," *New York Review of Books*, 12 March 1970, pp. 6–15.

2. The basic collection of Rembrandt documents is C. Hofstede de Groot, *Die Urkunden über Rembrandt, 1575–1721* (The Hague: Martinus Nijhoff, 1906). For a useful compilation, with translations, of these and, in addition, newly discovered documents on Rembrandt's life and works up until the date of his death, see the book I have abbreviated as *Documents*. A review by B. P. J. Broos offers important additions and numerous corrections, *Simiolus* 12 (1981–82): 245–62.

3. For the higher value placed on paintings by painters who had visited Italy, see Hanns Floerke, *Die Formen des Kunsthandels, das Atelier und die Sammler in den Niederlanden von 15.–18. Jahrhundert*, Munich-Leipzig 1905; reprint Soest: Davaco, 1972), p. 180.

4. The exhibition catalogue *Jan Lievens: Ein Maler im Schatten Rembrandts* (Braunschweig: Herzog-Anton Ulrich-Museum, 1979) is the most convenient survey of Lievens's art. For the disputed English sojourn, see Christopher Brown, "Jan Lievens in Leiden and London," *Burlington Magazine* 125 (1983): 663–71.

5. The sitter was Sir Robert Kerr, Earl of Ancram, painted by Lievens in Amsterdam the year of his death. For the Earl's comments and his portrait, which is in the Scottish National Portrait Gallery, Edinburgh, see *Jan Lievens*, p. 113.

6. For a discussion of Rembrandt as the painter of a pro-Orangist image, see Margaret Deutsch Carroll, "Civic Ideology and Its Subversion: Rembrandt's *Oath of Claudius Civilis*," *Art History* 9 (1986): 12–35.

7. The self-portrait apparently entered the collection of Charles I through a third party and was not commissioned by the king from the artist; see *Corpus*, 1:329. An early excursion to the Hague is mentioned by Houbraken, p. 255, and in *Corpus*, 2:97. J. Bruyn notes, on the basis of some Hague portrait sitters, that Rembrandt must have worked in The Hague in 1632. There is not enough evidence to accept Gary Schwartz's proposal of a court phase early in Rembrandt's career, nor his statement that in 1633 "the most eligible bachelor among the court painters of Holland was unquestionably Rembrandt"; see Schwartz, *Rembrandt: His Life, His Paintings* (New York: Viking, 1985), p. 184. An English trip in 1641 has been considered on the basis of some landscape drawings, but has not been generally accepted in the literature.

8. It has been suggested that Rembrandt went to Uylenburgh to bide his time until he was accepted in the Amsterdam painters' guild. See *Corpus*, 2:60. For a nuanced analysis of Rembrandt's work in the Uylenburgh shop, see the review of *Documents* by B. P. J. Broos. See also Jan Six, "La Famosa Accademia di Eeulenborg," *Jaarboek der Koninklijke Akademie van Wetenschappen te Amsterdam* (1925–26): 229–41.

9. For Rembrandt's reputation, see Seymour Slive, *Rembrandt and His Critics* (The Hague: Martinus Nijhoff, 1953), and R. W. Scheller, "Rembrandt's reputatie van Houbraken tot Scheltema," *Oud Holland* 12 (1961): 81–118; for the encyclopedic nature of his collection, see R. W. Scheller, "Rembrandt en de encyclopedische verzameling," *Oud Holland* 84 (1969): 81–147; for Rembrandt as failed courtier, see Gary Schwartz, *Rembrandt*.

10. Albert Blankert has suggested that we should be less quick to reject the attempt of the classicizing critics to relate the style of Rembrandt's art, and the style of his ideas about art, to what we would call his life-style; see Albert Blankert, "Rembrandt, Zeuxis and Ideal Beauty," *Album Amicorum J. G. van Gelder*, ed. J. Bruyn et al. (The Hague: Martinus Nijhoff, 1973), p. 39, n. 46.

11. For Bol, see Albert Blankert, *Ferdinand Bol (1616–1680): Rembrandt's Pupil* (Doornspijk: Davaco, 1982). For the meaning of the *Self-Portrait*, see E. de Jongh, "Bol Vincit Amorem," *Simiolus* 12 (1981–82): 147–61.

12. In July 1634, a few weeks after his wedding, Rembrandt signed a document authorizing power of attorney in which he is referred to as "a merchant of Amsterdam" ("coopman te Amsterdam"). This was not in itself a distinctive designation for an artist. To declare oneself a *koopman* gave one freedom to do business without the restrictions incurred as a member of a professional guild. Bol and Karel du Jardin are among the other artists who are recorded as having done so. My point is not that Rembrandt enjoyed running a business, but that his notion of art devised for the market was distinctive. For this, see the next chapter. For the reference to Rembrandt, see *Documents*, no. 1634/7, p. 112, and the comments of B. P. J. Broos in *Simiolus* 12 (1981–82): 255; for Karel du Jardin, see Albert Blankert, *Nederlandse 17e eeuwse italianiserende landschapschilders* (Soest, 1978), p. 196, n. 4; for Bol, see Albert Blankert, *Ferdinand Bol*, p. 23.

13. For the artist and his wife in the picture, see Otto Naumann, *Frans van Mieris*, 2 vols. (Doornspijk: Davaco, 1981), 1:60, 127–29; for the Bol historiated portrait, see Albert Blankert, *Ferdinand Bol*, cat. no. 34, p. 103, which also discusses the drawing, perhaps done after a model, which served for the figure of the half-nude wife.

14. For evidence that artists' models were prostitutes, see S. A. C. Dudok van Heel, "Het 'Schilderhuis' van Govert Flinck en de kunsthandel van Uylenburgh aan de Lauriergracht te Amsterdam," *Jaarboek Amstelodamum* 74 (1982): 70–90; for Hendrickje's summons before the church council, see *Documents*, nos. 1654/11, 12, 14, 15, pp. 318, 320.

15. For a possible northern tradition of the painter depicting his wife naked, see the discussion of the seventeenth-century reference to the lost painting of a nude woman by Jan van Eyck as being of his wife: Julius S. Held, *Rubens and His Circle*, ed. Anne W. Lowenthal, David Rosand, John Walsh (Princeton: Princeton University Press, 1982), pp. 50–51. To paint a portrait of one's wife naked is different from Rembrandt's practice of taking Hendrickje into the studio as a model.

16. For the artist's studio, see W. Martin, "The Life of a Dutch Artist in the Seventeenth Century," *The Burlington Magazine* 7 (1905): 125–32, 416–27; 8 (1905–6): 13–24; 10 (1906–7): 144–54, 363–70.

17. See James Turner, "The Visual Realism of Comenius," *History of Education* 1(1972): 132–33, for a discussion of the possible symbolism of the family scene in Comenius. In Antwerp there was a pictorial tradition that linked the painter's career to his family. Jacob Jordaens celebrated his entrance into the Antwerp Guild of St. Luke in 1615 by making the painting now in Leningrad of himself and his family. For the dating of this family portrait see "Jordaens' Portraits of His Family," in Julius S. Held, *Rubens and His Circle*, ed. Anne W. Lowenthal, David Rosand, John Walsh, Jr. (Princeton: Princeton University Press, 1982), pp. 9–14. The so-called Master of Frankfort's *Self-Portrait with the Artist's Wife*, now in Antwerp, is decorated with the emblems of both the painters' guild and of the chamber of

rhetoric. The ideology binding art and the family is confirmed by the opposition we find mounted against it: in a drawing of 1577 known as "The Cares of the Artist," the Fleming Marcus Geeraerts depicted an artist distracted and disabled by familial demands. In an engraving by Abraham Bosse, the vulgar painter impoverished amidst his family (represented in an engraving within the engraving) is contrasted with the noble painter flourishing alone at court (figs. 3.21, 3.22). For Geeraerts and Bosse, see *Maler und Modell* (Baden-Baden: Kunsthalle, 1969), nos. 40 and 55.

18. Gossip on the part of Saskia's relatives had it that as Rembrandt's wife she was squandering away her inheritance with ostentatious display ("met pronken ende praelen"). In 1638, Rembrandt unsuccessfully brought a libel suit against the slanderers, saying that on the contrary he and Saskia were favored with a superabundance of earthly possessions. Though it might have confirmed the relatives' worst fears, the *Prodigal Son* could be Rembrandt's view of the situation. For the Rembrandt suit, see *Documents*, no. 1638/7, pp. 152–55. For the Dresden painting as disputing bourgeois marriage, see Berthold Hinz, "Studien zur Geschichte des Ehepaarbildnisses," *Marburger Jahrbuch für Kunstwissenschaft* 19 (1974): 203 and n.

19. For a very different interpretation of this etching as a portrayal of marriage as friendship, see David R. Smith, *Masks of Wedlock: Seventeenth-Century Dutch Marriage Portraiture* (Ann Arbor: UMI Research Press, 1982), pp. 137–44.

20. For the description of the warehouse with its partitions, see Houbraken, 1:256, "Hy een Pakhuis huurde op de Bloemgraft, daar zyne Leerlingen elk voor zig een vertrek (of van paper of zeildoek afschoten) om zonder elkander te storen naar 't leven te konnen schilderen." For the partitions removed at the sale of the house, see *Documents*, no. 1658/3, p. 412.

21. There is little disagreement about the fact that Rembrandt's gold chains are studio props. Held, estimating that fifteen of fifty painted self-portraits had a chain, saw its artifice as a sign of his rebellious wish to be free from ties binding him to patrons, and Chapman as a way to enrich the image of the artist that he wished to project. See Julius S. Held, "Aristotle," in *Rembrandt's Aristotle and Other Rembrandt Studies* (Princeton: Princeton University Press, 1969), pp. 35–44; H. Perry Chapman, "The Image of the Artist: Roles and Guises in Rembrandt's Self-Portraits," (Ph.D. diss., Princeton University, 1983), pp. 10–82.

22. The military image of the artist was an overdetermined one: Hoogstraten defined the hierarchy of genres in terms of military ranks, referring to the lesser genres such as still-life as being the foot-soldiers in the army of art; he praised Rembrandt's *Nightwatch* in the manner of history paintings as a work in which the painter, like a general, had ordered his troops; the painter's conquest is a peaceful one, defending the virtues of art as well as the nation against its enemies; last but not least in importance to the Dutch was the likeness of *schild*, shield, to *schilder*, painter. For the artistic force of military imagery as applied to the making of art, see Celeste Anne Brusati, "The Nature and Status of Pictorial Representation in the Art and Theoretical Writing of Samuel van Hoogstraten" (Ph.D. diss., University of California, Berkeley, 1984), pp. 145–52. For the meanings that armor invoked in portraiture and, in particular, its nationalistic connotations, see "Rembrandt's Portraits in Armor," in H. Perry Chapman, "The Image of the Artist," pp. 83–132, and her "A *Hollandse Pictura*: Observation on the Title Page of Philips Angel's *Lof der schilder-konst*," *Simiolus* 16 (1986): 233–48.

23. For gold chains as discussed by Hoogstraten, see Brusati, "Nature and Status," pp. 145–52.

24. Though collaboration seems to have occurred rarely if ever in his studio, Rembrandt did give permission for works executed by others to bear his signature. Houbraken reports that Flinck painted works that were sold as autograph Rembrandts, "Verscheiden van zyne stukken voor echte penceelwerken van *Rembrant* wierden aangezien en verkogt," Houbraken, 2:21. Also see E. van de Wetering, "Problems of Apprenticeship and Studio Collaboration," in *Corpus* 2:50, 61. For the precise form his signature took, see J. Bruyn, "A Selection of Signatures, 1632–34," in *Corpus* 2:99–108.

25. It turns out that there is no basis for more than half of the fifty names commonly mentioned in the Rembrandt literature as his assistants, but there is reason to believe that he in fact had more than this number who have remained nameless. The current emphasis on the large number of Rembrandtesque paintings, often by "nameless" assistants, has edged out the notion of a "Rembrandt school," with its consideration of the degree to which presumed students took up or fell off from his style. For this latter approach, see "The Rembrandt School," in Jakob Rosenberg, Seymour Slive, and E. H. ter Kuile, *Dutch Art and Architecture 1600–1800* (Harmondsworth: Penguin Books, 1966). When I use the word "pupil" or "student" it must be understood in the broad sense as referring to artists who had done their basic training elsewhere and came to Rembrandt as journeymen or studio assistants to learn more. For this point and a general consideration of workshop organization in the Netherlands at the time, see E. van de Wetering, "Problems of Apprenticeship and Studio Collaboration," *Corpus* 2:45–98; Albert Blankert, Ben Broos, Ernst van de Wetering et al., *The Impact of Genius: Rembrandt, His Pupils and Followers in the Seventeenth Century* (Amsterdam: Waterman Gallery, 1983); and Peter Schatborn et al., *Bij Rembrandt in de Leer: Rembrandt as Teacher* (Amsterdam: Museum het Rembrandthuis, 1984). Still basic are C. Hofstede de Groot, "Rembrandts onderwijs aan zijne leerlingen," in *Feestbundel Dr. Abraham Bredius . . . ,* (Amsterdam, 1915), pp. 79–94, and Egbert Haverkamp-Begemann, "Rembrandt as a Teacher," in *Rembrandt after Three Hundred Years* (Chicago: Art Institute of Chicago, 1969), pp. 21–30.

26. For an account of the Dutch program of teaching, see Peter Schatborn, *Dutch Figure Drawings* (The Hague: Government Printing Office, 1981).

27. See, by contrast, the copy, apparently one of fourteen, made by Moses ter Borch after Rembrandt's etching of *The Descent from the Cross* (B. 81). For this copy and an account of artistic training in the Ter Borch family, see Allison McNeil Kettering, "Ter Borch's Studio Estate," *Apollo* 117 (1983): 443–51.

28. For an exception, see the copies attributed to Hoogstraten after some Elsheimer drawings which were apparently in Rembrandt's collection; see Werner Sumowski, "Hoogstraten und Elsheimer," *Kunstchronik* 19 (1966): 302–4.

29. For the notion of Rembrandt's studio as an alternative to Italy, though not quite in the sense that I mean it here, see Albert Blankert, *Ferdinand Bol*, p. 17.

30. J. Bruyn has characterized what he refers to as "Rembrandt's seemingly purposeless drawing activities" as a stock of compositions and motifs like those model or pattern sheets used in painters' workshops in the Middle Ages. This emphasis on the nature of the teaching is somewhat different from my own. See J. Bruyn, "On Rembrandt's Use of Studio-Props and Model Drawings during the

1630s," *Essays in Northern European Art Presented to Egbert Haverkamp-Begemann* (Doornspijk: Davaco, 1983), pp. 52–60.

31. E. van de Wetering has found only nine compositional drawings by Rembrandt related to his paintings; see his "Een schilderwedstrijd," in the *Bulletin* of the Centraal Laboratorium voor Onderzoek van Voorwerpen van Kunst en Wetenschap, September/October 1977, p. 88, n. 31. For a discussion of the entire issue of the relationship between Rembrandt's inventions and those of his students, with the added complication of copies of both done by third parties, see the review by J. Bruyn of W. Sumowski, *Gemälde der Rembrandt-Schüler,* in *Oud Holland* 98 (1984): 148–49.

32. There are, of course, a few notable exceptions, for which see Peter Schatborn, "Rembrandt: From Drawings to Prints and Paintings," *Apollo* 117 (1983): 452–60. As my analysis of paint suggests, I remain unconvinced by those who argue that Rembrandt worked in a similar manner and for similar effects in the three media; see Jakob Rosenberg, "Rembrandt's Technical Means and Their Stylistic Significance," *Technical Studies* 8 (1940): 193–206, and the abstract of an unpublished paper by Maryan Wynn Ainsworth, "Rembrandt's Working Method: The Parallelism in Different Media," in *Abstracts of Papers Delivered at the College Art Association of America* (machine copy, 1983), p. 95.

33. There were a few exceptions, such as Ferdinand Bol, who etched in a Rembrandtesque manner. But Houbraken reports that Rembrandt did not let his students know how he printed his etched plates; see Houbraken, 1:271, "Hy had ook een eige wyze van zyne geëtste platen naderhand te bewerken en op te maken: 't geen hy zyne Leerlingen nooit liet zien."

34. Though not explained in this manner, the innovative character of these works has been described this way before: "He produced self-portraits, and developed a new kind of history painting consisting of one or two biblical, mythological or historical figures, for which Hendrickje and Titus sometimes acted as the models." B. P. J. Broos, review of *Documents,* in *Simiolus* 12 (1981–82): 261. It could be argued that some of the later portrait etchings share what I am describing as the painted format.

35. For the students' production of copies after Rembrandt, see Peter Schatborn, *Bij Rembrandt in de Leer: Rembrandt as Teacher* (Amsterdam: Museum het Rembrandthuis, 1985); for Hoogstraten's despair as a student, see Hoogstraten, p. 12.

36. Hoogstraten, p. 13.

37. Peter Schatborn has pointed out that in copying the Indian miniatures Rembrandt consistently left out the backgrounds, made the poses more natural, and concentrated on the figures and their relationships. His interest in theatrical groups in the studio, I would add, had its effect here. See Peter Schatborn, *Drawings by Rembrandt in the Rijksmuseum* (The Hague: Staatsuitgeverij, 1985), pp. 126–31.

38. "It deserves observation also, that though he furnished himself with the finest Italian prints, drawings, and designs, many of them taken over from the antiques, he never improved his taste by the study of them." *A General Dictionary of Painters* (London, William Tegg and Co., 1857), p. 451. This view goes back to de Piles; see Broos, *Rembrandt en zijn voorbeelden/Rembrandt and His Sources* (Amsterdam: Museum van het Rembrandthuis, 1985), p. 59. It could be amended to read that though he never let on to studying them, they did improve his taste.

39. Kenneth Clark, *Rembrandt and the Italian Renaissance* (London: John Murray, 1966).

40. For Rembrandt's use of Leonardo's *Last Supper,* see Joseph Gantner, *Rembrandt und die Verwandlung klassischer Formen* (Bern and Munich: Francke Verlag, 1964).

41. E. de Jongh, "The Spur of Wit: Rembrandt's Response to an Italian Challenge," *Delta* 12 (1969): 49–67. For a survey of the various ways in which imitation was considered, see G. W. Pigman III, "Versions of Imitation in the Renaissance," *Renaissance Quarterly* 33 (1980): 1–32. *Eristic* is the term Pigman uses for what De Jongh calls *emulation.*

42. For an account of Rubens and tradition in these terms, see Jeffrey M. Muller, "Rubens's Theory and Practice of the Imitation of Art," *Art Bulletin* 64 (1982): 229–74.

43. For a list of all the sources that have been cited for each of Rembrandt's works, see B. P. J. Broos, *Index to the Formal Sources of Rembrandt's Art* (Maarssen: Gary Schwartz, 1977). See also the exhibition catalogue by Broos, *Rembrandt en zijn Voorbeelden/Rembrandt and His Sources,* (Amsterdam: Rembrandthuis, 1985).

44. The Dutch phrase as written by Karel van Mander reads, "Wel ghecoockte rapen is goe pottage." See Ben Broos, *Rembrandt en zijn Voorbeelden,* pp. 11–15, for the proverb in its textual and pictorial ramifications.

45. *Eristic, transformative,* and *dissimulative* are the triad of terms used to define three classes or modes of imitation by Pigman, "Versions of Imitation." They do not describe what Rembrandt did.

46. I am describing the devices by which Rembrandt sought to avoid what Gombrich has described as the formulaic gesture; see E. H. Gombrich, "Ritualized Gesture and Expression in Art," *Philosophical Transactions of the Royal Society of London,* 251 (1966): 392–401.

47. This has also been explained as an act of exemplary teaching through the resuscitation of an unfashionable master; see Leo Steinberg, "The Glorious Company," in *Art about Art,* ed. Jean Lipman and Richard Marshall (New York: E. P. Dutton, 1978), pp. 27–28. I am less certain than Steinberg that for Rembrandt "it would have been easy to launch a new angel." Rembrandt looked to Heemskerck in order to solve this problem, and, in my judgment, Rembrandt wanted his solution to look like life, not art.

48. Houbraken 1:262: "[Caravaggio said] *hy niet eenen enkelen streek deed, of hy zette het leven voor zig.* Van deze meening was ook onze groote meester Rembrandt, stellende zig gen grondwet, *enkele naarvolging van de natuur.*"

49. For a discussion of what the author calls "Herauslösung," see Christian Tümpel, "Studien zur Ikonographie der Historien Rembrandts," *Nederlands Kunsthistorisch Jaarboek* 19 (1969): 107–98; for the Edinburgh painting, see pp. 176–78.

50. See Wolfgang Stechow, "Some Observations on Rembrandt and Lastman," *Oud Holland* 84 (1969): 148–62.

51. Although Rembrandt and Caravaggio were linked on this account by Houbraken, they differed in what they made of the studio situation. The difference between their paintings makes one uneasy about the recent attempt to attribute the sexual invitation offered by Caravaggio's models to studio practice. Even paintings done after a model are a representation of the studio situation and not the situa-

tion itself. For evidence that Caravaggio worked from the live model, see Keith Christiansen, "Caravaggio and 'L'esempio davanti del naturale,'" *The Art Bulletin* 68 (1986): 421–45.

52. He is perhaps a tradesman, not a beggar; see Peter Schatborn, *Drawings by Rembrandt, His Anonymous Pupils and Followers* (Amsterdam: Rijksmuseum, 1985), p. 11.

53. Hoogstraten, pp. 113–14; Houbraken 2:169–70.

54. Another scenario of the beggar, or in this case, the peasant, in the studio was brought to my attention by Wolfgang Kemp. It is one of Teniers's paintings of a gallery, in which a simple peasant, flail in hand, is sitting for the artist, who is watched as he paints by two men of the court. The painter has become royal gallery director and the great collection itself serves him as a studio. He admits the base peasant as a reminder of what brought him to this palace of art (fig. 3.46). One is reminded that the genre of the painted gallery was a Flemish one, and that the painted studio was Dutch.

55. For the case of the gypsy, Jean Lagrène, see Marilyn R. Brown, "Manet's *Old Musician:* Portrait of a Gypsy and Naturalist Allegory," *Studies in the History of Art* 8 (1978): 77–87. These matters, of course, are not simple. It is said that once, when Manet was still a student of Couture's, he exchanged some heated words with Dubosc, an experienced model, over a pose. When Manet accused him of not being natural, Dubosc said that it was thanks to him (i.e., his poses) that many had gotten (i.e., by means of a prize) to Rome. Manet, in a reply worthy of Rembrandt, answered that they were not in Rome, and he did not want to go there. See Antonin Proust, *Edouard Manet: Souvenirs* (Paris: Librairie Renouard, 1913), p. 21.

56. For the identification of the woman, see I. H. van Eeghen, "Elsje Christiaens en de Kunsthistorici," *Amstelodamum* 56 (1969): 73–78. A student copy after fig. 3.49 attributed to Nicolaes Maes is in the Fogg Art Museum, Cambridge.

57. It is in keeping with Rembrandt's theatrical sense of the studio that Lucretia's rope would be a model's sling rather than a cord controlling a stage curtain. For the suggestion that it belongs to the stage in this second sense, see Julius S. Held, "Rembrandt and the Classical World," in *Rembrandt after Three Hundred Years* (Chicago: Art Institute, 1974), p. 54.

58. Rembrandt made a drawing (Ben. 400) of two butchers at work on the carcass of a pig, which precedes the presentation of the carcass itself in two paintings.

59. For the meaning of *borrón* and the reference to Lope de Vega's *La corona merecida* (1603), see Gridley McKim-Smith, *Examining Velázquez* (New Haven: Yale University Press, 1988). The term continued to be used of paintings in Velázquez's time, when rough paint came in for praise. In a similar vein, Paula Modersohn-Becker wrote from Paris in 1903, "There are a great many Rembrandts here. Even if they are yellow with varnish, I can still learn so much from them, the wrinkled intricacy of things, life itself." *Paula Modersohn-Becker: The Letters and Journals,* ed. Günter Busch and Liselotte van Reinken (New York: Taplinger Publishing Company, 1983), p. 297.

60. See Seymour Slive, *Rembrandt and His Critics* (The Hague: Martinus Nijhoff, 1953), p. 81.

61. An analysis of the portraits of the 1630s confirms that Rembrandt's major emphasis is on the faces and that his "guiding principle involves the . . . hierarchy of optical intensity, decreasing towards the periphery." Joos Bruyn and Ernst van de Wetering, "Stylistic Features of the 1630s: The Portraits," in *Corpus* 2:13.

62. [On the Proper Shape of Pictures and Engravings], *The Works of John Ruskin,* ed. E. T. Cook and Alexander Wedderburn, 39 vols. (London: George Allen, 1903), 1:235–45.

63. For the Rembrandt nomenclature in general, see Carl Chiarenza "Notes on Aesthetic Relationships between Seventeenth-Century Dutch Painting and Nineteenth-Century Photography," in *One Hundred Years of Photographic History,* ed. Van Deren Coke, (Albuquerque: University of New Mexico Press, 1975), p. 23; most dictionaries of photography well into the twentieth century inevitably have several entries under Rembrandt; for the staging of the sitting, see Robert A. Sabieszek and Odette M. Appel, *The Spirit of the Fact: The Daguerreotype of Southworth and Hawes* (Boston: David Godine), xvii–xviii, and Alan Trachtenburg, "Brady's Portraits," *The Yale Review* (1984), pp. 244–46. Not surprisingly, the reaction against Rembrandt among photographers came from those who were against artifice and for nature.

64. The original painting was commissioned in 1661, installed in the Town Hall by 1662, then returned to Rembrandt for unknown reasons that have been the subject of much speculation. The painting was subsequently reworked and presumably cut down to its present size by the artist. For a recent study with citations of the massive literature on the painting, see Margaret Deutsch Carroll, "Civic Ideology and Its Subversion: Rembrandt's *Oath of Claudius Civilis,*" *Art History* 9 (1986): 10–35.

65. Rembrandt's drawing after Leonardo is Ben. 445. While Rembrandt, like Manet after him, trimmed his works down to manageable size (he even, on occasion, cut his etching plates), Rubens compulsively expanded his works, adding paper to drawings and wood or canvas to paintings.

66. Albert Blankert, *Ferdinand Bol* (Doornspijk: Davaco, 1982), cat. no. 167 and p. 84.

67. The man appears to have also served as the model for Br. nos. 259, 283, and 309.

68. One need not be persuaded by the proposal that the *Jacob Blessing* is a family portrait to see why this makes pictorial sense; see Gary Schwartz, *Rembrandt: His Life, His Paintings* (New York: Viking, 1985), pp. 269–71.

69. The relationship between artist, sitter, and model came to be fictionalized as the stuff of studio life. In Henry James's *The Real Thing,* an artist finds that poor Miss Churm and an Italian named Oronte can pose as real aristocrats as the real aristocrats Major and Mrs. Monarch cannot. Though James speaks as one would want Rembrandt to have done of the "alchemy of art," the "real thing" in his story is social in nature and is constituted by the model's ability to perform. Rembrandt turned both model and patron into new coin. The painting, it turns out, is the real thing, and that, in a final turn, is himself.

70. The entangled, and essentially self-imposing relationship of artist to sitter represented by Rembrandt's paintings has been described by James Lord in his account of having his portrait painted by Giacometti. "There is an identification between the model and the artist, via the painting, which gradually seems to become an independent, autonomous entity served by them both. . . . One day his foot accidentally struck the catch that holds the easel shelf at the proper level causing it to fall. . . . 'Oh, excuse me,' he said. I laughed and observed that he'd excused himself as though he'd caused me to fall instead of the painting. . . . If he could not work without me, the painting could not exist without him. He had absolute

control over it, and by extension . . . control over me, too." The relationship is also inescapably economic: one day in despair at ever finishing, Giacometti said he would have to pay his sitter for posing. Though he was struggling to get his sitter right, Giacometti, like Rembrandt, succeeded in making his portraits look disturbingly alike. See James Lord, *A Giacometti Portrait* (New York: Farrar Straus Giroux, 1980 [first printing, 1965], pp. 37, 62.

CHAPTER 4

1. "Il n'aimoit que sa liberté, la Peinture, et l'argent." J. B. Descamps, *La Vie des Peintres Flamandes, Allemands et Hollandois* 4 vols. (Paris: C. A. Jombert, 1753–64), 2:90.

2. Terence J. Johnson, *Professions and Power* (London: Macmillan, 1972) analyses the role played by power in different social models of producer-consumer relations.

3. For an account of Flinck's life and works see, Houbraken, 2:22–23, translated in Gary Schwartz, *Rembrandt: His Life, His Paintings* (New York: Viking, 1985), p. 282.

4. The phrase comes from Baldinucci's life of the Danish painter Bernard Keil, who was the Italian's major informant about Rembrandt. Filippo Baldinucci, *Delle Notizie de' Professori del Disegno da Cimabue in qua*, 21 vols. (Florence: 1772 [first published 1681–1728]), 18:139.

5. Cited by Broos in his discussion of Rembrandt at Uylenburgh's, *Simiolus* 12 (1981–82): 252, n. 33.

6. Schwartz, *Rembrandt*, p. 315, points out the conditions of Rembrandt's highest level of production, but draws a different conclusion.

7. "Dat men hem (als het spreekwoord zeit) moest bidden en geld toegeven." Houbraken, 1:269.

8. References, in order, are to the *Documents* whenever possible: (1) Baldinucci, p. 63; Houbraken, 1:263; (2) *Documents*, nos. 1636/1, 1636/2, 1639/2, 3, 4, 5, 6, 7, pp. 129–34, 161–75; 1665/17, pp. 554–55; (3) *Documents*, nos. 1654/4, pp. 310–11; 1659/21, p. 451; 1662/11, pp. 506–9; there is no documentation about the return of the *Civilis*.

9. For the very rare depictions of the connoisseur's visit to the artist's studio in Dutch seventeenth-century art, see Hans-Joachim Raupp, *Untersuchungen zu Künstlerbildnis und Künstlerdarstellung in den Niederlanden im 17. Jahrhundert* (Hildesheim: Georg Olms, 1984), pp. 329–30. A painting by Mieris in Dresden is an exception. For the Bosse engraving with its explanatory inscription and the engraving within it by Paulus Furst after G. Walch, see Pierre Georgel and Anne-Marie Lecoq, *La peinture dans la peinture* (Dijon, Musee de Beaux-Arts, 1982), pp. 123, 135.

10. See *Documents*, nos. 1648/8, p. 263; 1652/7, p. 289; 1653/11, p. 302; 1656/10, p. 347; and 1657/3, p. 398.

11. "Le Bourguemestre Six a essayé plus d'une fois de mener Rembrant dans le monde, sans pouvoir jamais l'obtenir." J. B. Descamps, *Vie des Peintres*, 2:90.

12. For Rembrandt's retention of his plates and their later history, see Walter L. Strauss, "The Puzzle of Rembrandt's Plates," *Essays in Northern European Painting Presented to Egbert Havenkamp-Begemann* (Doornspijk: Davaco, 1983), pp. 261–67.

13. Though I see the painting somewhat differently, I owe a lot of my thinking about the relationship between the painter and the sitter it represents to an unpublished paper by Harry Berger, Jr. For a different account, which relates the "nonchalance of Rembrandt's brush" to that courtly *sprezzatura* recommended by Castiglione, a Dutch edition of whose *Il Cortegiano* was dedicated to Jan Six, see E. de Jongh's review of Bob Haak, *Hollandse schilders in de gouden eeuw*, in *Simiolus* 15 (1985): 67–68.

14. The travelers' accounts most often cited on the matter of the marketing of pictures are *The Diary of John Evelyn*, ed. E. S. de Beer, (Oxford: Oxford University Press, 1959), pp. 22–23, and *The Travels of Peter Mundy*, ed. R. C. Temple, 5 vols (London: The Hakluyt Society, 1925), 4:70. It is possible that the purchase of pictures by the farm population is evidence of new, commercial interests. We know that Uylenburgh's shop produced paintings to be sold in Friesland, and De Vries argues that, in respect to both the division of labor and the demand for goods, the Netherlands had developed a commercialized rural economy. For peasant inventories with pictures and the nature of the rural economy, see Jan de Vries, *The Dutch Rural Economy in the Golden Age, 1500–1700* (New Haven, Yale University Press, 1974), p. 214–24; for ownership and the market in a small urban center, see John Michael Montias, *Artists and Artisans in Delft* (Princeton: Princeton University Press, 1982); still basic is Hanns Floerke, *Studien zur niederländischen Kunst- und Kulturgeschichte, Die Formen des Kunsthandels, das Atelier und die Sammler in den Niederländen von 15.–18. Jahrhundert* (Munich, Leipzig, 1905; reprint Soest: Davaco, 1972). While studies of household inventories such as those by De Vries and Montias expose the sheer number of inexpensive, anonymous paintings, studies of institutional patrons have tended to swing attention back to commissioned works.

15. Hoogstraten, p. 310.

16. See Ivan Gaskell, "Dou, His Patrons and the Art of Painting," *The Oxford Art Journal* 5 (1982): 15–61 with bibliography; Otto Naumann, *Frans van Mieris the Elder*, 2 vols. (Doornspijk: Davaco, 1981); John Michael Montias, "Vermeer's Clients and Patrons," *Art Bulletin* 69 (1987): 68–76.

17. See Barbara Gaehtgens, *Adriaen van der Werff: Ein Beitrag zum Stilwandel der holländischen Malerei um 1700* (Munich: Deutscher Kunstverlag, 1987).

18. For the inscription, see *Documents*, undated no. 16, p. 610; for Van Cattenburgh, *Documents*, no. 1655/8, pp. 333–35, and no. 1654/6, pp. 311–12. It is surely due to the value of the drawing that Rembrandt's notation about Thysz on the back was preserved. One of the other rare notations about the business operations of his studio in Rembrandt's hand is also on the back of a drawing. It refers to the price for which he sold assistants' paintings which were perhaps copies after his own works; see *Documents*, undated no. 3, p. 594.

19. For tulip speculation, see Simon Schama, *The Embarrassment of Riches: An Interpretation of Dutch Culture in the Golden Age* (New York: Knopf, 1987), pp. 350–66.

20. For the positive reading, see Julius S. Held, "Juno," in *Rembrandt's "Aristotle" and Other Rembrandt Essays* (Princeton: Princeton University Press, 1969), pp. 85–89; for the negative reading, see Gary Schwartz, *Rembrandt*, p. 287.

21. The Rembrandt project has gone so far as to comment that "from this year [1656] onwards Rembrandt was insolvent, and the supplying of paintings generally took on the nature of paying off debts," *Corpus*, 2:96n.

22. See Hans J. Miegroet, "*The Twelve Months* Reconsidered: How a Drawing by Pieter Stevens Clarifies a Bruegel Enigma," *Simiolus* 16 (1986): 29 and n.

23. For a general consideration of art dealers and the market in nineteenth-century France, see Harrison C. White and Cynthia White, *Canvases and Careers* (New York: John Wiley & Sons, 1965).

24. The differences of manner that have been noted within the works of Dou and Mieris tend to be exaggerated (as, for example, the description of Dou's figures seen under magnification as "almost Halsian in the break-up of forms"), and at any rate do not seem to contradict their designation as smooth as opposed to rough painters. For another view, see Otto Naumann, *Frans Van Mieris*, 2 vols. (Doornspijk: Davaco, 1981), 1:40–42, 64–65.

25. "Qui voira une des ses peintures, jugera qu'il ait consommé des années entieres, qu'il y ait perdu san santé, gâté la veue. . . . Ses Tableaux sont maintenant des bijoux plus chéris. . . . ," Giorgio Maria Rapparini, writing in 1709, as quoted by Barbara Gaehtgens, *Adriaen van der Werff*.

26. For Rembrandt's remark about finish, see Houbraken, 1:259, "een stuk voldaan is als de meester zyn voornemen daar in bereikt heeft"; for the d'Andrada case, see *Documents*, 1654/4, pp. 310–11.

27. For the Van Ludick agreement, *Documents*, no. 1662/6, pp. 499–502; for the Ruffo exchange, *Documents*, no. 1662/11, 1662/12, pp. 506–9.

28. For the comment on the production and marketing of Rembrandt's prints, see Houbraken, 1:271; for the general market for prints at the time, see William W. Robinson, "'This Passion for Prints': Collecting and Connoisseurship in Northern Europe during the Seventeenth Century," in Cliff Ackley, *Printmaking in the Age of Rembrandt* (Boston: Boston Museum of Fine Arts, 1981), pp. xxvii–xlviii.

29. I refer to the unusually large etchings of the *Descent from the Cross* (1633) and the *Ecce Homo* (1635/36) (B. 81, B. 77) done most likely with the help of assistants. The first replicates the painting for the Stadholder, and the second was first worked out in the preparatory oil sketch now in the National Gallery, London. The *Descent from the Cross* was published (in the Rubens manner) with a privilege granted by the States General to protect the artist, and the third state carries the publisher's address of Hendrik Uylenburgh.

30. There is another view of Rubens. What he sacrificed in his factory production was that originating wielding of the brush which, in the oil sketches and in some of his own paintings like the *Kermis*, treats invention and execution as one. This was recognized in the role in which he was cast by a tradition of French writers on art as the arch colorist in contrast to those painters bound by the rules of *disegno*.

31. One possible exception, a painting of *Abraham's Sacrifice* in Munich which is signed "Rembrandt.verandert. En overgeschildert. 1636," has, however, been identified as either Rembrandt's second version of his own painting or a studio reworking of his Leningrad painting which he signed. See Ben Broos, "Fame Shared Is Fame Doubled," in *Rembrandt: The Impact of Genius* (Amsterdam, 1983), pp. 38–39, and *Corpus*, 2:50. In the 1656 bankruptcy inventory there were six still-lifes listed as retouched or overpainted by Rembrandt.

32. This analysis of Rembrandt's "hand-made" paintings as suited in specific ways to the marketplace contrasts with Meyer Schapiro's analysis of abstract art as the "last hand-made, personal objects," which, by his implication, oppose the general culture; see his "Abstract Art," reprinted in *Modern Art: Nineteenth and Twen-*

tieth Centuries (New York: Braziller, 1978), pp. 217–18. Rembrandt is, of course, not the only artist in the tradition whose aura of individuality in the production of his works was extended through assistants. But Mark Rothko (like so many artists, an admirer of Rembrandt) did not reveal the fact that he used assistants to lay down the ground for his paintings.

33. Schwartz makes a similar point about Rembrandt and the market, but construes it negatively; *Rembrandt*, pp. 226–27.

34. The German painter and writer Sandrart reports the high fees charged to pupils and deplores Rembrandt's lack of a sense of social rank and his mixing with the lower classes: "hat er doch seinen Stand gar nicht wissen zu beachten und sich jederzeit nur zu niedrigen Leuten gesellet. . . ." Joachim von Sandrart, *Academie der Bau- Bild- und Mahlerey-Künste von 1675*, ed. A. R. Peltzer (Munich: G. Hirth, 1925), p. 203.

35. For grabbing at painted coins, see Houbraken, 1:272; for the purchase at auction of the Dürers, see *Documents*, no. 1638/2, p. 150. While other artists were characteristically accused of squandering their money on drink, *the* artist's disease at the time, Rembrandt squandered it on more possessions. It is worth noting that Rembrandt was never accused of drinking, indeed Houbraken specifically says that he did not spend much time at taverns; Houbraken, 1:272. For Mieris's drinking, and drinking as a general problem for Dutch painters, see Otto Naumann, *Frans van Mieris*, 2 vols. (Doornspijk: Davaco, 1981), 1:31–32.

36. In explaining Amsterdam's economic dominance in the seventeenth century, historians differ on the degree of innovation that was involved. Most conclude that the Dutch extended practices that existed already. It was not in the organization of production, in which they remained protective and fixed in their ways, but rather in the establishment of, and enthusiastic support of, a market for capital and for commodities that they shone. The basic, general account of the Dutch economy is still Violet Barbour, *Capitalism in Amsterdam in the Seventeenth Century* (Ann Arbor: University of Michigan Press, 1963 [first published in 1950]); Rembrandt's collection was described as encyclopedic by R. W. Scheller, "Rembrandt en de encyclopedische verzameling," *Oud Holland* 84 (1969): 81–147.

37. *Documents*, no. 1642/10, p. 232.

38. Baldinucci, p. 80. Hoogstraten also says that paying a high price for the Lucas enhanced the appreciation of art in general; Hoogstraten, pp. 212–13. Given Rembrandt's interest in establishing value on the market, it must have been particularly devastating for him that at the bankruptcy sale his collection of prints—retroactively to be valued at 4,000 guilders—apparently sold for only 470 guilders! Not only did he lose what he had collected, but the value of art was not upheld. For the evidence that the market for old prints was weak at the time, see B. P. J. Broos's review of the *Documents* in *Simiolus* 12 (1981–82), p. 260. It is possible that the small amount realized was due to the fact that much of the collection had been sold previously; see *Corpus*, 2:93.

39. See P. J. Mariette, *Abecedario de P. J. Mariette et autres notes inédites de cet amateur sur les arts et les artistes*, 6 vols., *Archives de l'art francais* (Paris: J. B. Dumoulin, 1857–58), 4:350–51. Baldinucci had earlier made a general point about Rembrandt buying back his own etchings at extravagant prices to establish their merit: "Conquesti suoi intagli elgi giunse a posseder gran ricchezza, a proporzione della quale se fece sì grande in lui l'alterigia, e 'l gran concetto di se stesso, che parendogli poi, che le sue carte non si vendesser più il prezzo, ch'elle

meritavano, pensò di trovar modo di accrescerne universalmente il desiderio, e con intollerabile spesa fecene ricomperare per tutta Europa quante ne potè trovare ad ogni prezzo." Baldinucci, p. 80.

40. Motto from Burchard Grosmann's Album, ms. 113 C 14. fol. 233r. The Hague, Koninklijke Bibliotheek. The full text reads: "Een vroom gemoet / Acht eer voor goet," which has been translated as "The resolute, or a pious mind, places honor above wealth or possession." *Documents*, no. 1634/6, p. 111. Ben Broos has dated the entry from before, not after, Rembrandt's wedding, and he translates *goet* as gold. He remarks on the connection between this phrase and Rembrandt's behavior towards the profession at auctions, though without a market emphasis. See B. P. J. Broos, review of *Documents*, in *Simiolus* 12 (1981–82): pp. 254, 257.

41. Karel van Mander had cited honor and profit, Samuel van Hoogstraten the Senecan love of art, wealth, and fame; and the artist Hendrick Goltzius made his singularly appropriate name into the device "*eer over Golt*," which stressed the implicit moral hierarchy. For a view of Rembrandt as a supporter of this system of values in his encyclopedic collection, see R. W. Scheller, "Rembrandt en de encyclopedische kunstkamer," *Oud Holland* 84 (1969): 132–46; on Rembrandt and honor, see Julius S. Held, "Aristotle," in *Rembrandt's "Aristotle*," pp. 42–45.

42. The quotations are from Thomas Hobbes, *Leviathan*, ed. C. B. Macpherson (Harmondsworth: Penguin Books, 1968), pp. 151–52. The *Leviathan* was first published in London in 1651. In the Dutch translation the passages read, "De *Valuatie*, ofte WAERDYE van een persoon, is, gelijck van alle anderen dingen, zijn prijs," and "De bekentmaeckinge van de Valuatie, daer wy malkanderen op stellen, is dat gene, het welck wy gemeenlijck Eeren, ofte Onteeren noemen." *Leviathan* (Amsterdam: Jacobus Wagenaar, 1667), sig. F2, p. 83, and sig. F2v, p. 84. The Dutch edition, reprinted in 1672, was, as far as I can ascertain, the only translation in the century of this book which, after the first edition, could not be openly printed in England. See Hugh Macdonald and Mary Hargreaves, *Thomas Hobbes: A Bibliography* (London: The Bibliographical Society, 1952), no. 47, p. 36, no. 47a, p. xvi. For his reading of Hobbes, I am indebted to C. B. Macpherson, *The Political Theory of Possessive Individualism: Hobbes to Locke* (Oxford: Oxford University Press, 1983 [first published in 1962]). See Schama, *Embarrassment of Riches*, pp. 330–35 for a discussion of "honor before gold" in its traditional Christian and humanist usage.

43. See Th. van Tijn, "Pieter de la Court: zijn leven en zijn economische denkbeelden," *Tijdschrift voor Geschiedenis* 69 (1956): 304–70.

44. I have in mind such English writers as Hobbes, Petty, Locke, and Adam Smith, as well as those pamphleteers whose reactions to Holland's success are discussed by Joyce Oldham Appleby, *Economic Thought and Ideology in Seventeenth-Century England* (Princeton: Princeton University Press, 1978). This is not the only subject at the time on which the English supplied the words to match Dutch practices: Bacon and natural knowledge was another. Of the many accounts of the change from barter to an exchange system, I found particularly helpful Louis Dumont, *From Mandeville to Marx: The Genesis and Triumph of Economic Ideology* (Chicago: University of Chicago Press, 1977; Midway reprint, 1983).

45. For the modern economic definition of value, see Michael Allingham, *Value* (London: The Macmillan Press, 1983). See Joseph Schumpeter, *History of Economic Analysis* (New York: Oxford University Press, 1954; paperback ed., 1986)

for the definition of the field of economic thought, and Louis Dumont, *Mandeville to Marx*, for a commentary on what it is that Schumpeter defined.

46. The comments on credit and the bourse are quoted from the memoirs of a Dutch merchant in 1699 by Violet Barbour, *Capitalism in Amsterdam*, pp. 45, 79.

47. Joseph Penso de la Vega, *Confusion de Confusiones: Dialogos Curiosos entre uno Philosopho Agudo, un Mercader Discreto y un Accionista Erudito, descriviendo el Negocio de la Acciones* (Amsterdam, 1688; reprint and tr., Cambridge, Harvard University Press, 1957).

48. "Among the plays which men perform in taking different parts in this magnificent world theater, the greatest comedy is played at the Exchange," ibid., p. 16. For a consideration of the relationship between the market and the theater, see Jean-Christophe Agnew, *Worlds Apart: The Market and the Theater in Anglo-American Thought, 1550–1750* (Cambridge: Cambridge University Press, 1986).

49. For a powerful analysis of this, see Ferdinand Tönnies, *Community and Association*, tr. Charles P. Loomis (London: Routledge & Kegan Paul, 1955), pp. 84–85.

50. Adam Smith, *The Wealth of Nations* (1776; New York: Modern Library, 1965) vol. 1, chap. 4, par. 1.

51. For the Kassel *Holy Family*, see Wolfgang Kemp, *Rembrandt: Die Heilige Familie oder Kunst: Einen Vorhang zu Lüften* (Frankfurt: Fischer, 1986). The collectible character of the Kassel painting does not explain other paintings from the forties—the years when Rembrandt and his assistants experimented with illusionistic effects. For the description of paint like dung, see Gerard de Lairesse, *Groot Schilderboek* (Haarlem, 1740 [reprint, Utrecht: Davaco, 1969]), p. 324: "het sap gelyk drek langs het Stuk neer loope," or, roughly, the sap runs down the piece like dung. Lairesse included Jan Lievens along with Rembrandt in this criticism.

52. Georg Simmel, *The Philosophy of Money*, tr. Tom Bottomore and David Frisby (London: Routledge & Kegan Paul, 1982), pp. 157, 156, 328.

53. Among other essays on art and artists, Simmel also wrote a disappointing study of Rembrandt (1916). He could summon up the ideals suggested by real money, but he was unable to grant what is real behind the ideals of art.

54. See *Corpus*, vol. 1, no. A10, pp. 137–42, for a summary of what is known about the painting.

55. I am indebted to Simon Schama for calling attention to what he astutely refers to as "the sexual economy" of Dutch images and Dutch society. The only whorish sexual play in Rembrandt, to my knowledge, is a single sheet of drawings, Ben. 100 verso.

56. One hundred thirty-five drawings by Rembrandt of women and children ("135 tekeningen sijnde het vrouwenleven met kinderen") were inventoried in the estate of the painter Jan van de Capelle in 1680. The category is assumed to have been established by Rembrandt. See Hofstede de Groot, *Die Urkunden über Rembrandt* (The Hague: Nijhoff, 1906), no. 350. For an account of these drawings which relates them more firmly to artistic sources than I have done here, see Peter Schatborn, "Over Rembrandt en kinderen," *De kroniek van het Rembrandthuis* (1975): 9–19.

57. Karl Marx, *Capital* tr. Ben Fowkes (New York: Vintage Books, 1977), pp. 742, 739.

58. Simmel, *Philosophy of Money*, pp. 248–51.

59. See Roger de Piles, *Abregé de la Vie des Peintres* (Paris, 1699), p. 434, and Houbraken, 1:273.

60. Held, "Aristotle," pp. 42–43.

61. There has been much written on the problem of how to characterize Rembrandt's interest in himself and in mankind. See Margaret Deutsch Carroll, "Rembrandt as Meditational Printmaker," *Art Bulletin* 63 (1981): 585–610 for a religious contextualization; Eleanor A. Saunders, "Rembrandt and the Pastoral of the Self," *Essays in Northern Art Presented to Egbert Haverkamp-Begemann* (Doornspijk: Davaco, 1983): pp. 222–27 for a poetic one.

62. See John Locke, *Second Treatise*, in *Two Treatises on Government*, ed. Peter Laslett (Cambridge: Cambridge University Press, 1960), secs. 123, 173. Where Rembrandt's paintings are concerned, the descriptive force of texts such as these is evident. Although written by a Leveller, a passage by Richard Overton is helpful to read with Rembrandt's multiple self-portraits in mind: "To every Individuall in nature is given an individual property by nature, not to be invaded or usurped by any: for everyone as he is himselfe, so he has a self propriety, else could he not be himselfe. . . . Every man by nature being a King, Priest and Prophet in his owne naturall circuit and compasse"; quoted in C. B. Macpherson, *The Political Theory of Possessive Individualism: Hobbes to Locke* (Oxford: Oxford University Press, 1983), p. 140. For an explanatory account, a study is needed which will focus on the representation of the individual in Dutch society and texts of the time. For now, Rembrandt serves as our native informant and representative figure. For a nuanced consideration of the concept of the individual, see *The Category of the Person*, ed. Michael Carrithers, Steven Collins, and Steven Lukes (Cambridge: Cambridge University Press, 1985).

63. For self-portraits as the taking on of different roles, see H. Perry Chapman, "The Image of the Artist: Roles and Guises in Rembrandt's Self-Portraits" (Ph.D. diss., Princeton University, 1983).

64. For Mieris's order from the Medici, see Otto van Naumann, *Frans van Mieris*, 2 vols. (Doornspijk: Davaco, 1981), 1:27–28 and 125–26. I cannot agree with Naumann (p. 126) that self-portraits are exceptional "because it is much more likely that an artist would paint his own image according to some personal whim." For the sheer number of self-portraits, see Götz Eckardt, *Selbstbildnisse niederländische Maler des 17. Jahrhunderts* (Berlin: Henschelverlag, 1971); for the iconographic traditions engaged, see Hans-Joachim Raupp, *Künstbildnis und Künstlerdarstellung in den Niederlanden im 17. Jahrhundert* (Hildesheim: Georg Olms, 1984), and Richard Whittier Hunnewell, "Gerrit Dou's Self-Portraits and Depictions of the Artist" (Ph.D. diss., Boston University, 1983). For artist self-portraits with their families, see above, chapter 1. It is notable how few of Rembrandt's self-portraits fit the categories of an iconographic study such as Raupp's.

65. The 1667 visit of Cosimo de' Medici to Rembrandt's house is his only recorded meeting with royalty; see *Documents*, no. 1667/6, pp. 569–70.

66. It is puzzling that no self-portraits are inventoried in the 1656 bankruptcy sale. Schwartz's conclusion that they must have been already sold does not seem warranted. It has also been suggested that perhaps they were exempted from the inventory because they were considered family portraits; *Corpus*, 2:94 n.

67. It has been noted that Rembrandt painted a noticeably large number of his self-portraits (including the Liverpool painting) on reused supports over previous figures which were scratched down for the purpose; see *Corpus*, 1:32 for this

point. This essentially economical procedure suggests that they were study works. One might also consider what was involved in inscribing one's own face over another figure.

68. See Martin Heidegger, "The Origin of the Work of Art," in *Poetry, Language, Thought,* tr. Albert Hofstadter (New York: Harper & Row, 1971), p. 36; Meyer Schapiro, "The Still-Life as a Personal Object," in *The Reach of Mind,* ed. Marianne Simmel (New York: Springer, 1968), pp. 206, 207; Jacques Derrida, *La Verité en Peinture* (Paris: Flammarion, 1978), p. 340; tr. Geoff Bennington and Ian McLeod, *The Truth in Painting* (Chicago and London: University of Chicago Press, 1987), p. 298: "—so a work like the shoe-picture exhibits what something lacks in order to be a work, it exhibits—in shoes—its lack of itself, one could almost say its own lack."

69. Writers did on occasion, it is true, identify themselves with a book; see "The Word of God in the Age of Mechanical Reproduction," in Stephen Greenblatt, *Renaissance Self-Fashioning* (Chicago: University of Chicago Press, 1980).

70. For the multiple Six portraits, see Corn. Hofstede de Groot, "De portretten van het echtpaar Jacob Trip en Margaretha de Geer door de Cuyp's, N. Maes and Rembrandt," *Oud Holland* 45 (1928): 255–64. Another recorded instance of multiple portrayals are those ordered by the calligrapher Lieven van Coppenol, who was etched by Rembrandt; see B. P. J. Broos, "The 'O' of Rembrandt," *Simiolus* 4 (1971): 150–84.

71. For a list of English eighteenth-century artists who did self-portraits in the manner of Rembrandt, see Christopher White et al., *Rembrandt in Eighteenth-Century England* (Yale Center for British Art, 1983), p. 23.

72. "Well, if you think of the great Rembrandt self-portrait in Aix-en-Provence, for instance, and if you analyze it, you will see that there are hardly any sockets to the eyes, that it is almost completely anti-illustrational. I think that the mystery of fact is conveyed by an image being made out of non-rational marks. . . . There is a coagulation of non-representational marks which have led to making up this very great image," said by the English painter Francis Bacon to David Sylvester. *Interviews with Francis Bacon 1962–1979* (London: Thames & Hudson, 1980), p. 58.

73. *Corpus,* 1:xx.

74. For the point about the increasing number of works attributed to Rembrandt, see *Corpus,* 2:48–51.

INDEX